THE PLAINS OF ABRAHAM

Jacques Mathieu
Eugen Kedl

THE PLAINS OF ABRAHAM
The Search for the Ideal

Translated by Käthe Roth

septentrion

Each year, les éditions du Septentrion receives financial aid from the Canada Council for the Arts and the Ministère des Affaires culturelles du Québec for its publishing program. Production of this book was an initiative by the National Battlefields Commission.

Cover: "A view of the Orphans or Ursuline Nunnery Taken from the Ramparts." Drawn by Richard Short. Engraved by James and sold by Thomas Jeffereys. Short made the drawing standing near where the Commission's offices now stand. At the time, fifty nuns lived in the nunnery and "instructed sixty boarding-school students and about 150 little day students."

Editorial supervision: Denis Vaugeois, assisted by Michel Leullier and by Louise Germain of the National Battlefields Commission.

Production team: Louise Chabot, Marie Guinard, Josée Lalancette, Andrée Laprise, Pierre Lhotelin, Christian Paradis

Researchers: Alain Beaulieu, Serge Lambert, Sylvie Tremblay

Translator: Käthe Roth. French edition available through Éditions du Septentrion.

Graphic design: François Tremblay

Total print run of 4,200, including 1,200 in English. Two hundred copies have been specially bound and include a silkscreen after a work by Antoine Dumas.

Legal deposit – 1st quarter 1993
Bibliothèque nationale du Québec

Co-published in cooperation with the National Battlefields Commission and the Canada Communication Group—Publishing, Supply and Services Canada.

Catalogue number: EN143-2-1992E

If you would like to know about publications by
ÉDITIONS DU SEPTENTRION,
please write us at
1300 av. Maguire, Sillery (Québec) G1T 1Z3
or send a fax to (418) 527-4978.

Canadian cataloguing in publication data

Mathieu, Jacques, 1940-

Plains of Abraham: the search for the ideal

Translation of: Les Plaines d'Abraham.

ISBN 2-921114-85-2

1. Plains of Abraham (Québec, Quebec) – History. 2. Québec (Quebec) – History. 3. Plains of Abraham (Québec, Quebec), Battle of the, 1759. I. Title.

FC 2946.65.M3713 1992 971.4'471 C92-097351-5
F1054.5.Q37P5213 1992 744 24

A WORD FROM THE PRESIDENT

*I*T HAS BEEN ALMOST A CENTURY since the National Battlefields Commission was founded. Its first president, George Garneau, also mayor of Québec City at the time, established the Commission's mission: the conservation and development of the exceptional site that is the Plains of Abraham.

The presidents and commissioners that succeeded him, all volunteers, have made a sustained effort to execute the landscaping plan skillfully laid out by the landscape architect Frederick G. Todd.

This unique promontory, bordered by the majestic St. Lawrence River and the old fortified town, has been the site of the great battles of 1759 and 1760, secret host to numerous love trysts, and a green space for the industrial city of the nineteenth century. Today, Battlefields Park is the scene of great socio-cultural gatherings. Traditionally reserved for military manoeuvres, then for munitions manufacturing, its vocation gradually evolved to include sports activities like golf, horse racing, and snowshoeing, and, later, family outings.

The Plains of Abraham are the pride of the people of Québec City. They are also the envy and delight of the millions of visitors that come to admire the site's wealth and beauty each year.

This book pays homage to the thousands of people who have shaped and refined the image of what we know as National Battlefields Park.

In the name of the commissioners and employees of the National Battlefields Commission, I hope that in this beautifully illustrated book you will discover the magnificent history of the Plains of Abraham, marked with the most noble memories and passions.

Jacques Villeneuve
Président

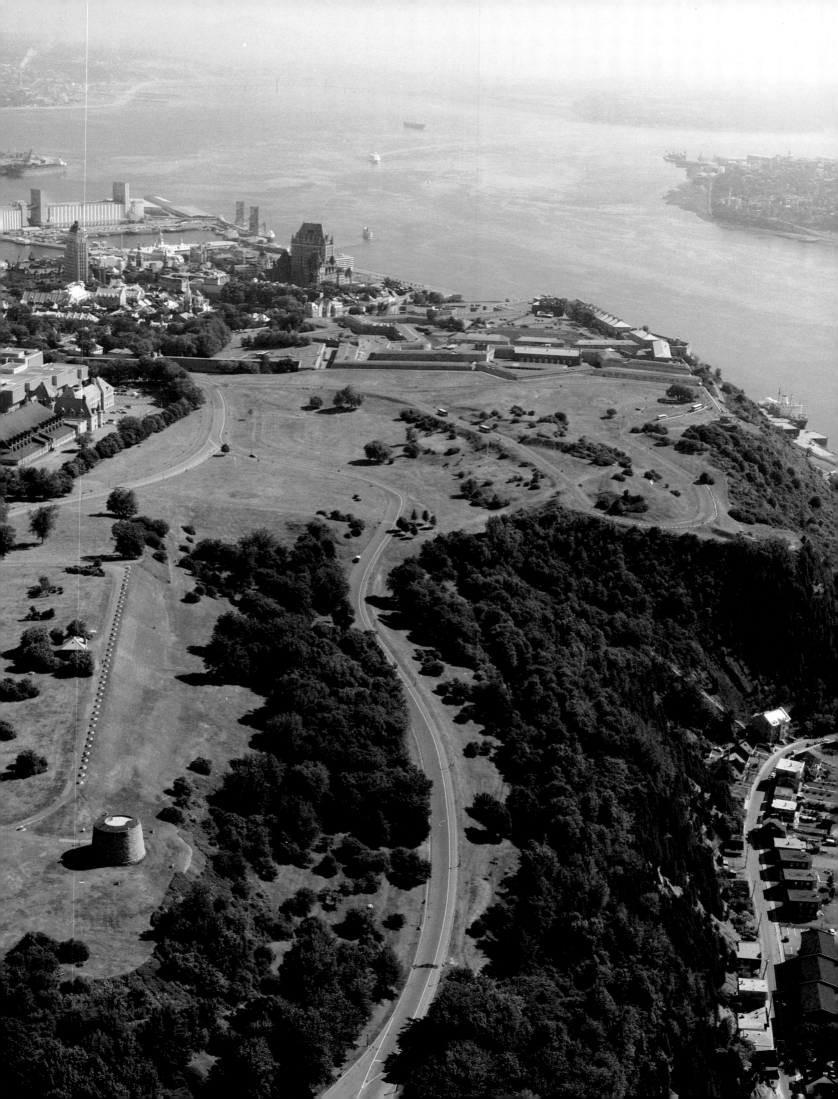

INTRODUCTION

The Search for the Ideal

"Le culte de l'idéal." These were the words used by George Garneau, mayor of Québec City and future first chairman of the National Battlefields Commission, on October 28, 1907, to convince the prime minister of Canada, Wilfrid Laurier, to purchase the site of the Plains of Abraham. Garneau wanted the Plains to have a future as brilliant as their past had been.

*T*HE PLAINS OF ABRAHAM. Here, the cliffs are emerging instead of subsiding. For the discoverer of Canada, the site was a cape of gold and diamonds; for the founder of Québec City, it was a promontory that would permit control of commercial traffic with China. A battlefield where the struggle for world hegemony and, incidentally, the destiny of Canada, was played out in armed conflict between France and England, its citadel was the seat of power and the key to a continental defence system. Its views are unparalleled in North America. Today, it is an immense romantic garden, the "lung" of a city, a commemorative park, a place for leisure and memories, an extraordinary playing field, where sports wed a sound body to a sane mind. The Plains have been an unexplored promontory, a space on the edge of the city and on the margin of accepted ways of life, a living heritage, a natural landscape modified by humans. From its beginnings to the present, this site has excited people and expressed their ideals.

All of these images, incarnate in the Plains, are part reality and part fantasy—both truth and fabrication. Revered because of the aspirations they raise among both Québecers and visitors, the Plains bespeak authority for some; for others, they express the margins of society—a sacred spot which Québecers have occasionally joyfully profaned.

On this splendid stage, carved out of slate millions of years old, defined by a very particular geographic configuration—a promontory of a few square kilometres towering eighty metres above sea level—pivotal acts of history took place. To the spatial understanding of the site is thus added that of the facts that have shaped it over time. Every period has left its very vivid mark.

Over the years, generations, and centuries, these facts have accumulated into a considerable collection of major events and daily actions, integrated into the lives and memories of Québecers, yet with an impact far beyond the region itself. In the sixteenth century, the escarpment embodied Europe's expectations for the New World: gold and diamonds. In the seventeenth century, the promontory rose as a beacon from where, it was hoped, the lucrative trade in spices with

Cap-aux-Diamants, the escarpment and indentations of the southern cliff.

9

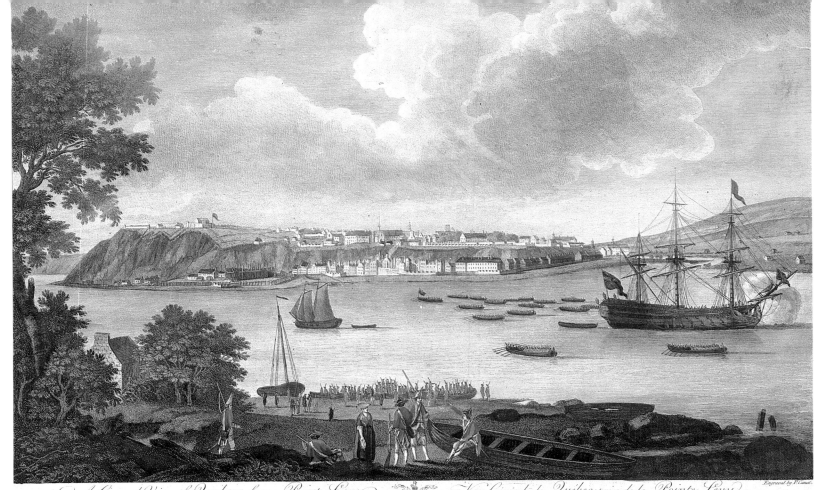

A General View of Quebec, from Point Lévy. — Vue Générale de Québec, prise de la Pointe Lévy.
To the Hon.ble S.r CHARLES SAUNDERS Vice Admiral of the Blue and Knight of the most Honourable Order of the BATH
These Twelve Views of the Principal Buildings in QUEBEC, are most Humbly Inscribed by his most Obedient Humble Servant Richard Short
Sept.r 1761. Published according to Act of Parliament by R.Short, & Sold by T.Jefferys the Corner of S.t Martins Lane, Charing Cross.
Engraved by P.Canot.

Asia could be controlled, and as an outpost of colonization. In the mid-eighteenth century, it was the site for a war that had worldwide effects, waged between the American colonies, supported by the English home country, and France, its "Canadian" subjects, and its aboriginal allies. Later, the site was attacked by the Americans, who, during the War of Independence, were even fiercer adversaries of the English. When the British erected an imposing citadel on the promontory at the beginning of the nineteenth century, they were of course aiming to protect Québec against attacks by the Americans or the French, but they were also preparing for a possible conflict with the French Canadians, who comprised the majority of the population along the shores of the St. Lawrence River. This fortress, deemed impenetrable, was never attacked, but it profoundly influenced the urban development of and ways of life in Québec. The gates, the ramparts, the advance defence positions, and the promenade shaped the city in the second half of the nineteenth century. Military men first laid out the town and then, from the heights of the Citadel, both dominated it and decided its future. And it was on this promontory that the military played their games and introduced their sports, infusing town life with a respect for discipline of body and mind as well as a philosophy of life. In these periods, when cities were hard hit by epidemics, the Plains became a symbol of healthy air for Québecers.

The wave of Romanticism rolling through the Western world had positive repercussions in Québec City. The ramparts of the city and the Citadel, obsolete but protected by the authorities, were preserved rather than destroyed when the British troops retreated in

The Québec promontory seen from Lévis. (R. Short 1760, NAC)

1871. Urban development, a sign of economic prosperity, was accompanied by a desire to safeguard green spaces. The Ursulines' proclaimed plan to divide the Plains of Abraham into parcels of land was aimed more at accelerating negotiations with the government to purchase the Plains and turn them into a public park than at starting construction projects. Inspired by the examples of Central Park in New York, the Bois de Boulogne in Paris, and Mount Royal in Montréal, the political authorities and cultural milieux also pressed for a park. The government of Canada acceded to the demands: on the Plains, a natural and commemorative park was created. At the great public gathering there in 1908, when tens of thousands celebrated the tricentennial of the founding of Québec, there was an attempt to create friendly relations between Francophones and Anglophones.

In the twentieth century, the park provided Québec City residents with an escape from urban constraints. The park became a site for family outings, recreation for young children, and more marginal activities. In every way, the unique is cheek by jowl with the international on the Plains of Abraham.

These great evocations of the Plains recall only part of the history of the site. Some extraordinary facts lie forgotten behind the veils of memory! The individual who lent his name to the site never set foot on it. How did he inadvertently come to have the honour of being associated for posterity with the Plains? Other little-known people also lived there: master printer-booksellers from Paris, an Italian noble, a Belgian herbalist, and others. Two army chiefs died there during a battle that lasted less than thirty minutes yet changed the course of world history. A woman, Corriveau, infamous for murdering at least one of her husbands, was hanged there, near the spot where a statue of Joan of Arc stands today. Hidden underground is a huge water reservoir that serves the city. On the present site of the race track, ethnic strife was once played out. The Citadel was erected in part by the descendants of the vanquished of 1759. At the other end of the park, a century later, a children's garden was created. At one time, there were astronomical and meteorological observatories, beside a rifle factory and military barracks which later sheltered homeless poor people. The Plains offer fireworks and commemorative festivals to punctuate the daily rhythm of life, marked by quiet strolls along flowered paths. Replaying its role of impressive fortress, it hosts mock battles which provide very popular entertainment. Time and space, stories grand and humble, are melded in a tale more incredible than one could have imagined.

And yet . . . all the stories are true!

Jacques Mathieu

CHAPTER ONE

The Natural Setting
of the Heights
of Abraham

Jacques Mathieu, with Gilles Ritchot

A Site Imbued with Symbolism

*T*HE HEIGHTS OF ABRAHAM form a distinct geographical and topographical entity. However, this natural setting is insepa rable from the symbolism evoked by its physical attributes, which imbue it with strength, energy, and significance.

The shapes of a landscape, its visible contours, are not simply an interface between living beings and the elements of air, water, rocks, and fire. Upon closer examination, we observe that the countryside is composed of geometric figures which have a certain evocative power. Even the morphological characteristics of a natural setting immediately impose a symbolic dimension. In this sense, the Heights of Abraham evoke a platform of honour devoted to the valorization of a special place. The Heights speak to us.

The naming of this site is very eloquent. The official name, Battlefields Park, refers to events impressive in amplitude and historical significance. The cliff that dominates the Heights is known as Cap-aux-Diamants. As for the name "Abraham," perhaps it was added because it had a biblical resonance.

These various names do not find concrete justification in the countryside itself. The sites of battle overflow the boundaries of what is now known as the Plains of Abraham. Abraham Martin was a simple subject of the King, in the seventeenth century, who had nothing to do with how the Heights were used. The diamonds of the Cap-aux-Diamants were merely quartz.

The rocky crags of Cap-aux-Diamants crown the eastern end of the Heights. It seems self-evident that in 1608 Samuel de Champlain was somewhat taken in by the same illusion as Jacques Cartier. Champlain told of diamonds "better than those of Alençon." If you say so! But why did the founder of Québec choose to attribute this quality to this site? There were other sites—for instance, the south shore around the Etchemin River —where the geological formation had similar mineral properties. Did the quartz resemble diamonds only here, where the silhouette of the cliffs projected a feeling of strength that reminded Champlain of the durability of this everlasting crystal? Was it the imposing presence of the cape itself that sug-

In this natural environment, rich with strength and serenity, symbols and uses constantly multiply and overlap.

15

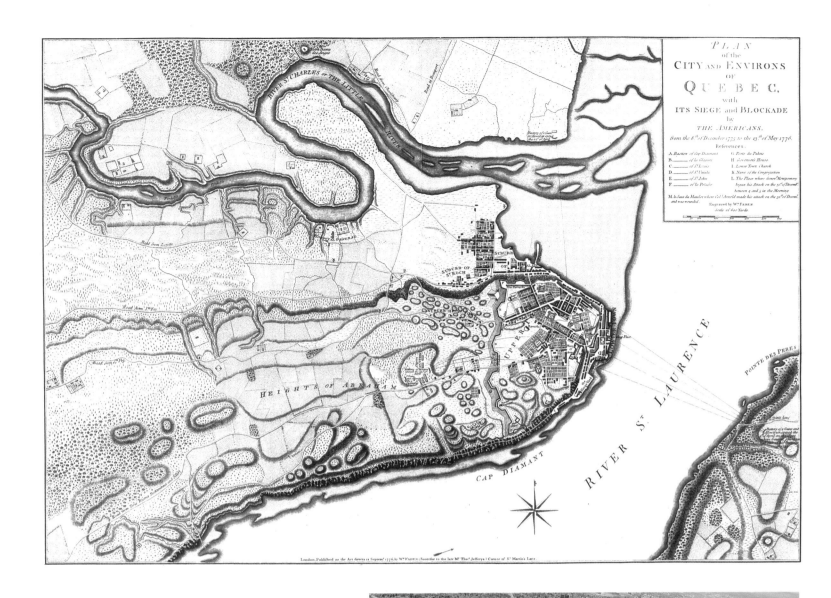

Bordered by steep cliffs to the south and by subsiding cliffs to the north, the site of the Plains of Abraham is not at all flat. The rocky bar swelling at their end is, where Cap-aux-Diamants rises, almost one hundred metres above sea level. (**Plan de la ville et du siège de Québec en 1775–1776**, NAC)

The Plains of Abraham, from the fortified wall to the urban zone to the north and west.

gested that its substratum must harbour precious stones? Although the diamonds were mythical, the site symbolized what would become "one of the most beautiful urban sites in the world." Québec, with its Cap-aux-Diamants and its Plains of Abraham—this God-given site, to use an expression of Françoise Choay—was gradually converted into a jewel of world heritage, even if the jewel in question is symbolic, like the diamonds in the cape.

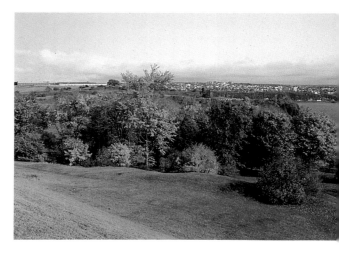

The Characteristics of the Promontory

Although it is called a plain or a plateau, the Québec promontory is not flat or uniform. From the east to the west—that is, from the far end of the Citadel to Pointe-à-Puiseaux, marked by the spire of Saint-Michel Church on the heights of the river shore—the altitude dips from one hundred to sixty metres. Close to the Citadel, the crags of Cap-aux-Diamants are impregnable cliffs, a sheer drop of one hundred metres' altitude to the river; to the east and the north, the escarpment is less high and less abrupt. At its foot, the river waters are tumultuous, compressed between cliffs that narrow the river for at least a kilometre and impose a short and sudden change of direction, in contrast to the lazy little St. Charles River, which meanders through the valley between the Laurentians and the promontory. Although the vertical drop of the cliffs is sensational at Cap-aux-Diamants, elsewhere rock ledges interrupt the vertical lines. These steps, which comprise a transition between the summit of the promontory and the river shores or the north valley, have been tamed by humans: the Saint-Jean *faubourg*, Terrasse Dufferin, Lord Grey's belvedere on the Plains, the luxurious Mérici buildings.

The relief characteristics of the landscape provide unequalled vistas. At the cliff where the Citadel sits, the bottleneck that squeezes the river between the cliffs gives the impression of a very strong unity. The Algonkian word "Québec" means that the river, which provides access to the heart of the continent, has from time immemorial been constricted by a narrowing; navigators of bygone centuries called this passageway the "Gibraltar of North America."

Just west of the Citadel, the vista changes utterly: the steep, closed landscape gives way to a restful, open panorama. The rocky stratum dips below the alluvial lowlands of the Etchemin River, which widens out and is, in places, as calm as a lake. It blends with the lowlands, which gently undulate all the way to the far-off horizon of the Appalachians. Toward Sillery, the St. Lawrence River is banked by a monotonous stretch of rocky bars. One must look northeast to remind oneself of the proximity of the fascinating crags of the Citadel, abutting the Heights of Abraham.

The promontory pierced by a ravine; in the autumn, wild nature offers its most beautiful colours there.

The uneven natural terrain lends itself to all sorts of uses, in every season.

In front of the Citadel, at the summit of the cliff, is a belvedere looking out on "the most marvellous view in the world."

The uneven natural terrain on the site of the Plains was respected when the park was landscaped. In the background, the fortifications; right, the raised ravine; front right, animals in a paddock. (J. Peachey, **La citadelle temporaire depuis les hauteurs d'Abraham**, 1784, NAC)

Trees, shrubs, and undulations create surprising effects.

Morphological Organization of the Plains

The Québec promontory is about ten kilometres long and one kilometre wide. The eastern end, around Cap-aux-Diamants, is occupied by the Citadel and an urban habitat most of which is old and institutional. The northern and western parts are given over to housing the quality of which improves as the elevation rises toward the river, the site of the Plains—in short, the Heights of Québec.

The Plains of Abraham occupy a part of this hilly bar. Stretching along the river for a few kilometres, a few hundred metres wide, the Plains have an area of a little more than one hundred hectares, comprising one of the largest landscaped parks in the world. At either end of the Plains is a hollow. Just west of the Citadel cliff, a slight ravine is enclosed in a semicircular valley that looks like it was scooped out by a giant spoon. Farther west, another small ravine pierces the cliff, Côte Gilmour; the primary natural pathway providing almost unimpeded access to the summit, it was used by the besieging army of 1759.

The plateau of the Heights between these two ravines is broken into a sort of keyboard, with keys raised or depressed, flat or inclined, subtly articulated. Their profiles and softly undulating slopes give the valleys a look of softness, evoking a crisscrossing of waves rather than the well-defined squares of a checkerboard. The landscaping efforts of Frederick G. Todd at the beginning of the twentieth century have subtly enhanced this natural topography.

Some parts of this romantic garden recall historical events, while others reflect the activities that take place there now.

- West of the fortifications, the highest points of Cap-aux-Diamants extend a little beyond the fortifications, providing breathtaking views of the surrounding countryside.
- Immediately below, the ravine that broaches the cliff extends from the southern summit to Grande Allée. Below the Citadel cliff and Buttes-à-Nepveu, the ravine runs right across the Plains. It recalls the logic of military architecture; from the fortifications, it was possible to watch the movements of besiegers, see them coming from far, and keep them from installing their batteries within firing range of the walls.
- The next level covers one end of the municipal reservoir and hosts Jardin Jeanne-d'Arc. It leads to new heights.
- Buttes-à-Nepveu, where a windmill was erected under the French régime, then the Martello towers at the beginning of the nineteenth century, was once the second-highest point of the Plains.
- Adjoining these knolls and partly integrated with them are two slightly undulating rises about a hundred metres apart. This was the site of the 1759 military engagements.
- West of the Musée du Québec's two buildings stretch the Plains of

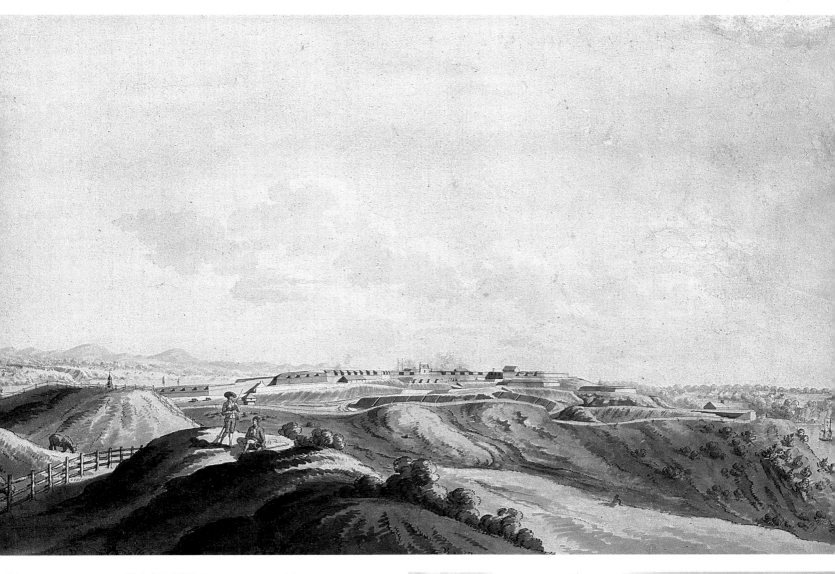

Gentle stepped rises provide access to various parts of the promontory.

Rolling hills invite people to stroll through the trees.

the Ursulines, a large and very flat area where playing fields have long been ensconced.

This general outline of the topography and uses of the Plains of Abraham provides some physical reference points, but it is not evocative of the symbols and values with which each of its parts has been invested.

The Formation of the Natural Setting

Our examination of the topography of Québec begins with a look at the central morphological component: the Québec plateau. It is clearly detached from the neighbouring corridors, which were overdeepened during the period of glaciation. This relief has been only slightly altered in recent millennia. Flanked to the north by the Laurentian Mountains and to the south by the Appalachians, the Québec plateau includes the floor of the Laurentian Valley. In and around Québec City, this floor cuts across geological formations of slate schist interspersed with sandstone; these lamellar formations are emerging at an angle of up to sixty degrees. Thus, the primeval reliefs throughout the region indicate a general erosion that cuts the surface of the landscape from its geological support. The lowlands were submerged by the vast expanse of water formed when the glacial ice melted, and the promontory of Québec was an island in the Champlain Sea.

The natural morphology of the entire region recalls, above all, the internal dynamic of the primeval surface that forms the Heights of Québec. This undulating surface divides the plateau into the Plains of Abraham (integrated with the hill of the upper town), Lévis, Charlesbourg, Île d'Orléans, and so on. It also divides the corridors, like that of Limoilou, drained by the small St. Charles River, northeast of the Québec hill, and that of St. Romuald, partially submerged by the St. Lawrence River. These corridors describe two arcs of a circle laid out end to end. At first an estuary of a post-glacial sea that once covered all of the lowlands, The St. Lawrence River was left behind as the water retreated. By the time the first European explorers arrived, the hilly bar of what is now the upper town was no longer an island.

The cliffs of the Québec promontory are alive; they are not just standing up well, they are actually emerging. Although they are relatively stable today, they are still active; some portions are even in a process of rejuvenation. The fact that vegetation, even shrubbery, has a hard time taking root, that the springtime rockslides are not uncommon, and that large boulders occasionally detach themselves are evidence of this activity. That the cliffs are emerging is the only explanation for the fact that they maintain their steep slope and severe profile instead of softening their lines and becoming covered with trees. The rocky substratum of the promontory is flexible and

Rockslides

Eight rockslides were counted between 1836 and 1864. Huge sections of rock, weighing several tons, fell with an unimaginable thunder. Sometimes entire slices of the cliff, measuring around 70 metres wide by 50 metres high by 15 metres deep, detached themselves and slid as far as the road. They flattened houses in their path, half of them resulted in mortalities. ✍

Avalanches

It is said, justifiably, that Québec City is the snow capital. It is no surprise that accumulations at the top of the promontory sometimes tumble from the cliff. On February 8, 1875, an avalanche swept away two houses; eight persons, including five children, were killed. In February of 1836, the avalanche that left twelve metres of snow on the road and caused one death was attributed to a noon cannon shot at the Citadel. ✍

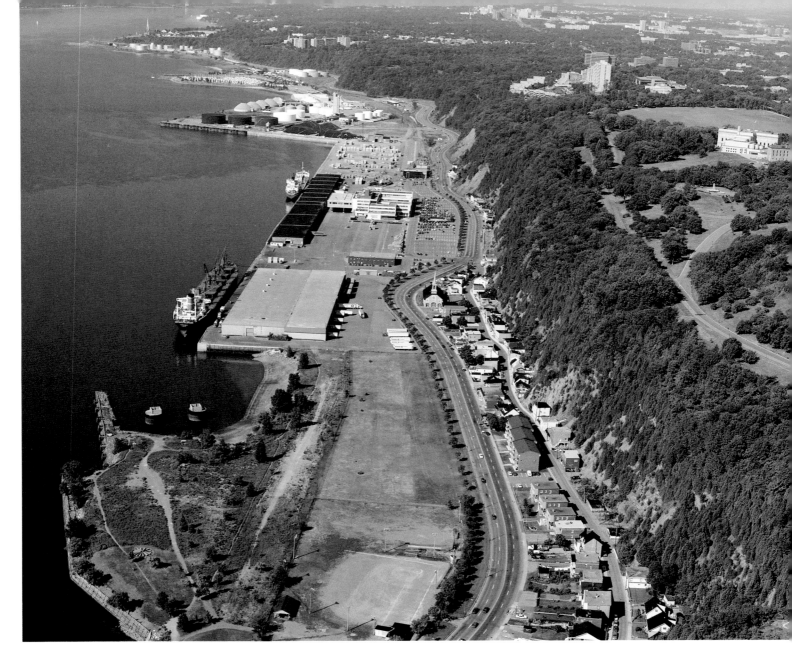

An abrupt cliff borders the promontory to the south. In the background, a notch that facilitates access to the Heights of Québec. This emerging cliff sometimes provokes rockslides.

At the foot of the cliff, on a narrow strip of debris, a building stretches lengthwise.

The slate, angled steeply, gives the impression of supporting the faces of the promontory, but it sometimes detaches.

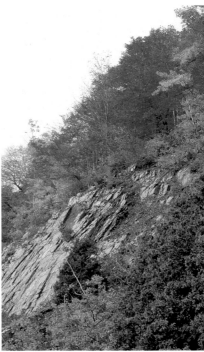

permeable. Where the schist layers dive in the same direction as the slope of the cliff, the low mechanical strength of the rock permits a slight subsidence at the summit, creating hollows. This subsidence goes hand in hand with a localized emergence of the top of the cliff. The resulting break in equilibrium causes large pieces of debris to fall in the form of boulders.

The Spirit of the Place

The geographical analysis of a natural setting inevitably has a part in the ensemble of interpretations concerning how life develops in the site. The relationship between humans and nature is complex and rife with meaning and symbols. Humans do not directly transform nature; they start by appropriating its characteristics and qualities. Then, they act upon the site for political, military, economic, or cultural reasons, thus consolidating the space's natural proclivities.

A wide variety of events, functions, and practices, with a taste of spirituality vocation or the strength of the soul, mark the feeling of the Plains of Abraham. Breathtaking views, invulnerable cliffs, and pure air are the site's innate traits, no less durable today. It has harboured mythical diamonds, soaked up the blood of heroes, been a laboratory for nature and a romantic garden. An excellent strategic location, it evokes power and even holiness. Relaxation and tranquillity give way to the explosiveness of festivals. The exciting discipline of sports exists side by side with shadowy expressions of promiscuity, the victories of individuals, couples, or groups over nature or the adversary. The founding of Québec City; the battles of 1759 and 1760; the nineteenth-century festivities; the reconciliation of the founding nations in 1908; the Eucharistic Congress in 1938; and the revitalization of the area would not have happened at a place named, simply, the Plains of Martin. All of this underlines the attraction of the site, but does not give a larger explanation.

These paths through time and transformations of the site were not foreordained. They were possibilities, inherent in the natural site, in the spirit, in the heart. This is where the character of the Plains of Abraham resides.

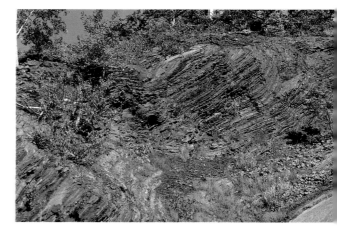

Rocky folds illustrate the shifts and vitality of the promontory.

Variations in the angles of the slate layers.

23

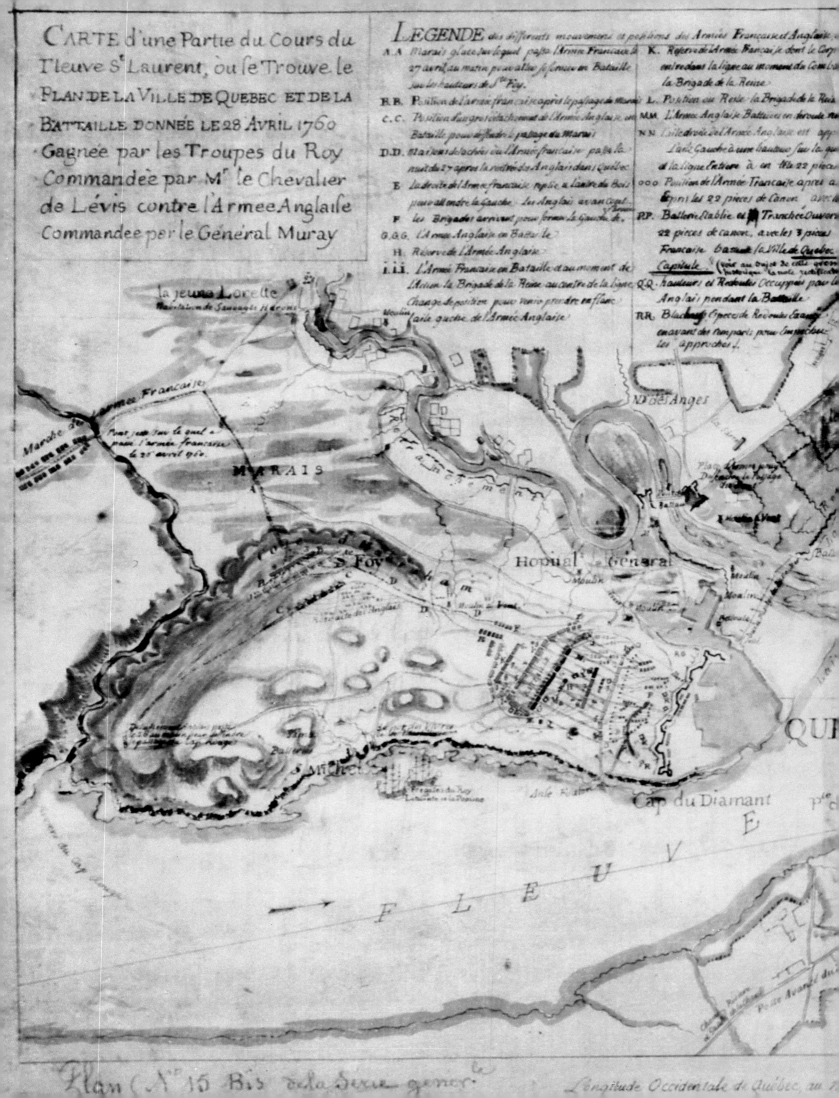

The Name and the Location

Jacques Mathieu
Alain Beaulieu

Where does the name *"Plains of Abraham"* come from? Who lent his name to this site on the Québec promontory? Should the place be called *"the Plains"* or *"the Heights"*? Is this name really appropriate? These questions have long been debated. Scholars, historians, and cultural leaders have undertaken research and rethought their positions.

An Interpretation and a Debate

The most commonly cited interpretation was made in 1863 by the historian J.-B.-A. Ferland, who studied the marriage registers of the parish of Notre-Dame de Québec during the French régime. He was following up on the theory of Vicar-General Thomas Maguire, who had "suggested that part of the Plains belonged to an individual with the name of Abraham." Ferland's review of the marriage registers revealed only one person with this first name, Abraham Martin dit l'Écossais, who arrived in New France in 1617. He had sailed with the founder of Québec, Samuel de Champlain, from whom he received a large plot of land; the first king's pilot in Canada, he soon established himself on the north side of the Québec promontory. The hill leading to his land, starting at the St. Charles River, is often called Côte d'Abraham, thus inheriting his name. This interpretation is viable, and has convinced most researchers.

Although Ferland's hypothesis on the origin of the name is widely accepted, some have questioned its pertinence, especially since it was not supported by a solid logical explanation. These researchers invoke historical, geographical, and moral arguments: Abraham Martin never possessed or lived on the parcels of land that carry his name today. As well, the custom was to use the last name of a person, rather than the first name. Furthermore, Abraham Martin was a fairly obscure character, who did nothing remarkable that would have justified lending his name to this site. Finally, he died in relative dishonour for having forfeited his honour with a sixteen-year-old seductress in 1649. He was married at the time, and three months earlier his wife had delivered a new baby, their ninth. It was also their last.

Other Proposals

Given the lack of pertinence of the name, other names have been proposed. Gérard Morisset has suggested that the site be called the Plains of the Ursulines. This idea had a historical foundation, since the religious community once owned a large part of the site and agreed to the exchange and sale necessary to make the magnificent public park. However, the name was almost as banal as "the Plains of Martin"—it had none of the symbolic power of the name of the great biblical prophet—and the suggestion was not taken up. Exiled in a faraway

This diagram of the 1760 battle locates Côte d'Abraham at the northwest end of the promontory, far from the current site, and portrays a foreign, military perception of the environs. It refers to the series of gently escarped hills which make access to the summits of the promontory possible. (NAC)

Abraham Martin, portrayed by artist Charles Huot in 1908. (NBC)

land and far from his compatriots, Abraham had been brought by God to a high mountain; there, commanded to look to the north, the east, the west, and the south, he received the promise of innumerable progeny who would reign over all these regions and would spread glory and the name of the true Lord. Finally, some tourists wonder if the place name refers to Abraham Lincoln, the anti-slavery American president, although Lincoln died a century after the name first appeared on documents.

A Path to Follow: Abraham Martin

Although all indications are that the origin of the name of the Plains of Abraham can be traced to Abraham Martin, there are still some questions to clear up. How, when, and why was this name decided on?

It seems that its origins were popular, military, and to a large extent English. The name "Abraham" appeared in Québec toponymy during the French régime. Notarial acts of the seventeenth and eighteenth centuries refer to Côte d'Abraham, and a 1734 map gives a precise location for Rue d'Abraham. All evidence for these place names points to Abraham Martin. Indeed, in 1635 Abraham Martin received from the company of New France a land concession of twelve arpents on the Québec heights. In 1645, he added another parcel of land, this one of twenty arpents, given to him by Adrien Duchesne, a navy surgeon. Thus, Martin's property, thirty-two arpents in area, was situated in the upper town but on the north side of the promontory, on what was called Coteau Sainte-Geneviève, not on the site of what we know as the Plains of Abraham. On the other hand, the road that ran in front of his land went as far as Grande Allée, as can be clearly seen in the 1734 map, but without encroaching on today's Plains. As a partial explanation for the choice of the Plains' name, this is not a very good one.

In a deed executed by the notary Romain Becquet on October 16, 1675, Charles-Amador Martin, Abraham's only surviving son, a priest and one of his heirs, sold to the Ursuline order "the number of thirty-two arpents of land situated on the outskirts of this town to the place called Claire Fontaine with a few old buildings fallen to ruin, for the sum of twelve hundred livres," a considerable amount for the time. It is possible that the Ursulines referred to this parcel as "the land of Abraham" to distinguish it from other lots they owned or from the Plains; their archives, however, are silent on this issue. The land registers and surveyors' boundary documents never mention a name for the land or for the Plains of Abraham before the nineteenth century.

First Mentions: Military Sources

The first mentions in documents of the name "Abraham" in association with the site of the Québec promontory, the part to the west outside the walls, comes from military sources referring to events in 1759. The diary entry of Chevalier de Lévis dated July 19, 1759, mentions that "four English ships had passed above the town" and that as a consequence he "sent detachments to the Heights of Abraham and as far as Cap Rouge." In his evaluation of the town's defences during the following winter, Lévis wrote that "the ramparts of the Heights of Abraham" were high and well protected. The name was also used by the English military. On the date that Montcalm's and Wolfe's troops clashed,

September 13, 1759, the captain of an English regiment, John Knox, wrote in his diary, later published under the title The Siege of Québec, that once they landed at the foot of the cliff, they did not stop "till we came to the Plains of Abraham." On December 3, Knox used the expression again in his journal, in another form: "Our artificers are now completing a chain of block houses, which are to be erected upon the Heights of Abraham, extending from Cape Diamond down to the suburbs of St John." Another officer, John Montresor, in his description of events, referred to "the General Battle on the Heights of Abraham."

The application of the name "Abraham" to certain parts of the Québec promontory definitely dates from the French régime. But it wasn't until the last days of the era that the name is found in documentation. The nature of the name, its origin, the fact that the town and colonial authorities did not recognize it—in short, everything indicates that the name had a local, popular origin. Paradoxically, the first persons from the élite to record the name officially came from the mother countries and were not very knowledgeable about colonial and Québec realities. Lévis adopted a popular terminology, perhaps communicated by the militiamen under his command. British officers doubtless did the same. We shall return to this.

This 1734 plan has the first precisely located mention of the place name "Abraham." "Rue d'Abraham" joins Chemin de la Grande Allée, but does not continue southward to the current site of the Plains of Abraham park. (1734 plan appended to a notarized contract, ANQ, Henry Hiché)

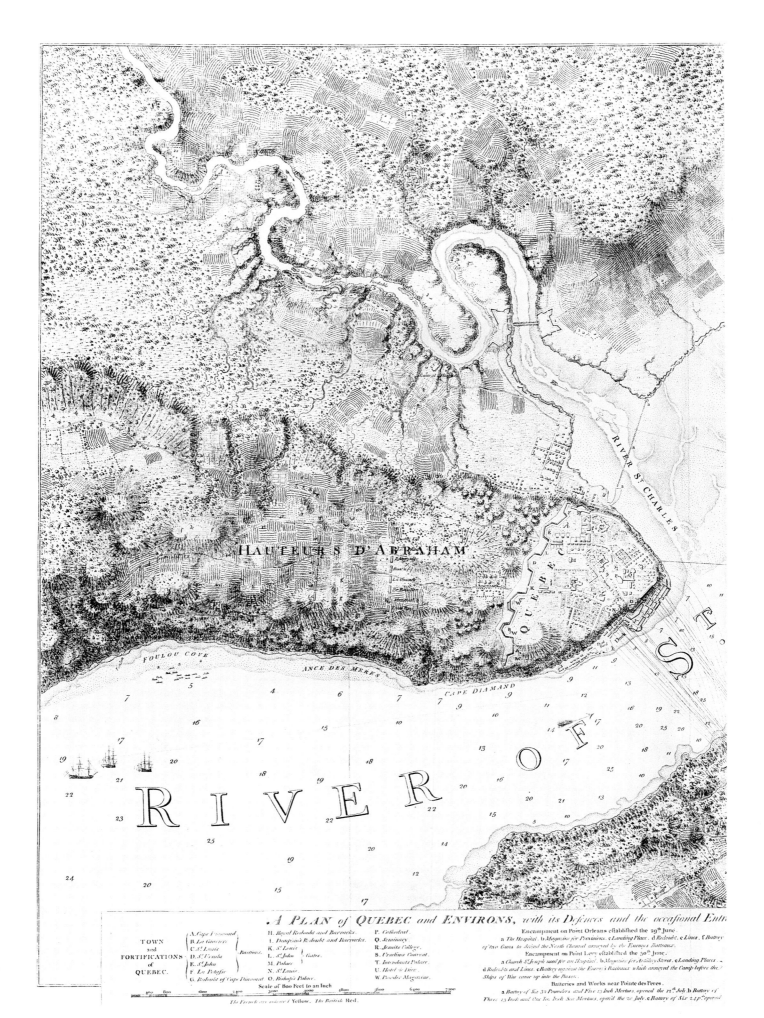

HAUTEURS D'ABRAHAM

FOULON COVE

ANCE DES MERES

CAPE DIAMAND

RIVER St CHARLES

QUEBEC

RIVER OF S

A PLAN of QUEBEC and ENVIRONS, with its Defences and the occasional Entr

THE ORIGIN OF THE PLACE NAME

The name "the Plains of Abraham" was manifestly established by military sources, but this does not explain its origin or its siting. In order to understand the origin of the name, it is essential to review the exact topography of the site, the conditions in the town of Québec—its population and fortifications—at the time, the correspondence exchanged between the military leaders of the two camps, the precise place where the battle took place, and the military strategies.

The Topography

Québec was not an easy town to capture. The British generals planned to land their troops at a distance—to the east, at Beauport; to the west, at Pointe aux Trembles, near Neuville—then march to the town. Three points, protected with ramparts, gave access to the upper town. It seemed almost unthinkable to attack directly to the heart of the city and march up Côte de la Montagne to reach the heights. The path, steep and arduous, was very closely watched and well protected by batteries of cannons installed in both the upper and lower towns. On the south side, near Anse-au-Foulon, the foot of the cliff was level enough for landing boats. This was the spot finally chosen by General Wolfe, in some desperation. But the north side of the promontory also offered interesting possibilities for landing. Up the St. Charles River a few hundred metres was a stepped hill, gradual and not too steep. The French often used this route to climb what was known by the residents as Côte d'Abraham.

Access to the Promontory

This easy access to the Québec promontory via its north side was a nightmare for military engineers, and made this approach a path coveted by invaders. The first fort, constructed in 1690 by Major Prévost, planned for solid fortifications to be built all around the zone. Chaussegros de Léry had a redoubt built there during the 1720s, at the foot of the cape, on land belonging to the General Hospital nuns near the St. Charles River. At the beginning of the nineteenth century, two Martello towers were built at the first summit of the peak, one of them on Coteau Sainte-Geneviève, exactly where Abraham Martin had lived when the colony began.

In their turn, generals Phips in 1690, Wolfe in 1759, then Montgomery and Arnold in 1774 thought of taking this route to conquer Québec. Chevalier de Lévis's strategy during the 1760 battle, in which his French troops were victorious, rested precisely on the ease of going around and scaling this escarpment to take the enemy from behind. At the end of the French régime, Franquet, an engineer and inspector of the fortifications, estimated "that it is utterly necessary to work on them, or else the funds spent on the wall around the upper town would become a pure loss, even more so if enemy forces arrived at the St. Charles River and forded it at low tide, and it would take just one strike to capture the upper town." He explained that "this cape is infinitely losing height and steepness and, aside from the two paths and the ramp that leads to its summit by boulders that lengthen its slope, can be climbed easily." When he arrived in the town of Québec and first evaluated its defence system, the English governor, James Murray, also estimated that this area was the most exposed, and he began to consolidate the fortifications starting in the winter of 1760. All an

At the time of the decisive battles of 1759 and 1760, the place name "Heights of Abraham" appeared in the centre of the promontory, farther north than the current site of the park. (**Plan de la ville de Québec et de ses environs**, 1759, NAC)

invader needed to do, in short, was land near the General Hospital and then, taking existing routes, capture the heights and establish himself on Abraham Martin's old land. The Heights of Abraham were an objective to be won.

Information Transmitted to the English

How did the name reach the English military officers? There are many viable hypotheses. Robert Stobo, a hostage who was brought to Québec in 1754 who moved around with complete freedom, then was imprisoned before escaping in the spring of 1759, knew the city well. Inhabitants of Île d'Orléans, the Beaupré shore, and Lévis, where Wolfe's troops camped for several months, and the prisoners he took along the shore downstream of Québec might have given him this inconsequential bit of information. Moreover, officers of the two camps exchanged civilities during truces and diplomatic discussions. Certain people were even invited to dine with General Wolfe; others exchanged special considerations. It is even plausible that this popular place name was heard by English officers during conversations at Québec's General Hospital. Indeed, after the battle of Montmorency, on July 31, 1759, the nuns of the General Hospital nursed the injured of both armies, for which General Wolfe thanked them profusely. Thus, during almost five weeks before the great battle, English and French were talking to each other. Captain Knox, the first English officer who seems to have used the name "Plains or Heights of Abraham," was completely trusted by the nuns. From the hospital the view was directly toward Côte d'Abraham and the Heights of Québec; naturally, they were a familiar sight. In short, many exchanges, spoken or written, would have enabled English officers to know the place names of Québec quite well—well enough, at least, that, like Lévis, they used the name "Abraham" to indicate the promontory. The name was also used in the lower town, which could explain why the uneven surface of the promontory still received the qualification "Plains."

THE TERRITORY COVERED BY THE PLACE NAME

The territory designated "Plains of Abraham" has shifted considerably over time. Nevertheless, it corresponds to sites where the events that validate the name took place.

Location of the Events

The correspondence between the site of the battles of 1759 and 1760 and the location of the place name reinforces the pertinence of the name. It is true that Abraham Martin's land is not part of today's Plains. It is also true that the battle of 1759 was not confined to what we now call the Plains. There is much corroborative evidence of this. The English and French regiments were stretched out from the southern summit of the promontory to Chemin Sainte-Foy. Thus, the 1759 battle took place along the width of the promontory, in a vast, almost uninhabited area. All indications are that the two armies exchanged fire on what had been Abraham Martin's land; however, if generals Wolfe and Montcalm were mortally wounded on what are the Plains today, it would have been at their very edge. As well, the main part of their armies overflowed toward the north slope. Indeed, Wolfe commanded his right wing, while

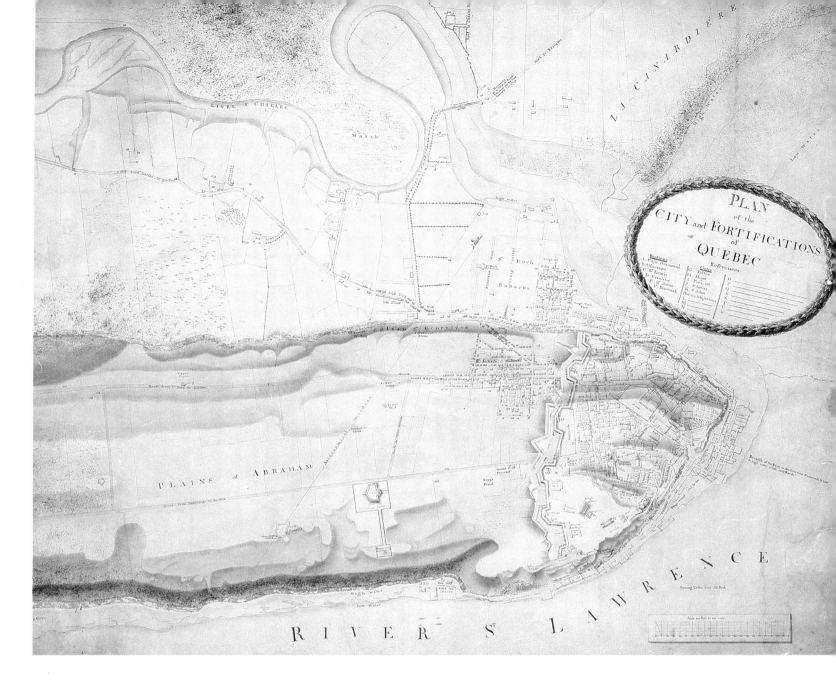

At the beginning of the nineteenth century, when urban development had not reached most of the north part of the promontory, the place name "Plains of Abraham" still appeared north of Grande Allée. (Jean-Baptiste Duberger, **Plan de la ville et des fortifications de Québec**, 1808, NAC)

In this 1845 plan, the name, as if pushed by the urban subdivision, appears south of Grande Allée, precisely where the 1759 battle took place, not far from the city's fortified walls. (**Plan de la ville de Québec**, 1845, NAC)

Montcalm commanded his left wing. The centres and the other wings were in a zone today covered with houses. Thus, with regard to the site of the battle, the place name corresponds to reality.

Historical Maps

Cartography provides more precise information on the use of the place name. On a historical map of the 1760 battle, the term "Côte d'Abraham" does not designate the hill that carries the name today, but the entire slope from the road that goes from Sainte-Foy to Lorette (de la Suète) to the site of today's Avenue de Salaberry. This Côte d'Abraham comprises more or less the eastward extension of Coteau Sainte-Geneviève.

At the beginning of the English régime and again at the beginning of the nineteenth century, thus while survivors of the battle were still living, mapmakers marked the place name "Plains of Abraham" or, more often, "Heights of Abraham" well north of Grande Allée, closer to Abraham Martin's land than to the current site of the Plains. In 1808, the name still designated the entirety of the Québec promontory and appears on maps in capital letters between Chemin Sainte-Foy and Grande Allée, stretching as far as the fortifications. The extension of the Saint-Jean faubourg, built in 1820 on a virgin part of the promontory, forced the place name "Plains of Abraham" to be moved far to the west. In the 1840s, it slid progressively toward the southern part of Grande Allée, and the territory it covered shrank considerably and irreversibly. An 1865 map situates it in the army's exercise grounds, on the Ursulines' property, where the race track was. In 1879, in the final constriction, maps of the city and environs showed it inside the race-track oval, on the Ursulines' land. It was a prisoner there until Battlefield Park was created, in 1908.

THE CONSECRATION OF THE NAME

It is easy to understand why the English so quickly adopted and spread the name Heights or Plains of Abraham. The 1759 battle symbolized the happy culmination of a long and very expensive effort, in terms of both money and men, to ensure England of global hegemony. The site of the battle that brought Canada under British rule could not rest in relative anonymity; for it to enter the history books, it had to have a name. It is easy to understand how the use of a popular name led to confusion. Referring to a bygone, partly forgotten, reality that was not very evocative, especially for foreigners, and having little to do with local place names, the designation of the site was not at all precise or official. On the other hand, for Protestants, whose religious practice was heavily impregnated with a biblical tradition, the name "Abraham" held great symbolic power. The conquerors could not help but recognize themselves in the image of the great prophet. They adopted it without question and propagated it with all the force of a victor who feels that he has become master of the world.

The Variants

The Plains or the Heights? Neither word had particular significance at the time; nor was there a special national connotation. The official name is the result of a suggestion made by a superintendent of public education, Boucher de la

Bruère. In a letter to Lieutenant-Governor Louis Jetté on January 22, 1908, he proposed that the site be named "Le parc des batailles"—a short, self-explanatory name.

But aside from the higher power of the political and military world, the place name kept part of its original meaning, its source, allowing for an aspect of marginality. The current name, the Plains of Abraham, thus seems to refer to Abraham Martin. Although he is an obscure character, he is by no means completely anonymous, since the Jesuits sent him a bottle of brandy as a gift on New Year's Day of 1646, addressing him as "Maistre Abraham." It is a name with a popular French source, consistent with occupation of the site. Its symbolic values are applicable as much to the origins of the site, to its beauty, and to its natural wealth as to its historical significance in the collective memory. Even today, the place is known and recognized by its popular name. Although its legal name is National Battlefields Park and the commission responsible for its purchase, landscaping, and development has been working for more than eighty years, this official name evokes little emotion among the public. Québecers' sensitivity to the natural beauty and historic wealth of the Plains of Abraham are evoked in two words: "The Plains."

In this 1871 plan of Québec City, the name "Plains of Abraham" designates only the Ursulines' land, at the west end, where horse races took place in the nineteenth century. (NAC)

CHAPTER TWO

෨

The New France Era

Jacques Mathieu, with Alain Laberge

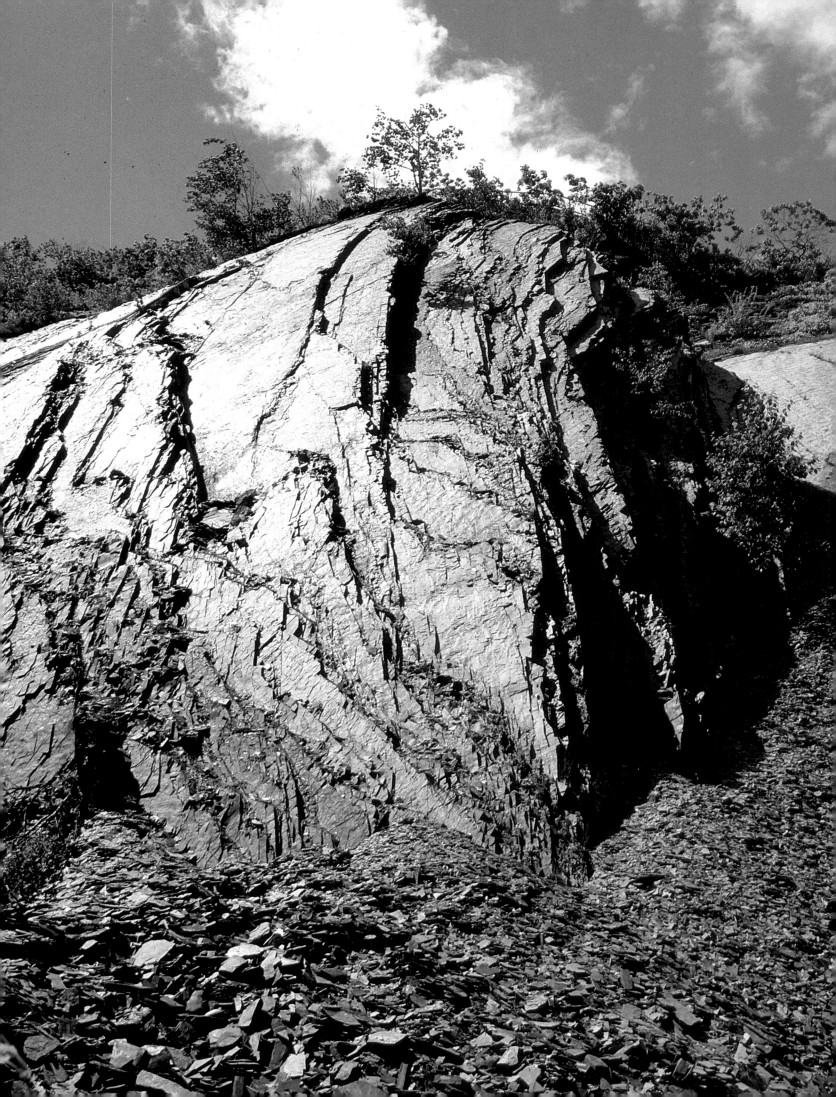

The Promontory

*T*HE QUÉBEC PROMONTORY is like a jewellery box in the heart of the immense North American continent. It contains many riches, some of known value and some undreamed of. It has raised marvellous hopes. Jacques Cartier, the discoverer of Canada, thought he would find gold and diamonds there. The founder of Québec City, Samuel de Champlain, was so impressed by the site that he decided to establish a permanent settlement at the foot of the cape. The St. Lawrence, a great river, stretching inland almost four thousand kilometres, was a majestic portal. An imposing cliff caught his eye; at its foot, a small river fed a tranquil, fertile valley, emptying into the magnificent waterway that was the link to the outside world. The abundance of indigenous animals and plants later attracted both scientists and settlers in search of food. According to many travellers, the cape offered the most beautiful view in the world: nature had carved out an extraordinary site.

Québec was an ideal place to establish an outpost for French colonization of North America. Ships that had crossed the Atlantic Ocean had little problem finding it, for the narrowing of the river and the depth of the channel necessitated a stop. At the foot of the cape, the small St. Charles River offered a natural harbour, sheltered from wind and ice: the promontory facilitated protection of the settlement and control of river navigation.

The discoverers and first explorers of this site would have been very pleased with how the town of Québec looked a century after its foundation. Like a medieval city, perched on a cape and defended by fortifications, the heart of the settlement commanded and protected the surrounding area. Towers and steeples, bastions and cannons, religious and administrative buildings, and grand residences stood cheek by jowl. The location was invested with great symbolic value: with its stony crags on the heights, it embodied power and authority. In its domination of the surrounding countryside, this magnificent site was designed by nature to be the seat of power.

The first Europeans to land on these shores quickly took stock of the potential for development Québec offered. In this they had been preceded by the original occupants of the territory. For many centuries, aboriginal peoples had lived at Québec. Some, such as the

Rock weathering: a combination of solidity and fragility.

Upon examination, the "Gold" and "diamonds" that Jacques Cartier had gathered on the promontory turned out to be fool's gold and quartz.

The First Description of the Promontory: 1541

In 1541, leading a venture composed of five ships and a few hundred people, Jacques Cartier settled at the western end of the promontory, near the Cap-Rouge River. He described the spot thus: "There are good, beautiful lands filled with as good and large trees as anywhere in the world. . . . There is a high, sheer cliff, where we created a path shaped like two staircases, and on top we made a fort to keep watch on the land below and the ships and anything that might pass on either the large river or the small river. As well, a man could keep a large part of the land for cultivation, level and beautiful and a little inclined toward the south, as easy to plough as I could wish. . . . On the top of this high cliff, we found a beautiful spring close by the fort; beside it, we found a good reserve of stones which we believed were diamonds. . . . At the foot of the cliff, we found a seam of the best iron in the world. And on the riverbank, we found some leaves of fine iron. . . . In certain places, we found stones like diamonds, very beautiful, polished, and as well cut as a man could possibly see. When the sun hit them, they shone as if they were sparks of fire." ∾

Iroquoians who greeted Cartier, practised agriculture; others were hunters, fishers, and gatherers, such as the Montagnais encountered in the following century. From spring to autumn, when the weather was at its best and prodigal nature offered abundant resources and set the table for a banquet, the First Nations met to establish their trade and friendship relations.

Jacques Cartier stayed in Québec from September, 1535, to May, 1536. Moored in the St. Croix (or St. Charles) River, his ships, their sides covered with ice four fingers thick, provided shelter for him and his crew. Scurvy ravaged his men: twenty-five died before the aboriginals brought him an effective remedy. When he returned to Québec in 1541, with several hundred people, including a number of women, Cartier felt that the aboriginals mistrusted him. He therefore settled his group a little farther away: bypassing Québec, he sailed up the St. Lawrence River some ten kilometres and stopped at the western end of the promontory. Here, the cliff was pierced by another river, and there were features similar to those of Québec: fresh water, a harbour for the ships, arable land, and a promontory.

This attempt at colonization did not have an immediate follow-up. In the spring, Cartier returned to France. He remained silent on the reasons for the abandonment, and there is no record of whether he brought his entire party back with him or whether some died during the winter, from the cold, or in skirmishes or mutinies. But he had brought back what he believed were a dozen barrels of gold and diamonds—which might in fact explain his precipitous return. He must have been very disappointed when these "precious stones" proved, upon examination, to be nothing but quartz and iron pyrite. An adage was coined, "False as Canadian diamonds," and French royalty lost interest in the faraway regions for more than half a century.

Jacques Cartier's settlements at Stadacona in 1535–36 and 1541–42, at each end of the promontory. (Drawing: Jacques Letarte)

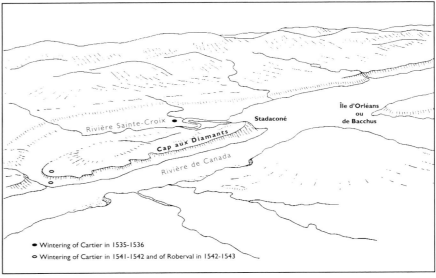

After J. Lemieux

Time has obscured the details of Cartier's voyage. For example, we do not know exactly where his men gathered the stones that sparkled brightly in the sunlight. It is likely that they were on and around the escarpment near the fort they had established, a few leagues away from Québec. Over the years, people confused the two ends of the promontory; Samuel de Champlain and other travellers who later described Québec situated Cap-aux-Diamants very close to the town.

In 1608, Samuel de Champlain, a navigator and cartographer from Saintonge in the employ of the privateer Du Gua de Monts, arrived in Québec. He landed at the foot of the cape, where he erected an imposing settlement, defended by cannons. Champlain immediately recognized the advantages of this site, which commanded access to a territory larger than France. The proximity of aboriginals meant a supply of furs for trade, and the fertility of the soil ensured subsistence; below the surface might be valuable ores. Champlain also speculated that the St. Lawrence River might provide a new, much shorter route to India. Once this passage was opened up, every merchant in Christendom would use it and France, which would control it thanks to its hold on the Québec promontory, would collect taxes ten times higher than the Kingdom's current revenue.

On his 1613 map of Québec, Champlain located the gravel slope where the "diamonds" were found in the slight recess in the Cape, one kilometre from his settlement, on the south side of the promontory. Thus, between the upper and lower towns, on the flanks of an impressive cliff dominated by the heights of Mont du Gua, the

Québec in 1613 (map by Samuel de Champlain, in *Les voyages du sieur de Champlain*, Paris: Chez Jean Berjon, 1613, BNQ). Note, in particular, the following legends:
- G (on the promontory), where hay was gathered for the cattle brought from France;
- V, "Mont Du Gas" (Du Gua de Mons), very high, on the river bank, today Cap-aux-Diamants;
- Y, "Côte de gravier," where "are found a quantity of diamonds, a little better than those at Alençon."

Next page:
This view of the Heights of Québec at the end of the eighteenth century illustrates that the site was used for grazing, as it was a century earlier. (J. Peachey, **Vue des fortifications depuis les hauteurs**, 1784, NAC)

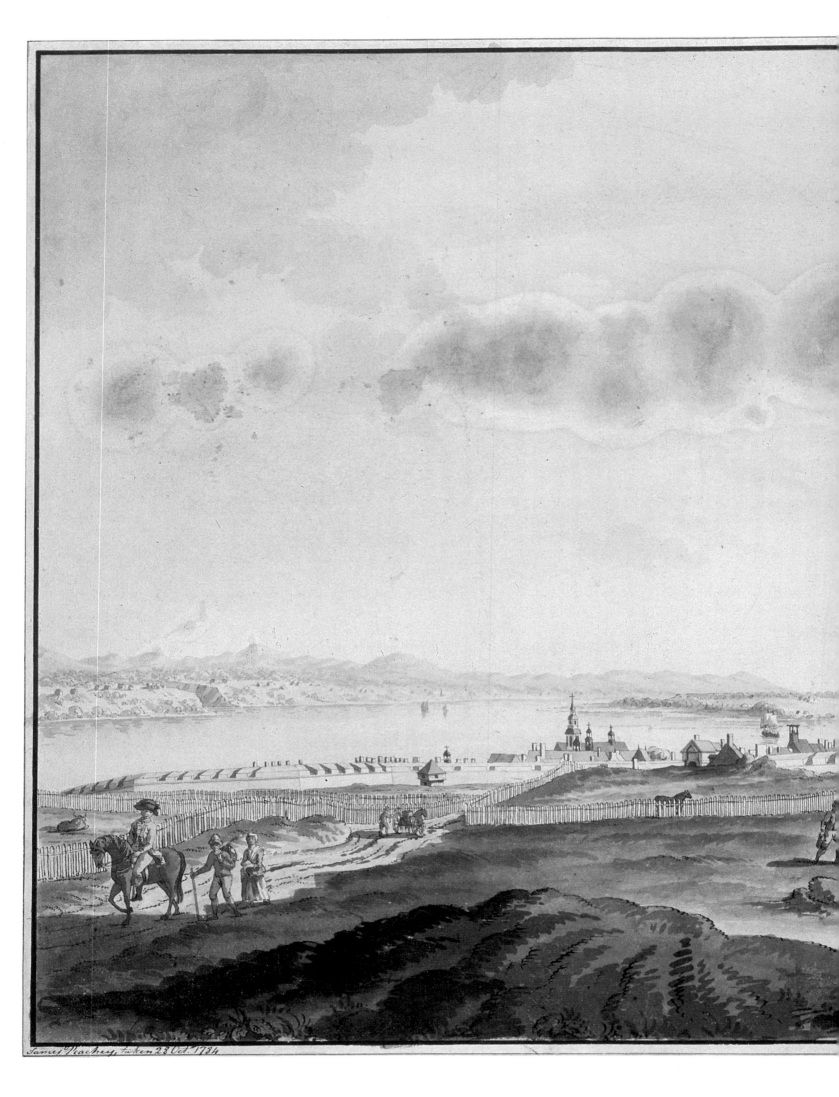

James Peachey, taken 23 Oct. 1784

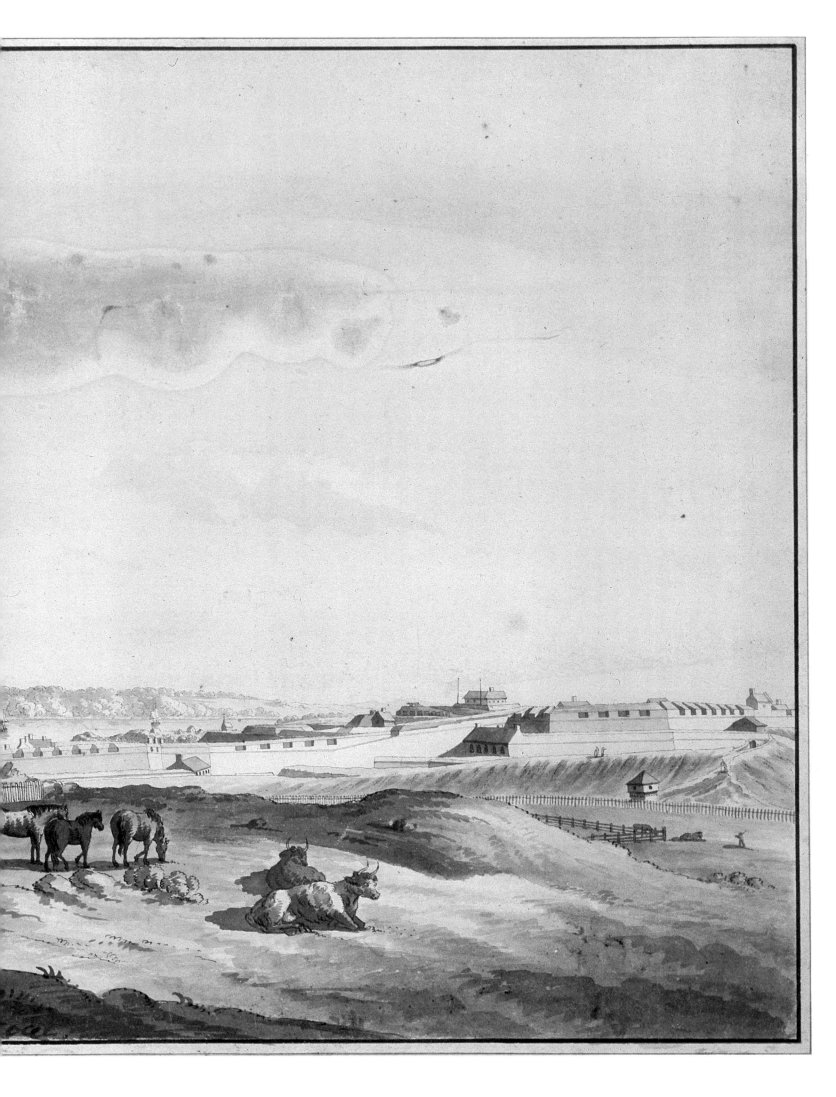

Québec as Seen by Champlain

"We dropped anchor at Québec, which is a strait in this river of Canada (the St. Lawrence), which is about three hundred paces wide. There is at this place, on the north side, a very high mountain that slopes on two sides. The rest is flat, beautiful countryside, where there is good land full of trees such as oak, cypress, birch, fir, and aspen, and other wild fruit trees and vines, which, in my opinion, if they were cultivated, would be as good as ours. All along the slope of Québec, there are diamonds in slate rocks which are better than those of Alençon." ∾

The wild vine, similar to what Champlain might have seen on the Heights of Québec. (Jacques Cornuti, **Canadensium Plantarum Historia**, Paris, 1635, BNQ)

name Cap-aux-Diamants took root. Presaging its later use, Champlain also indicated on his map the natural pastureland on the Heights of Québec where he put his livestock out to pasture.

In 1620, Champlain had a fort constructed halfway up the cape to consolidate his settlement. Soon after, the apothecary Louis Hébert, also a farmer, cultivated the land there. In 1628, when the Kirke brothers wanted to take Québec, the town, with its position on the heights and its fortifications, seemed impregnable. But we shall pick up this story later. Already, new uses were being planned for the site.

The hope that a passage to India via the St. Lawrence River would be found persisted for a long time, but it was never realized. The river's narrowness and depth at Québec, however, made the town an obligatory stop for ships arriving from France, and the promontory became increasingly important to the colony's defence. The beauty of the site and the surrounding areas was gaining a widespread reputation. Activity on the cliff and the heights intensified. The religious communities, the governor, and, a little later, the bishop established themselves there. In the meantime, the desire to populate the colony took hold, transforming the site of the promontory into a colonization outpost.

A Colonization Outpost

The king of France left it up to trading companies to populate and colonize New France. In return, he granted them a monopoly on trade, as well as total seigneurial control of the territory. The seigneurial system was based on the concession of large plots of land to seigneurs, who had to populate their property and take steps to increase its value. Copyholders were responsible for clearing the land, keeping home and hearth, and paying the seigneur an annual rent. This mode of land occupation, inspired by the feudal régime, spread throughout the St. Lawrence Valley and was maintained up to the mid-nineteenth century. It left an indelible imprint on the countryside in the division of land into long, narrow bands, generally perpendicular to the river, the principal communication route.

This model of occupation was also used on the Québec promontory. Between 1639 and 1660, a number of persons obtained land concessions. A road linking Québec and Cap-Rouge divided the promontory into two parts. At first called Chemin Cap-Rouge or Grande Allée, this road—one of the first major land-travel routes in the Québec region—still exists today. Land concessions on the northern part of the promontory were granted to various individuals who were not from the upper classes, among them Abraham Martin, *dit* l'Écossais. This was an extension, starting in the lower town and reaching the Heights of Québec, of the St. Charles River region.

Land south of Grande Allée was granted to upper-class individuals. Occupied later and by fewer people, it was a more elegant neighbourhood, with a view of the St. Lawrence River; most of the lots stretched from Grande Allée to the waterfront—that is, to the bottom of the cliff—and included fishing rights. This part of the promontory also had natural pastureland, useful for raising livestock.

In the eastern part of this area south of Grande Allée, the Plains of Abraham eventually came into being. From Québec to Sillery, from the seventeenth century to the present, the characteristics of this space have not changed. For the most part, it contains mansions belonging to wealthy owners—the beauty of nature and the landscape wedded to the power of authority or money. In spite of successive changes in ownership, the upper crust of the social élite has appropriated this land, generally preserving the intentions of its first European occupants.

The part of the promontory south of Grande Allée is divided into several distinct zones from east to west, the usage of which has been perpetuated up to the present. The town occupied the eastern end. A natural seat of power because it overlooks the environs, this area became home to the political, religious, and military leaders of the colony. Very quickly, the authorities recognized the strategic value of the heights as the keystone of a defence system. In 1618, Champlain proposed to erect a bastioned fort, an idea that was to persist for more than two centuries. Under the French régime, several redoubts and a fortified wall enclosing the city were constructed. West of the space protected by the walls was the land granted to individuals.

Because of the homogeneity of its natural setting, its uses, and its symbolism, the promontory constituted a harmonious ensemble,

First Uses of the Heights of Québec

"There is another house at the top of the high ground, in a very convenient place, where we feed the quantity of livestock that we brought from France; we also plant every year large amounts of corn and roughage, which we trade with the Savages for pelts. I have seen in this wilderness a young apple tree that was brought from Normandy, bearing very beautiful apples, and young vine plants that were very beautiful, and many other small things that bear evidence of the bounty of the land."

Gabriel Sagard, Le grand voyage du pays de Hurons *(1623).* ↻

A flowering apple tree on the Plains. In 1621, a Normandy apple tree was planted on the Heights of Québec.

43

A New Year's Day on the Québec Promontory, January 1, 1646

"His honour the governor informed us and was here at seven o'clock to greet all our fathers [Jesuits], after whom he asked, one after another. Mr. Giffard also came to see us, and the nuns sent letters very early in the day to pay their compliments; and the Ursulines had a great many gifts of candles, rosaries, crucifixes, and at dinner [hour] two nice pieces of tourtière. I sent them two images of St. Ignatius and of St. Xavier in enamel. We gave Mr. Giffard a book by Father Bonnet on the life of Our Saviour; to Mr. de Chastelets, one of the little tomes by Drexellius de AEternité; to Mr. Bourdon, a Galilean telescope with a compass; and to others reliquaries, rosaries, medals, images, etc. We gave a crucifix to the woman who bleached the church linens; four handkerchiefs to Abraham's wife and to him a bottle of eau de vie and to others some devotional booklets; two handkerchiefs to Robert Hache and two others that he asked for. I went to see Mr. Giffard, Mr. Couillard, and Mrs. de Repentigny. The Ursulines sent to ask me if I would go to see them before the day ended; I went and I greeted also Mrs. de la Pelleterie, who sent gifts . . ."

Relations des Jésuites ↢

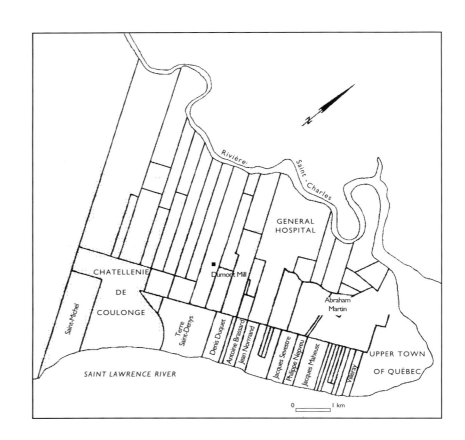

Occupation of the Québec promontory and the lowlands near the St. Charles River in 1663. Note the site of the properties of Abraham Martin and Louis Rouer de Villeray, and of the future Dumont mill. (Drawing: Jacques Letarte)

Québec, founded in 1608, outpost of French colonization in North America. Beyond Île d'Orléans, at the turn in the St. Lawrence River, the rocky point of Cap-aux-Diamants and the promontory. (**Carte générale des paroisses et missions établies des deux côtés du fleuve Saint-Laurent**, 1750, Service historique de l'Armée, Vincennes, France)

The settlement in Québec and environs in 1709; the town on the heights and neighbouring land. (Gédéon de Catalogne et Jean-Baptiste de Couage, **Carte du gouvernement de Québec**, 1709, detail, Bibliothèque nationale, Paris)

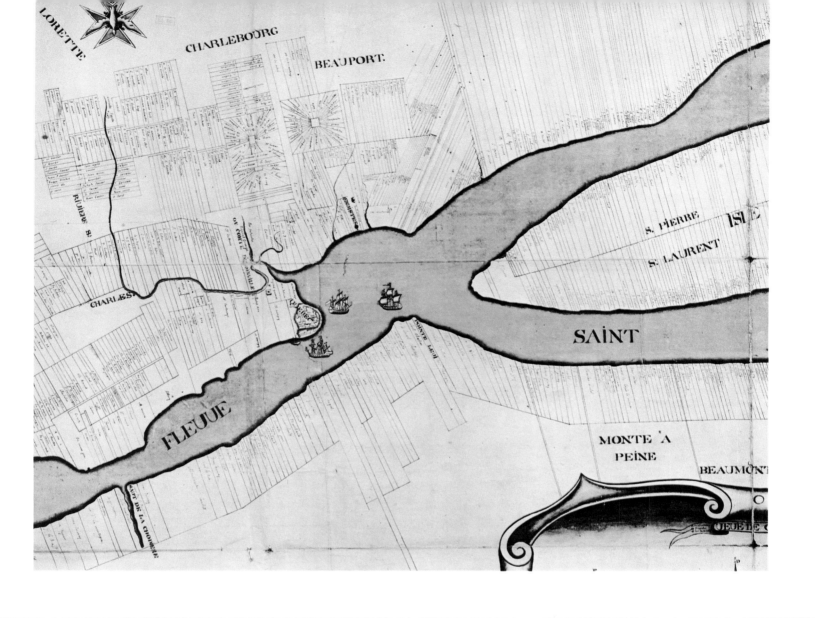

LORETTE CHARLEBOURG BEAUPORT.

S.te PIERRE ISLE

S.t LAURENT

CHARLES.

SAINT

RIUIERE S.

POINTE LEUI

FLEUUE

SAULT DE LA CHONDIE

MONTE A PEÎNE

BEAUMONT

QUEUE DE C

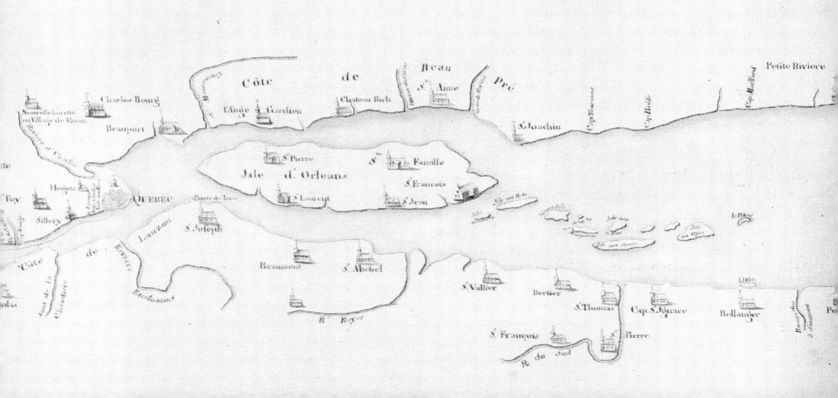

Nouvelle Laretto ou Village de Huron Charles-Bourg Côte de Beau de Pré Petite Riviere

Beauport l'Ange Gardien Chateau Rich S.te Anne Cap Maillard

Riviere S.t Charles S.t Joachin Cap Brûle

Hogen S.t Pierre S.te Famille

QUEBEC Isle d'Orleans S.t François

Sillery Pointe de Levie S.t Laurent S.t Jean

Lauzon S.t Joseph

Côte de Riviere

Beaumont S.t Michel S.t Vallier Bertier

Berthimus R. Boyre S.t Thomas Cap S.t Ignace Bellanger

S.t François S.t Pierre

R. du Sud

Parisian Master Printer/Booksellers on the Plains in the Mid-Seventeenth Century

The Sevestres were from a family of Parisian master printer/booksellers. Their uncle, Louis, also a master printer and a typesetter, published an edition of Samuel de Champlain's third voyage, as well as the sermons of the famous religious reformer John Calvin. Charles and Thomas were themselves recognized master booksellers in Paris in 1633 and 1634.

In 1636, the brothers Jacques, Charles, and Thomas Sevestre settled in Canada with their mother, Marguerite Petitpas. We do not know why they emigrated, but it is possible that publishing books on religious reform and alchemy put them in disfavour and they felt it wise to put some distance between themselves and the authorities, in particular the all-powerful Cardinal de Richelieu. On April 5, 1639, the Sevestre brothers acquired a parcel of several lots, measuring twenty-four arpents (almost 1.5 kilometres) wide and stretching from Grande Allée to the St. Lawrence. The lots were situated just west of the Citadel ramparts, on what today are the Plains. Life was not easy. Marguerite Petitpas died "in her cabin on Cape Diamond" on September 14, 1640, five months after one of her sons, Thomas, drowned during a fishing trip in the Bellechasse Islands. Jacques Sevestre remained single and died in Québec in 1685, at the age of seventy-one. Charles Sevestre filled several important positions in the colony. He was appointed representative of the Communauté des Habitants—the company that controlled colonization and trade in New France—by the authorities of the town of Québec. He became chief magistrate of the seigneury of Lauzon in 1651, then a civil lieutenant and criminal judge of the Seneschalsy of Québec. He also acted as general clerk of stores, a prestigious title, since it made him responsible for all supplies and fur trading in New France. He died at age forty-seven, on December 9, 1657, and was buried beneath his pew in the Québec basilica. ∽

even if only part of it is now the Plains. In the area that is now part of the town of Sillery, a number of large properties from the long-ago era of New France still exist. Right beside the Plains, the Mérici estate, originally land of Saint-Denys, was first granted to the Juchereaus, one of the largest and most prestigious families in Québec under the French régime. Later sold to the Séminaire des missions étrangères, the estate was purchased in 1762 by James Murray, first governor of the new British colony. A century later, called Marchmont, it was home to the governor general of Canada, Francis Hincks; finally, in 1908, it was given to the Ursulines in exchange for their part of the land on the Plains. To the west of the Mérici estate, another estate has just as long a history: the Bois de Coulonge. The parcels of land acquired by Louis d'Ailleboust, governor general of New France from 1648 to 1651 and from 1657 to 1658, were assembled as a castellany by Louis XIV, to thank his representative in the colony for his loyal services. The Séminaire acquired the property in 1678. Fifty years later, Monsignor Pierre-Herman Dosquet, Bishop of Québec, who wished to live in the country, had a residence constructed there. For more than a century, starting in 1867, the castellany was the official residence of the lieutenant governor of Canada; finally, it was converted to a public park. With its orchard, trees, flowers, and natural vegetation, its view of the river, and its rustic appearance in the middle of the city, it was a place where the charms and beauty of nature represented the qualities and aspirations of the authorities.

Over the centuries, these occupation zones were both protected and coveted. Religious communities, private estates, and, more recently, large insurance companies have preserved and enhanced the innate qualities of the site. Even today, developments aimed at a choice clientele evoke the initial values of the site.

The Plains Today

Today's Plains of Abraham are no less laden with history—both mundane and spectacular, unique and extraordinary—where Francophones and Anglophones have shared the same emotions. The natural features of the Québec promontory are partly responsible for the way it has been occupied and used throughout its history. In spite of the many changes over the years, the general areas that we know today (the playing fields, the site of the Museum, the area once landscaped as Buttes-à-Nepveu, etc.) seem to have been designed by nature for the purpose. In just half a century, all the components were united in the hands of a single owner. References sprinkled through archival documents give an idea of how this part of the promontory was first used. Indications in deeds, plans, accounts of voyages, and references to local place names show that the natural features of the site were always used to advantage.

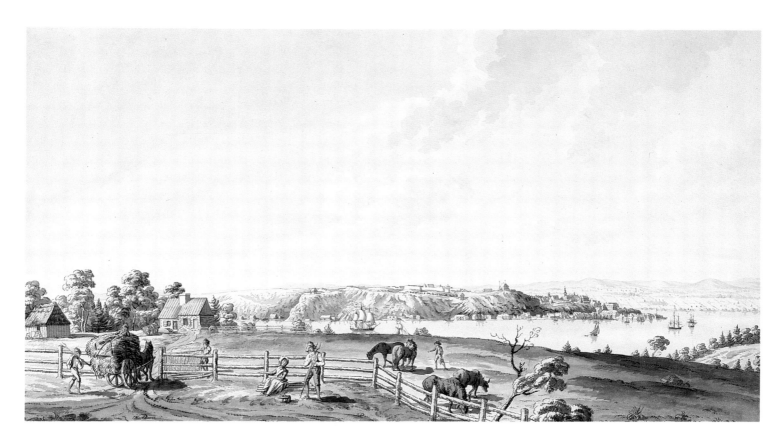

In 1613, Champlain reported that he was using the natural pastureland situated at the top of the cape to feed his livestock. Ten years later, the Recollet Gabriel Sagard reported that a number of livestock were being grazed there, that corn was being planted, and that a young apple tree from Normandy was bearing good fruit. In the second half of the seventeenth century, a number of notarized contracts mentioned the presence of arable land, buildings, and areas where numerous animals grazed. In 1652, sites called "la grange" and "la glacière" served as reference points for locating land. The presence of "parks for horses and horned beasts" was noted, providing forage for these animals, and for a large number of sheep. Later, hops, various fruits, and asparagus were cultivated there. Mention was often made of "old" and "new" orchards. All that one needed to settle in this natural pastureland was a well-built house.

Between 1639 and 1670, this land was the object of numerous sales and transactions, typical of the unsettled state of a new colony. Near the end of this period, however, parcels tended to be divided more systematically and the main elements of land use were laid out.

During the second half of the seventeenth century, at least thirty heads of families possessed a piece of land on this part of the Heights of Québec. Not all of them lived there, but most used their property for grazing animals. Among the many names that flood the archives, two groups clearly stand out, one linked by place of origin, the other

The Québec promontory, viewed from the south shore of the St. Lawrence. The fences, animals, and buildings indicate the activities that may have taken place on the site of the Plains a half-century earlier. (J. Peachey, **Vue de la citadelle, des fortifications et du Cap-aux-Diamants**, ca. 1785, NAC)

The Sevestre Wives

Since they left no male descendants, the Sevestres are not well known. However, through their wives and their daughters, their blood line was spread across North America.

The first Sevestre wife was Marie Pichon. When she married Charles Sevestre in Paris, in 1627, she was already a widow and the mother of three children: Guillaume Gauthier de la Chesnaye, Charles Gauthier-Boisverdun, and Catherine Gauthier de la Chesnaye, who married Denis Duquet. Thus, this neighbour of the Sevestres on the Plains was in fact a relative through the remarriage of Marie Pichon.

All the children of the Sevestre-Pichon union were girls. Denise married Antoine Martin-Montpellier, and later Philippe Nepveu, another neighbour who became a relative. One of their sons was killed by aboriginals in the Kaskaskias (Illinois) region, and another died on the Pelican, commanded by Captain Pierre Le Moyne d'Iberville in 1705. Another Sevestre daughter, Madeleine, married Jacques Loyer sieur de Latour, then Louis de Niort de Lanoraie. Thus, the Lanoraye land and Duquet's pasture, situated at the western end of the Plains, became part of the Sevestre heritage. Finally, Catherine Sevestre married Louis Rouer de Villeray. Through these marriages, the Sevestres were linked with the great families of the colony and left many descendants. ❧

by family ties. Quite a few copyholders were from Tourouvre or Mortagne-au-Perche, whence came an exceptionally high proportion of the first arrivals in New France. This is the only case of a dense and continuous provenance, while the general immigration pattern was more sporadic and discontinuous. Certain important families, such as the Juchereaus, became recruiting agents for New France. As pioneers, they opened the seigneuries of Sillery, Beauport, Deschambault, and Beauce to French immigrants. In the mid-seventeenth century, they occupied part of the promontory just west of the site of today's Plains. Among the immigrants they recruited at Tourouvre and Mortagne were Marie Langlois, Zacharie Maheust *dit* Point-du-Jour, Jacques Maheust, Jean Côté, Jean Normand, Gervais Normand and his wife, Antoine Brassard's wife, and the father of Noël Pinguet.

Almost all of these settlers found themselves owners of contiguous lots, measuring about one or one-and-a-half *arpents* wide and stretching from Grande Allée to the river, where the playing field is now. This land was used mostly for grazing animals, although a 1667 deed shows that a resident sold thirty-five *arpents* of land there, including house, grange, stable, yard, and garden. In 1668, the Ursulines of Québec began to buy up these lots. In succession, they purchased the land belonging to Massé, Brassard, Pinguet, Lemire and Duquet; the land acquired from Soumande was sold to the Hôtel-Dieu nuns, and was later part of an exchange between the two religious communities. In the survey and census of 1737, the Ursulines declared that they owned land ten *arpents* wide by ten *arpents* deep, "fronting on said king's road of the Grande Allée and backing to the south, on the St. Lawrence River, on which there are thirty *arpents* of arable land, the rest in pasture without a building." The community thus gained a great degree of independence from market fluctuations for its provisions.

Several people also acquired land where the old prison and the museum stand today. Here too, however, a religious community rapidly accumulated a large estate. Between 1668 and 1702, the Hôtel-Dieu de Québec order acquired four contiguous lots: one was purchased, two were nuns' dowries, and the last came from an exchange with Louis-Théandre Chartier de Lotbinière. The nuns did not work the land themselves; they leased it to various tenants, both for grazing animals and for the beauty of the place. A century later, this same usage dominated. William Church rented plots along Grande Allée, measuring about thirty by ninety metres, to various people, among them the daughter of the Chief Inspector, a lawyer, a law student, the director of the army billeting office, and Joseph Tardif, caretaker of the courthouse in Québec. The identity of these occupants bespeaks the attraction of the site and some of its major uses: leisure for the military, the prison, and, bordering on Grande Allée, the upper-class

residences much sought after by those in the liberal professions. The leases were bought up in 1838 and 1839 by Joseph Bonner, who also acquired land from Hôtel-Dieu in 1841.

The largest part of the Plains, extending from the ramparts of the Citadel to the Martello towers, had an extraordinary history. Through the stories of four people, we can catch a glimpse of life on the Plains in the New France era. In the 1640s, six of the eight lots on this portion of the Heights of Québec belonged to the Sevestres, a family of master printer/booksellers from Paris. The three Sevestre brothers, Charles, Thomas, and Jacques, landed in New France with their mother, probably in 1636. With their abilities, accomplishments, and profession, they thought that this destination would provide a refuge—they wanted to put some distance between themselves and the French authorities. Although the profession of the Sevestres was relatively new, it was important, and it was closely controlled by the royal powers, which were uneasy about an invention enabling extensive and rapid circulation of information. The Sevestres came from a line of printers who had published many books and had a prosperous business. In fact, the children managed to gain admittance to this closed profession, wagering on its promising future. However, the Sevestres made some serious blunders: they published treatises on alchemy and Huguenot and Calvinist religious writings, all subjects strongly condemned by the Paris government in the 1630s. The Sevestre family probably preferred to emigrate to a faraway colony and be forgotten. How else to explain the presence of these cultured Parisians in a farflung region where they were forced to abandon their craft? The colony, numbering only several hundred persons, was poorly equipped, preoccupied with survival, and could not afford a book publisher. In fact, it wasn't until more than a century later that such a company was founded. In Québec, the Sevestres took administrative positions, for which their level of education qualified them.

The fate of the Sevestre family illustrates the difficulties of life in New France. One brother drowned during a fishing and hunting expedition. Another remained unmarried. The mother, who had wed in the prestigious Saint-Étienne-du-Mont church in Paris, died in 1640 in "her cabin on Cape Diamond." The only son to have a family had only daughters, so the name was extinguished in Canada. However, the Gauthiers, Royers, and Duquets are associated with this bloodline. In time, the Villerays joined them.

On February 19, 1658, two months after her father died, Catherine Sevestre married Louis Rouer de Villeray. She was fourteen years old, he almost thirty, but this was not unusual. Since there were few women in the colony, they married early; the men, more numerous, waited to become established before taking a wife. The youngest of the Sevestre daughters, Catherine, was living with her mother and her twelve-year-old brother. The oldest daughter was already married

From a Pope's Family

Through his marriage to Catherine Sevestre and the inheritance received from her father, Louis Rouer de Villeray became one of the largest landowners on the Plains. The Rouer de Villerays were a family of ancient nobles, originally from Italy, and counted three popes among their ancestors: Sixte IV (1471–1484), who excommunicated the powerful Medici family; Jules II (1503–1515), who built Saint Peter's in Rome; and Paul iv (1555–1559), seventh general of the Company of Jesus. Louis Rouer de Villeray was named first councillor to the Conseil Souverain de la Nouvelle-France when it was formed, in 1663, and retained that position until his death, in 1700. ✌

The Plains in a Random Draw

After Charles Sevestre died, there was a dispute between his seven children as to how his possessions should be divided. They sought a solution by visiting a notary, who divided the possessions into seven lots, which were drawn at random by a child who was passing by in the street. One of these lots, comprising the Plains of Abraham, was a problem, for it was divided between Philippe Nepveu and his wife, Denise Sevestre, Estienne de Lessart and his wife, Marguerite Sevestre, and Louis Rouer de Villeray and his wife, Catherine Sevestre. The notarized record lays bare the question, and the solution: "Seeing that there are difficulties in dividing the said concession and making equal portions, because of a house and a garden which would be useless if they were divided, [the parties] are of one mind and have agreed to leave this concession to the person who is chosen by random draw. . . . This done, there were three tickets made, two of which were marked A and the other C, to signify said concession. After having been mixed a number of times by me, said notary, each took a ticket and that marked C, and thus the said concession, fell to Mr. de Villeray."
Notary Gourdeau, 9 February 1662. ✌

La Cardonnière

*T*his estate, sometimes called a manor, a mansion, or a château, included a house that had belonged to Mr. de la Martinière and was rebuilt in 1664. After Catherine Sevestre died, in 1760, an inventory was made, the basic elements of which will serve to describe the way of life on this property situated on the Plains. To understand how the building was arranged, it must be noted that at the time settlers usually ate, slept, and lived in a single room.

La Cardonnière had seven rooms: kitchen, granary, bedroom, small kitchen, cellar, battery, and small workshop. The residence was surrounded by other small buildings and by a grange more than fifty feet long. Behind them was a good-sized orchard.

There were a number of animals: fourteen oxen, two bulls, twelve cows, four young bulls and three heifers, five calves born that year, nine pigs, and nine lambs, along with animals belonging to other individuals, which Rouer kept for a monthly fee.

The notary also listed forty-three books on religious matters, law, history, and travel, as well as paintings of Colbert and Sainte-Catherine. ❧

and the second daughter had settled on the Beaupré coast; Rouer de Villeray became their protector and supporter. The active role that parental death played in the formation of couples was confirmed. The match was mutually advantageous: Catherine Sevestre had goods and Rouer de Villeray had an influential position in the young colony.

Born in Amboise, France, in 1629, Rouer de Villeray arrived in Québec in 1650 or 1651 as a simple soldier. During his first years in Québec, he made his living by his wits, as secretary to the governor, notary, and clerk-registrar. He lacked neither intelligence nor culture. He was from a noble Italian family, members of which, in the preceding century, had been popes. In 1663, he became first councillor of the Conseil souverain de la Nouvelle-France, the fourth most important position in the colony, after the governor, the intendant, and the bishop. He thus gained the advantage of a permanent position and an official residence, and the prestige of representing the interests of the inhabitants of the colony.

Through his marriage, Rouer de Villeray inherited part of the Sevestre land on the Plains. He thereafter concerned himself with enlarging his estate; after acquiring a second lot from the company of New France, he purchased five more lots, for five hundred *livres* apiece, in 1660 and 1661. With almost fifty *arpents* on the site of the Plains, he had an immense estate. In 1664, he built La Cardonnière, a manor with orchards and outbuildings, at the gates to the town; he called this complex a mansion or château. He lived the life of a country lord on the most beautiful spot in Québec, profiting both from the wealth and bounty of nature and from his position as arbiter of lawsuits in the colony. In business on his own behalf, he conducted a number of transactions both at Charlesbourg and on Île d'Orléans. His social position in the colony was no hindrance, although he was sometimes weighed down by his responsibilities. Finally, forced to take sides between the governor and the bishop or the intendant, he decided to step down from his position. However, the La Cardonnière estate ensured that he wanted for nothing.

Rouer de Villeray's private life saw a number of upheavals. He had three sons through his union with Catherine Sevestre, but she died in 1670, not yet thirty years old. Two years later, his youngest son died in a fire. His second marriage, to Marie-Anne Du Saussay de Bémont, whom he wed in November of 1675, was barren. When his sons left home, Louis was still single and Augustin made what was considered a poor marriage—Rouer de Villeray even refused to attend the wedding. The witnesses were a bailiff from the Prévôté and a merchant.

Louis Rouer de Villeray seems to have had some happy days at La Cardonnière, in spite of his daily obligations. He soon planted a new orchard. In 1682, a grange measuring eight by sixteen metres was built for the breeding of cattle and sheep. His oldest son had

The de la Cardonnière manor, the d'Artigny mill, and the pastures on the Plains in 1734. (Plan appended to a notarized contract, ANQ, Henry Hiché)

Marie-Anne du Saussay and the Filles du roi

Marie-Anne du Saussay, second wife of Louis Rouer de Villeray, who lived in the la Cardonnière manor on the Plains from 1675 to 1701, was an active participant in a unique and original settlement initiative. New France was populated very slowly; after more than fifty years in existence, the colony still had fewer than three thousand settlers. Women, in particular, were very rare; there was one for every six men. The French authorities thus undertook a recruitment campaign among rural priests and at the Hôpital de la Salpêtrière, a hospital which also served as a shelter for young girls in difficulty and provided food, lodging, and education for the orphans of military men who had died in the service of the king. In total, more than 880 young women, promised a dowry by the king, decided to take their chances in New France between 1657 and 1672. These were the filles du roi. They travelled to the colony under the watchful eye of responsible people. While they waited to be married—which usually took place within three weeks of their arrival—they stayed with the Ursulines of Québec. Marie-Anne du Saussay was the tutor of one of these groups. Between the seventh and the thirteenth of October, 1671, she signed as witness on the marriage contracts of some twenty filles du roi before the notary Becquet. Four years later, this trustworthy person of high rank married Rouer de Villeray, who had been a widower for several years. ↶

already blessed him with three grandchildren: Louis in 1690, Angélique in 1692, and Jacques-Augustin in 1696. However, the future of his own children caused him some anxiety. The king remained deaf to his requests for administrative positions for them. His second son, Augustin, committed an indiscretion: in 1695, aged thirty, he impregnated a seventeen-year-old woman. A young husband matching her own station in life had to be found as quickly as possible. Three months before her child was born, the young woman was able to rectify her situation. The scandal could not help but reflect on all of the Villerays, even though they alleged, according to the logic of the time, that the fault lay with the young woman: she had not known enough to keep her rank or her virginity. Furious, Rouer de Villeray took this opportunity to remind his children that he seen to their future up to that point. Although he did not threaten to disinherit them, he scolded them roundly. On the one hand, in spite of everything, Rouer de Villeray had a good life, with fifty years in one of the most important positions in the colony. On the other hand, the future of his two sons was not yet assured.

Louis Rouer de Villeray's will, read on April 17, 1701, called for an interesting division of goods. According to the notarized record of the transaction, "there was great difficulty in arriving at a division, since the said goods consisted only of two bottom lots on which there are a considerable number of useless buildings, the appraised value of which comprises a considerable part of the goods which absolutely cannot be divided." Louis Rouer d'Artigny, the second son, who now tacked on the name Villeray, ended up appropriating the estate on the Plains, taking possession of the goods, effects, furniture, and livestock of La Cardonnière. However, a high price was exacted: he had to pay off debts amounting to the tidy sum of eight thousand *livres* (almost twenty times the annual salary of a skilled worker) and pay out a sum of sixty-three hundred *livres* to be shared between his brother and his mother-in-law.

The life of the inheritor of the large La Cardonnière estate, on the Heights of Québec, is not well known. We do not know, for example, why he remained single and why the representative of the king of France never bothered to respond to his requests for an appointment. Rouer d'Artigny nevertheless claimed the honours that he felt were due to his rank. In 1707, before the courts, he managed to obtain the use of a pew of honour at the church and to receive communion before others. In 1717, at the more than respectable age of fifty years, he was finally appointed a councillor, but, insisted the minister, lowest in the hierarchy. Forced to quit his post in 1728, he regained it the following year, once his good will was proved.

At La Cardonnière, Rouer d'Artigny continued to raise livestock, with the aid of hired help. Suddenly, in 1703, he sold two work oxen, six beef cattle, ten cows, three bulls, and fifty sheep to a

Québec butcher. He began growing hops, then got into the business of fishing for porpoises. He also constructed a mill. In 1727, he took advantage of an intendant's order which forbade anyone from entering his enclosures, climbing his fences to hunt game, or breaking into his pastureland.

However, between 1720 and 1740, Rouer d'Artigny progressively broke up his estate. In fact, the first transactions were imposed on him by the authorities, who appropriated part of his land to erect a new line of fortifications. Thus, he had to cede, on pain of great penalty, twenty-three *arpents* of land, of which seven were levelled down to the rock. Then he divided up the land bordering on Grande Allée; possibly because he needed the money, he sold a number of sites measuring ten by thirty metres. One of the purchasers was Guillaume Fabas, who owned a house bearing the sign "Les Trois Pilliers." It was probably an inn, the first bordering the Plains. In 1727, d'Artigny let go of the land he had inherited from the Sevestres, selling to the Ursulines the seven *arpents* of frontage that constituted the Buttes-à-Nepveu. Finally, in 1734, he gave up his windmill and the land of the Villeray estate to Paul Costé. As an old man, he lived in Madame de Morville's house, facing La Cardonnière. In his holographic will, written in 1742, he stipulated that his goods must be leased out for three years following his death in order to pay off his debts. The money and goods acquired by his father seemed to have been squandered by this strange, enigmatic person, and the records of how his goods were divided have disappeared from the archives.

It was the Belgian herbalist Hubert-Joseph Lacroix who proceeded to piece the lots back together, a project he had envisaged since 1735. Between 1754 and 1758, he procured one lot on the Plains by allocation, and purchased five others from various inheritors of the remnants of the Villeray fief and the La Cardonnière estate. Lacroix's wife survived him; when she passed away, in 1793, her probate inventory indicated that she had lived very comfortably during the last years of her life. She had four houses in Québec and a lot, named the Fief of Villeray, with fifteen *arpents* of frontage, on the Plains.

The descendants of the Lacroix-Dumont marriage made legal claims on the property of the fief of Villeray at the beginning of the twentieth century. The archivist Pierre-Georges Roy was asked to examine the titles and perhaps to refer the matter to the courts. A number of records relating to successions of Louis Rouer d'Artigny et de Villeray and to that of the Lacroix-Dumont couple have not yet been found.

The presence of a Belgian herbalist on the Plains was not unusual; it could be traced back to the beginnings of New France. It was the expression of another form of attraction exercised by the Québec promontory on people who came from Europe.

MILLEFOLIA TVBEROSA.

The Plains: A Laboratory of the New World

*J*ACQUES CARTIER was interested in the ores, trees, and plants that he discovered at the west end of the promontory. In some respects, he could be considered the first European naturalist in New France. Champlain, in his turn, also conducted several experiments. He planted on the Plains an apple tree from Normandy, which adapted easily to Québec's cold climate, and even some wheat and corn. Many who followed were astute observers of Canadian flora and fauna.

In his journal for the years 1607–09, Pierre de l'Estoile mentioned that he had met a certain Mr. Du Monstier who "possesses many rarities from India and from Canada." He showed him, among other things, "a small bird from Canada, which he called *Menidon*, very beautiful, resembling our nightingale, and which he said made more noise, singing, and melodies." Before the founder of Québec City died, in 1635—even before Trois-Rivières and Montréal were founded—a "doctor regent in the faculty of medicine in Paris," Jacques Cornuti, published a book entitled *Canadensium Plantarum, Aliarumque nondum Editarum Historia*. This 167-page work, written in Latin, described eighty Canadian species and plant varieties and contained thirty illustrations, including some in colour. The New World provided a marvellous laboratory for these early scientists.

In the following century, several prominent people, today almost forgotten, explored in their turn the riches of the New World and of the Québec promontory, and obtained worldwide recognition. The Heights of Québec were crisscrossed by scholars who kept up a close correspondence with the great institutes of Europe and whose work was published by the Académie royale des sciences in Paris. Their discoveries were regarded as an important contribution to the world body of knowledge of nature. Working in the areas of botany, mineralogy, meteorology, medicine, zoology, and agriculture, these researchers added new species and information to the international taxonomy of the time. Aside from Joseph-Hubert Lacroix, whose activities are not well known, three people did remarkable work in this respect: Michel Sarrazin, Jean-François Gaultier, and Pehr Kalm. Each of them, in pursuit of a common ideal, helped to spread the

Yarrow (**Achillea mellefolium***). This plant is very popular for its many medicinal qualities. It was used as a styptic poultice, and to lower fever when brewed in an infusion.

Title page of Jacques Cornuti's work on Canadian plants, published in Paris in 1635. (BNQ)

SARAZIN

fame of the site and its environs, as well as forging a vocation and a memory that are still respected and cherished today.

Michel Sarrazin arrived in New France in 1685 as a surgeon for the French navy, and stayed as chief surgeon for the troops. When he returned to France for three years, in 1694, he studied botany at the Jardin royal des plantes, later renamed the Museum d'histoire naturelle, under one of the great specialists of the time, Joseph Pitton de Tournefort, the predecessor of Buffon and Linnaeus. When he returned to New France, Sarrazin lived at the fief Saint-Jean, which was contiguous with the site of the Plains, and perhaps even included part of it. Soon after (1699), he was named a corresponding member of the Académie des sciences in Paris, to which he regularly sent reports, theses, and specimens of what he had found in Québec. In the opinion of the Académie, he was a great scientist, on a par with Sir Isaac Newton in England and William Sherard, author of *Sherardian Herbarium*, at Oxford University. His works were well received by scientific critics, including the *Journal des Scavans*, which regularly published abstracts of his papers.

For twenty years, Sarrazin sent specimens to the Jardin des plantes in Paris and prepared a *Catalogue des plantes du Canada*, including new species or varieties such as *Aralia*, a type of ginseng, a plant well known among the Chinese. His master in Paris, Tournefort, also discovered a new species, which he named in Sarrazin's honour, *Sarracenia purpurea*. Sarrazin was passionate about his research, and his scientific work matched that of the great scholars of the time. His son was to succeed him in New France, but he died in an epidemic before he finished his studies.

Michel Sarrazin's position of king's physician remained vacant for seven years. It then fell to a protégé of Duhamel du Monceau, Jean-François Gaultier, who also studied at the Jardin des plantes and the Académie des sciences. Gaultier was in receipt of the 175 works left by Sarrazin, as well as his *Histoire des plantes de Canada*, a two-hundred-page manuscript written in 1707. When he arrived in Québec, Gaultier settled in the upper town, on the fortuitously named Rue des Jardins. Like his predecessor, he was elected a corresponding member of the Académie royale des sciences and kept up a written exchange with Duhamel du Monceau and Ferchault de Réaumur. The governor of New France, Roland-Michel Barrin de La Galissonière, himself an avid follower of the natural sciences, charged Gaultier with creating an complete inventory of plants in Canada.

Each year, Gaultier sent Duhamel du Monceau seeds, bulbs, and plants for the Jardin du roi and for the experimental tree nursery at Château Denainvilliers. He prepared a manuscript about four hundred pages long on plants in Canada, complementing Sarrazin's work; his mentor used many of these new species descriptions in his *Traité des arbres et arbustes*. Gaultier also helped popularize pharma-

Michel Sarrazin (1659–1734), scholar, member of the Académie des sciences de Paris, surgeon, and naturalist, who collected plants on the Plains of Abraham. (Oil painting by Pierre Mignard, Musée de l'Île Sainte-Hélène)

Pitcher-plant (**Scarracenia purpurea**). This carnivorous plant grows in very humid, very acid habitats. It has become the provincial flower of Newfoundland. It was named in honour of herborist Michel Sarrazin, who worked in Québec in the seventeenth and eighteenth centuries. (Photo: Ariane Giguère)

A plant on the Québec promontory, described and drawn in Jacques Cornuti's book. (BNQ)

ceutical usage of a number of plants, such as the maidenhair fern and wintergreen, to which he lent his name (*Gaulthiera*). The botanist applied his knowledge to medicine; among the remedies he used at the Hôtel-Dieu hospital were teas, poppy infusions, couchgrass, licorice, and mineral waters. He also experimented with mineral water the source of which he found "a small distance from Québec, in a western direction, about a quarter of a Swedish mile [thus, probably on the Plains]. It contains iron oxide. . . . This water is usually given to ill people to combat obstructions, hypochondria, and ills of this nature."

In addition to being a physician and botanist, Gaultier was interested in other scientific areas. He devoted a good deal of time to meteorology. In November of 1742, he established the first meteorological station in Québec. Each year, he transmitted to the Académie des sciences a journal of his daily readings of the temperature, taken regularly between seven and eight o'clock in the morning and between two and three o'clock in the afternoon, along with notes on the state of the sky, the precipitation, and the wind. In 1753, his correspondent at the Académie des sciences, Ferchault de Réaumur, sent him a new thermometer specially adapted to the cold conditions in Québec.

It was but a short step from meteorology to astronomy. Gaultier observed the flight of a comet for several months at the end of 1745 and in 1746, then an eclipse in 1754, and described the beauty of an aurora borealis which kept him up late into the night. He sent for a sextant and a telescope to conduct his studies. However, he was not allowed to construct an observatory; the authorities felt that study of the heavens should take place at a distance from the town.

As if the skies were not enough, Gaultier also occupied himself with analyzing the ground beneath his feet. Along with Pehr Kalm, whom he met in 1749, he studied the schist that formed the bedrock of the Plains, and included samples of it, along with sand, stone, limestone, and slate, among the specimens he sent to France. Using Gaultier's packages, the mineralogist Guettard, of the Académie des sciences, published the first geological and mineralogical map of Canada. The Heights of Québec were at the forefront of the world's scientific research.

One of the great moments in Gaultier's career was the official visit to Québec, in 1749, of the internationally renowned Swedish botanist Pehr Kalm. Gaultier served as Kalm's guide, and they gathered plants for two months on the Heights of Québec and the surrounding area. Their research was so fruitful that Kalm produced a manuscript entitled *Flora canadiensis*, unfortunately not available today. However, in his travel diary, Kalm identified some forty different plants, situating a good number of them "a short English mile south

American erythronium (**Erythonium americanum**). The popular name, trout-lily, alludes to the mottled petals. Very common and well liked by cattle, this "soft garlic" was also used as a poultice to reduce swelling and ulcers. The sweet bulbs are edible; the leaves, when boiled, can be eaten as vegetables.

Bull thistle (**Cirsium vulgare**). This plant was long used to combat varicosities. It is originally from Eurasia, but it was soon naturalized in Canada. It was considered to have antibiotic properties; the root contains a starchy gland; peeled, it is edible.

The buds burst forth on the Plains in springtime.

Louis Hébert: Farmer, Apothecary, and More

Louis Hébert has a special place in Québec's history and in Québecers' hearts. He was considered the first farmer of New France, as evidenced in the writings of Champlain and the Jesuits. The incarnation of the fundamental, traditional values of French-Canadian common society, he evoked the image of the courageous rural settler, living piously in the shadow of the church steeple. He symbolized attachment to the land and family and, in his respect for authorities, the foundation of the survival of the French-Canadian community in North America.

In fact, Louis Hébert was an apothecary by trade. Before he arrived in New France, in 1617, he had lived in the city—at 27 Rue du Faubourg-Saint-Honoré, near the Louvre in Paris. Nor was he particularly well known; he worked in the court of Catherine de Medici, and his cousin was a commander in Acadia. How he became the first farmer in New France is quite a mystery.

What does an apothecary do? He prepares remedies. From what? Plants, naturally. In fact, Hébert was charged with seeing to acclimatization of the apple trees transplanted from Normandy. Where did he settle in Québec? On the promontory, near the fort built by Champlain; he was the first person to try to live from the fruit of his labour on the Heights of Québec. And why was he there? To exploit the rich soil. He farmed, but without a plough; he probably was more of a gatherer. In fact, in 1634, a herbalist of Italian origin, Jacques Cornuti, published in Paris a catalogue of Canadian plants, listing more than eighty species or varieties. Aside from Champlain, who was very busy, and the Jesuits, who had just arrived, only one person knew the plants well enough to describe them so carefully and in such detail: herbalist and herborizer Louis Hébert. ❧

of Québec, near the St. Lawrence, where the hills are quite high." He was no doubt in the shadow of today's Plains.

Of all of these identifications, three merit special mention. *Gaulthiera* was named by Kalm in honour of Gaultier. Kalm wrote, "Another plant was found here that neither Mr. Gaulthier [sic] nor myself have encountered before, and which I do not think has been previously described. It grows in the underbrush . . . about half an English mile outside the town," to the west. It was a wintergreen, a species comprising about 150 varieties distributed throughout Asia, the Pacific, and the Americas, often used in horticulture as background greenery or ground cover. Another plant described by Kalm was named *Sarracenia purpurea*, named in honour of Gaultier's master and predecessor, Michel Sarrazin. Finally, he named another plant *Galissoniera* "in memory of Marquis La Galissonière, ex-governor general of this country, a man admirably competent in all sciences and, in particular, a very great lover and connoisseur of the natural sciences . . . a man with qualities to which one cannot render enough honour." This plant had been discovered by the botanist Jungstrom of Pennsylvania, to whom Kalm regularly sent seed specimens.

Like other scientists of the time, Kalm was also interested in astronomy. He described measuring the variation of true north from magnetic north by spending a night, Wednesday, August 9, 1749, in an empty field just at the gates to the town—that is, very probably, on the site of the Plains:

> That night, I observed for the second time a variation in the magnetic needle. I had proceeded to observe this subject in the night of the 7th to the 8th of this month, but as the sky was not as clear as I would have hoped and the weather was not completely calm, I first found 12° and 37° west, or thereabouts. But I remarked that at two ends of the stand on which I had placed the compass there were nails and, since these were situated at a distance of about one *ell* [approximately one metre] from the compass, I judged it necessary to take another stand that did not contain any metal objects. . . . On the other hand, this night was more favourable: a perfectly clear sky, the air so calm that a feather would not have moved. I thus had a good chance to take my meridian, in a field situated just at the gates of the town, with no house nearby. I made my observation when the first star of the Chariot (Ursus Major) was perpendicular to the Pole Star. It was just before three o'clock in the morning. When day came, I put my compass and its dioptres on a wood stand; I had taken great care beforehand to separate from me, at a distance of at least three *toises* [about eight metres] from the compass, all iron objects, shoe buckles, knife, etc. The stand also contained nothing but wood, and I checked to see if there were any nails; there were none. After placing the compass such that the dioptres showed the cross hairs very exactly, that is to say, the meridian line—something I had examined carefully a number of times—the magnetic needle indicated 12 degrees and 35 to 37 minutes west. The air was still so calm that a feather would not move and there was not the slightest movement in the trees. One can thus take for a fact

Red baneberry (**Actea rubra, Wildenow**). This plant, nicknamed doll's-eye, is widespread; its fruits are toxic, and its root is a violent purgative and emetic.

Teaberry (**Gaultheria procumbens**). This variety of wintergreen was named by the great French herborist Linnaeus, who dedicated it to Jean-François Gaulthier, botanist and king's physician in the mid-eighteenth century. This plant was known for its properties as an astringent, stimulant, and anti-diarrhetic. (Photo: Ariane Giguère)

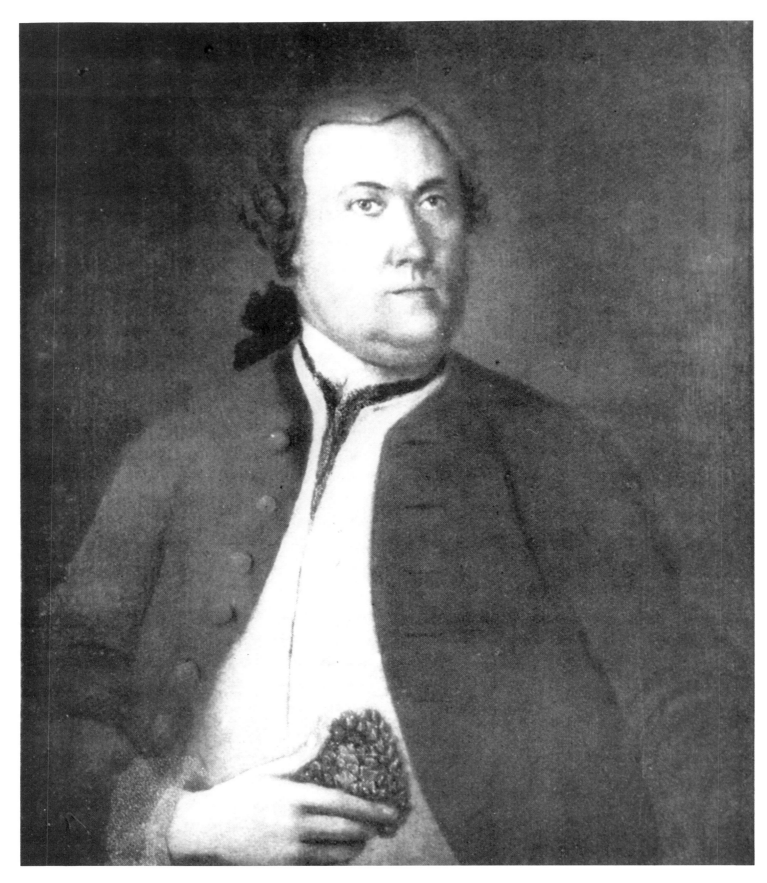

Pehr Kalm (1716–79). This Swedish scholar visited
Canada in 1749, and wrote a catalogue of the
country's plants and an inventory of its minerals. He
went to the site of the Plains and calculated its
position in relation to the meridians. (Musée national
de la Finlande, Helsinki)

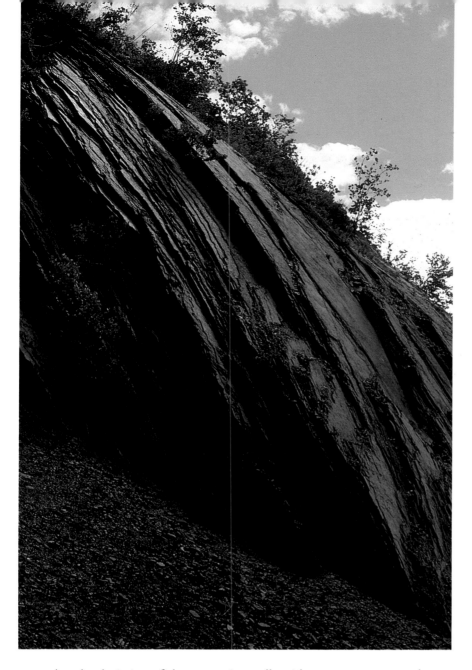

"Leaving the fort and turning left, one takes a fairly wide esplanade and climbs on a gentle slope to the summit of Cape Diamond, which is a very beautiful plateau. Aside from the captivating view, one can see a quantity of porpoises, white as snow, playing on the surface of the water, and one sometimes gathers diamonds, more beautiful than those of Alençon."

F.-X. de Charlevoix, Journal d'un voyage, 1720. ଓ

A Botanist's Feelings when Spring Arrives

Almost every year between 1743 and 1754, Jean-François Gaultier noted the exact dates when the first soft signs of spring appeared: the melting snow, the notches in the maple trees, the arrival of the swallows, butterflies, and ducks, the chirping of the nightingales, the fattening buds on the lindens and apple trees, the ground covering itself in greenery and the plants coming to life, the flowering of the apple trees, shadberry bushes, lilies, tulips, and narcissus, and the ripening of the first strawberries. ଓ

that the deviation of the magnetic needle with respect to true north east of Québec is at this time, 12°37' west.

From the Plains, on the promontory, the position of Québec in the world was forever precisely fixed on that night, August 9, 1749.

Kalm was also interested in the rocky hill on which the town had been constructed. On the afternoon of Wednesday, August 16, he went outside the walls, where workers were "breaking up the compact black schist that is used to build the houses and most of the walls of the town":

> The compact black schist is that which forms the hill of Québec, and also most of the heights and the abrupt slopes found in the area. When this rock is in the ground about one *ell* below the surface, it is perfectly compact and it is impossible to see the slightest striation in it. . . . This schist is distributed in the form of layers the thickness of which varies from the width of a hand or less to one *ell* or more. In the whole of this hill on which Québec is built, the rock is not horizontal, but has a fairly strong inclination which can go as far as the vertical. . . . The layers are separated by a number of fine grooves and most of these narrow crevices are filled with a fine white spar which, when the rock is broken, can

The inclined slate layers on the Plains, like those described by Pehr Kalm.

A Temporary Botanical Garden

The botanist Jean-François Gaultier, charged with making an inventory of all the plants in Canada, wrote a short manual for commanders of forts dispersed throughout the colony. They sent many specimens, for him and for the home country. While waiting to ship them to France, Gaultier used the intendant's garden as a stopover nursery. He also maintained a permanent collection, an embryonic botanical garden. ✌

Other Observations and Innovations by Botanist Gaultier

From his correspondent in Paris, Gaultier received instructions on techniques for preserving eggs and raising chickens in all seasons. This was probably the invention of incubators.

In 1742, Gaultier observed that for the first time in Québec "we were advised to make holes in the ice to fish for small eels, and this fishing was successful." ✌

sometimes be taken out with the blade of a knife and presents itself as a fine white paillette.

With this exploration, Kalm was able to resolve, at least in part, an enigma that had endured almost two centuries:

Where the fissures are the largest, they are filled with rock crystals of greater or lesser size and of very dense matter. These are quite clear and, hit with a flint, they produce a strong spark. In certain places on the hill, one finds a great quantity of these crystals, and this is why it, as well as the cape which is just to the south-southwest of the château, was given the name *Pointe de Diamant*. . . . The entire hill, from the summit to the base, is composed only of this schist.

As it was quite easy to cut, the schist "was used for construction of most of the public buildings and private homes of Québec, as well as a good part of its walls, not to mention walls around convents and gardens." It could, however, pose architectural problems:

After being exposed for one or several years to the air and the light of the sun, [the stone] divides into sheets of more or less thickness. . . . However, this phenomenon causes no particular damage to the wall; indeed, the stone is placed in such a way that its cleavage is horizontal and the stones place pressure on each other; in this way, the flaking is produced only on the exterior surface of the wall and not on the interior. The older a house, the finer the sheets.

This use of the rock mass of the promontory continued in the nineteenth century. The government operated what it called "engineering quarries," under the supervision of military engineers. The softness (friability) of this rock made it possible to construct a huge subterranean water reservoir. Later, ladies combed the hills and hollows of the promontory in an attempt to expand their collections of rare specimens of plants, birds, or butterflies. The military, for its part, was interested particularly in astronomy and meteorology, and pursued its attempts to understand the weather and nature.

Thanks to the French who settled in Canada and to the local population, enriched by the knowledge of aboriginal peoples, the qualities and riches of the Québec promontory were recognized and appreciated in Paris, London, Philadelphia, and Stockholm. All of these people made the Plains a veritable laboratory of the New World, contributing to science—especially the natural sciences. Ecological and environmental concerns, as well as the desire to live a healthy life, submitted these qualities to the tastes of the time . . . sometimes for more than a century.

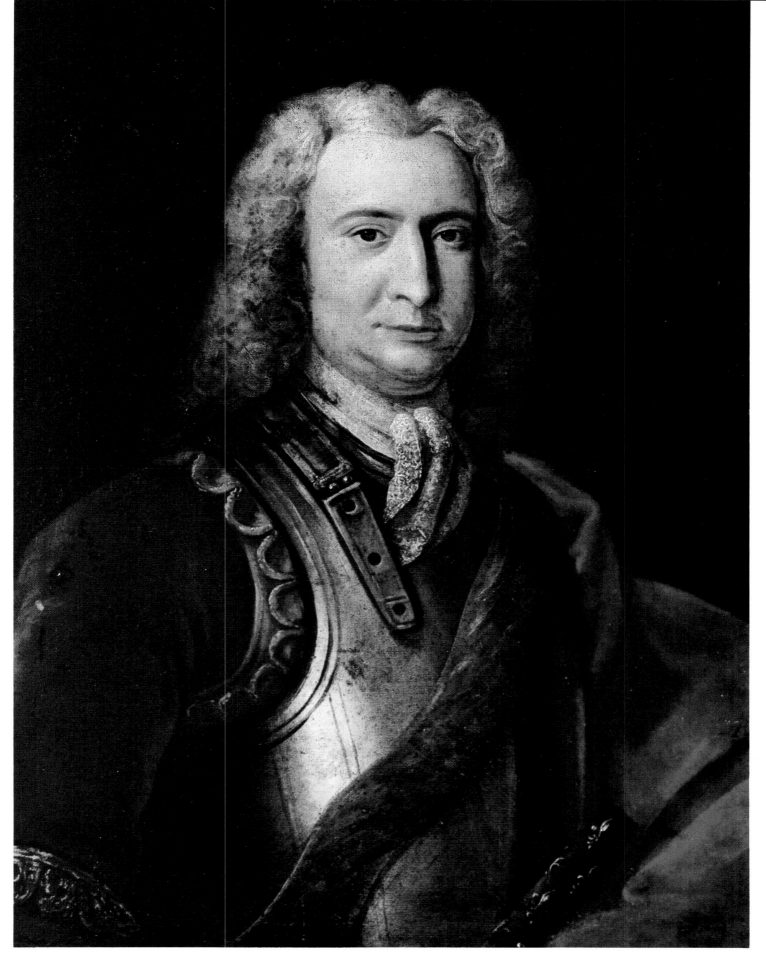

Roland-Michel Barrin de la Galissonière (1691–1749).
Scholar and nature lover, he directed a major project
for gathering and analysis of Canadian flora. (Musée de
l'Île Sainte-Hélène)

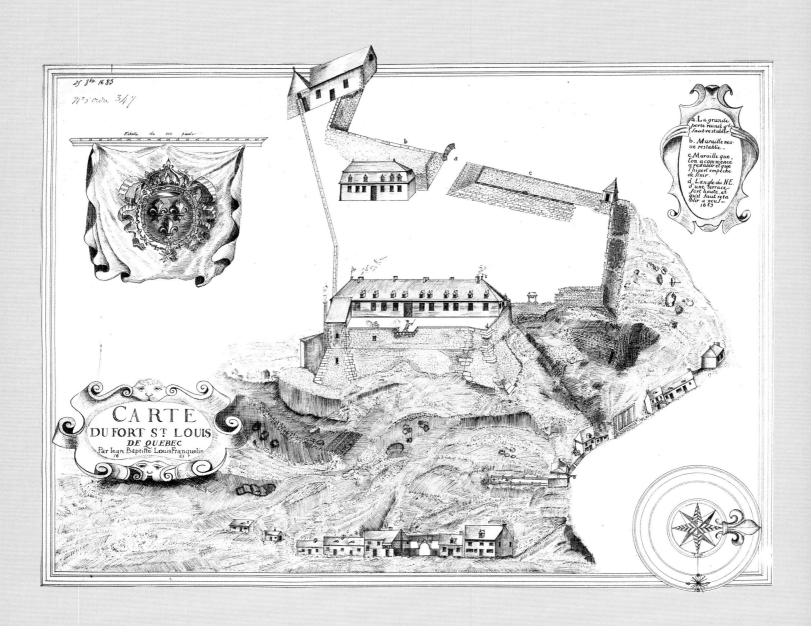

25 8bre 1683

N°. d'orde 317

Echelle de 100 pieds

a La grande
porte ruiné q'il
faut restablir

b. Muraille neu-
ue restablie

c. Muraille que
l'on a commence
a restablir et que
l'hiuer empêche
de finir

d. L'angle du NE.
d'une terrace
fort haute et
qu'il faut reta
blir a neuf
1683

b

a

c

CARTE
DU FORT St LOUIS
DE QUEBEC
Par Iean Baptiste LouisFranquelin
16 83

The Command Post
of the French American Empire

*I*n the seventeenth and eighteenth centuries, the Québec promontory symbolized France's empire in North America. The French flag flew here, at the prestigious Château Saint-Louis, residence of the governor general of New France. From here came the orders regarding war or peace; from here, diplomatic relations were conducted with the First Nations or the British colonists. Explorers, commanders, missionaries, and emissaries came here to collect their mission orders before heading off to Acadia, Newfoundland, Hudson Bay, Detroit, Michillimackinac, Illinois, Louisiana, or to the English towns of Boston, Albany, or Manhattan (New York City). From the Heights of Québec, New France was ruled.

Supervision was always entrusted to a person who was both a noble and a military man; as the king's representative, he was invested with the powers and prerogatives of royalty. At the summit of the political, social, and military hierarchy, he was also privy to the highest symbols of power. His residence, rising from the most visible and impressive spot (near today's Château Frontenac), reflected the attributes of this primacy. Around it were the buildings that housed the main institutions of the small French town and that made it the seat of political and religious administration—the capital of the colony. The residence overlooked and dominated the river, the valley, and the lower town. At a time when great distances could be travelled only by maritime routes, it was the first impressive building seen by new arrivals from the home country. After alterations, the greystone building was two storeys high and had a façade measuring 120 feet (almost forty metres). Visitors admired the garden and terrace, protected by a stone wall and bastions, which symbolized the fortified town.

Québec needed this symbol, since it was a coveted spot. If Québec could be taken, all of New France could be seized; to dominate the heights of the town would be to subjugate the rest of the colony. In its struggle with France for world hegemony, England made Québec its main North American objective. The town became a stake between kings: on one side, the Sun King, Louis XIV, and his successor, Louis XV; on the other, the kings George and their great ministers Robert Walpole and William Pitt. The keystone of the North American defence system, at the summit of the cliffs, atop Cap-aux-Diamants, Québec seemed impregnable, invulnerable.

Québec at the End of the Seventeenth Century

"*T*he upper town is no less beautiful nor less populous. The [Saint-Louis] Château, built on the highest ground, commands it on all sides. The governors general who make their regular residence in this fort are comfortably lodged there, and also enjoy the most beautiful and extensive view in the world.*"

Baron de Lahontan, Nouveaux voyages. ✑

Fort Saint-Louis, residence of the governor of New France, on the Heights of Québec. (J.-B. Franquelin, 1683, NAC)

Elevation du côté de la cour.

fait a quebec ce 10.º Juillet 1724 Chaussegros de Léry

Terrasse.

Plan du Second étage.

Partie de la Batterie du fort

Cabinet · Chambre · Chambre · Cabinet · Chambre des Gardes · Cabinet · Chambre · Chambre · Cabinet

Garde Robe · Garde Robe · Corridor. · Garde Robe · Cabinet · Chambre

Garde meuble

However, the capital of New France was small, underpopulated, and poorly defended. In 1685, there were some two hundred houses, fewer than five hundred adults, and 249 guns. By 1744, there were 4,073 inhabitants, but this was fewer than the number of soldiers who participated in the various sieges of the town. To ensure its defence, military engineers devised scores of fortification projects. Each year, grandiose proposals were made to the French authorities, but little of the work was actually done. Improvised when the threat was imminent, the fortifications proved to be both slipshod and expensive. In the absence of resources, some had to be imposed. The image of Québec as a stronghold was created from its cape, its cliffs, and its symbolism. There was no doubt that Québec was impressive. And, starting on the Heights, this image of the stronghold both defined and delimited the plans for the city.

The Sieges of Québec

In the seventeenth and eighteenth centuries, all plans for attacking New France used a similar model. To take Québec, troops sailed up the river and were joined by a land army brought up from Lake Champlain via the Richelieu River, enclosing Québec as if in a vise. Once they arrived, the physical characteristics of the landscape dictated their military strategy. The ultimate target was to seize the fortified town on the heights. Various armies tried, in different

Plans et élévations du château Saint-Louis dans la ville de Québec, Chaussegros de Léry, 1724. (NAC)

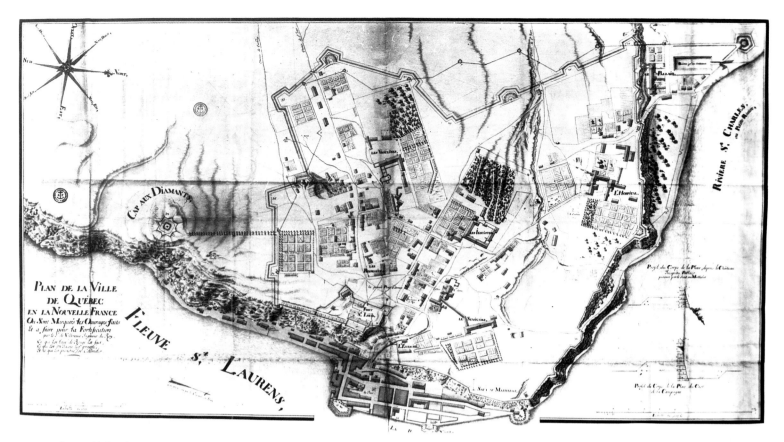

Plan de la Ville de Québec en la Nouvelle France

ways, but all had as a target this high ground, the symbol of power. If the cliff at Cap-aux-Diamants constituted an insurmountable obstacle, the stepped north escarpment presented a natural staircase, easily scaled from the St. Charles River. As well, there was the great promontory to the west of the city; it was also known to offer an advantageous position, although it was not easily accessible.

The Kirke brothers launched the first assault in 1628, but their small fleet could not take Québec by force. The fortified settlement, the surrounding forest, and the fort on the Heights provided refuges from which it seemed impossible to dislodge the French. All that was left was to lay siege to the town. Deprived of resupply, Champlain had to surrender in the spring of 1629. This English victory was, however, short-lived. In Europe, hostilities had ceased before Québec fell; three years later, the colony was returned to France.

A new threat arose in 1690. Reacting to French incursions on its borders, New England assembled a force of two thousand militiamen and thirty-two ships, which were placed under the command of William Phips. When they arrived at Québec, an emissary summoned Governor Frontenac to Phips's camp; Frontenac's response has become as famous as it was scathing: "Go tell your master that my cannons will give my answer." Phips installed his men on the Beauport shore and launched his attack. He bombarded the town, but it was he who lost a flag, cut from its mast by a French cannonball. As winter approached, Phips, with no support, lacking provisions, and worried about becoming trapped in the ice, decided to retreat.

The invasion of 1711 was even more formidable: ninety-eight ships and twelve thousand troops—ten times the adult population of the town—set their sights on Québec. However, a storm arose, and

The Strategic Value of Québec

"To become master of New France, one must first seize Québec, then all the other places around it that are fortified only with simple palisades will be obliged to lay down their arms, since they are wedged in at the top of the St. Lawrence River, all communication is blocked, the passage closed, navigation and help interrupted. In a word, by taking Québec one takes at the same time the entire country."
Baron de Lahontan, unpublished material and various texts. ☙

A hundred and fifty years after its discovery, Cap-aux-Diamants still fed the imagination of Canadian and French people alike. (Robert de Villeneuve, **Plan de la ville de Québec en la Nouvelle-France**, 1692, NAC)

The Difficulty of Defending Québec

"Québec is a poorly fortified town commanded by a mountain called Cape Diamond; its defensive wall is of such a vast circumference that it would take ten thousand men to guard it; as well, the land is so uneven that this defence can be swept away at once in a number of different spots."

Baron de Lahontan, unpublished material and various texts. ❧

Prise de Québec par les Anglais, 1629. Fictional portrayal of the taking of Québec by the Kirke brothers. (Louis Hennepin, **Nouveau voyage d'un pays plus grand que l'Europe**, 1698, BNQ)

a number of Admiral Walker's ships broke on the reefs of Île aux Oeufs, in the estuary of the St. Lawrence River. The rest of the fleet turned tail.

These attacks illustrate the importance and the symbolic value of Québec. They also provided the incentive to create proper protection for the town. Certainly, the natural features comprised a good rampart. Added together, the difficulties of sailing up the river, its narrowing, the cliffs of the Québec promontory, and the severe winters were a considerable discouragement. But these natural barriers did not suffice to guarantee defence of the town and its heights.

Fortifying the Heights

Protection of the town involved defending two large zones of vulnerability: the north, because of the ease of scaling the escarpment, and the west, because of the varying elevations of the promontory. In 1664, at the height of the conflict with the Iroquois, Jean Bourdon, royal surveyor and attorney general of the colony, proposed that the upper town be surrounded by a wall. This fortification, with bastions and gates, would limit access to the heart of the capital. Twenty years later, when the English became a greater menace than the Iroquois, a new project involved a wall around the commercial and administrative section of the lower town, where the intendant lived. The stress was put on the most exposed areas, at the foot of the escarpment and the western part of the town.

These new fortification projects were inspired by Vauban, chief engineer of the French armed forces. Vauban had considerably improved military defence systems, developing the art of fortifications to take account of everything from topography to gun angles. The "Lachine massacre" perpetrated by the Iroquois in 1689 and the fear of an attack by British colonists incited Governor Frontenac to rush his defensive preparations. He had a palisade of wooden posts erected, flanked by some solid stone bastions. Over the following years, a masonry wall replaced the wooden one, and redoubts rose in strategic spots: one on the heights of the cape, the other on the shores of the St. Charles River. All of this was, however, just a temporary defence system, the fruit of the initiative of colony's managers.

However, the notion of turning Québec into a stronghold made only slow progress. In 1700, the king approved Levasseur de Néré's proposal for a permanent masonry wall around the town. But the project languished: costs were higher than planned, and the king, in the throes of a new war elsewhere by 1702, wanted to lower his expenses. As rumours of an attack against Québec spread, makeshift defences were thrown up, independent of the main project. Serious tensions then arose between the engineer and the intendant. The situation grew so bitter that in 1710 the king ordered the creation of a fortifications council, composed of the town's notables, to make a

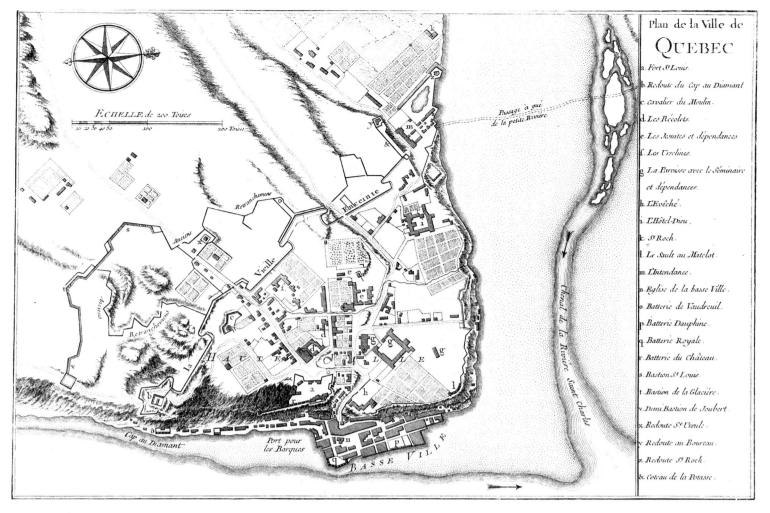

Plan de la Ville de
QUEBEC

a. Fort St Louis.
b. Redoute du Cap au Diamant.
c. Cavalier du Moulin.
d. Les Récolets.
e. Les Jesuites et dépendances.
f. Les Ursulines.
g. La Paroisse avec le Séminaire et dépendances.
h. L'Evêché.
i. L'Hôtel-Dieu.
k. St Roch.
l. Le Sault au Matelot.
m. L'Intendance.
n. Eglise de la basse Ville.
o. Batterie de Vaudreuil.
p. Batterie Dauphine.
q. Batterie Royale.
r. Batterie du Château.
s. Bastion St Louis.
t. Bastion de la Glacière.
v. Demi Bastion de Joubert.
x. Redoute Ste Ursule.
y. Redoute au Bourreau.
z. Redoute St Roch.
&. Coteau de la Potasse.

clear decision on which project to undertake. Given the poor economic situation, the council chose to replace Levasseur's project, which was too expensive, with an old plan proposed by Beaucours some years before. But the work, started in 1712, was interrupted the following year because a peace treaty was concluded. Exhausted by more than twenty years of war, France had no choice but to postpone construction of the Québec fortifications.

At the dawn of a thirty-year period of peace, the western flank of the town, in spite of some work, was still open. The other frontiers were better defended, but the general state of the Québec fortifications left something to be desired. The authorities in the home country well understood the necessity of protecting the capital of their North American colonial empire, as evidenced by the decision to construct a permanent fort, the arrival of the engineer Chaussegros de Léry in 1716, the consideration of a citadel project, and the approval of a new fortification plan in 1718. However, there was a major obstacle between intention and action: lack of funds. It was expensive to built fortifications—in Québec more than elsewhere. As well, Maurepas, the minister responsible for the colonies, was increasingly of the opinion that Québec was not the only town to protect. Construction of a fortress at Louisbourg and the beginning of a fortifications project in Montréal were indications of a new defence strategy that did not devote the entire budget to the colonial capital. In the 1720s, plans for the defence of Québec multiplied, but they were almost completely without follow-up. There were always further explanations required before a decision could be made and more time needed before the project could be undertaken.

A Fortification Treatise by the Royal Engineer of Québec

As well as executing his responsibilities as royal engineer of Québec, Chaussegros de Léry wrote a Traité de fortification, comprising eight books with 132 "very cleanly" drawn plates. In this monumental work, he used the experience he had gained in designing the Québec fortifications. The engineer was particularly insistent about adapting fortifications to the surrounding topography, a notion that he continually sought to apply in the defence works he formulated. ↄↄ

This plan of Québec shows the grip of institutions and fortifications on the upper town. (Plan of Québec published in Charlevoix, **Histoire et description générale de la Nouvelle-France**, 1744, NAC)

The First Citadel

"Québec is not regularly fortified, but we have been working for a long time to make it a good place. . . . A small, square fort, named the Citadel, still sits above, and the roads from one fortification to another are extremely steep. From the corner of the Citadel, which overlooks the city, we have made an outthrust bastion, from where we have pulled a curtain in at right angles, which will join a very raised cavalier, on which there is a fortified mill. Descending this cavalier one comes to a gun range, a first bastioned tower, and, at an equal distance, a second one."

F.-X. de Charlevoix, Journal d'un voyage, 1720. ✑

Developments on the Heights of Québec

"The château is on the edge of a large hill, with an escarpment of thirty fathoms. The house of the Governor General is a hundred and twenty feet long and in front of it is an eighty-foot terrace which looks over the lower town and the canal. The building is very pleasant, both inside and out.

"There is a battery of twenty-two embrasures at the side of this house, commanding the lower town and the river. Four hundred feet above is Cape Diamond, eighty fathoms high, on which is a redoubt which overlooks the fort, the upper town, and the countryside."

Bacqueville de la Potherie, Histoire de l'Amérique septentrionale, 1722. ✑

The resumption of hostilities between France and England in the 1740s revived fears and a sense of urgency. The capitulation of the Louisbourg fortress, in 1745, which in theory should have kept the enemy from sailing up the St. Lawrence to Québec, was a catalyst. As in the 1690s, the initiative came from the colony. Given the possibility of a massive attack, a group of prominent men met at Québec in August of 1745, and decided to proceed with construction of a fortified wall, without waiting for approval from the minister. Maurepas's anger and his threat to have the costs of the work defrayed by the population did not succeed in stopping work on the site, which dragged on in a haphazard manner through the following years. Performed in haste, without much planning, the work constantly required corrective measures and modifications—so much so that, in spite of using militiamen as forced labour, the cost became astronomical. In fact, the wall itself had not yet been completed at the time of the battle of the Plains in 1759. Although it was judged severely at the time, this work comprised the most complete defensive system Québec had had since its foundation.

Work on the fortifications was placed under the direct responsibility of the engineer, who designed the defence system based on his analysis of the land. Ideally, everything should start with a citadel, which would completely dominate the surrounding area for several hundred metres. Soldiers, arms, and gunpowder would be securely stored there, available on demand to respond to emergencies. However, at Québec under the French régime, this dream was never realized. Instead, the authorities contented themselves with constructing an insurmountable, bullet-resistant wall five or six metres in height around the town. The soldiers, well sheltered, could shoot through small embrasures, pierced at angles to widen the range of their aim. Bastions, well advanced from the wall at regular intervals, left no dead space where the enemy could hide from bullets. Just in front of the wall, a ditch, as wide and deep as possible, broke the attacker's momentum. Farther away, redoubts were erected overlooking the most vulnerable routes to serve as lookout towers and slow the advance of the enemy.

In this fortification design, several different principles had to be respected and, at times, reconciled. First and foremost, the Heights had to be controlled. In this respect, the dells of the Québec promontory, notably the Buttes-à-Nepveu, raised a number of problems. The enemy must be kept at a distance to avoid damage to the fortifications from his cannons. From both near and far, he must not be able to elude the fire of soldiers in the fort. Any knoll or structure offered an undesirable refuge. His progress must be slowed as much as possible to gain the time to concentrate troops and heavy arms. Even the design of the town itself was affected: it was necessary to place and align streets, terraces, and esplanades in such a way as to

ensure the effectiveness of the fortifications. Finally, the walls had to be strong enough.

Construction of the fortifications required a high level of technical knowledge and constant supervision to ensure their quality and solidity. The soil had to be levelled down to the bedrock, ditches and terraces made, high-quality, good-sized stones used. Ease of movement within had to be ensured, the powder protected from humidity and bullets, the cannons placed at strategic spots, and so on. As well, daily life had to continue as usual and the project had to remain affordable. The master contractor responsible for the fortifications, a competent engineer and a respected military man, a calm and meticulous civil servant, had to combine theoretical knowledge with technical know-how. As foreman of the workers and client of the contractors, he had to know how to motivate men and carry on construction-contract negotiations—and to do all this to the satisfaction of his superiors and in spite of the discontent of people expropriated or forced to work. The enterprise was considerable; the task seemed superhuman. But the engineer was not alone; he had expert advice from France. Usually, the governor and the intendant supported his proposals and other engineers assisted him. Some skilled workers— masons and stonecutters—were put at his disposal. However, realization of the work was above all a community effort. Soldiers were requisitioned, and townspeople and settlers from the countryside put their shoulders to the wheel. The fortifications accentuated the image of the imposing stronghold. Even unfinished, this extraordinary undertaking both impressed itself physically upon the urban landscape and became a strong and lasting symbol in the minds of Québecers.

In both the seventeenth and eighteenth centuries, in reality and in perception, the Québec promontory brought together worlds that were diametrically opposed: the old and the new, the military and the civil, the noble and the common, diamonds and iron. Even indirectly, nothing escaped these dreams of knowledge, power, and riches. The scene was set for great events. It was time to raise the curtain.

Engineer Chaussegros de Léry's Citadel Project

A little more than a hundred years before the first real citadel was built in Québec, the royal engineer, Chaussegros de Léry, proposed this type of fortification for the capital of the French empire in North America, but the project was not pursued at the time. Commenting on the engineer's design, Intendant Dupuy wrote to the minister, on July 3, 1727, "The Québec citadel that is proposed, sir, is a long and exhausting task, the type which, by its very nature, one begins but never finishes." For its part, the government of the home country believed that "these sorts of fortifications are not attractive to the spirit of Canadians, who do not like to be enclosed, and there are not enough regular troops to defend it. As well, His Majesty is not in a state to spend the sum of 325,290 livres requested for the execution of this project." ເວ

Québec besieged by William Phips in 1690. (NAC)

CHAPTER THREE

✼

The Battlefield

Jacques Lacoursière

See here O fair Britania at thy Feet. Quebec no more is hers, Auspicious Heav'n!
The Gallic Genius does her Keys submit. Has that to Britains braver Genius given;
The Standards too of her proud boasting band No more Acadian Swains, beneath the pow'r
She suppliant brings with her submissive hands Of Tyrants groan, but bless the happy Hour.
 When the brave Wolfe heroic, led the Way.
 To Victory, and dying, won the Day;
 Which brought them under George's milder sway.

At the Heart
of a World Struggle

*I*T WAS JUST A SMALL SPOT on the world map—the Heights of Abraham, on the Québec promontory. A single gun shot on the morning of September 13, 1759, and two generals were dead on the field of honour. This spelled the end of the French presence in North America; the political face of the world was forever changed. And so symbolism has amplified in the collective memory these episodes in a secular struggle between France and England for world hegemony.

The symbols portray ideals, but they betray reality. The rivalry had stretched back for more than a century, and the conflicts took place as much in Europe as in North America. Austria, Prussia, Sweden, Russia, the Netherlands, and the German states were also participants. In America, the confrontations took place in the Ohio Valley, on Lake Champlain, in Hudson Bay, in Acadia, in the Great Lakes region, and in the St. Lawrence Valley. The forts called Necessity, Monongahela, Oswego, William Henry, Carillon, Duquesne, Niagara, Frontenac, and Louisbourg are landmarks on a path that inevitably, inexorably, returns to the battlefield on the Québec promontory. On the other hand, it is easy to forget that the British victory of 1759 was followed by a defeat the following year, and that subsequent peace treaties would once again reshuffle the world political map.

Since the papacy had divided up the world, via the *Inter Cetera* bulls of 1493, the European powers had never stopped arguing over the Americas. Crosses marking possessions, exploration of penetration routes, establishment of posts and forts, wars of influence, economic rivalries, raids, and expeditions succeeded each other in a long parade of misfortune and cruelty. The Virginian Samuel Argall seized Acadia for a short time in 1613; the Kirke Brothers captured Québec in 1629. In 1648–49, the Iroquois destroyed Huronia. Dollard des Ormeaux died at Long Sault in 1660. Lieutenant-General Tracy conquered the Iroquois in 1665–67; in their turn, the Iroquois destroyed Lachine in 1689. Also in 1689, Frontenac launched raids on New England villages, and he even prepared a plan to attack New York. William Phips besieged Québec in 1690. Pierre Le Moyne d'Iberville laid waste to the forts of Hudson Bay and the shores of

France's surrender to England. In the background, a portrayal of Québec. (NAC)

Naming a War

The war between France and England and their respective colonies in North America between 1754 and 1760—or 1763—carried various names. The French Canadians called it the War of the Conquest. For them, this war marked the end of the French régime; it signified a switch in allegiance, with all that this implied on the political, economic, and cultural levels. The English talked of a new French and Indian War, because of the territorial stakes and the importance of alliances with the First Nations. The French, on the other hand, referred back to European events that took place up to 1763 and called it, simply, the Seven Years' War, because it officially lasted from 1756 to 1763, the year the Treaty of Paris was signed. ᴇᴏ

Louis-Joseph, Marquis de Montcalm (1712–59), commanded the French troops in 1759. (NAC)

Newfoundland in 1695–96. In 1710, Walker headed for Québec at the head of a powerful fleet. The French profited from the respite brought by the Treaty of Utrecht, in 1713, to fortify the access routes to the heart of North America. Designed to protect the entrance to the St. Lawrence, the powerful fortress at Louisbourg, built between 1713 and 1740, fell into the hands of the English for the first time in 1745. In 1754, less than ten years later, a new confrontation began in America, when the Treaty of Paris dictated that France cede its North American possessions to England.

At the end of the seventeenth century, the New England colonists, who were suffering the French presence less and less gladly, became convinced that confrontation was inevitable. The zones for fishing and trapping, the two main economic activities of the continent, blurred boundaries. In 1689, the enemy was clearly identified. The Bostonian pastor Cotton Mather declared, "Just as Cato could make no speech in the Senate without concluding that *Delenda est Carthago*, thus the conclusion of all our debates concerning the security of our country is that Canada must be conquered."

In London and in the thirteen colonies, the authorities became increasingly aware that possession of America was more important than a series of victories in Europe. In France, however, the stakes of North America do not seem to have been recognized. In 1759, governor Roland-Michel Barrin de La Galissonière recommended that the French presence in North America be strengthened, but his advice was not heeded. The governor had predicted the grave consequences of inaction: America would fall into English hands, and this loss "would carry along with it the loss of the superiority that France must claim in Europe." While the French authorities turned a deaf ear and a blind eye, a new war was brewing.

The Sites of Conflict

At first continent-wide, the conflict became focused on the towns of Québec and Montréal, the two main French urban centres in North America. In 1754, the population of the English colonies was over a million and a half, while there were only sixty thousand in New France. Despite their numeric inferiority, however, the French Canadians, acting in concert with a number of First Nations, had the New Englanders trembling in their boots. The leaders of the thirteen colonies decided that the time had come to do away with the French threat.

In 1754, two years before war was officially declared, bloody confrontations were taking place in the Ohio Valley. A French emissary, Joseph Coulon de Villiers de Jumonville, was killed by George Washington's soldiers; his brother, Louis Coulon de Villiers, called for revenge. The violence rolled on unchecked over the next few

years, with armed engagements in the Acadia, Lake Champlain, Great Lakes, and Ohio regions. Thousands of men were sent as reinforcements from France and England. The taking of forts Beauséjour and Gaspareau (at the border of Nova Scotia and New Brunswick) culminated in the deportation of Acadians. The aboriginal style of war was devastating. Unlike European soldiers, who marched in ranks to the sound of a drum, the colonial gunners hid in the trees, launching surprise attacks and not hesitating to take a scalp or two. Often it was enough to know the birthplace of a troop commander to figure out the nature and outcome of a battle.

After signing a treaty of alliance with Prussia to force France to widen its combat zone, England officially declared war on France on May 17, 1756. For two years, cannons thundered across the continent, with Québec as the ultimate goal. However, before entertaining the thought of sailing up the St. Lawrence, the English troops and New England militiamen first had to expel the French from other parts of their vast North American empire. As long as the French used an offensive strategy, England suffered more defeats than it won victories. The three forts defending Oswego (Ontario, Vieux Chouaguen, and George) fell into French hands in 1756, and the five flags taken from the enemy were shared among the churches of Québec, Montréal, and Trois-Rivières. The following year, French Canadians and aboriginals stepped up their attacks against various New England settlements, sowing terror in that region. On August 9, 1757, the two thousand soldiers of Fort William Henry surrendered. Two days later, the aboriginals who had participated in the battle attacked the prisoners and killed about fifty of them. Exasperated and indignant, New Englanders vehemently called for the destruction of New France.

England's immense war effort, involving twenty-three thousand regular and colonial soldiers, not including militiamen, against sixty-eight hundred French soldiers, did not immediately bear fruit. In July of 1758, more than fifteen thousand men, commanded by Major General James Abercromby, failed in their attempt to seize Fort Carillon. But in that year, the tide began to turn. The fall of the Louisbourg fortress and the surrender of Fort Frontenac, in the Great Lakes region, and Fort Duquesne, in the Ohio Valley, liberated the invasion routes to the Laurentian Valley. General Montcalm, who had succeeded in imposing a defensive military strategy on the governor of New France, brought most of his troops back to Québec and Montréal.

The time had come for England to strike at the heart of New France. On December 29, 1758, the English Minister of War, William Pitt, wrote to Major General Jeffery Amherst, "The king has resolved to assign a major portion of his forces in North America, that is, twelve thousand men, to make an attack against Québec, via

The Aboriginals' Style of Battle

"They do not fight normally, but entrenched behind trees or a mound of earth; and, in this posture, they await their enemies for five or six days, without moving and almost without eating. They conceal themselves so perfectly that it is impossible to see them, even in a completely cleared area. They creep along the flat ground, clutching a handful of grass which they hold up in front of them until one is in within range of their guns, then they fire and they never miss. They laugh at our troops, whom they turned away in the battle in which Mr. Dieskau was taken. They were, they said, like a wall that did not move, in spite of the hail of gunfire, and they walked without ever fearing death, which they say is a lack of courage; they say that twenty of them would all have been killed one after another like pigeons. They utterly disapprove of our way of making war."
Louis-Guillaume de Parsacau du Plessis. ❧

James Wolfe (1727–59) commanded the English troops in 1759. (NAC)

The Scalp

For a long time, the scalp was tangible proof to the aboriginal that he had vanquished his enemy; the number of scalps on his belt was an indication of his bravery. For the French and the English, scalps became a trade item. Between February and April of 1757, Philippe-Thomas Chabert de Joncaire purchased thirty-eight English scalps from the Iroquois. Both French and English colonists used scalping as a psychological tactic of intimidation. The New England settlers filled columns of their newspapers with stories of atrocities in which Canadians were presented as "true savages." The New York Mercury of June 27, 1757, demanded, "Can we . . . remain in scandalous inaction while we see our country ravaged, our women killed, our innocent children assassinated, and our aged parents massacred?" The authorities of the colony of Maryland decided to pay fifty pounds for each scalp of an aboriginal.

During the siege of Québec, the English killed three French Canadians from the Beaumont parish and scalped them. However, General Wolfe did not authorize this practice except "when the enemies were Indians or French Canadians dressed as Indians." ↷

the St. Lawrence River using Louisbourg as a point of departure." The attack had to be launched as early as possible in the year, around May 7, weather permitting. Pitt entrusted the operation to Brigadier General Wolfe. On the very day on which he told Wolfe of his decision to attack Québec, Louis-Antoine de Bougainville, Montcalm's lieutenant, who was on his way to France to ask for the king's help, analyzed this eventuality: "The Court must expect to lose Canada, a certainty unless its troops there fight for the land inch by inch. With Québec gone, Canada must be surrendered, and the Court, foreseeing this case, must let its generals know its intentions with regard to this surrender." Before a shot was fired, the French authorities had conceded defeat in Québec.

France decided not to send reinforcements to the colony. Meanwhile, an imposing English fleet, commanded by Admiral Charles Saunders, left a Spithead berth on February 17, 1759. Major General James Wolfe made the crossing on board the flagship. On April 30, the vessels dropped anchor in the port of Halifax, where the fleet of Rear-Admiral Philip Durell was moored. The English fleet was ready to sail, finally, at the beginning of June. During the delay, a small French fleet composed of seventeen merchant ships, escorted by a twenty-six-cannon warship, the *Machault*, was able to sneak past the English ships to reach Québec in mid-May. A few days later, the inhabitants of the capital learned that the first English ships had been spotted at Saint-Barnabé, not far from Rimouski. Through a system of fires lit in relay from one location to the next, the news arrived in Québec during the night of May 24–25; a cannon shot marked the official announcement. A war council planned the final measures to take in defence of the colony.

Preparing the Defence of Québec

Before the English fleet arrived at Québec, the military and civil authorities jerry-rigged all sorts of defence structures. They constructed fire-ships, a type of raft loaded with gunpowder and inflammable materials launched to try to set the enemy ships afire; reinforced the town's fortifications; built wagons for transporting munitions and provisions by covering hay carts with printed cloth; threw together a pontoon bridge over the St. Charles River to facilitate travel between the two shores; and built bridges over the Jacques-Cartier and Cap-Rouge rivers. As soon as the soldiers and militiamen quartered at Trois-Rivières and Montréal arrived in the capital, they were put to work on various tasks, especially in the zone between the mouth of the St. Charles River and the Montmorency River. On June 3, an observer noted,

> Never had works gone up so quickly, such that our generals soon had the satisfaction of seeing themselves ready to receive the enemy as he came; there was no sight better than these entrenchments defended at intervals

by good redoubts furnished with many cannons, two ships moored at the entry to the small river [the St. Charles] with ten cannons, as well as a chain of masts that make it impossible to force entry, and the last defence is our batteries on the commissariat dock.

In the town itself, people were preparing physically and mentally for the great confrontation. On June 4, Montcalm urged people who felt they were not suited for military service or who feared for their lives to leave the town and go to settle around Trois-Rivières or Montréal. In the lower town, workers started to wall up all the openings in houses fronting on the riverbank, and erected a palisade from the Chevalier house to the Cul-de-Sac construction pier. The generals wondered if it would not have been better to raze the lower town, as most of the inhabitants had left, shipping their furniture and possessions to people in the upper town. Governor Vaudreuil's opposition to this idea displeased certain military men, who feared that "the zeal he has for the welfare of individuals will be disastrous for the state, since it seems impossible to avoid a fire." In the upper town, a wall was raised on Rue Buade, between the house of Louise-Geneviève de Ramezay and the bishopric, and a cannon was installed to protect the rise of Côte de la Montagne. All of this had to be done quickly since, on June 18, news came that the English fleet had anchored in the Bic region.

War French-Canadian Style

"The French Canadians can be considered light troops; they make war like the Savages, and are better suited for surprising the enemy and lying in ambush than for attack in the open. They are robust and, from a young age, are used to running through the woods and enduring the fatigue of the hunt. The English, who are not alert or brave enough, are always surprised because they do not practise as our French Canadians do, making war in the woods. This will always give us superiority, since one cannot fight except in the woods, which stretch across this entire country, unless one keeps oneself enclosed in forts, like the English do."
Louis-Guillaume de Parascau du Plessis. ✍

The attack by French boats converted to fire-ships failed. (Samuel Scott, June 28, 1759. ROM, Canadian Department, Sigmund Samuel Collection)

81

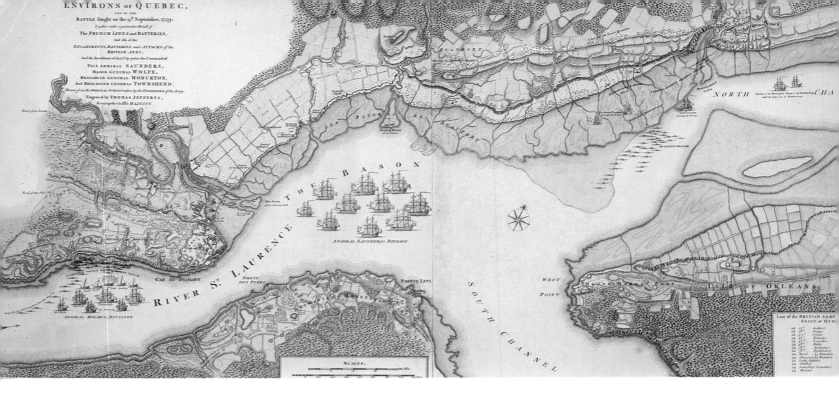

ENVIRONS of QUEBEC,
AND OF THE
BATTLE fought on the 13th September, 1759;
Together with a particular Detail of
The FRENCH LINES and BATTERIES,
And also of the
ENCAMPMENTS, BATTERIES and ATTACKS of the
BRITISH ARMY,
And the Investiture of that City under the Command of
VICE ADMIRAL SAUNDERS,
MAJOR GENERAL WOLFE,
BRIGADIER GENERAL MONCKTON,
And BRIGADIER GENERAL TOWNSHEND.
Drawn from the Original Surveys taken by the Engineers of the Army.
Engraved by THOMAS JEFFERYS,
Geographer to His Majesty.

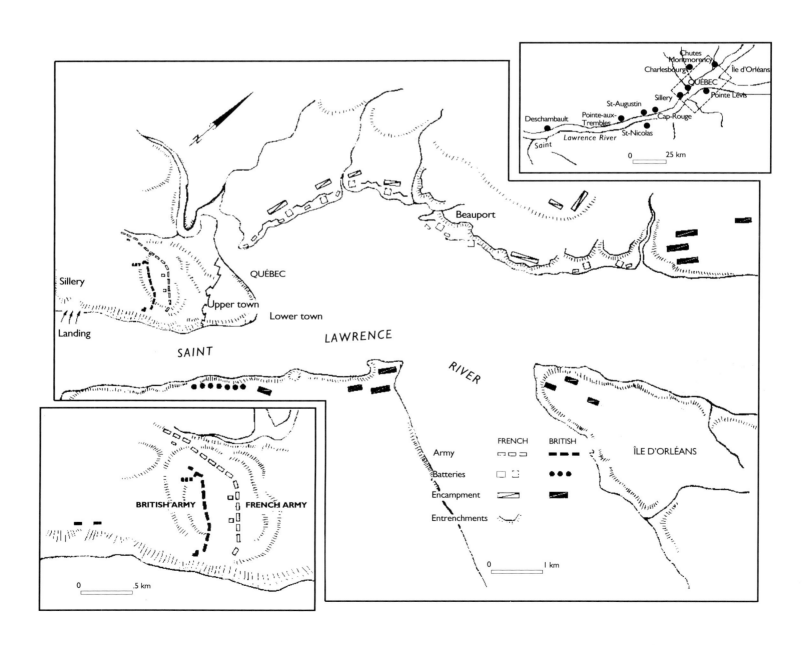

In Front of Québec

O N JUNE 24, a day when residents usually lit celebratory bonfires, some thirty thousand men set up camp near Québec. Twenty-nine large ships had been counted passing through Île d'Orléans the previous evening, including three with three bridges, twelve frigates and corvettes, two bombing galliots, eighty transport ships, and fifty to sixty small ships and schooners anchored in two lines, from Pointe Lévy to Île Madame. The English also had about thirty flat-bottomed boats, each capable of transporting eighty to a hundred men, and more than eighty landing barges. Some nineteen hundred cannons were aimed at the town. Eighty-five hundred soldiers, along with the thirteen thousand five hundred sailors and crew, were ready for combat. General Montcalm's opposing forces numbered almost fifteen thousand regular soldiers, navy troops, and militiamen, supported by almost a thousand aboriginals.

A War of Positions

On June 27, Wolfe installed most of his soldiers at Saint-Laurent, on Île d'Orléans. The next day, he established another group on the south shore, at Beaumont. Soon after, four regiments commanded by Robert Monckton arrived at Pointe Lévy, just across from Québec; their mission was to protect the fleet, then to bombard the town. From the time the English established themselves near Québec to the day when they landed near the Plains, September 13, it was a war of positions. Each side watched, performed manoeuvres, shifted corps of troops, made occasional forays. This long waiting period set nerves on edge, despite exchanges of civilities.

From the beginning to the end of the 1759 siege of Québec, Montcalm and Wolfe were both convinced that the Beauport shore offered the best landing area. In a letter to a relative, Wolfe wrote, "I am sure that we will have a lively engagement when we cross the St. Charles River, unless we can stealthily move up a detachment farther up the river and land three, four, or five miles or more above the town, and have the time to retrench ourselves so strongly that they will not dare to attack us." For his part, Montcalm hurried to dig massive entrenchments on the Beauport shore. He placed most of his

Plan of the English and French positions during the 1759 siege of Québec. (Thomas Jefferys, 1760, NAC)

The 1759 siege of Québec. The French entrenchments on the Beauport coast. The English positions at Lévis, on Île d'Orléans, and east of the Montmorency River. Inset, the position of the troops during the confrontation of September, 1759. (Drawing: Jacques Letarte)

A False Alarm

While the English were bombarding Québec and the French were fortifying the Beauport camp, the seasons turned as usual. With the approach of autumn came the migrating birds, signifying the start of the hunting season. At one point, the rifle fire was so continuous that many thought the English had landed at Anse-des-Mères. But it was just a pigeon hunt; thousands of birds were killed. Lost ammunition for some, essential supplies for others! Governor Vaudreuil forbade the shooting of pigeons. Fifty scofflaws found themselves in prison for having disobeyed his order. ✑

army, twelve thousand five hundred men, along the shores of the St. Lawrence from the St. Charles River to Sault Montmorency.

Both generals made the same evaluation of the strength of Québec's defences. According to military logic, the besieger would land quite far to the east, march quickly on Québec, ford the St. Charles River, and, using the least steep route, gain the heights of the town. As the days went by, other strategies were planned. Landing in the Neuville region also presented undeniable advantages: it would block resupply of the town, shut down communications with Montréal, and impede troop movements. As well, it would free up the route for Amherst's army through the Richelieu Valley.

Residents of Québec feared a landing at Anse-des-Mères:

> The enemies are making great movements at Pointe Lévy; they are parading their troops as if they wanted them to be seen, or as if they were trying to make a descent from the Anse-des-Mères side or elsewhere on high, but we are taking everything on this side for feints, and we constantly await them from the Beauport side, as if they could not make an attempt elsewhere. Our generals are experienced. God willing, they are not mistaken, but I am very afraid.

Another wealthy Québec citizen believed that the Plains of Abraham would eventually be a battlefield and that the cliff was not invincible: "We place much trust in the situation of the terrain which nature has been kind enough to fortify, but in the end many positions have been taken or attacked from the most inaccessible places and it often happens that there are no obstacles but the difficulty of the terrain." In fact, he had learned from the aboriginals that a "slope wide enough to march thirty men abreast" existed, and he felt that the few troops that had been moved there were insufficient.

In the meantime, the English began to bombard the town from their camp on Pointe Lévy. From the twelfth to the nineteenth of July, Québec was hit daily by a battery composed of five thirteen-inch mortars, six thirty-two-pounders, and a few cannons. By the end of the first week, more than 240 houses had been destroyed. The Ursulines and the Hôtel-Dieu nuns took refuge at General Hospital, which was not under attack. By July 24, it was calculated that about fifteen thousand bombs and cannonballs had been launched at Québec!

The wait was nerve-wracking and everyone was anxious. On June 27, at daybreak, militiamen fired on an invisible enemy; this false alarm set off the town tocsin. There were many troop manoeuvres. On July 8, part of the English army was moved to the left bank of the Montmorency River, at the foot of the falls, without opposition from the French or French-Canadian forces. The next day, the English troops on the other shore, at Pointe Lévy, lobbed a few incendiary bombs at the lower town. The bourgeois of Québec feared that the town would be destroyed by this pounding, and they petitioned Marquis de Montcalm to organize an expedition against the

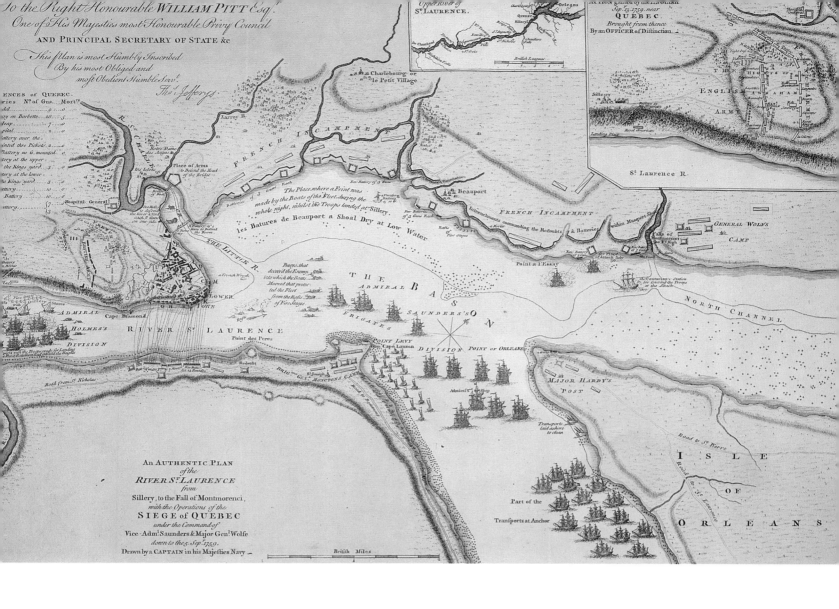

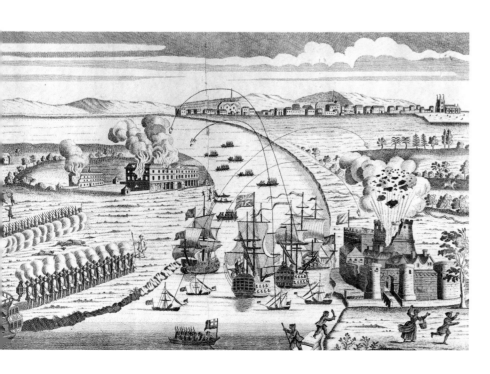

The English in front of Québec in 1759. (NAC)

Artist's impression of the 1759 bombardment of Québec. (**London Gazette**, October 18, 1759, NAC)

English camp at Pointe Lévy. A group of fifteen hundred men, including regular soldiers, militiamen, volunteers, and some students from the Québec seminary, was placed under the command of Jean-Daniel Dumas. Confused by shadows, one part of the group fired on the other, and the expedition withdrew in disarray. Under increasing threat, the lower town was evacuated.

General Wolfe became more and more interested in the region upstream of Québec. During the night of July 18–19, he ordered three ships and two boats to sail up the St. Lawrence. This operation took place under the watchful eye of Commander Dumas, who, camped on the promontory with six hundred men, was charged with preventing a landing on the Sillery side. Two days later, the English swooped down on Pointe-aux-Trembles, near Neuville, and seized two hundred women and children. The prisoners were well treated on board the ships, and they were freed the following day, at a spot that Wolfe was eager to reconnoitre: Anse-des-Mères. Chevalier de Lapause wrote that the English "were happy to see that the women they set free climbed with unequalled intrepidity and in no time at all."

The energy-sapping ordeal that was the war of positions continued. A number of officers made no secret of their desire to begin the battle as soon as possible. On July 31, Wolfe attempted an action east of the Montmorency River, an assault that left some four hundred dead. The rules of military etiquette dictated that the wounded soldiers of both armies be tended to at Québec's General Hospital, and Wolfe got to know it very well.

The Montmorency victory was soon overshadowed by the news that the Carillon, Saint-Frédéric, and Niagara forts had fallen to the

The day after the 1759 bombardment, Québec's lower town was in ruins. Here, Place Royale; centre, the Notre-Dame-des-Victoires church. (R. Short, 1760, NAC)

English. The vise was tightening ever more firmly on the Québec and Montréal regions. It was feared that the army commanded by Jeffery Amherst would march on Montréal and take it easily, since almost the entire French army was quartered in the Québec region. The stretch of the St. Lawrence between the two main towns of the colony thus took on added importance, as the French and French Canadians used it to transport their supplies. As for the English, at the beginning of August they began to target French ships anchored near Pointe-aux-Trembles, in order to free the way for the Amherst army. Colonel Louis-Antoine de Bougainville replaced Jean-Daniel Dumas at the head of the troops charged with protecting the north shore between Québec and Cap-Rouge. One of the most vulnerable spots was Anse-des-Mères. On August 6, reinforcements numbering four to five detachments of ground troops were sent in case "the enemy tries to descend there." The next day, two hundred French Canadians left the town heading for Anse-au-Foulon.

In Québec, the drawn-out conflict began to sap the courage of some. On August 7, Lapause noted in his diary, "Dark and rainy times: the deserters are warning of an attack in the near future. One starts to look to the poor colonists, who are silly enough to wonder whether it would be better to abandon Québec and flee to Montréal, or to dig in their heels and remain in our camp." Rain and fog moved in as of mid-August; the poor weather and the prospect of the coming cold made the end of the campaign urgent. For the French-Canadian militiamen, harvest time had arrived. The work before them lay in the farm fields, not the battlefield, if they were to have enough food for the winter. An officer complained, "All my men are going on vacation; yesterday, after my detachment of eighty men withdrew, I had, by my count, a hundred and forty-one men left. And I could raise only twenty-four men out of forty-eight." And Montcalm passively waited for operations to continue. In a letter to his mother, dated August 31, Wolfe analyzed the situation thus:

> My antagonist has wisely shut himself up in inaccessible entrenchments so that I can't get at him without spilling a torrent of blood, & that perhaps to little purpose. The Marquis de Montcalm is at the head of a great number of bad soldiers & I am at the head of a small number of good ones, that wish for nothing so much as to fight him—but the wary old fellow avoids an action, doubtful of the behaviour of his army.

In the meantime, the English fine-tuned their strategy. It seemed impossible to land on the Beauport shore; a better possibility was the north shore above Québec. "When we have established ourselves on the North Shore," Wolfe's generals concluded, "the Marquis de Montcalm must fight us upon our own terms; we are between him and his provisions, and betwixt him and the French army opposing General Amhurst [sic]." The tactic was risky: the English troops could be squeezed between two French army corps.

The Civil Side of the War

As they waited for battle, the two sides exchanged courtesies and civilities. At the beginning of July, the English set twenty Acadian prisoners free. The frigate captain Charles Douglas sent intendant François Bigot some bottles of liquor. The French administrator thanked him with a gift of "four or five basketfuls" of fine herbs. Wolfe very politely invited some women taken prisoner at Neuville to dinner. An officer asked an enemy officer of equivalent rank to introduce him to a bold and pretty brown-haired woman. After the failed landing at Montmorency, the wounded soldiers of both armies were hospitalized and tended to at Québec's General Hospital. From his camp on Île d'Orléans, General Wolfe specified that "no church, house, or structure of any nature shall be burned or destroyed without authorization; persons who are living in their homes, their wives, and their children shall be treated humanely; if any violence of any sort is perpetrated against a woman, the perpetrator shall be punished by death." ✌

Each regiment possessed its own flag. Béarn's regiment came to Canada in 1757. (Parks Canada)

Taking advantage of the dark and the fog, English troops landed at the foot of the promontory on the night of September 12–13, 1759. (F. Swaine, ca. 1763, NAC)

The landing of the British troops at the foot of the cliff and their installation on the promontory on September 13, 1759. (ANQ)

The English examined the north shore of the St. Lawrence, from Québec to Pointe-aux-Trembles, even more closely. Bad weather required them to delay a plan to land a little beyond Pointe-aux-Trembles. On September 10, Wolfe communicated to brigadier-generals Monckton and Townshend and Admiral Charles Holmes his decision to land at Anse-au-Foulon. The spot was steep and wooded. It was "so impractical for the French themselves, that they have only a small detachment to defend it." He noted that the path from the shore was barricaded only by an abatis, and that a bank situated about two hundred metres farther, provided a way around the obstacle.

The English Take Action

Events started to speed up. The orders for Tuesday, September 11, specified,

> The troops that are on shore, except the light infantry and the Americans, are to be up on the beach to-morrow morning, at five o'clock, in readiness to embark; the light infantry and the Americans will re-embark at, or about, eight o'clock; the detachment of artillery to be put on board the armed sloop this day. The army to hold themselves in readiness to land and attack the enemy.

On the twelfth, Wolfe gave a speech to rally his troops' courage and tell them of the next day's march:

> The enemy's force is now divided, great scarcity of provisions now in their camp, and universal discontent among the Canadians. . . . A vigorous blow struck by the army at this juncture may determine the fate of Canada. Our troops below are in readiness to join us; all the light artillery and tools are embarked at the Point of Levy, and the troops will land where the French seem least to expect it. The first body that gets on shore is to march directly to the enemy, and drive them from any little post they may occupy; the Officers must be careful that the succeeding bodies do not, by any mistake, fire on those who go before them. The battalions must form ranks on the upper ground with expedition, and be ready to charge whatever presents itself. When the artillery and troops are landed, a corps will be left to secure the landing-place, while the rest march on, and endeavor to bring the French and Canadians to a battle. The officers and men will remember what their country expects from them, and what a determined body of soldiers, inured to war, is capable of doing, against five weak French battalions, mingled with a disorderly peasantry. The soldiers must be attentive and obedient to their Officers, and resolute in the execution of their duty.

Judging this operation hazardous, generals Monckton, Townshend, and Murray asked for more information. Wolfe had a stinging response:

> It is my duty to attack the French army. To the best of my knowledge and abilities, I have fixed upon this spot, where we can act with the most force and are most likely to succeed. If I am mistaken I am sorry for it and must be answerable to his Majesty and the public for the consequences.

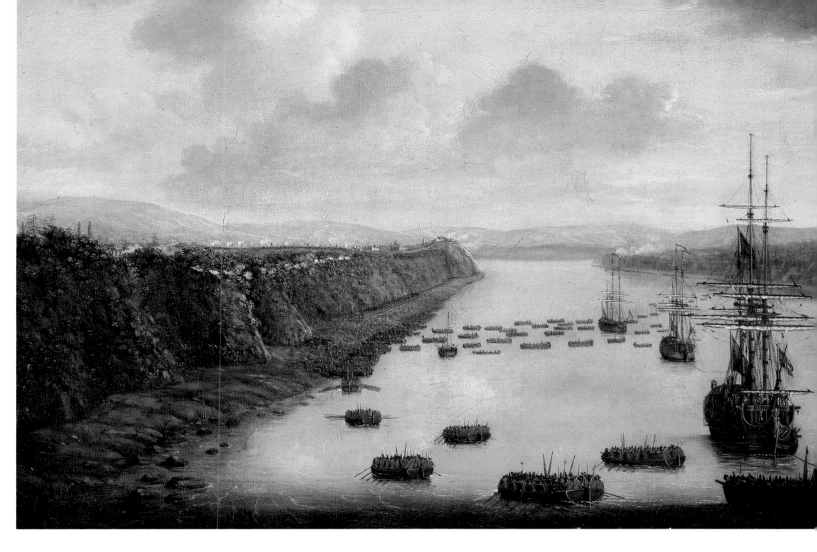
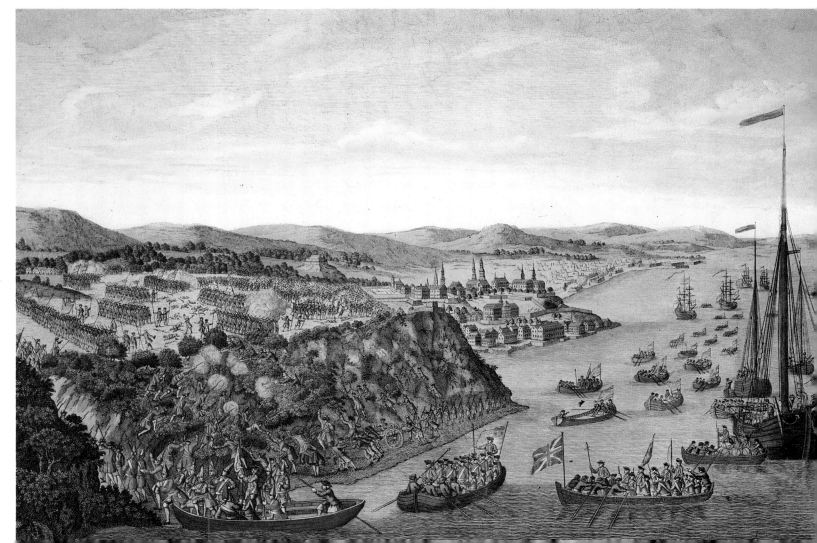

A stepped area on the Plains; one of the paths probably taken by Wolfe's troops in the early morning of September 13, 1759 to take up their position on the heights of Buttes-à-Nepveu.

This photograph, taken at the end of the nineteenth century, shows the bushes and shrubbery that dotted the site during the military confrontations. (**Mémoires de la Société royale du Canada**, section 2, 1899)

On the evening of September 12, everything was calm at the Beauport camp. Montcalm and his aide de camp, Marcel, spent a long time walking along the entrenchments. "And the more I examined them," wrote Marcel, "the more I was persuaded that the enemy would not attack them. We had repaired the lines and the redoubts, and I reckoned that our troops, entrenched therein, were invincible." As a precautionary measure, Montcalm ordered the Guyenne battalion to set up camp at Anse-au-Foulon, but Governor Vaudreuil revoked this order, putting off to the morrow an analysis of the situation.

During the night, events sped up precipitously. Boats bringing provisions from Trois-Rivières to Québec were expected, and the guards posted between Pointe-aux-Trembles and the capital were ordered not to shout, so that they would not alert the enemy. But the English learned of the plans. The rest of the soldiers camped at Pointe Lévy and Saint-Nicolas took their places on the landing barges. Warships sailed up the St. Lawrence to Cap-Rouge, and others dropped anchor facing the Beauport camp to create the impression that there would be landings at two places. At around one o'clock in the morning on September 13, the troops designated to land at Anse-au-Foulon let themselves float in slowly, with the tide.

At a little before four in the morning, the frigates anchored in front of Québec began a violent bombardment of the town. At the same time, Brigadier James Murray and some forty men landed at Anse-au-Foulon. Soldiers on sentry duty watching the river banks were fooled; they believed that they had seen French ships bringing provisions. Once on land, Murray signalled the other barges. General Wolfe and sixty soldiers landed, and a first detachment climbed to the Plains. According to Admiral Saunders, "the climb was difficult. There was no path on which we could march two abreast; the soldiers were obliged to use roots and tree branches that covered the cliff." However, a good number took the "steep slope" at Anse-au-Foulon, and another group found a path. On the heights, Murray's men seized Vergor's guard post, where there were about thirty French and French Canadians, most of them asleep. Vergor was injured and most of his men were taken prisoner; the rest managed to slip away into the corn field surrounding the post.

Alert on the Promontory

Dawn broke dark and rainy; at 5:30, the alert was sounded at Québec. English soldiers continued to flood the Plains, and there were more advancing in files. Part of Guyenne's regiment, camped near the town, received an immediate order to intercept the English. At around six o'clock, the French soldiers and militiamen left the town. "The enemy," noted John Knox, "first made their appearance upon the heights, between us and the town; whereupon we halted, and wheeled to the right, thereby forming the line of battle."

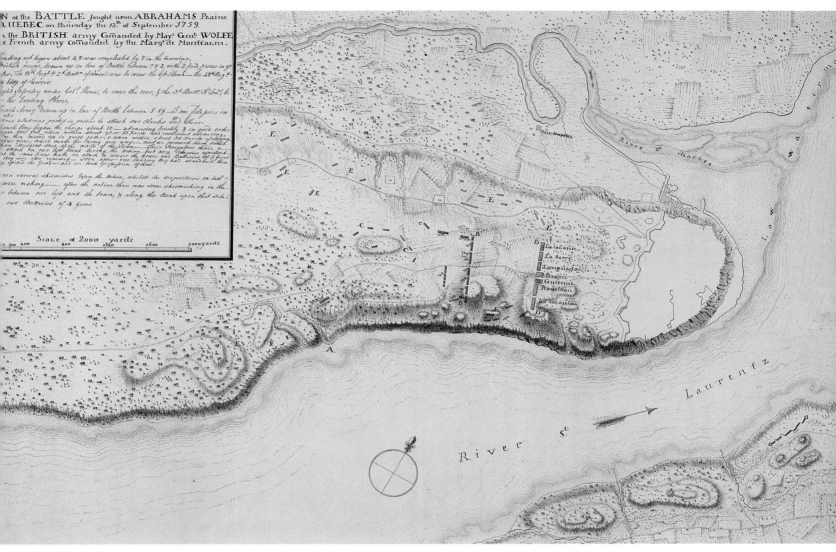

The French army had spent the night bivouacked at the Beaufort camp. But at daybreak, as if nothing had happened, the men received authorization to return. At almost the same moment, a French Canadian who had been part of Vergor's party arrived.

> This French Canadian, who appeared to be extremely frightened, told us that he alone had escaped and that the enemy was on the heights. We knew so well the difficulties of penetrating by this point, even though it was not well defended, that we did not believe a word of this man's story, thinking that fear had confused him. I went home to sleep, asking Mr. Dumas to send to general quarters for news and to warn me if there was something to do.

With the bad news confirmed, Montcalm and a hundred men rushed out of the Beauport camp a little before 6:45 A.M. At the St. Charles River bridge, the French general ordered the rest of the Guyenne regiment to march toward the enemy. The La Sarre, Languedoc, and Béarn regiments, two Royal Roussillon detachments, and the Québec government's militia followed. Soldiers and militiamen arrived on the Plains of Abraham at around eight o'clock and quickly took up battle positions.

While the two generals were preparing their armies for the confrontation, skirmishes took place on the north side of the promontory. The English took François Borgia's house, north of Chemin Sainte-Foy, then seized a few neighbouring houses. A group of seven to eight hundred French Canadians and aboriginals kept these houses

Position of the troops on the Plains of Abraham in September, 1759. (NAC)

under constant fire. At around nine o'clock, they set the Borgia house afire. Hidden in the underbrush and corn fields, they greatly importuned the English.

A little before ten o'clock, the English army took up battle positions in two ranks the width of the promontory. Montcalm hesitated. The uneven terrain concealed part of the enemy's army, so he could not know exactly how many soldiers were facing him. Although he was expecting reinforcements, he dared not strip the town of its thirty-five hundred defenders. He hoped that Bougainville had learned of the English troops' landing and that he was on the way to lend a hand, since he had considerable forces at his disposal: all the army grenadiers, two hundred volunteers, quite a few pickets of ground troops and colonial troops, militiamen, a corps of cavalry—in all, more than two thousand men, comprising the "flower of the army." But Bougainville was waiting for orders from the governor and surveying the ships that could, at any time, discharge hundreds of men on the shore in front of Cap-Rouge.

The Two Armies Clash

At around ten o'clock, Montcalm decided that there was no reason to delay any longer. He told one of his assistants, "We cannot avoid combat. The enemy is dug in; he already has two pieces of cannon. If we give him the time to establish himself, we'll never be able to attack him with the few troops we have. Is it possible that Bougainville doesn't know this?"

Wolfe positioned his forty-four hundred men in combat lines behind a rise. Monckton commanded the right flank, Townshend the

The death of Wolfe. Victor of a decisive battle, for a prize long sought by England, fallen on the field of honour, the young General James Wolfe knew incomparable posthumous glory. (Benjamin West, 1770, NAC)

left, and Murray the centre. The space separating the two armies was "difficult, encumbered, uneven, full of underbrush and corn." Montcalm, on horseback, placed himself in the centre, in front of his forty-five hundred soldiers. The English army was composed almost exclusively of regular soldiers, who were used to fighting in formation and obeying orders. Montcalm's troops were less homogeneous: a number of settlers, in three ranks, were sprinkled among the regular soldiers in his battalions.

Montcalm ordered his troops to engage in combat. The platoons of French Canadians, placed in front, took a few shots then fell back through the gaps between the battalions. This movement created uncertainty, then disorder. The two sides were only partway within firing range, at a distance of about twenty metres. The English soldiers absorbed two or three volleys without firing back. Kneeling on one knee, the front line awaited the order to fire. Each soldier had two bullets in his gun. When this front line fired, it exploded like cannon shot. The French and French Canadian side took flight—the right flank first, quickly followed by the left. The second line of English soldiers did not even have to fire. The French troops retreated in disorder toward the city and the St. Charles River bridge, where they attempted to overcome their panic. A corps of eight to nine hundred men set up an ambush in the woods on the north side of the Plains of Abraham, holding up the advance of the attackers. Others formed new platoons and put up some resistance. Confrontations continued in various areas of the promontory, until the troops took refuge within the walls.

The main battle was over in less than half an hour, by the time the sun pierced the clouds. On both sides, there were many dead and

The death of Montcalm. The French general died less than twenty-four hours after his defeat on the Plains of Abraham. He would ever be associated with his rival as heroes who gave their lives for their countries. (Musée du Québec)

The flags of the French and English regiments
(Drawing by Charles Huot, NBC)

wounded. Wolfe had been wounded in one hand, then shot in the right lung. Immediately taken behind the battle lines, he decided that it was useless to call a surgeon. At his side, a soldier cried out, "They run, see how they run." "Who runs?" asked the mortally injured general. An officer replied, "The enemy, sir; egad, they give way everywhere." With his remaining strength, Wolfe gave the order to send Webb's regiment as quickly as possible to the St. Charles River to cut off the retreat. Then, turning on his side, he said, "Now God be praised! I will die in peace." He passed away soon after.

Montcalm suffered a similar fate. Mortally wounded, he was taken inside the walls of Québec on his horse, held up by three soldiers, and he died the following night. As for the troops, General Townshend counted fifty-eight killed, five hundred and ninety-six wounded, and three unaccounted for among the English army. Among the French and French Canadians, the losses were three times as high.

As they waited for the town to surrender, the English troops settled on the Plains of Abraham and immediately threw up a dozen redoubts. Artillery and munitions were brought, in case there was a sortie from the garrison. But Bougainville heard of the rout of his compatriots and withdrew his eight hundred men toward Ancienne-Lorette. The man responsible for the defence of Québec, Jean-Baptiste-Nicolas-Roch de Ramezay, received reinforcements of five detachments of thirty men each and some cannons. At the beginning of the afternoon, some French Canadians and sailors tried, unsuccessfully, to fetch the wounded stranded on the Plains of Abraham.

At six in the evening, Governor Vaudreuil presided over an emergency war council; it was decided to send the army and militiamen to the right bank of the Jacques-Cartier River and fend off any assault on Québec. Vaudreuil sent Ramezay instructions for an eventual surrender. If there was an attack, or even if they ran low on supplies, he was to "hoist the white flag and send the most capable and intelligent officer of his garrison to offer the surrender."

In the following days, there was much hesitation and anxiety. The English rushed to take hold of the strategic spots, placing armed guards at the mill, near the General Hospital, "to cut access to the Petite-Rivière road" and to the road above Côte d'Abraham. A party was sent to reconnoitre in the Saint-Roch *faubourg*. On the Plains, the soldiers dug a ditch barely one hundred metres from the walls, in which they placed imposing fire power: twelve twenty-four-pounder cannons, six twelve-pounders, some large mortars, and forty-eight-inch howitzers.

The townspeople watched this work uneasily. They feared a new siege and a bombardment that would destroy what remained inside the walls. They knew that they had enough food for only a few days and that it was almost useless to hope for the return of the French army. A group of wealthy men asked Ramezay to surrender. Ramezay

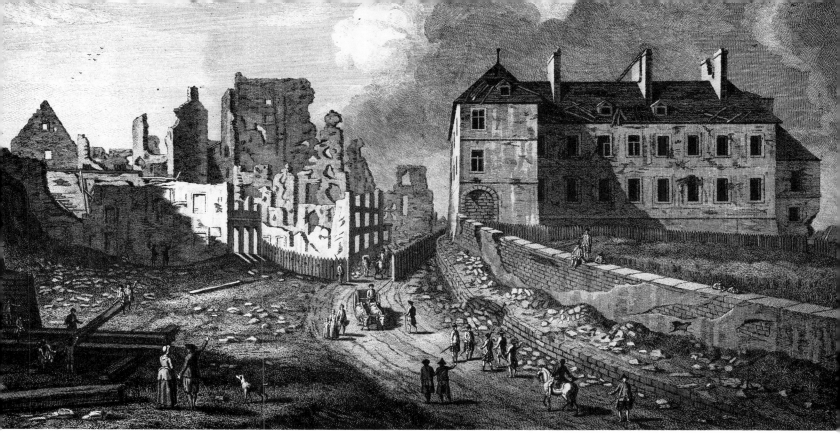

made a precise inventory of the supplies and provisions in the king's stores and reviewed the troops. He had about twenty-two hundred men available, of whom just three hundred and thirty were regular soldiers. On September 15, he met again with his war council, and thirteen of the fourteen officers present pronounced themselves in favour of a surrender. Though it had been refused the evening before, a truce was now arranged to enable women and children to leave the town. The English used this time to "put forward a large corps, with men to cover it, to clear the terrain of underbrush."

On the French side, the situation changed when Chevalier de Lévis arrived at the army command, on September 17. He planned to attack the English army "in the hope of keeping the enemy from spending the winter there." But this had to be done quickly, since it was known in the Jacques-Cartier camp that Québec was getting ready to give in. In fact, on that very day, at three in the afternoon, an officer went to the English authorities to negotiate the conditions of a surrender. That evening, at eleven o'clock, against the advice of Governor Vaudreuil, who had asked that signature be delayed, he went to Townshend with a document signed by the commandant of Québec.

At eight o'clock on the morning of September 18, 1759, Admiral Saunders and General Townshend signed the articles of surrender. Bougainville, who was on his way to Québec with six hundred men, followed by a larger contingent commanded by Chevalier de Lévis, heard the news of the surrender when he was just three-quarters of a league from the town. The French counterattack was called off. At three in the afternoon, the English garrison entered the town and took possession of the place. The Union Jack flew at the Citadel, and the English colours were raised at the summit of the slope linking the upper town to the lower town.

But it was not quite over yet. As Bougainville remarked, "The English have only the walls, and the colony still belongs to the king."

The ruins of the episcopal palace of Québec after the town was bombarded in 1759. (R. Short, 1760, NAC)

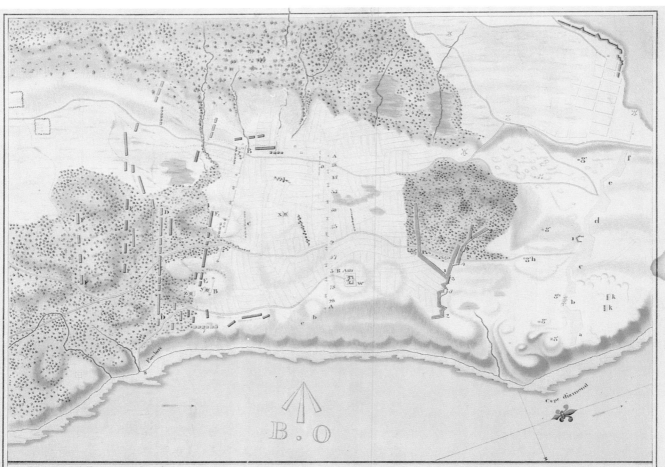

B. O

Cape diamond

PLAN of the Battle fought the 28.th of April 1760 upon the Height of Abraham near Quebec, between the Brittish Troops Garrison'd in that place and the French Army that came to beseige it. The whole effectives of the Garrison amounted to about 3000 men only, They were Commanded by the Honorable Brigadier General *MURRAY GOVERNOR*. The French army was Commanded by the *CHEVALIER de LEVI*, and amounted to upwards of 12000 men of which there were ten Battalions of Regulars, the rest were Canadians and Indians. The British came out in two Columns one by St. Johns gate, the other by St. Lewiss gate; the French came along the road from St. Fois, and would have been attacked before they could form, if the difficulty's of the Snow and ground had not retarded the advancing of our Cannon which deprived us of a great advantage.

REFERENCES

A The first forming of the British troops drawn up two deep the num-bers of the Regiments are inserted by which their order may be distin-guish'd. a, a Body of light Infantry advanced before their right. b, a Company of 120 volunteers and c, a Company of rangers advanced before their left.

B. Position of the British troops soon after the action began in which position they nearly remained untill they retreated, which was full three hours. The British line in passing from A to B dropt the 35.th Regiment and the 3.d Batt.n Royal Americans, as a reserve.

C. Ten Companys of French grenadiers and three of Canadians sent forward early in the morning probably to seize the advantages of the ground and to watch our motions, upon our lines advancing a little way from A, they retreated without disputing the ground. Six Companys of grenadiers went round to the St. Fois road where they took possession of a house and windmill to keep that road open for their troops coming up; the rem-aining Companys retired into the woods a little way, where a part of their army was now gathering.

D. The first forming of the French army drawn up four deep, they got into this position when our army had got about two thirds of the way between A and B, they remained in it but a short time when they advan-ced into the position E in which they were favoured by the woods to conceal their movements and by the snow and slipperyness of the ground that kept back our Cannon and saved their being attacked sooner.

F. Their Body of reserve which advanced as their line did.

The action which lasted full three hours was chiefly upon the Flanks, there the Enemy made all their Efforts without making scarce any at-tempt towards the center. Tho' their numbers were sufficient to make a push there likewise, But even upon the Flanks we for some time gained con-siderable advantages. Upon the right our light Infantry beat back their grenadiers from the house and windmill, but they unluckily pursued too far to be Sustained, and suffered accordingly, they were beat back in their turn and with such a loss as to appear no more in action, upon our left we gained a good deal of ground. the volunteers and grenadiers of the 28.th drove the enemy out of the two redoubts, y and z. they kept pos-session of them for some time but being at length Surrounded, they were oblig'd to force their way back.

The Enemy had now over powerd our flanks with such superior num-bers as left us no more hopes of success, a retreat began of its own accord in which it must be observed that the Redoubt w. was of great service and kept the Enemy at bay for above ten minutes which saved our rear and many of our wounded from being cut off from the Town: this was raised only a few Fascines high on account of the frosts, but there being two pickets left there during the action it deceived the enemy as a com-pleat work, we brought off only two pieces of Artillery, it was imprac-ticable to bring off the rest on account of the Snow. x, y, z, are Redoubts raised by us at the Siege 1759, but were not thought of consequence enough to be demolished when the other works were

N.B. The dead, all the wounded men and several of the wounded officers who could not get off the field was as usual every one Scalped for the entertainement of the Conqueror.

REFERENCES of the TOWN.

a. Cape diamond. } { d. St. Ursula. g, Blockhouses erected by
b. La glaciere. } BASTIONS { e. St. John. us during the winter to
c. St. Louis. } { f. La Potasse. prevent Surprizes which
were of great use now in keeping the enemy at a distance, even after the principal one, g, h, was blown up which happened by accident.

Works of the Besieged during the Siege.

i. Small fascine work to cover Sorties and retreats by St. Louis's gate.
k. Two Batteries erected to check the Enemy approaching to the Bastion of St. Ursula, which they seemed to attempt, and was the most acces-sible.

NB. There were a great many things done but the prin-cipal was that of opening a heavy Fire toward the Enemy in which we succeeded so as not only to maintain but even to augment the superi-ority of Fire. This great work would have been impracticable, were it not for a large provision of facines happily made early in the Spring.

WORKS of the BESIEGERS

1, An approach. 2, a parallel, both begun the Evening of the action. 3, Bat-tery of four guns. 4, Six guns 5, three guns 6, two mortars all opened bet-ween the 10.th and 15.th of May. 7, Six mortars to keep off our Shipping from flanking their Camp. 8, provision Magazine at Foulon.

The Enemy after battering five or six days with no great Effect, finding our garrison vigilant and active, our Superiority of fire in-crease, and three of our Ships of war arrived which had driven away their Shipping or run them aground_they between the 16.th and/at night, quitted the Siege and went off with the loss of all their Artillery, amunition, provision, baggage, Shipping and about 3000 of their best troops; and thus they disappeared like a beaten army, and in stead of recovering the Capital of their Country facilitated the loss of the whole.

NB. In the Battle, the red expresses the British, and the blue French; the pale Shews each in first forming, and the deep, Shews them in the heat of the action; the prick'd lines Shew the movement, & the Darts point as they move.

Scale of 800 Feet to an Inch

Feet.

Pat. McKellar Major th. Esq.

B.19. F.64

The English in Québec

T HE TAKING OF QUÉBEC did not mark the end of hostilities, but a reversal of roles. The victorious English army established itself in the town and consolidated its conquest at strategic points: the St. Charles River, the heights of Côte d'Abraham, and the site of the Plains. Admiral Saunders' fleet was anchored in two lines between Sillery and Sault Montmorency. The French soldiers who had been garrisoned in the town were now disarmed and taken prisoners of war; they were loaded onto ships bound for England. However, the situation remained delicate and tense. The English had to demonstrate that they "had come not to ruin and destroy the Canadians, but to let them have a sweet taste of a just and equitable government"—on the condition, of course, that they were docile and stayed home. Over the following days, the upper and lower classes of Québec prepared to take the oath of allegiance to the king of England. On September 21, just eight days after the battle, the conquerors were allowing the citizens to "come and go freely to attend to their business or peaceably to take possession of their goods."

As winter approached, positions hardened on both sides. At the end of October, the English soldiers camped on the Plains moved into their winter quarters. The regiments were placed in various areas of the town: three battalions moved into the lower town; the five companies of Highlanders moved into the Saint-Roch *faubourg*, the 48th Regiment could be found in the Intendant's palace. As well, guard posts were maintained on the promontory, including one in the Sainte-Foy church, at the western end, where French troops might arrive. Québec residents accommodated themselves as best they could to this occupation. They supplied the new masters with sheep, pigs, chickens, and vegetables, which they traded for silver coins, salt, lard, wheat, and biscuits.

During this time, the French army, under the orders of Chevalier de Lévis, retreated to the vicinity of the Jacques-Cartier River and erected a fort. In November, most of the troops left for Montréal to link up with the governor and the intendant; Lévis kept only about three hundred men at the Jacques-Cartier fort. He housed the others

Plan of the position of the armies during the battle of April 28, 1760. (NBC)

General Murray (1721-94). In 1760, he commanded the English troops to avenge the defeat in the battle of Sainte-Foy. (Musée du Séminaire de Québec)

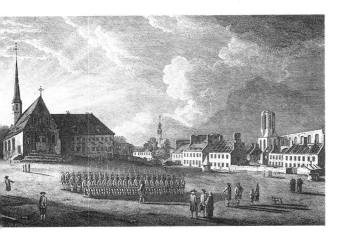

The English in Québec in 1760. In the background, the cathedral, the Jesuits' college, and the Recollets church. (R. Short, 1761, NAC)

with settlers in different villages, on both shores of the St. Lawrence, all the way to Montréal. He had not yet given up on the prospect of launching another attack on the conquerors of Québec, but the cold and the poor weather precluded a battle of any size.

Both armies were still on alert. In mid-November, English soldiers attempted to dislodge the French and French Canadians from Pointe-aux-Trembles. Detachments were installed in the Lorette and Sainte-Foy churches, making the road connecting them an advance line of defence. Because there was a corps of two hundred aboriginals in this region, the English soldiers charged with gathering wood for heating had to be extremely careful. In the dead of winter, the commandant of the Jacques-Cartier fort ordered an expeditionary party to swoop into the Lévis region to gather needed meat and cereals for the French troops. On February 13, 1760, Murray had about twelve hundred men cross to the south shore to chase away French soldiers. A few days later, another detachment fired on Pointe-aux-Trembles and Saint-Augustin.

With the return of spring, large-scale manoeuvres began again. Time was of the essence. Lévis felt that he must retake Québec before the ice completely broke up on the St. Lawrence—before navigation could begin. He was counting on the French authorities to send fresh troops, supplies, and arms before the British reinforcements arrived.

The Battle of Sainte-Foy

In mid-April, Lévis started out for Québec. His army included 6,910 soldiers, including 3,021 militiamen, and a retinue of 352 noncombatants, including 16 surgeons and 33 "black soldiers." By land routes, because the ice made the river unnavigable, he rapidly advanced toward the capital region. On April 22, the French advance guard attacked an outpost of the English army at Cap-Rouge.

Five days later, the two armies prepared for another major confrontation. Once again, the topography of Québec, in particular the configuration of the promontory, played a key role in military strategy. Arriving by foot from the northwest, Lévis crossed the bridges high on the Cap-Rouge River and took the road leading to Vieille-Lorette at Sainte-Foy. Murray hurried the main body of his troops to the Lorette and Sainte-Foy posts. From there, he pounded the French troops when they emerged from the woods. The size of the French army, however, soon drove the English back to the shelter of the town. Murray abandoned the Sainte-Foy outpost, but not before he set fire to the church.

During the rainy night of April 27–28, Lévis's soldiers were billeted in houses in the Sainte-Foy region, while Murray's retreated to the town. At daybreak, a skirmish took place when the French troops took up their position. This was just the prelude to a large battle. With the Sainte-Foy outpost liberated, Lévis could deploy his

troops on the heights. As well, what had been called Coteau d'Abraham, which stretched from Sainte-Foy to the fortifications of the St. Charles River, near the General Hospital, could be scaled in many places by regiments kept in reserve. Lévis was also expecting reinforcements from the other side of the promontory. The French ships, which had pulled back past Pointe-aux-Trembles, were sailing to Anse-au-Foulon with artillery, munitions, provisions, and soldiers.

Murray decided to leave Québec with most of his garrison. He had thirty-one hundred soldiers still in battle formation, on two main fronts on the Buttes-à-Nepveu: the left flank toward Anse-des-Mères, the right flank toward the front of the French grenadiers led by Lévis. Murray counted heavily on his artillery, composed of twenty-two cannons. In fact, when the French troops advanced in columns on the Chemin Sainte-Foy, they were decimated by cannon fire. Lévis had his men retreat to near the woods to take up battle formation. Murray, believing that he had defeated the enemy troops, left his strong position and moved quickly to follow them toward the Dumont mill, which had fallen into French hands. His marching troops cut the angle of fire of the cannons, depriving them of a distinct advantage. The French left flank, under the command of Lieutenant-Colonel d'Alquier, instead of retreating, attacked. "A few steps away from the enemy, my children, is no time to retreat. Bayonets on our guns, let's charge the enemy, it's more worthwhile."

There was a fearsome man-to-man battle involving bayonets and knives. At the same time, the French troops, profiting from the unevenness of the terrain, began a double encircling movement. The two English flanks were pushed in upon their centre. Murray ordered a retreat in order to avoid being completely surrounded. But it was still a rout. The dead, the wounded, and the artillery were left behind.

During the afternoon, Murray tried to reassemble his troops for another engagement, but he did not succeed. Chevalier de Lévis's men were able to take the Plains, just six hundred metres from the fortifications, and retrench there. At Anse-au-Foulon, French vessels came and went constantly. The matériel necessary to besiege Québec for as long as necessary—or as long as they could—was brought to the Plains. In less than one year, Québec readied itself for a second siege and bombardment, but this time the military positions were reversed.

Over the days following the defeat of the English troops, there was a great deal of activity on the Plains. Lévis installed batteries, hoping, in spite of the distance and the small calibre of his pieces, to make a breach in the wall. Within the town, the English pierced embrasures in the curtains to install new cannons. They fired incessantly on the French workers in an attempt to retard progress on the retrenchment work. Murray's army camped in tents along the walls of the town. The residents were ordered to evacuate the town "or to

The Horrors of War

Sister Marie-Josée Legardeur de Repentigny, of the order of the Visitation, a nun at the Québec General Hospital, wrote in the community records in the days after the battle of April, 1760, "It would take the pen of another to describe the horrors that we have seen for the last twenty-four hours, during transportation of the wounded, the cries of the dying, and the pain of the relatives. In these moments, one needs superhuman strength to keep going without dying.

"After having set out more than five hundred beds, which we got from the King's stores, there were still many more to place. Our granges and our stables were filled with these poor, wretched people. . . . In our infirmaries were seventy-two officers, thirty-three of whom died. We saw only cut-off arms and legs."

In fact, the engagement cost 259 lives and 829 wounded among the English. On the French side, there were 183 killed—28 of them officers—and more than 600 wounded. ✍

The Dumont Mill

The Québec promontory was an ideal site for a mill, because the wind blew in unobstructed. There were also good water sources, useful for tanneries.

The Dumont mill occupied a site acquired by Louis-Henri Pinguet in 1637. The land was purchased by master tanner Jean Laviolette in 1705; Jean-Baptiste Dumont, a Québec trader, purchased it from the Jesuits in 1741. The transaction included a house, a tannery and its fittings, a small adjoining house, a grange, and a bank mill, made of stone and weathered by the wind. This building, about ten metres high and endowed with solid walls, probably offered the best protection in the area to soldiers engaged in battle. Taken and retaken during the morning of April 20, 1760, it was the site of fierce, inch-by-inch combat lasting about three hours. Its owner, in his turn, put it up for sale in 1779. By the middle of the following century, all that remained were the foundations. ❧

stay in communities during the siege." The wait began again. There was much speculation about the duration of the siege, the timing of the assault, the type of war that would be waged, and when reinforcements would arrive.

An English Flag

Both the besiegers and the besieged constantly watched the St. Lawrence River to the east. They knew that the nationality of the first ship to drop anchor in front of Québec would foretell the outcome of the war. On May 9, at eleven o'clock, a frigate was spotted beyond Pointe Lévy. At the Québec Citadel, an English flag was raised three times; on the frigate, the same colours were hoisted. When the ship, the Leostoffe, commanded by Captain Dean, dropped anchor facing the town, it gave the garrison a twenty-one gun salute. The English military men could not contain their joy: "Both Officers and soldiers mounted the parapets in the face of the enemy, and hazzaed, with their hats in the air for almost an hour; the garrison, the enemy's camp, the bay, and circumjacent country for several miles, resounded with our shouts and the thunder of our artillery."

The arrival of the English ship was a very bad sign for the French. Lévis had few cannons and little powder, and each piece was limited to twenty shots per day. Without immediate, significant reinforcements, his army posed a weak threat indeed.

On May 15, at 8:30 p.m., the die was cast. Three English ships—the warship Vanguard, the frigate Dianna, and an armed schooner—entered the port of Québec. Lévis had expected this. That very morning, he had written to intendant Bigot, "I truly fear that France has abandoned us. . . . We have done and are doing what we can. It is my opinion that the colony will be lost without resources. If no help comes, all that we can do is prolong the time, in the hope that peace can be made during this interval." When he was certain that the three ships that had just arrived were flying the Union Jack, he ordered the French ships anchored at Anse-au-Foulon to sail back up the St. Lawrence as quickly as possible. The next day, he had all of his iron artillery thrown to the bottom of the cliff, and that very evening the French army left the Plains of Abraham. The following morning, the Québec garrison and the residents who had remained in the town awoke to find the Plains deserted.

The French army retreated to Montréal, where, on September 8, 1760, Governor Vaudreuil signed the surrender of New France. Three years later, France officially ceded its North American possessions to England. For a while, the Plains of Abraham bore tangible signs of the two battles, but gradually they were again taken over by their original vocation, agriculture. Now, however, new masters occupied the positions of command.

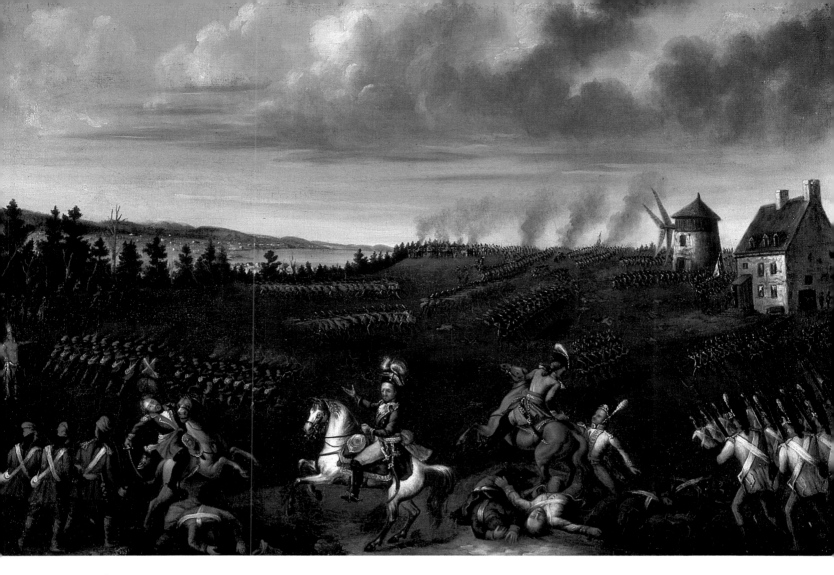

The battle of Sainte-Foy, April 28, 1770. Symbolic impression of this French victory, painted by Joseph Légaré in 1854. (National Gallery of Canada)

Chevalier de Lévis (1719–87). He replaced Montcalm at the command of the French troops in 1759 and won the battle of Sainte-Foy in 1760. (ANQ)

Hommage à Montcalm

« J'ai de Montcalm vu l'ombre glorieuse!
 il m'apparut aux bords du Saint-
 Laurent,
 L'épée en main, la face radieuse,
Il s'écriait: «Canadiens, en avant!
«L'entendez-vous? le clairon des batailles
«Vient d'entr'ouvrir la tombe où je dormais;
«L'heure a sonné des justes représailles...
«Bons Canadiens, soyez toujours Français.

«Déjà cent ans ont roulé dans l'espace
«Depuis qu'un prince, au souvenir maudit,
«Pour des loisirs indignes de sa race,
«D'un trait de plume aux Anglais nous vendit.
«Mais notre sang, comme un salut héritage,
«Au sang anglo-saxon ne se mêlant jamais,
«S'est à ses fils transmis pur d'âge en âge.
«Bons Canadiens, soyez toujours Français.»

F.D.L., Le Courrier des États-Unis, *reproduit
dans* Le Canadien, *21 septembre 1859.* ❧

Le héros de Sainte-Foy

«[...] Non loin de ce chemin, promenade
riante,
Dont l'oisif Québécois aime l'abord charmant,
Est une triple assise, où le lierre serpente,
Qui demain d'un haut fait sera le monument.
Passant, arrête ici, contemple cette terre;
Elle fut le champ clos d'un terrible combat
Et ce sol remué par la foule légère,
Il fut alors rougi par le sang du soldat:
 Ici gît sa poussière

«Jour fatal d'Abraham, tu brisas notre fer,
Mais un dernier tronçon armait notre courage,
Et ce frêle débris, à l'appui d'un cœur fier,
Nous suffisait pour vaincre et laver notre
outrage.
Nos pères, recueillis devant notre avenir,
Qu'ils voyaient se montrer sans le drapeau de
France,
Promirent que leurs fils n'auraient pas à
rougir:
Là fut fait leur serment, serment de vaillance
 Triompher ou mourir»

Arthur Casgrain, L'Islet, Le Courrier du
Canada, *30 avril 1860.* ❧

An Essay to an Epitaph on Major General Wolfe

Here rests from toil, in narrow bounds confined,
 The human shell of a celestial mine,
 Who, once, with splendor fill'd a scene so large!
And took the fate of Empires in his charge:
A Hero with a Patriots Zeal inspired,
By publick Virtue, not by passion fir'd;
A Hero disciplin'd in Wisdom's school,
In action ardent, in reflection cool;
In bloom of years, who gain'd a glorius name,
And reap'd betimes, the Harvest of his fame.
Before Québec he chac'd the flying foe,
And, quick as lightning, struck the fatal blow;
By active valour made the day his own,
And liv'd to see the num'rous foe o'erthrown;
corwn'd by just Vict'ry drew his latest breath,
As won't to smile on Danger, smil'd on Death;
And, having bravely for his country fought,
Died nobly as he wish'd, and calmly as he ought.
The troops around him shar'd a gen'rous grief,
And, while they gather'd Laurels, wept their Chief,
Their Chief, to whom the great Montcalm gave way,
And fell, to raise the Honours of the Day.

Québec, October 7th, 1759, V. Nevill. ❧

Les Braves de 1760, à l'occasion de l'inauguration du monument

« Ils étaient tombés là, ces lutteurs magnanimes,
Ces héros épuisés par tant d'efforts sublimes...
Et sur ce sol couvert de leur généreux sang,
Rien ne nous rappelait ni combat ni victoire. [...]

«Mais la Patrie, un jour, se souvint de ces braves
Succombés en voulant la sauver des entraves;
Leurs noms, d'un long oubli, retirés par lambeaux
Furent bientôt gravés sur le bronze et la pierre...
Et le passant alors, courbant sa tête altière:
Ils moururent en vainqueurs, honneur à leurs tombeaux»
Et vainqueurs et vaincus alors s'agenouillèrent:
Les haines d'autrefois, ce jour-là, s'oublièrent;
Ensemble on célébra les héros malheureux;
Et la France elle aussi, la vieille et noble France,
Pour nous faire oublier sa longue indifférence
Apporta son hommage aux mânes de nos preux.

«Sur la plaine longtemps muette et solitaire
On entendit alors une salve guerrière
Mêlée aux sons bruyants des trompettes d'airain;
Les guerriers endormis s'émurent dans leurs bières;
Et les deux ennemis se souriant en frères,
Sur le vieux champ d'honneur se donnèrent la main.

«Oh! puissions-nous toujours nobles et fortes races,
Suivant de ces héros et l'exemple et les traces,
Marcher vers l'avenir!...et, grande nation,
Dans les beaux jours de paix, comme aux jours des tempêtes,
Puissions-nous toujours voir, s'unissant sur nos têtes,
L'étendard de France aux couleurs d'Albion!»

Louis-Honoré Fréchette, Le Canadien, *21 octobre 1863.* ∾

La perte du Canada en chanson

1

Quand Georges trois prit l'Canada
La sainte Vierge est au combat,
À la trahison de Valgor [Vergor]
Elle était entre les deux camps,
Pour défendre nos régiments.

2

Courage mes frères Canadiens
Prenons notre sort en chrétiens
Et soutenons notre couronne
Braves soldats et miliciens
Soutenons-la jusqu'à la fin.

3

Invoquons les Anges et les Saints,
Qu'ils nous tendent aujourd'hui la main.
Et implorons la Vierge sainte
Qu'Elle daigne par sa bonté,
Nous conserver la liberté.

4

Qu'en a composé la chanson,
C'est un soldat du bataillon
Qu'est prêt à se livrer lui-même
Pour la défense de ses droits,
Vive le Roi! vive la paix!

Bulletin des recherches historiques, *vol. XXVII, n° 2, février 1921, pp. 30-31.* ∾

On General Wolfe

The Pride of Britain, and the Boast of
 Fame,
 Was Wolfe! Immortal be the Warrior's
 Name.
Rouse then, ye British Youths, at Glory's Call,
Nor for your Country's Sake lament to fall:
Blooming in Youth he bade the World Adieu,
And died content with Vict'ries gain'd for you.

Approach, ye Brave, in Sorrow's silent Gloom,
Wolfe's sacred Relicts lie beneath this Tomb!
Briton advance—behold thy Country's Pride.
He came, he saw, he conquer'd—and he dyd'd!
Anonymus, Québec Gazette, *June 10, 1773.* ℮℈

The Centennial of Montcalm's Death

"The day of Wednesday (September 14, 1859) was a truly full day. In the morning at the Chapel of the Ursulines, a expiatory mass was said at the tomb of Montcalm. . . .

"At two o'clock in the afternoon, everyone from our social élite who could fit into the chapel of the Ursulines was there to attend the absolution that was announced on the occasion of the placement of a gravestone on Montcalm's tomb, on the day of the one-hundredth anniversary of his death. Monsignor the administrator, surrounded by numerous clergy, attended dressed in his pontifical ornaments, and a choir, led by Mr. Gagnon, led the musical part of this lugubrious and touching ceremony. A catafalque erected in the middle of the nave, at the front of which was a canvas on which Mr. Bingham had painted the arms of Montcalm, recalled the tomb of the hero that had been placed there, just one century before, at that very hour. On this catafalque, one saw the head of chivalrous Montcalm enclosed in a reliquary that bore the inscription of his name.

"The gathered crowd heard a lugubrious chant, the last moving sounds of which were still echoing in the breasts of all when the Reverend Father Martin, from the Company of Jesus, crossed the choir to pronounce the funereal elegy of the vanquished hero and the generous Christian who was named Marquis de Montcalm in our history and a saint in the martyrology of Canada."

Le Canadien, *September 16, 1859.*

Les Plaines en 1815

«Sur le chemin de la Grande Allée, derrière la Porte Saint-Louis, se trouvent la maison et le jardin qui appartiennent à Mr Jones; plus loin le long de la route, à main gauche, est le bâtiment appelé la maison de Fergusson, situé sur le terrain le plus élevé des célèbres plaines d'Abraham. Il est calculé qu'il est à 330 pieds au-dessus du niveau de la rivière, et qu'il domine sur la plupart des bâtiments de ce côté de la ville, excepté ceux qui sont sur le sommet du Cap Diamant, qui sont encore plus hauts de dix ou quinze pieds. Pour rendre moins probable qu'on puisse jamais s'emparer de cette éminence comme d'un point d'attaque contre la ville, on a construit quatre tours à quelque distance en avant, depuis le Saint-Laurent, à travers la péninsule jusqu'à Sainte-Geneviève; elles sont à environ 250 ou 300 toises l'une de l'autre, et placées de manière à pouvoir balayer toute la largeur des plaines; elles sont solidement construites, et garnies de canons de gros calibre. En avançant le long de la Grande Allée à l'ouest, il y a à main gauche plusieurs grandes pièces de terre qui appartiennent à l'Hôtel-Dieu et au Couvent des Ursulines; du côté opposé, des champs bien cultivés et de riches pâturages s'étendent jusqu'à la route de Sainte-Foy. Les quatre méridiennes placées en 1790 par feu le Major Holland, alors arpenteur général du Canada, sont élevées à des distances convenables les unes des autres à travers les plaines; elles représentent une ligne astronomique septentrionale, et elles ont été établies pour ajuster les instruments dont on se sert dans l'arpentage public des terres. Une de ces méridiennes, qui est située à l'angle d'une redoute où l'on dit que le Général Wolfe rendit le dernier soupir, a été beaucoup endommagée par le pieux respect des étrangers curieux qui, voulant emporter des reliques de quelque partie du terrain consacré par la mort du héros, ont cassé des morceaux de la pierre placée en cet endroit trente ans après cet événement. Derrière ces pierres, il y a quelques champs ouverts qui appartiennent à l'Hôtel-Dieu, mais que le gouvernement a retenus pour des usages militaires.»

Joseph Bouchette, Description topographique de la province du Bas Canada avec des remarques sur le Haut Canada et sur les relations des deux provinces avec les États Unis de l'Amérique. *Londres, 1815, pp. 482-483.* ເນ

Le héros de 1760

«Lévis, noble soldat qu'anima la vaillance,
Digne et valeureux fils de notre vieille France,
Guerrier dont le nom seul fait battre notre cœur,
Par qui le Canada sur le champ de la gloire
Vit sa tombe s'orner d'un drapeau de victoire
 Et mourir en vainqueur!

«Ô sublime héros d'une grande épopée,
Qui voyait tout trembler devant ta noble épée;
Guerrier dont le grand cœur brûlait d'un feu si beau!
Toi qui pulvérisais les hordes ennemies...
Mais pourquoi réveiller des cendres endormies
 Dans la nuit du tombeau?

«Pourquoi par mes accents évoquerai-je une ombre?
Les hauts faits du héros sont là témoins sans nombre,
Pour redire sa gloire aux âges à venir.
Sa gloire, elle sera l'honneur de notre race
Et la main de l'oubli qui sur les siècles passe
 Ne pourra la ternir. [...]»

F.H.L. Nicolet, Journal de Québec, *26 juin 1860.* ເນ

Salut aux aïeux

«Salut, ô des vieux jours immortelle épopée,
Qu'inaugura le glaive et qu'acheva la Croix!
À ton grand souvenir notre âme retrempée
Frémit d'un noble orgueil en lisant tes exploits;
 Le clairon de l'histoire
Les répète aux échos des plus lointaines mers,
Et, d'un vol assuré tu parcours l'univers
 Sur l'aile de la gloire.

«[...] C'est Montcalm et Lévis, glorieuses images,
Comme un phare brillant sur le fronton des âges;
Une épée à la main, debout sous leurs lauriers,
Ils sont là près de nous qui gardent nos foyers,
 Et leur vaillance surhumaine
Fit sentir à l'anglais qu'au jour des grands combats
La France eut de tout temps au sein de ses soldats
 Et des Bayard et des Turenne.

«[...] Ils sont morts, mais leur sang a passé dans nos veines
Et leur drapeau sans tache étincelle en nos plaines
 Comme au soleil d'Abraham;
Abraham, Carillon! ces victoires rivales
Que la France guerrière adjoignit aux annales
 D'Austerlitz et de Wagram.

Édouard Sempé, La Minerve, *23 juin 1860.* ເນ

CHAPTER FOUR

❧

From a Strategic Site to a Fortified Town

1759-1830

Yvon Desloges

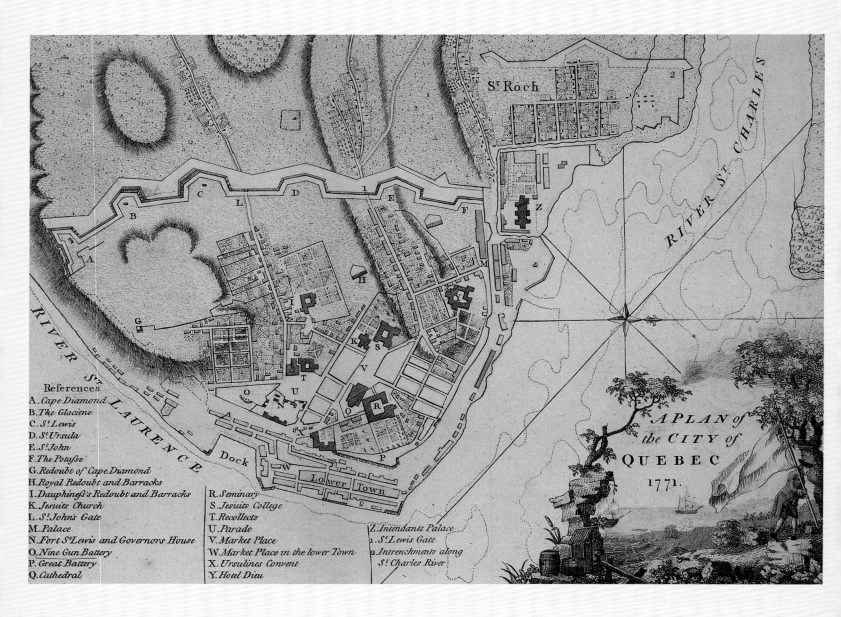

St Roch

RIVER St CHARLES

RIVER St LAURENCE

Dock

Lower Town

References
A. Cape Diamond
B. The Glaciere
C. St Lewis
D. St Ursula
E. St John
F. The Potasse
G. Redoubt of Cape Diamond
H. Royal Redoubt and Barracks
I. Dauphiness's Redoubt and Barracks
K. Jesuits Church
L. St John's Gate
M. Palace
N. Fort St Lewis and Governors House
O. Nine Gun Battery
P. Great Battery
Q. Cathedral

R. Seminary
S. Jesuits College
T. Recollects
U. Parade
V. Market Place
W. Market Place in the lower Town
X. Ursulines Convent
Y. Hotel Dieu
Z. Intendants Palace
1. St Lewis Gate
2. Intrenchments along
 St Charles River

A PLAN of
the CITY of
QUEBEC
1771.

A Strategic Site
in a Conquered Town

1759-74

A S SOON AS THEY ENTERED THE CONQUERED TOWN, the British military commanders closely examined every corner of the stronghold. The appropriation of the heights of Cap-aux-Diamants was significant in many ways: it would ensure control of navigation on the St. Lawrence and domination of the Heights of Abraham, and it would symbolize the submission of the town and its inhabitants. However, the fortifications were not satisfactory. To protect itself better, the military wanted a citadel, the ultimate in the art of fortification at the time and the future cornerstone of the defence of Québec. It would be seventy years before this dream was realized, and then at a high price: with their eyes fixed on their ideal, the authorities lost sight of the development of the town.

A number of factors militated in favour of fortifying the Heights of Abraham. To start with, the army had to be protected and its grip on Québec solidified. The population of the town was growing: from thirty-five hundred in 1762, it grew to sixteen thousand in 1818, and reached twenty-seven thousand in 1831. People of British origin represented one-fifth of the town's population in 1790, and a little more than a quarter in 1830. As well, the colony became profitable. Exports of fur, then of wood, from the port of Québec fulfilled various needs of the British Empire and contributed to its prosperity. These commercial interests were not, however, the most important; political and military strategies continued to take precedence. Québec was still the keystone of the North American defence system: the flag that flew over the Québec promontory would fly over the rest of the colony. This logic, which had prevailed since Champlain's time, remained a reality until the English troops retreated in 1871.

On September 17, 1759, Lieutenant Nicolas de Ramezay officially delivered the town of Québec to James Wolfe's successor, General George Townshend. Their preliminary examination of the fortifications and their mistrust of the French-Canadian population made the new masters very uneasy. What would happen if France attempted to recapture the country? Could the English defend effectively against simultaneous attacks from within and without? Having a citadel in which to

Chevalier de Lévis
and the 1760 Siege

" Québec is defended by a defensive wall with six bastions and revetments, almost in a straight line. A shallow ditch, in some places dug deeper than five or six feet, some made ground on the counterscarp, and six or seven wood redoubts built by the English covered this wall. The approach by land is stony; it becomes almost rock as one approaches the place, and even the heights where we were ensconced have only six inches of earth. After reconnoitring the area, we decided to dig a parallel on the heights in front the Saint-Louis, La Glacière, and Cap-aux-Diamants bastions, and to establish batteries. From there we hoped, in spite of the distance and the small calibre of our pieces, to make a breach, since the revetments are weak in this part. . . . It was extremely difficult to construct the parallel and its batteries. We advanced to a position on the rock and we had to carry earth in sacks for a very long distance. "

Journal du maréchal de Lévis. ∾

Plan of Québec City in 1771. The fortified wall covering the width of the promontory and the batteries protecting access via the Plains. (NAC)

" I t appears that the enceint of Québec is very large and would require a strong garrison to defend it, tho' properly fortified; that at present it is opened on two sides, has no outworks, not even a covered way, nor hardly a ditch, for the foot of the rotten walls is to be seen from most of the environs, at a distance of 500 yards; that the whole rampart is enfiladed from the other side of the river St-Charles, and that in its present situation with a garrison of 3,000 men it is not proof against a well-conducted coup de main; any temporary works that can be added would be of little significance as matters now stand and to fortify the place upon the old plan is by no means devisable, the situation never can be rendered strong and the attempt must cost an immense sum. I therefore am of opinion that if its Majesty should judge proper to be at the expense of strengthening Québec, the most effectual method will be to erect upon the rising ground of Cap-aux-Diamants a Citadel which will answer every purpose of the town's being strongly fortified, may be defended four months at least by a small garrison, awe the inhabitants whose fidelity in case of an attack we cannot for some years rely upon and secure our magazines. "

Report by Governor James Murray, 1762. ✑

take refuge, Chaussegros de Léry's old dream, seemed to be the ideal solution.

The First Evaluations

For the first fifteen years of the English occupation, reports by both engineers and administrators emphasized the weakness of the Québec fortifications. Just five days after the surrender of the town, engineer Patrick Mackellar submitted his evaluation of the ramparts: the western wall (facing the Heights of Abraham) was incomplete and fragile; because they were so low, the enemy could scale the La Glacière and Cap-aux-Diamants bastions (today beneath the Citadel); the fortifications could hold back an enemy for a few days at most, and it would take twelve months of work to improve them.

With winter rapidly approaching, governor James Murray had no choice but to fix things as quickly as possible. In the autumn of 1759 and the following spring, he had the weakest points of the fortifications reinforced, especially Cap-aux-Diamants. The urgency of this work was manifest, since Montréal had not yet surrendered and a French counterstrike was expected. Indeed, it came on May 12, 1760, when Lévis besieged Québec. From the Heights of Abraham, his gunners hammered the La Glacière bastion. As we know, the arrival of an English fleet forced Lévis to retreat. Nevertheless, this episode gave British strategists a better idea of the topographic and strategic realities of the town. The observations made at this time influenced all later evaluations of the town's defences.

In 1762, one year before the signature of the Treaty of Paris, which made Canada an English colony, Governor Murray exposed other problems created by the Québec enceinte. Summarizing previous evaluations, he advised his superiors in London that a citadel should be built on the heights of Cap-aux-Diamants. Once the idea was put forward by the governor, all of the engineers charged with evaluating the fortifications took up the cause. Although they recommended that the most urgent repairs be made, they favoured pouring available funds into controlling the heights of the cape.

But London hesitated. The considerable financial effort spent during the Seven Years' War, in both Europe and the colonies, had emptied the treasury coffers. To ensure its superiority over France, England had aimed for total control of America. Since it could not win by itself, it had had to "purchase alliances," an expensive venture. When a new government took power, immediately after the Treaty of Paris was signed, a policy of reorganization of public finances was instituted. This context explains the successive refusals of the British authorities. However, the situation was rapidly worsening in the American colonies: agitation was intensifying and the notion of independence was giving rise to the threat of armed conflict. Instead of fortifying its new colony, London decided that the more pressing concern was to find a way to transport troops and supplies between Québec and New York quickly.

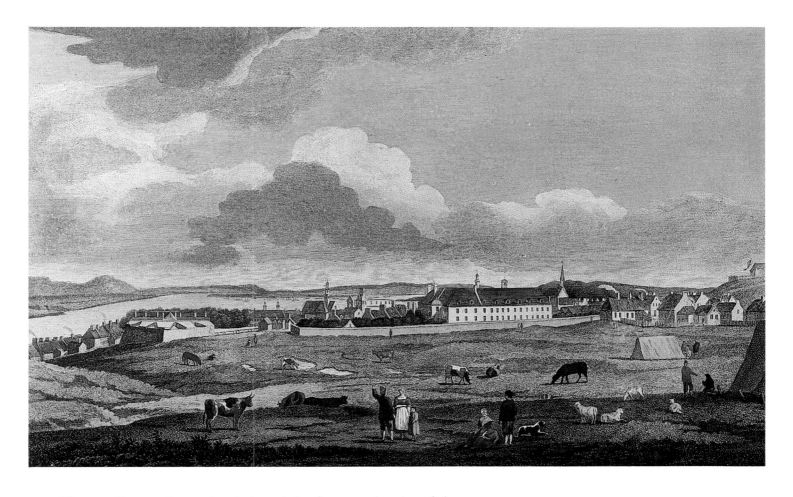

Thus, a climate of austerity darkened the first two decades of the British military presence in Québec. The proposed defence works languished in the planning stage, and the existing fortifications were not even repaired. The engineers and administrators were, in some ways, the authors of their own misfortune, for they had convinced London of the uselessness of the ramparts. In the absence of a citadel, however, it might have been preferable to shore up the fortifications. The difficulty of designing an appropriate defence system for the Québec promontory also explains London's delays and refusals.

The Fortifications and Their Surroundings

The English, like the French before them, had to deal with the geography of the site. The upper town of Québec was triangular in shape; its base—the west side—had been fortified by the French, a choice explained by both the topography and the circumstances. When Chaussegros de Léry undertook to fortify the west side of the plateau, he had to act fast. The English enemy was preparing to sail up the St. Lawrence—or, at least, that was what those in the capital thought. It was unnecessary to fortify the other two sides, since the cliff provided natural protection. Priority was thus given to the rampart on the mainland side, since the military strategy of the time consisted of besieging the strong-

Throughout the nineteenth century, large portions of the site of the Plains were devoted to grazing and agriculture. (R. Short, **La ville de Québec depuis les fortifications**, 1761, NAC, and P.J. Bainbridge, 1841, NAC)

The ideal citadel, with its various components.
(S. Holland, 1762, NAC)

hold. Now a siege could be conducted only from the Heights of Abraham, as Chevalier de Lévis had demonstrated.

This position was of prime strategic importance since, in many places, the fortifications were not as high as the Heights of Abraham—or, as military parlance would have it, the heights commanded the fortifications. In fact, engineer John Marr noted that the upper town was divided into three successive plateaux, divided by an abrupt slope. While the cliff below Cap-aux-Diamants was 105 metres high, it was only 15 to 20 metres high at the northern end of the fortifications. The Heights of Abraham parallel to the wall had the same gradient, but they were three metres higher. For a besieger, this position on the promontory was even more advantageous, since at the time the average range of field artillery was between 950 and 1,400 metres. The enemy could thus pound not just the ramparts, but also part of the upper town. The defenders would be at a disadvantage since they had to increase their angle of fire to reach the enemy's batteries, thus shortening the range of their cannons.

The desire to resolve this tactical problem explains, in large part, the insistence of the colonial authorities on construction of a citadel on the promontory of Cap-aux-Diamants, which was at about the same altitude as the Heights of Abraham. Situated on the crest of the cliff, the citadel would also serve as a keep and control navigation on the St. Lawrence. Since it was the port of communication the farthest advanced into the continent, Québec was the hub for the interior of Canada, both for military communications, reinforcements, and warehousing, and for trade and immigration.

For a defensive structure to be effective, no building must block the view of the defender, obstruct the aim of artillery from the ramparts, or leave the enemy anywhere to hide. Thus, as soon as he arrived in Québec, Governor Murray was concerned with occupying the land on the promontory. In the winter of 1759–60, he had constructed on the neighbouring heights a series of seven armed blockhouses within firing range of the walls. In sawtooth formation, these structures flanked each other; four of them were situated on the Heights of Abraham, of which one was near the d'Artigny mill, the highest point. Their location ensured a fair degree of command of strategic places. In 1763, Murray began to appropriate the land necessary for construction of a citadel on the heights of Cap-aux-Diamants. The following year, he ordered that the concessions made by the French government before the articles of peace were signed be registered. It became important for the government and the military to know which lots were royal property, especially in the vicinity of the fortifications.

The construction of a citadel would solve two acute problems: the tactical question relating to geography and the political question relating to the population. The weaknesses of the existing wall would be permanently corrected, and domination of the St. Lawrence, the Heights of Abraham, and the town would be assured. The citadel would symbolize authority and power over the population. In fact, in the winter of 1759–

60 there were twice as many military personnel as civilians in Québec. Until 1774, the army maintained almost one thousand men in the town—about one soldier per four civilians. The large size of the garrison was justified by the importance of Québec to British military strategy, but also by the fear of a revolt by the newly conquered French-speaking Catholic population—especially since, during the first years of the English presence, the English-speaking population remained quite small. Thus, one of the main complaints of the military officers was that billeting, provisions, and arms for the soldiers were scattered throughout the town and even outside the walls. If Québec were besieged, the garrison might be separated from its command. A citadel would allow all soldiers to be quartered together, and would centralize storage of gunpowder and arms. In short, the garrison would be separated from the population.

Obviously, the Heights of Québec didn't lose their symbolic significance when the English arrived. On the contrary! The luck of war had brought victory, and victory brought power. But this acquisition proved fragile, because of the local population—the past masters of the country—and because of events to come. The strategic value of the cape and the promontory was thus reinforced.

The Heights of Québec: domination and control of maritime traffic. (S. Stretton, **Le poste de signalisation sur le Cap-aux-Diamants**, 1805)

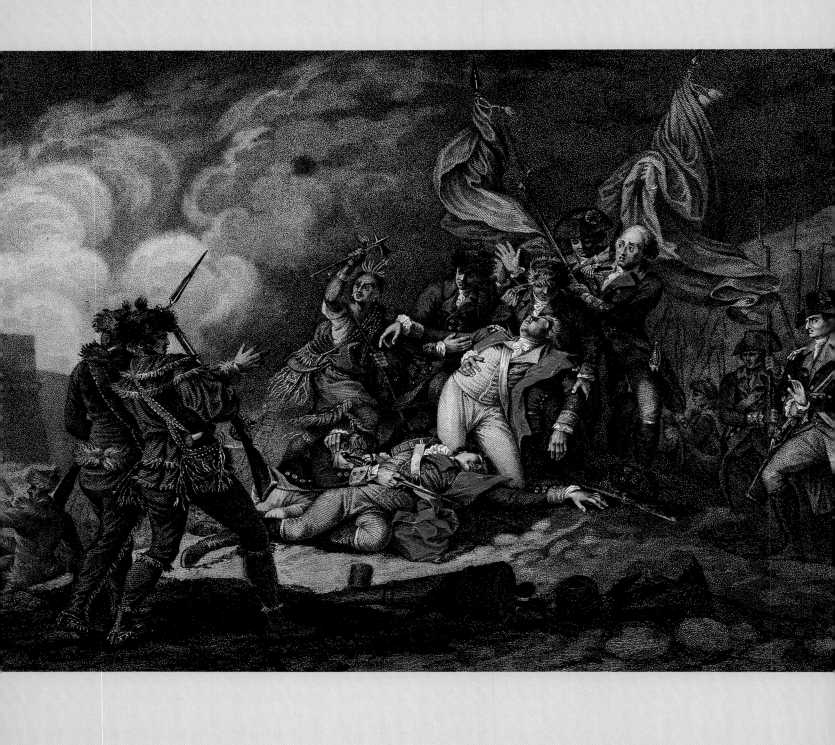

The Defence of a Continent

1775-1804

TEN YEARS AFTER QUÉBEC WAS TAKEN, the North American empire put together by the British at great cost began to crumble. The thirteen colonies to the south claimed independence. In April of 1775, the Americans and the English resorted to armed conflict. The former believed that the path to autonomy lay in ejecting the latter from the continent. Once again, Québec became a pivotal goal; once again, mastery of its promontory represented power. And, once again, its defences had to be quickly reinforced.

England had as many strengths as vulnerabilities. Using the St. Lawrence, it commanded a point of entry that provided risk-free communication to the interior of the continent, within one hundred kilometres of the rebellious colonies, from where it could dispatch its armies in almost total safety. It had the sympathy and support of the leaders of what had been New France, especially the clergy, for, in a conciliatory gesture toward all Canadians, Britain had passed the Québec Act in 1774, officially lifting a religious stricture that had deprived Catholics of certain rights and thus improving relations. From its command post on the Heights of Québec, Britain hoped to command the future.

But the threat was major, and it escalated when France entered the conflict on the side of the Americans, supplying them with money and arms. Marquis de La Fayette went on an official mission to America, while the American Congress rushed none other than Benjamin Franklin to Canada to curry favour with the settlers and rally them to his cause. In spite of French-Canadian hopes, France had no intention of trying to reconquer its old territories. Rather, it would take sweet revenge, maintain a threat by supporting a new alliance, and make a profit through its commercial links with the thirteen colonies. In the minds of the military men quartered at Québec, however, a French fleet might sail up the St. Lawrence at any moment. . . .

The American Threat

In May, 1775, Benedict Arnold gathered an expeditionary force. He ventured to the border of Lake Champlain and got as far as Saint-Jean-sur-le-Richelieu. These first successes were obtained at great cost, and the Americans suspended hostilities. During the pause, they

Montgomery and the Christmas Dinner

It was rumoured that General Richard Montgomery, who had arrived from Montréal at the beginning of December, was tired of waiting in the cold, and had predicted that Québec would fall before Christmas. Speculation had it that he would eat a good Christmas dinner within the walls. However, Christmas passed, and the Americans and their Canadian allies stayed put. Was this a tactic to wear on the defenders' nerves? Anything was possible. The attack order was given at around four in the morning on the night of December 30–31. The tactic was the following: a group of some five hundred men under Arnold's command would go through the Saint-Roch faubourg en route to the lower town, while a diversionary manoeuvre took place on the Heights near the Saint-Jean gate. Meantime, a second group would skirt the St. Lawrence, converging with the first; the combined troops would then assault the upper town via the Côte de la Montagne. The defenders, entrenched within the fortifications, sniped at the besiegers. Arnold, commanding the northern group, was wounded in the knee on Rue du Sault-au-Matelot, and Montgomery met a tragic end just a few metres away from the lower town. ᴏ

The death of General Montgomery, December 31, 1775. (NAC)

Forced Labour for the Fortifications

When he travelled to Beauport, in 1780, to read the order of forced labour, Captain James Thompson described the scene:

"Captain Twiss' order was read twice to the people, and notwithstanding their being allowed one livre more per pipe than they had last year, their clamour was great. The sergeant of that parish read a list of names and the quantity each was to furnish, which added to the noise, each man complaining of his own disabilities of performing what was required of him, some had wood land, but no road to get to it, others who had none paid eight and nine livres per cord, or kilns have tumbled in, and lime ready in the winter, were not able to bring the lime to town, much less on Cap-aux-Diamants, while others were insinuating that selling their property to the King one third less than it sold in town was highly unreasonable, to which I answered that if the King had no use for their lime, they would be glad to get the very bold of what was offered." ❧

launched a propaganda campaign aiming at winning over the French population, or at least encouraging them to remain neutral. In the fall, the Americans continued their advance. Montréal surrendered; Governor Carleton made a narrow escape to Québec. The next objective was to capture Québec. Already, an American army, under the command of Benedict Arnold, was camped in front of the capital. Montgomery's forces had marched along the north shore to meet Arnold's. When the colonial armies arrived, the defenders of the capital, composed of some sailors, militiamen, and regular soldiers, had to retreat inside the walls.

Though they had few artillery pieces, the Americans set up a battery of cannons near the d'Artigny mill, about where Lévis had done so fifteen years earlier. Exchanges of fire were sporadic once the first battery of cannons became operational, on December 9. But time was against the besiegers, for winter was beginning. Snow accumulated at the foot of the ramparts, impeding any approach. Arnold and Montgomery tried to mount an assault upon the town; Arnold was wounded, and Montgomery killed. The Americans retreated to their camp. At the end of April, a second battery opened fire, but this did not last long; the arrival of a fleet of British reinforcements pushed them back. Québec had resisted!

The end of autumn had kept the Americans from laying a true siege on Québec. Nevertheless, they had found the best site for their camp and their batteries: the Heights of Abraham. The attempted invasion brought the subject of defensive works back to the forefront. Since further attacks were likely, some emergency measures were needed, such as construction of barricades and the demolition of buildings that impeded defence around the edges of the Saint-Jean *faubourg*. In the aftermath of the aborted attack, all logical and likely invasion paths were fortified, especially the route from Lake Champlain (the posts at Île-aux-Noix and Fort Saint-Jean) and Upper Canada (the Detroit, Niagara, and Michillimakinac posts). In Québec, the new governor, Frederick Haldimand, had a topographic map of Cap-aux-Diamants drawn. However, he hesitated between temporary works (earth works and wood structures) and permanent works (masonry structures). Since the war had deprived him of manpower, the first solution seemed preferable; as well, it would be less expensive. However, his engineers were not happy with the concept. For William Twiss, temporary works constituted an expediency that would block later completion of true fortifications. London settled the question: burdened with heavy war debts, the home government had an eye only to the short term. Temporary structures it was to be.

Construction began in October of 1779, under the responsibility of engineer Twiss. The workers were busy winter and summer, but progress was slow because of a serious lack of available labour. Specialized workers were rare among soldiers in the garrison, so civilians, particularly quarrymen and miners, were called into action. Since the pay was low, civilians showed little interest; besides, their competencies sometimes seemed doubtful. The best craftsmen preferred to work for

private individuals in the town rather than for the government, which offered inferior working conditions and lower pay. Only the most desperate resigned themselves to working for the military. To pique their interest, Twiss decided to pay them by the job according to three separate salary scales. When this didn't work, he paid others for piecework, another way of reducing costs, but this method provoked little enthusiasm.

Twiss also resorted to the old formula of forced labour. All parishes of the government of Québec, on both the north and south shores, had to furnish their quota of wood, stones, lime, or wood charcoal, or the means to transport these goods. In principle, individuals aged sixteen to sixty who owned land and those over sixty who had a servant were subject to these rules. Thus, most families in the region around Québec contributed in one way or another to the fortifications on the Heights, though not always in good grace. Although the government paid these reluctant suppliers for their trouble, the compensation rarely matched the market price. This disguised form of taxation yielded only mediocre returns.

Under the circumstances, it seemed more prudent to rely on the military men in the garrison, whose salaries were half those of civilian craftsmen, a fairly important consideration given the tight budget. The garrison soldiers supplied more than 80 per cent of the specialized labour and more than 95 per cent of labourers, by far the most numerous workers on the construction site during the summer. Specialized soldiers were divided into twelve categories, from miners and quarrymen to masons, carpenters, harness makers, and blacksmiths. As for the labourers, they were divided into three trades: stonemason's help, cartwright, and handler. Thus, at the end of the eighteenth century, several hundred soldiers—most of them from the British Isles, but a good number from the German duchies—worked on the installations on the Heights of Québec. The home-country authorities rejected the idea of recruiting a company of craftsmen, as had been done for Gibraltar. The result was telling: Twiss had to teach some of the soldier-artisans how to use their tools!

In 1783, the Treaty of Versailles, which put an end to the war between England and the United States, also interrupted the fortification work at Québec. Severe winter weather, budgetary restrictions, and the lack of skills among the soldier-artisans had hindered progress on the defensive works, and there was little to show for their labour. London placed most of the blame on Twiss. However, he had made some innovations. His fortification design would give a stronger hold on the town and the surrounding heights, even integrating the old wall built by Chaussegros de Léry. A sophisticated citadel was at the heart of this defence system.

This temporary citadel, as it was usually called, was on the highest point of Cap-aux-Diamants, the only spot that could rival the battery installations on the Heights of Abraham. It used aspects of the French fortifications and incorporated the Glacière and Cap-aux-Diamants bas-

Construction Principles for a Temporary Citadel

According to Foreman Thompson, seven general principles guided the planning of Engineer Twiss's citadel project:

"1. to have a communication with the great river, and likewise to have a supply of water within themselves;

"2. to have a proportion of bomb-proofs in every part of the works, also to divide the powder provisions and stores as much as circumstances rendered it prudent;

"3. to enclose as much space as possible with as few works as we could, and yet to guard every part from the enfilade of batteries that may be constructed on the Heights of Abraham;

"4. to follow the strong defence of nature where tho in instances it obliged us to sacrifice the lineal defence of theory, by which means a great part of our advanced parapets are solid rock;

"5. to have the communications very numerous and very extensive through all the works, so as to enable a governor to collect his forces against any given point in the shortest time possible;

"6. to construct every advanced work in such a manner that it may have no command against its interior, and yet so as to be entirely seen into from thence;

"7. to form every covered way and advanced parapet with the idea of enabling the governor to sally with any force he pleases, and also to move this force in as extensive a front as circumstances may require." ☙

PLAN
of the FORTIFICATIONS of QUEBEC
with the proposed NEW WORKS.

The line of the wall of Québec and the advance fortifications, Martello towers 1 and 2. (G. Mann, 1791, NAC)

tions. Twiss designed entrenchments to enclose the gorge (that is, the back) of the two bastions to turn them into redoubts. Within each one, he created two-storey blockhouses, which Overseer Thompson described as buildings with four wings of thirty-two square feet and a similarly sized central block. On the crest of the cliff, Twiss added a powder magazine. Beside the town, from the right flank of the Glacière bastion, he erected three redoubts; these works, built of earth and stones, provided a position for extra artillery. Counterguards (defensive works with ramparts) protected the redoubts from the front. On the highest points, two cavaliers were constructed for a cannon platform, to provide opposing fire to that of the command position.

To the west, beyond the bastions, Twiss built various works, including redoubts and batteries (notably the "zigzag" battery, easily identified by its shape) to secure the heights. A covered way, a ten-metre-wide corridor, was beyond the ditch; here, the defenders assembled to keep the enemy from the gentle slope of the glacis. Traverses—masses of earth placed across the covered way—protected soldiers against ricochets from enemy shells. Tenails covered the exits at the ditch level; this enabled the infantry to stop the enemy from crossing the ditch, since this type of structure was generally built close to a passage running right through the rampart. Finally, Twiss had long countermines dug under

the glacis. A spectacular project, the countermine was a network of small, branching subterranean galleries, which could be filled with gunpowder and exploded if the enemy approached. Thus, all of the land as far as Anse-des-Mères was used.

Twiss executed other large projects beside the western wall, in the areas between the Saint-Louis and Saint-Jean gates. Under his direction, the Esplanade of Rue d'Auteuil appeared on the urban landscape. He also supervised work on the Montcalm bastion on Rue des Remparts. In short, Twiss left his successor with important accomplishments in terms of structures. The protection systems immediately around the town were now adequate. The overall design involved the neighbouring heights; in particular, they integrated the wall, a solution proscribed by his predecessors. New projects were also outlined.

A New Enemy, A New Strategy, 1785–1804

The Treaty of Versailles did not eliminate tensions: reciprocal trade agreements, designed to thwart France, did not materialize; the new border between Canada and the United States was not respected; Loyalists found it difficult to recover their land. Uncertainty hung over the alliance with the First Nations, and negotiations were cut off. The situation was not much better in Europe. The French revolution of 1789 placed the tariff agreement concluded with England in jeopardy, and England feared for the future of its industries. Tempers flared. France invaded Belgium, opening the port of Anvers to its ships. London saw that Amsterdam, an important financial centre for the English, was in danger. Revolutionary wars directly threatened the foundations of Great Britain's economic development. When Napoleon began his march, England could not hope for any reprieve. Meanwhile, in the United States, the pitch of recriminations grew higher; some called for the annexation of Canada. In 1794, a rumour of invasion circulated in Québec: by land, an American army would invade Lower Canada; by sea, a French fleet would sail up the St. Lawrence! When the governor found it necessary to call up the militia, only English-speaking citizens responded. This was not at all reassuring to the military. In the end, British diplomacy defused the crisis: the Americans and the British signed Jay's Treaty in 1795.

In light of this complex situation, the engineer Gother Mann designed a four-point defence plan for Québec. Aware of the importance of the port and of communications with England, he proposed as a first priority to finish the ramparts on the two sides of the triangle delimiting the cliff. Second, he suggested that the Heights of Abraham be occupied. Third, he recommended protecting the front of Chaussegros de Léry's wall, notably the sector between the Saint-Louis and Saint-Jean gates, with auxiliary defensive works. Finally, he approved the construction of a permanent citadel.

Mann's reasoning was succinct: the ramparts had to protect the upper town against a surprise attack, while manned redoubts on the

heights must keep the besieger from getting too close to the stronghold. Auxiliary works would mask the main rampart and slow down the enemy if he succeeded in making a breach, giving the garrison time to take refuge in the citadel. In 1791, Mann clearly stated his fears with regard to the Heights of Abraham. Since they commanded the existing ramparts, they had to be occupied by defensive structures. He proposed to erect two redoubts which would flank each other, though they would not be attached to the main part of the stronghold. These structures were to be built on the heights, about 1,750 metres from the rampart. This would be the site of the Martello towers.

Mann had all the time in the world to perfect his plan, since new budget restrictions imposed by London limited progress on the project quite severely. Although he built a few powder magazines and the Prescott gate on Côte de la Montagne, he was not able to do anything on the Heights of Québec except repair Chaussegros de Léry's wall. He left Canada in 1804, when Napoleon's activities were of greater concern to London than the situation in Lower Canada.

Mann's heritage was his plan, which was now complicated by a more and more uncomfortable situation: the expanding town. In 1775, the Americans had hidden behind and in houses as they approached the fortifications, and the military had razed the Saint-Jean *faubourg*. The lesson was not well learned: the *faubourg* quickly rose again from its own ashes, with apparent tolerance on the part of the military authorities. Encroachments on the glacis of the fortifications beyond the Saint-Jean gate multiplied. On the heights, large landowners, notably the Ursulines and the Hôtel-Dieu nuns, tried to make their land profitable. For its part, the military wanted to extend its grip on the Heights of Abraham. The parliament of Lower Canada, which had just voted to draw up an overall plan to rationalize the growth of towns, also got mixed up in the question. Military engineers could not accept the *faubourg's* expansion onto land that was indispensable to defence. Suddenly, the promontory became a space coveted by a number of groups.

The Strategic Importance of the Heights of Abraham

"After an enemy and established his batteries on the heights, the most elevated part of which is equal to the highest ground on the Cape, and distant from it eight hundred yards; and to this spot on the heights he may approach under cover from the fire of any part of the works of the place and all his arrangements and previous operations may be carried on behind it unseen and unhurt except from shells which could alone give him any annoyance. An enemy possessing himself of this ground will have the right of his attack well secured. From hence along the front of the works down to the St John's suburb in some places within five hundred yards of the town, he may open batteries where he will find situations formed by hillocks of rock which will allow of his placing cannon behind them and making the natural ground his parapet, his guns will therefore be well covered which will have a powerful effect against the town and be in little danger of being dismounted by any batteries of the besieged."

Report by Engineer Gother Mann, 1791. ❧

M.M. Short, **Vue du fleuve depuis la citadelle**, 1840 (ANC)

121

Plate 2

PLAN'S Elevations and Sections of N.º 1 and 4

TOWER'S

Quebec 1823. Sep.ʳ 24
Scale 20 feet to an inch

Elevation of N.º 1

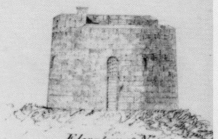

Elevation of N.º 4

Plan of Top

Section of N.º 4

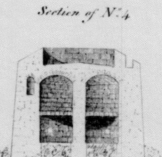

Plan of Top

Plan of Second Story

Section of N.º 1

Plan of Second Story

Plan of First Story of N.º 1

Plan of First Story of N.º 4

C 926
Tray 57.ᵗ —16

The Fortified Town

1805-30

THE PLAN DRAWN UP BY GOTHER MANN was exe-
cuted over the first three decades of the nineteenth century.
In succession, ramparts on the periphery of the cliff, advanced
works in front of the wall, Martello towers on the Heights of
Abraham, and finally the citadel on Cap-aux-Diamants appeared. The
first three were built in reaction to the rise in tension between Great
Britain and the United States, which resulted in the war of 1812–14.
Construction of the citadel began a little later, after the defence policy
was reviewed.

Over these years, Québec also grew by leaps and bounds; it became
the sixth most populous city in North America, and its port the third
largest. This was the result of a pick-up in the economy as exportation
of wood, potash, and agricultural products replaced that of furs. Prosper-
ity meant significant strategic modifications: it was no longer simply a
question of defending a military position, but of protecting commercial
interests and fellow countrymen. Thus, the gap was inevitably widening
between the concept of the stronghold and that of the city.

Preparing for War

The resumption of hostilities between France and England in
Europe gave new impetus to fortification projects in Québec. As well,
when Napoleon imposed a blockade, England required more and more
wood from its North American colony, creating an economic boom and
attracting a growing number of people to the town. The new governor,
James Craig, received precise instructions with regard to Canada's mili-
tary situation and its defence. Believing that the United States would not
dare attack the Royal Navy, but would, rather, try to take Canadian
colonies, the extended borders of which were difficult to protect, Lon-
don ordered Craig to protect Halifax and Québec. The loss of the
former would deprive Great Britain of its largest naval base in America;
the loss of the latter, its Canadian possessions.

Since attack seemed imminent, the English government did not
hesitate: twenty-three hundred soldiers from Halifax landed in Québec.
In two years, a rampart 650 metres long and averaging 6 metres high was
built along the northeast crest of the promontory. As soon as the ringing
of the cliff was completed, seven new powder magazines were built and

The Design of a Martello Tower

At the height of the Napoleonic Wars, the
British used this defence concept to
protect their coastal zones, adapting the
advanced fortifications to different riverside and
port topographies.

The towers were usually two storeys high; the
interior was circular, while the masonry was
elliptical in shape, so that the mass of stone
facing the fire of the besieger was twice as thick
as that facing the defender's fortifications.
Thus, if the tower fell into enemy hands, it
offered only weak protection: artillery from the
ramparts could easily reduce to rubble the wall
facing it. The upper storey was vaulted and
used as a barracks for troops, while the first
floor had a powder magazine and some small
storage areas. Access to the interior was from
the upper floor. The tower had a terrace with
a parapet, the upper part of a rampart that
protected artillerymen and infantrymen, with
embrasures for cannons. Two other embrasures
pierced at the upper level enabled covering fire
by one tower for another. This arrangement
enabled the tower to defend itself and profit
from its neighbour's fire. ✍

Plan of Martello towers 1 and 4, 1823. Note the
difference in the thickness of the walls. (NAC)

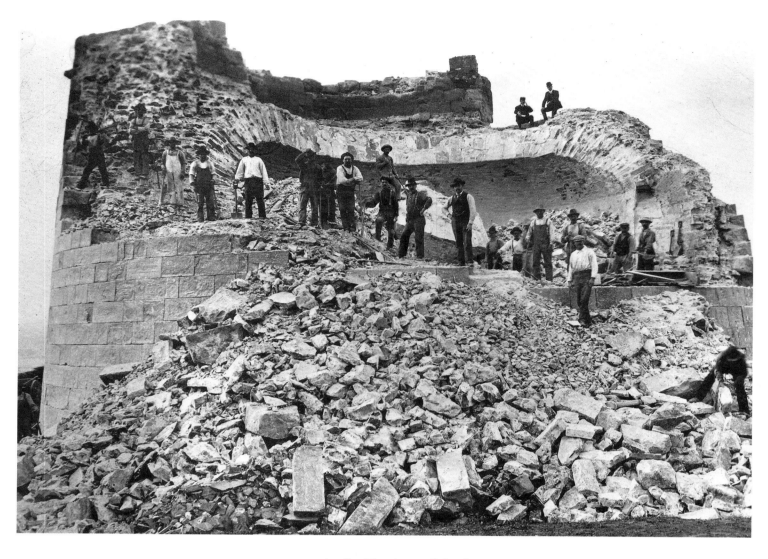

Demolition of Martello tower 3 at the beginning of the twentieth century, shows the thickness and solidity of the walls. (NBC)

the fortifications of the Saint-Louis Gate were reinforced. This gate into the town, adjacent to the heights, was the weakest sector, because it was the most exposed to enemy batteries installed outside the wall. In 1811, the rampart of the upper town was almost finished, and the Québec promontory could no longer be scaled.

A few years before, Governor Craig had authorized use of the Heights of Abraham for construction of Martello towers. The initial project called for construction of seven towers. The three farthest away were to be situated at Pointe Lévy and Anse-des-Mères, to prevent a landing, and on the St. Charles River, to prevent raking fire on the ramparts. They were never built. Starting in 1808, the four other towers were erected on the promontory: two of them on the Ursulines' land, a site that the governor regularized by purchasing the land three years later. Two others, erected on Buttes-à-Nepveu, the highest point of the Plains, provided mutual protection. They defended access to the promontory from the north via the slope of Abraham, the gentlest slope.

In terms of defending against attack, from both land and sea, the Martello towers were an interesting technical innovation of the early nineteenth century. These solid advanced works were intended to slow the advance of the enemy and to keep batteries of cannons from being installed within firing range of the ramparts. They had many other advantages, as well: they were not expensive to construct, they could be defended by a limited number of troops, and, except in times of crisis, they did not require maintenance of a garrison.

These massive stone monuments extended the military's grasp on the urban landscape. To be effective, their fire could not be constrained by buildings in the way; their cannons had to have maximum range. On the other hand, the town was growing rapidly and tended to take up all available space, especially on the heights. Both the military and civilians were fighting for space.

A Coveted Space

As soon as Canada was surrendered to England, in 1763, its population began to grow more quickly. Attracted by a burgeoning market, English-speakers comprised almost 30 per cent of the population by 1830. To these permanent residents were added several thousand soldiers and sailors. By the beginning of the nineteenth century, the lower town had doubled in area, while the walled upper town offered few possibilities for new construction because of the space reserved for the citadel. New arrivals were thus drawn to the town outside the walls.

The promontory raised much interest; it wasn't long before craftsmen established themselves in the northern part. In 1770, seventy-six households were counted there. The Hôtel-Dieu nuns began once again to parcel out land in 1776. By 1795, almost a thousand people lived there, and this number doubled within ten years. Even the erection of the Martello towers in this sector and the acquisition of twenty-two hectares of land by the government did not succeed in completely stopping urban development. As the population overflowed, the military had to give way to civilians on the northern part of the promontory.

The southern part, the site of the present Plains, was more hotly disputed, for both its strategic importance and its attractiveness as a residential site were indisputable. Some large landowners subdivided their property, others tried to hold on to choice plots for themselves, while the army appropriated the areas it deemed essential or complementary to its defensive function. Not content with selling or renting out this land, owners sold leases so that the property would one day revert to them.

Construction of the Martello tours retarded the advance of civilians onto the Heights of Abraham. The 1812–14 war between England and the United States provided the military with new arguments. To make Québec into a fortified town, they claimed, it was important to reserve the necessary space for defence. Hostilities ended in Europe with the exile of Napoleon, and in America with the 1817 Rush-Bagot Treaty, which limited the number of armed vessels on the Great Lakes. Under these circumstances, the military had an edge over civilians when it came to land appropriation on the Heights of Abraham.

This land was the object of numerous transactions between 1760 and 1860, but the military ensured itself of ultimate control. The most important acquisitions were made, by fair means or foul, from various owners. From the east to the west—that is, from the wall to Sillery— several were notable. The purchase of land belonging to Jenkin Williams

The Subdivision
of the Heights of Abraham

"I allude to the buildings which are daily rising in the suburbs in front of the works and lately on the Heights of Abraham. The greater part of this ground is held by the Ursuline and Hotel-Dieu convents. Until the year 1789, the Plains were entirely open, when the two Convents presented Memorials to the Governor and Commander in chief, praying to be allowed to set up inclosures, in order that they might lease or otherwise let the land to more advantage than they had hitherto been enabled to do. I give my opinion that if by inclosing nothing more was meant than the common post and rail fence of this country, I saw no harm in them, but if it was intended that buildings should be erected, there were very strong objections to it on the part of government, as they might be of very essential prejudice to the defence of the town and that the high ground (on which I now propose the redoubts) ought not to be granted or leased at all. It should appear however that what I then suggested has not been attended to as every part of the ground has been inclosed and let and several buildings are already erected thereon and of course more may be expected. This is a subject which requires to be speedily attended to as it is interesting both to government and individuals and indeed to the country at large whose security rests so much on that of Québec. Whenever any very serious attack shall be made on this place, one of the first measures which prudence will dictate to the garrison, will be to destroy these buildings in front of the works, which may possibly be the ruin of hundreds of the inhabitants, and perhaps may be very embarrassing to government. Individuals if permitted will nevertheless run all risks for a temporary convenience, where they do not see immediate danger or where they suppose it was remote. But it would be better to stop effectually at once the further progress of the evil, than to trust to consequences, which cannot fail ultimately to create much inconvenience, trouble and difficulty."

Gother Mann to Governor Hunter, 1804. ✧

allowed the creation, in 1781, then the expansion, in 1818, of the area known as King's Field. In 1819, Archibald Ferguson sold fourteen thousand square metres of land, acquired from the widow of the herbalist Lacroix, to the king, and the government had the general quarters of the chief engineer constructed there. Finally, in 1835, the government exchanged Bandon Lodge for the Marchmont estate. Through these transactions, the land that had belonged to Villeray, the immense La Cardonnière estate, now called Mount Pleasant, bordering on the wall, fell into the hands of the military. In 1802, Ferguson rented the Buttes-à-Nepveu from the Ursulines for a fifty-year term, and sold the lease to William Lampson. When it expired, in 1853, the Ordnance Department acquired another fourteen thousand square metres on the Ursulines' land reserves. Part of the land where the Musée du Québec now stands was ceded by lease in 1793; it was transferred to the king three years later. In 1839–40, Joseph Bonner made a number of purchases, totalling eleven *arpents*, or about three-quarters of a square kilometre, in area. But the king claimed this land and, in effect, expropriated it.

The western end of the site was rented by the Ursulines to the military in 1802 for a period of one hundred years. Before it became a playing field, it was a race track; before that, a place for military exercises. In total, the military acquired a little more than one hundred hectares of land, forming a corridor south of the promontory, beside the St. Lawrence.

The method of acquisition of these plots symbolized the great interest in them. A quarter of them were acquired by force or coercion. The military occupied the area, even though the courts would later order it to indemnify the owner. When acquisitions were made by negotiation, any means might be used by the seller to increase the value of the land or to preserve a parcel: subdivision, the threat of subdivision, construction starts, proposals to swap, offers to rent, and so on. For example, Archibald Ferguson agreed to sell his land for a fabulously high price; as well, he reserved for himself and his successors a lot sixty metres wide, the use of a house and outbuildings free of rent, and use of the land for planting hay, oats, and potatoes. The scenic environment of the Heights took on value, part of which was sentimental—an attachment beyond the reach of money.

The Apotheosis: The Citadel, 1820–31

The 1812 war also caused the military to re-evaluate its defence policy for the entire colony. Governor Richmond put forward an ambitious plan for military structures concentrated on the axis of the Ottawa and Rideau rivers, which would be canalized. Montréal and Kingston, at each end of this corridor, would be fortified. So would Île-aux-Noix, on the Richelieu, which protected a potential invasion route, to provide extra protection for Montréal.

Québec remained the keystone of this continental defence system. Once again, the proposal for a permanent citadel on Cap-aux-Diamants

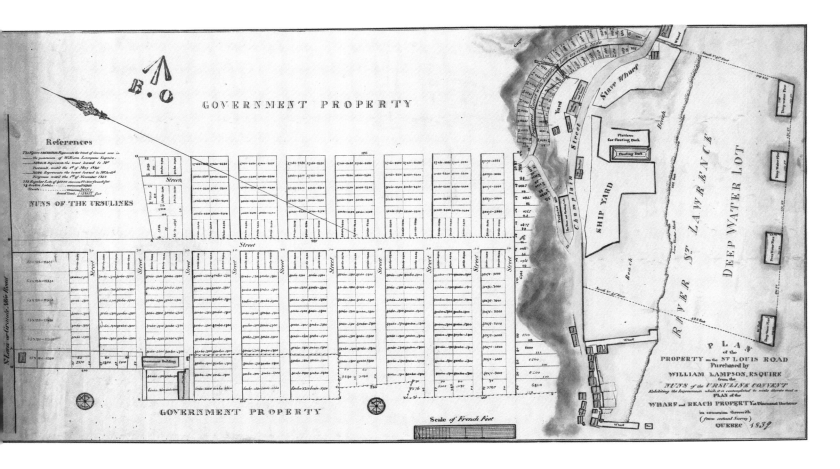

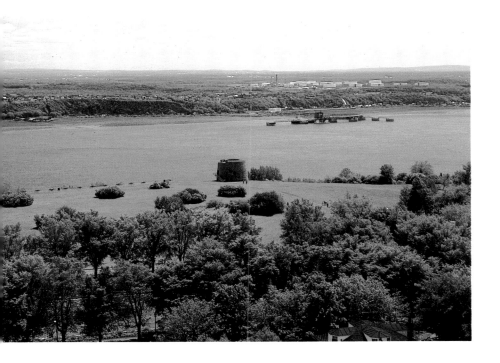

In 1839, William Lampson was planning to subdivide his immense property on the Québec promontory. (NAC)

Vigil.

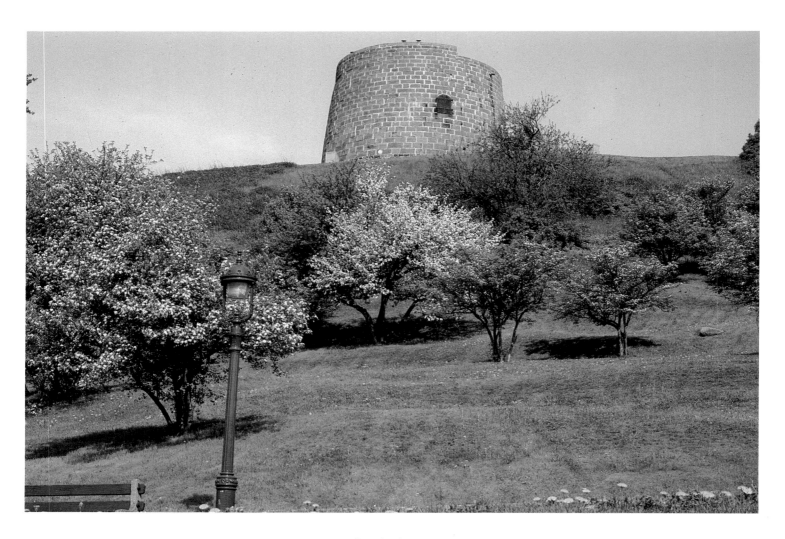

Vigil.

resurfaced; this time, London gave its consent. The citadel was started in the spring of 1820. Three years later, half of the planned walls were completed, but two-thirds of the budget had been spent! By 1831, all that remained to do was to add auxiliary buildings, such as a hospital and a prison. On a technical level, the geometry of the new structure included part of the old ramparts, along with the Glacière and Cap-aux-Diamants bastions. The wall met standards dictated by the increased power of armaments: it was seventeen metres deep, and its parapet was reinforced with an embankment. It was the heart of the Québec fortifications. But the cost had mushroomed—to three times the planned budget. Acquisition of the land required for the glacis alone gobbled up 10 per cent of all of the funds. The military paid heavily for their victory over the town.

Construction of the Citadel was essentially the work of the garrison posted in Québec; the plans were drawn up by Elias Walker Durnford, the engineer responsible for the work. Most of the stone came from government quarries. Regional entrepreneurs supplied lime, brick, and wood. Only 10 per cent of the labour was supplied by civilians; most tasks were performed by the fourteen hundred garrison soldiers, for extra pay. The working conditions were a little better than they had been the last time round; work was suspended in the winter, at least for the miners. But the foreman was just as likely as his predecessor to curse the days after pay day; there was nothing like a long evening spent in a pub—Québec had about one for every sixty persons at the time—to slow the rhythm of work. The foreman called these mornings after "holy days." Decidedly, everything about the site lent itself to symbolism.

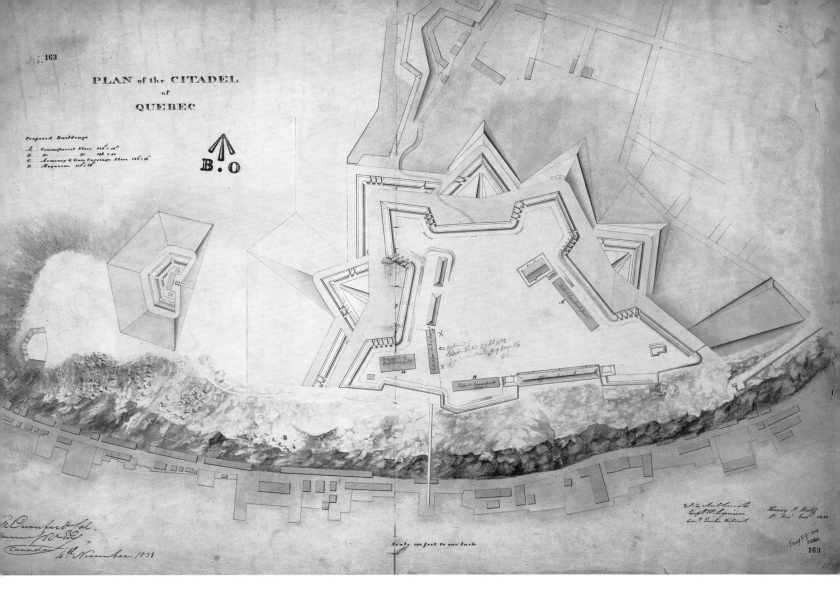

PLAN of the CITADEL
of
QUEBEC

Proposed Buildings

A. *Commissariat Store*
B. *Do.*
C. *Armoury & Gun Carriage Store*
D. *Magazine*

B.O

Scale ten feet to one Inch

4th November 1831

Plan of the Québec Citadel. (E.W. Durnford, 1831, NAC)

Construction and maintenance of the fortifications required a large number of specialized workers. (Atlas de Masse, Bibliothèque du Génie, France; R.A. Sproule, **Artisans de la Citadelle**, 1834, NAC)

In spite of a relaxation in the rules of military conduct, the soldier's lot in the nineteenth century was not an enviable one. After twenty years of service, he was a used-up old man. The routine and the poor living and working conditions wore him out, especially since his guard duties through the long, Siberian-style winter. (M.M. Chaplin, NAC)

Sentry Duty: Officers and Soldiers on the Heights

Once the Citadel was finished, the garrison was on guard there both winter and summer; sentries were also posted at the Martello towers, on the ramparts, and at the gates to the town. Aside from this tiresome task, what did the soldiers and officers do with their time? Once the first contacts were made, they tried to get to know the local population. Military ceremonies, concerts, leisure and cultural activities, and sports all provided opportunities for this. Relations between the soldiers and town inhabitants sometimes became strained and degenerated into brawls and scuffles. The officers' contacts with Québecers were a little more relaxed, for high society met in both salons and messes. It was no chore for both officers and soldiers to visit the Heights to observe nature, relax, get some exercise, or have romantic encounters.

The size of the garrison over these seventy years bears witness to the importance the London government accorded to Québec in its defensive strategy for Canada. The ratio of garrison soldiers to civilians constituted the defining criterion for battle. In theory, a town could be considered a stronghold when the garrison accounted for 10 per cent or more of the population. When this proportion comprised one soldier per ten to twenty-five civilians, the town could be considered a garrison town. In the winter of 1760, Québec contained two soldiers per civilian, an exceptional situation occasioned by the war effort, but revealing nonetheless of the desire of the conquerors. From then to the end of the eighteenth century, the capital counted at least one soldier per ten residents. By 1818, this proportion had dropped to one soldier per fifteen civilians, a situation obviously dictated by budgetary cuts by the imperial government, but also by demographic developments in the town.

Whether Québec was a stronghold or a garrison town, its citizens lived constantly with the military reality. The stronghold imbued the urban way of life, if only because of the comings and goings beyond the walls and the gates. As well, the fortified town, at risk of being invaded by yesterday's masters, had to count on vigilant artillerymen. At the beginning of the British occupation of Québec, the garrison used cannons on the ramparts for its target practice, to the consternation of residents in the lower town, who complained about fires caused by burning wadding. In 1802, the military solved the problem by renting land from the Ursulines on which to hold exercises. Every summer, a procession of artillerymen went out through the Saint-Louis gate with their field guns and their mortars for training; this was a spectacular event, drawing great numbers of the curious. The infantry also conducted drills there, even staging mock battles. Sometimes it was troop inspections that stole the show. Twice a year, the governor went to the heights to review the 103rd or the 76th regiment. The crowds appreciated the uniforms, dexterity, precision, and discipline of the soldiers.

Discipline also figured in the daily life of the soldier. His schedule was full: in the summer, he awoke at four o'clock in the morning and had to be ready for roll call fifteen minutes later. After one hour to wash

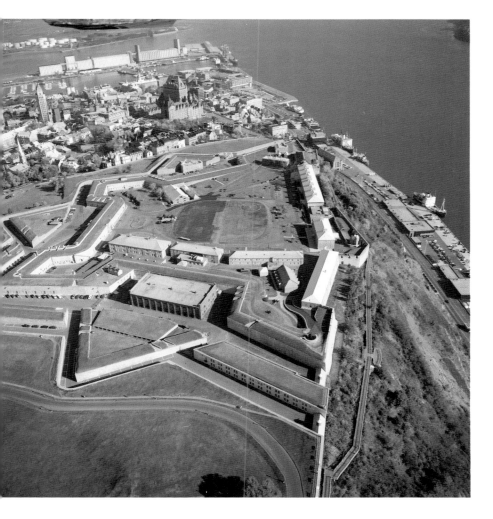

Meteorological Observations

*I*n the nineteenth century, it was said of Québec that it had the winters of St. Petersburg and the summers of Paris. Meteorological observations taken at the Citadel between 1824 and 1831 confirmed this statement within a few tenths of a degree. What distinguished Québec from other cities were its sudden drops in temperature, due mostly to the wind. Western winds predominated three days out of five, and the annual average temperature was 37.58° F (3.1° C). These observations were a prelude to the systematic registration of meteorological phenomena by the British military on an Empire-wide basis later in the nineteenth century. However, even earlier, James Thompson had noted in his journal the temperature and wind conditions for the site of the first citadel, remarking that the miners were working out of doors in Siberian temperatures (−36 on the Du Crest scale). ✌

up and clean the sleeping quarters, there was inspection, followed by manoeuvres. Before breakfast, the soldiers lined up for a second inspection. The tasks assigned for the day took up all the time to lunch, after which there was yet another inspection. It was only then that the soldier found himself with free time until curfew; he was as likely as not to use this time to quench his thirst.

There is no point in dwelling on the brawls and fights between drunken soldiers or on altercations between civilians and military men; they were well known, and even today they are the stuff of rumours. The garrisoned soldier, far from his homeland, tried to chase away his loneliness. This is why he readily accepted to work on construction of the fortifications. The military authorities attempted to keep costs down, prevent idleness, and make the soldier prouder and happier.

The soldiers who worked on Cap-aux-Diamants were allowed to get up at five o'clock during the summer. They worked until eight, stopped for half an hour to eat, then worked again until noon, when they had two hours off. Scullery staff set up a field kitchen on the site, and they stayed there to eat lunch. The quality of the food provoked no comments; at least, it was filling. The work continued until seven in the evening, though certain pieceworkers kept going past regular hours.

The Québec Citadel.

The soldiers were paid for their work, as were the officers supervising them. The latter, however, had a better lot than the mere soldiers; wealthy, educated, and well-bred, they kept company with high society. They took a fancy to the town and eulogized it in poetry, prose, and painting. In fact, a number of water colours left behind by Bainbridge, Cockburn, and others represent only part of the rich cultural heritage left by the British officers of the nineteenth century.

The Gibraltar of North America?

Between 1760 and 1830, three words summed up military thinking and dictated their actions: mistrust, citadel, and austerity. Like the upper town of Québec itself, this triad took the form of a triangle, since the three aspects were interrelated and interdependent. Mistrusting the conquered population and the poorly designed ramparts, the new colonial authorities immediately began calling for construction of a citadel, which could not be completed without the consent of London. Confronted with urgent economic situations (the Seven Years' War, the American War of Independence, the French Revolution, the Napoleonic wars, and, finally, the War of 1812), British parliaments constantly looked for ways to cut expenses. The engineer therefore had to adjust to an imperial context, without losing sight of his primary concern: fortifying Québec. With its ramparts, its powder magazines, its military warehouses, its advanced works, and its Martello towers, Québec was impressive. Even before the citadel was built, it was dubbed the "Gibraltar of North America."

In spite of the construction of a permanent citadel on the heights of Cap-aux-Diamants, the military could not declare itself completely satisfied with its stronghold. With their eyes fixed on an ideal, the commanders lost sight of the growing town, and a confrontation between the concept of a city and that of a stronghold became inevitable. In the end, acquisition of land gobbled up the equivalent of half the cost of building the citadel. This was the price of freeing up a corridor along the cliff so that they could have a good view of the future besieger . . . who never came. This corridor would later become better known as "the Plains of Abraham." To all intents and purposes, the military created Battlefields Park around 1830. What remained was to define its legal existence, civilian character, and cultural functions.

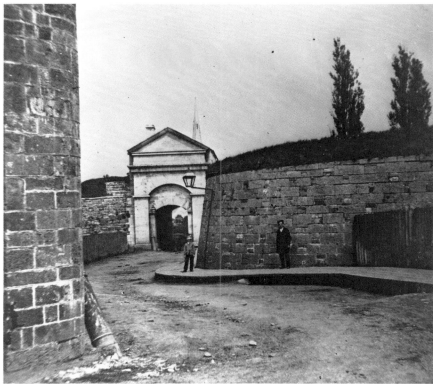

Demolition of the Saint-Louis gate. (**L'Opinion publique**, September 14, 1871, Bibliothèque de l'Université Laval)

Exterior façade of the Saint-Louis gate, hidden by the advance rampart. (AVQ)

In Honour of the Natural Sciences

The Québec Literary and Historical Society was prominent among the various associations and clubs attended, led, or even directed by military men. Devoted to the promotion of natural sciences, it published a number of major papers on botany. One of the most important speakers at the society was also one of the most brilliant Canadian botanists of the nineteenth century: William Sheppard. Sheppard owned the Woodfield estate, which bordered on Bois de Coulonge and M.H. Perceval's property. The wife of the latter was passionate about botany and gathered plants on the heights and in neighbouring estates for the Hooker and Torrey & Gray herbaria. Among other interested amateurs were Lady Dalhousie and Fannie Bayfield; the latter left a box containing more than fifty watercolours of plants found all over Canada. ✑

The countryside, whether it was strolled on or seen from the Heights of Québec, drew thousands of visitors to Québec City in the nineteenth century. (J.P. Cockburn, **Le cap diamant au pied de la tour Martello n° 1**, NAC, and J.P. Cockburn, **Le glacis de la Citadelle, délimité par les clôtures**, 1829, NAC)

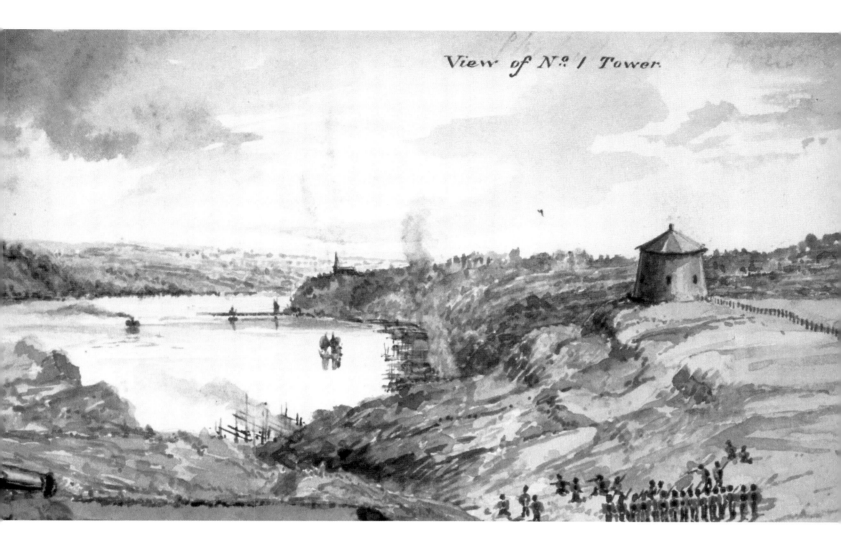

Military and agricultural vestiges and activities commingled on the site of the Plains in the nineteenth century. (NAC)

This plant, a bloodroot (**Sanguinaria canadensis**), was drawn by Fanny Amelia Bayfield, who gathered plants on the site of the Plains of Abraham in the nineteenth century. (NAC)

CHAPTER FIVE

Sports, Culture, and Leisure

1800-1900

Donald Guay

A Place of Memories

AFTER THE CESSION, the British took a firm hold in Québec. They established their own institutions, since "it is in no way a virtue of the English race to tolerate any manners, customs, or laws that seem foreign to them," as Lord Durham wrote later; they reproduced their culture and way of life, and introduced their sports and entertainments.

Loaded with souvenirs, the Plains were now permeated with the living memory of the new masters. As a historic site expressing the strength and grandeur of the Empire and a spectacular natural landscape, it drew more and more visitors. As they lost their strategic military significance, the Plains became a parade ground and a playing field for the garrison soldiers. Large-scale military displays and sporting competitions took place, and the Plains were enriched with a new cultural universe.

The 1759 battle on the Heights of Abraham, entailing the death of the generals of both armies, endowed this battlefield with an almost instantaneous historic and symbolic value. For the English, it held the memory of glory: the "site of the great victory of General Wolfe" embodied the realization of the old dream of an entirely British North America. For the French and French Canadians, the memories were bitter: on this battlefield, the fate of Québec and of New France was sealed. The surrender of Canada by the French, in 1763, marked the end of a dream. If Québec was one day to become the capital of a great empire, as Governor Frontenac had hoped, it would not be a French one.

Soldiers in the Québec garrison and English travellers passing through always made a point of visiting the battlefield. The place where General Wolfe had fallen was of particular interest. At the beginning of the nineteenth century, Joseph Bouchette emphasized the "pious respect" that English visitors showed by "wanting to take from some part of the site relics sanctified by the death of their hero." The Plains became, for the English, a site of reverence, a patriotic pilgrimage. Many times in 1807, John Lambert went sadly to the place where Wolfe had given his life for the glory of the Empire, deploring that sacrilegious hands had taken the large stone against which the mortally wounded general had been held up by his officers, and indignant that his compatriots did not show more respect. Only a small sculpture of the

The monument erected in honour of generals Wolfe and Montcalm in the Jardin des Gouverneurs. (M.M. Chaplin, NAC)

Transfer of the remains of the soldiers of 1760, on June 5, 1854. (ANQ)

The Transfer of the Soldiers of 1760

I n the summer of 1849, workers found weapons, cannonballs, and bones buried near the Dumont mill. The latter were the remains of British and French soldiers killed in the battle of 1760. In 1852, an archaeological dig was undertaken, and two years later there was a ceremony to mark the transfer of the remains. An observer described the scene in the June 13 issue of La Minerve:

At around nine o'clock on a morning that left nothing to be desired, a huge crowd was already gathered on the esplanade and overflowing onto the terraces beside the ramparts. In their best clothes, these people made a picturesque sight, and one might have thought one was in the middle of a great Roman amphitheatre where a show was to be presented to the thousands pressing in from all sides. Various branches of the Société Saint-Jean-Baptiste, the Institut Canadien et St. Roch, the Canadian Carabineers in their brilliant uniforms, a corps of artillerymen with three cannons, the 66th and 71st regiments, the officers of the garrison, and the seminarians ▶

general, standing in a niche of the façade of George Hipps's butcher shop on the corner of Rue Saint-Jean and Rue du Palais, reminded the public of his memory.

John Lambert's wish was granted twenty years later, in 1827, when the governor, Lord Dalhousie, decided to honour the memory of the conquering general, but also that of the vanquished general, Montcalm. A Neoclassical obelisk twenty metres high, designed by Captain Young, first planned for Place d'Armes, was finally erected in Jardin des Gouverneurs. On November 15, 1827, the governor, accompanied by his wife, the Countess of Dalhousie, placed the cornerstone of the monument. The bishop of Québec, the chaplain of the armed forces, the grand master of the Freemasons, numerous dignitaries, and a large crowd were there for the inauguration. Two regiments formed an honour guard, from the foot of the glacis to Château Saint-Louis. To the great displeasure of the English, there were very few French Canadians in attendance.

It was surprising that the conquerors erected a monument to the conquered, especially since the English held achievement, success, and victory in such high esteem. Governor Dalhousie's conciliatory gesture was aimed at improving relations between the English and the French Canadians. In fact, he could not have honoured Wolfe alone without reopening still fresh wounds. This "monumental" compromise did not, however, fully satisfy the pride of the English, for whom Wolfe was a true hero of the Empire; in 1832, to honour the memory of the victorious general, Governor Aylmer ordered a truncated column erected at the exact site of his death. In 1849, a Doric column replaced the first one, which had been defaced by visitors. The new column was

protected by a spiked iron fence. These monuments strengthened the symbolic meaning of the Plains of Abraham.

After the Patriotes were vanquished, in 1837–38, the monument to Wolfe and Montcalm was again seen as a symbol of reconciliation between English and French Canadians. In 1842, during the first French-Canadian *Fête nationale* in Québec, the newly founded Société Saint-Jean-Baptiste organized a patriotic visit to Jardin du Fort, which, on Durham's order, had been open to the public since 1838. Representatives of English, Scottish, Irish, and French-Canadian associations came to "salute, with the same respect and a legitimate feeling of pride," the monument erected to the memory of the two generals. However, the choice of a national flag, that of the Patriotes of 1837–38, coloured green, white, and red, was criticized by the English-language press, who saw in it an allusion to revolutionary fervour. The Société Saint-Jean-Baptiste came to the flag's defence, explaining that the colours represented the three Christian virtues of faith, hope, and charity.

The president of the Société Saint-Jean-Baptiste, J.-B. Caouette, recalling the ceremony fifty years later, said that a "well-reasoned patriotism" had replaced the previous fanaticism. Throughout the nineteenth century, the Société Saint-Jean-Baptiste cultivated an ambiguous nationalism, which accepted the duality of belonging and identity while timidly attempting to preserve certain cultural roots expressed in the slogan coined by Étienne Parent—"Our institutions, our language, and laws." This ambivalent patriotism obviously was not the sign of a strong community, but it took no more than this to be considered among the "ardent patriots."

A similar type of patriotism reigned over the transfer of the remains of the soldiers of the two armies of 1760. Buried on the battlefield itself, they were discovered near the ruins of the Dumont mill in 1852. A procession, religious services, and ceremonies were organized for the occasion. On July 18, 1855, before more than twenty-five thousand people and numerous dignitaries, the governor general inaugurated another hybrid monument. It all took place "without regard to national prejudices and with no question of who were the victors and who the vanquished." The presence of the commanders and crew of the French corvette *La Capricieuse*, for whom the ceremonies had been delayed several days, enhanced this great show of civility between French and English Canadians. The international political context lent itself well to this symbolic reconciliation, since France and England, two age-old enemies, had just formed an alliance to attack Russia in the Crimea. However, the old Patriote leader Louis-Joseph Papineau refused to attend the ceremonies, professing his surprise "that a national society asks both those who died to preserve their nationality and those who died\to subjugate them to celebrate together." It was, he wrote, "a bizarre contradiction and abject flattery." For Papineau, patriotism was never to be confused with submission.

arrived one after the other on the site and arranged themselves in a procession. In a funeral . . . chariot designed by the painter Joseph Légaré and drawn by six horses with black hoods . . . rested, in a coffin, the bones of these brave men.

The ranks soon moved off, to the strains of the touching melody known as the March of the Dead, played by the various bands scattered throughout the procession, which took St. Louis Street to the city. Thus, the heart-stopping effect, the military fanfares, the clinking of the arms, the flash of the brilliant uniforms reflecting the sun's rays, the quiet, respectful crowd, the standards and flags of the various corps floating in the breeze, the funereal tolling of the Catholic and Anglican church bells . . . everything added to the great spectacle, never before seen in Canada. . . .

When we arrived at the church, which was swathed in mourning drapery, the coffin was placed under a catafalque twinkling with light, at the four corners of which were attached the flags of the Canadian militia. The honour guard, under arms, arranged themselves around it, and then the vaults of the metropolis echoed with the grave and sublime chants repeated in the church on the tombs of heroes as well as private individuals. I cannot describe to you the feelings and emotions that rippled through this immense audience while the choir, under the able direction of Mr. Ernest Gagnon, sang the Libera: it was something that went to the bottom of the soul and could even have made marble shudder. . . .

When the archbishop finished the ceremony, the procession started up again, marching to the battlefield. . . . The crowd grew as the cortege advanced. . . . At one o'clock, the coffin was deposited in the grave, on which will be erected a monument that will honour the citizens of Québec and the cinders that it will cover. ❧

The French Military in 1855

In 1855, Québec hosted a special event. For the first time since the British occupation, a military ship flying the French colours, the corvette La Capricieuse, commanded by M. de Belvèze, sailed up the St. Lawrence and cast anchor at the town. This military presence, the first by the French in the port of Québec since 1760, was made possible by the French–English alliance in the Crimean War.

Québecers were very enthusiastic about this unusual visit. From July 13 to August 25, numerous ceremonies took place in honour of the French representatives, including a review followed by a military parade on the Plains. The officers and crew of La Capricieuse took part before a large crowd. ✑

The Société Saint-Jean-Baptiste de Québec organized other patriotic events around the Monument des Braves, including one on September 19, 1863, when a statue of Bellona, a gift from Prince Jérôme-Napoléon, was unveiled. Three metres high and placed on an iron column, it completed the monument designed by Charles Baïllairgé and built by John Ritchie and Joseph Larose.

It is understandable that, with all of their emotional and symbolic power, the Plains of Abraham were vaunted in the guides that were published by English Canadians for British and American tourists as a unique, glorious, and natural historic site, a must for any traveller. As well, the Plains offered a magnificent view of Pointe Lévy, the ferries, Île d'Orléans, and the St. Lawrence River. The captain of *La Capricieuse*, the much-travelled Paul-Henry de Belvèze, said that the town of Québec was surrounded by "one of the most splendid panoramas in the world." The only walled city in North America, it offered admirable scenery, according to Sir John Young, Governor General of Canada.

In the second half of the nineteenth century, with the new means of transportation, notably the railways, the Plains became a well-known stop for tourists from all over. Among the seven hundred visitors to the town of Québec each day during the summers of the 1870s, Americans were the most numerous. The symbolism and beauty of Québec also drew "distinguished outsiders"—notables from the worlds of business and politics, and even members of European royal families. As General Fenwick Williams put it, any English soldier who had read military history hoped to see "the plains where Wolfe and Montcalm fell" before he died.

At the turn of the century, the *London Telegraph* expressed surprise that the Plains of Abraham drew more visitors than the battlefield at Waterloo, where the defeat of Napoleon's army by Wellington's, in June of 1815, had changed the fate of Europe. When the Ursulines announced that they were planning to sell the site for residential construction, there was an outcry of indignation in English Canada that was echoed in other countries of the Commonwealth.

Battlefields Park was a product of Canadian dualism, based on a compromise. At the end of the nineteenth century, many French Canadians agreed with Prime Minister Wilfrid Laurier that "it was the design of Providence that the two races, enemies up to now, should live henceforth in peace and harmony on this continent and should comprise but a single nation." This vision is essential to an understanding of how French Canadians felt about the ambivalent symbolism of the Plains of Abraham during this period.

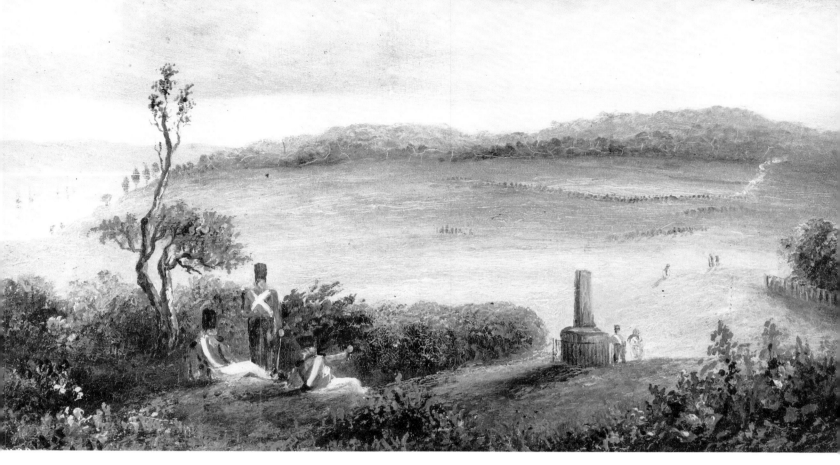

The first monument to Wolfe on the Plains. In the background, the cavalry performs exercises. (H. Church, 1838, NAC)

The Wolfe monument on the Plains of Abraham in 1880; in the background, the prison. (**L'Opinion publique**, June 10, 1880, Bibliothèque de l'Université Laval)

1 DE SALABERRY 2 SAINT-JEAN-BAPTISTE 3 LES CORROYEURS ET LES TANNEURS 4 LES MENUISIERS 5 LES BOUCHERS DE QUÉBEC 6 IMPRIMERIE ET RELIEURS

7 LA MESSE SUR LES PLAINES D'ABRAHAM

LA GRANDE FETE NATIONALE A QUEBEC

A Stage for Shows

ITH THEIR GREAT EXPANSES and their almost unbroken topography, the Plains presented an exceptional space for mounting huge shows. Few sites in the region around Québec could accommodate as large a crowd. Starting at the end of the eighteenth century, promoters of shows and large gatherings profited from this potential, starting what has become a continuing tradition.

The Circus

The Ricketts Equestrian and Comedy Circus, from Philadelphia, spent part of the summer of 1797 at Québec City and presented the first big show on the Plains. Founded in 1792 by John Bill Ricketts, considered the inventor of the American circus, the company offered equestrian and theatrical displays and exhibited exotic animals, including the first giraffe ever seen in Canada. The programme, presented three days a week—Tuesday, Thursday, and Saturday—also included comedic dances and songs and finished with fireworks. Ticket prices were very high—a dollar for a box seat and fifty cents for one on the floor—indicating that the Ricketts show was intended mainly for the upper class and the officers of the garrison; indeed, the price of a ticket represented up to a day's wage for a labourer. The prices apparently did not affect the financial success of the circus, which returned to Québec the following year.

The presence of the American circus was not appreciated by Father and Mother Marseille, marionnettists whose little theatre, though well known and liked by the town élite, had to compete with this unusual entertainment. Many other circuses came to Québec in their turn, raising their tents near the Saint-Louis gate or, more and more often, in neighbourhoods of the town.

Agricultural Fairs

At the beginning of the nineteenth century, the Plains still retained their agricultural function inherited from the New France era: farmers grazed their cows and grew some grain there. Thus, it was not surprising that the Québec Agricultural Society, founded in 1789 by Lord

Buffalo Bill

Of all the circuses that performed on the Plains in the nineteenth century, that of Colonel W.F. Cody, a.k.a. Buffalo Bill, was no doubt the most prestigious.

At the end of June, 1897, Buffalo Bill, "a magnificent specimen of American virility," arrived with his huge troupe of more than three hundred horsemen representing "a kaleidoscope of races of all colours." After parading through the streets of the town, the troupe set up on the Plains under a huge tent lit by electric lights, with seating for twenty thousand.

Crowds of Québecers went to see the most daring equestrian spectacles and to see in person the man "who, for his bravery, his valour, and his devotion to his country, was greatly appreciated by all the generals in the American army over the last thirty years." ༄

The great French-Canadian *fête nationale* in Québec City, June 24, 1880. The parade of floats and the mass on the Plains also drew a large crowd. (**L'Opinion publique**, July 8, 1880, Bibliothèque de l'Université Laval)

Dorchester, governor of the colony, held its first agricultural exhibitions there in the summers of 1818 and 1819. For two days, the public went to admire the handsomest animals in the region and samples of grains and vegetables "many of which would do honour to any country." Ploughing contests were organized to find out which were the best ploughs and how to use them most effectively. According to British observers, the small Scottish plough was found to be superior to the heavy Canadian wheel plongh. Among the many agricultural machines on exhibit was "a machine for thrashing grain."

At the end of the nineteenth century, the Plains were again used for agricultural exhibitions. In 1897, the Société d'horticulture de Québec presented its annual exhibition at the Skating Rink on Grande Allée. There were few English-speakers among the exhibitors, in contrast to exhibitions at the beginning of the century, when they had comprised the large majority. M. Cholette, of Spencer Wood, exhibited his famous collection of plants, one of which, a hundred years old, was ten feet high and twelve feet in diameter. It weighed almost a thousand pounds with its pot, and required ten men to carry it to the Skating Rink. In spite of the success of this exhibition, entitled *Flore et Pomone* (Flora and Pomona), the organizers noted that "the upper class of Saint-Roch" stayed away, perhaps for lack of rivalry or wanting to keep their beautiful flowers to themselves.

Military Reviews and Manoeuvres

At the beginning of the nineteenth century, reviews and manoeuvres by the garrison soldiers attracted many of the curious. They came in such large numbers to see hundreds of soldiers in colourful uniforms parading with discipline, order, and confidence that, in the 1830s, the officers organized several days of manoeuvres and even simulated battles. That this was indeed a show for the public was evidenced by the advertisements in the newspapers.

With strong support from the governor, the military used these impressive spectacles to express loyalty to Crown and country. At the same time, it made a show of its presence and represented the military might of the Empire, an effective tactic for intimidating French Canadians. On June 18, 1838, for example, the twenty-third anniversary of the Battle of Waterloo was celebrated with a great parade on the Plains of Abraham. A number of garrison soldiers and the commandant, Sir James Macdonell, at the time Colonel of the Goldstream Guards, recalled the perils and the glory of this memorable day for England. For sympathizers of the Patriotes en révolte, the message was clear.

Ten days later, on June 28, the coronation of Queen Victoria gave rise to a number of festivities, including a grand review of the troops of the garrison attended by Lord Durham. The governor, Sir John Colborne, and all land and sea officers were in Québec for the occasion. After the review, the troops marched down the streets of the gaily lit town, and there were superb fireworks on the Cape. Québec had never

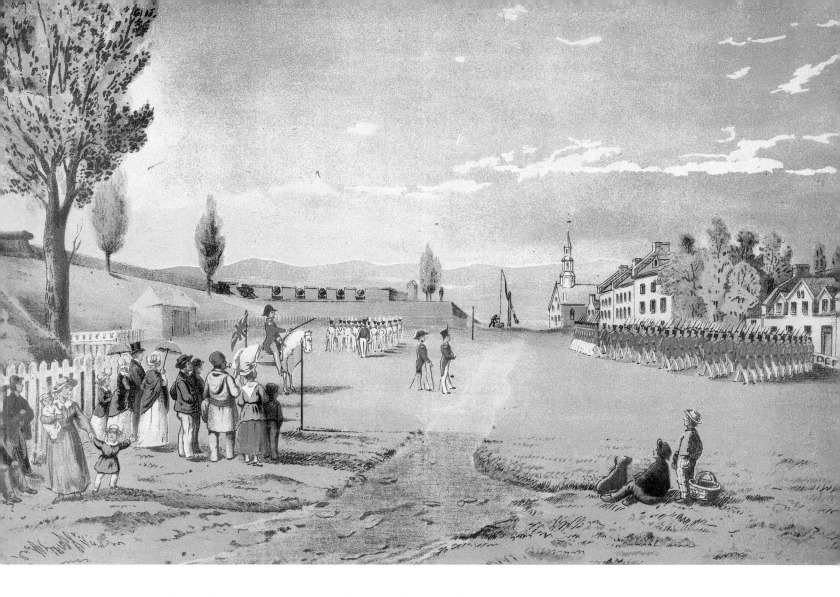

seen such a spectacle. According to a chronicler of the time, it was truly
a royal celebration. In these years of political turbulence, such
manifestations of power greatly impressed and pacified the population.

Throughout the nineteenth century, there was at least one military
review and parade each year attended by a high-ranking officer or even
by the governor general, who came with a large retinue according to an
impressive decorum and a rigorous protocol. The event was even more
exciting when a member of the royal family reviewed the troops, as
happened when Prince William, later King William IV, visited in 1787,
the Prince of Wales in 1860, and Princess Louise and Prince Leopold in
1880. The military also took part in a number of civil and religious
festivals. The arrival or departure of a governor provided another
opportunity for the military to make its presence known. The people of
Québec, most of whom did not have the financial means to pay for their
entertainment, usually turned out in great numbers for these free shows.

Such demonstrations of order, authority, and political power
helped maintain the social peace. The omnipresence of the military
surprised visitors, giving them the impression that the army was always
on alert. It also provided an opportunity to test the loyalty of French-
Canadian leaders. Some did not hesitate to declare their allegiance loudly
and proudly, but other attachments were also expressed.

Curious onlookers loved the military parades and
reviews. (R.A. Sproule, 1832, NAC)

147

Duelling Nationalisms: Festive Rivalries

When the Monument des Braves was unveiled, a few discordant voices were heard: one onlooker made fun of a fumble when the flag was raised; a journalist took pleasure in reporting that several dignitaries lost their footing; Louis-Joseph Papineau let the public know exactly why he did not attend. In 1880, another opportunity arose to express affiliation. A celebration was being prepared in Québec for the French-Canadian *Fête nationale.* It was to be as spectacular as the one held in Montréal six years earlier, which had attracted representatives from most Franco-American communities.

A journalist from *L'Opinion publique* explained the meaning of these festivities:

> The experience of nations proves the value of these sorts of demonstrations. . . . National faith, like religious faith, is tempered and fortified through external manifestations. Both, by grabbing attention and capturing the imagination, engrave a lasting impression in people's souls. They nourish and strengthen, they keep feelings from fading. They revive the self-confidence of a people.

These festivals were organized with greatest civility, with dignitaries leading the way. At the time, religion and nation were one for French Canadians. Thus, the national festival would also be a Catholic congress extending over two days. However, the English had not forgotten the famous adage from the days of chivalry: "Strike first."

One month to the day before the Saint-Jean festivities, the English organized a Field Day in honour of the queen's birthday. On May 24, 1880, the Plains of Abraham were host to an immense military review which attracted about twenty thousand spectators, according to the newspaper *Le Canadien:* "There were crowds everywhere that good points of view could satisfy the curiosity of onlookers. The roofs of houses on Chemin Saint-Louis were covered with hundreds of people." Queen Victoria's younger son, Prince Leopold, and Princess Louise attended the ceremonies.

A number of militia battalions came to Québec to participate in the event. On the morning of May 24, there were about three thousand militiamen on the Plains. According to one observer, "the volunteers looked very martial. The men were taller than average, their bearing perfect, their uniforms and equipment clean and in good order." The festivities began at eleven o'clock with a parade, followed by a bonfire in honour of Her Majesty. In the afternoon, the troops, divided into two corps, conducted a simulated battle on the Plains. An attacking army of twelve hundred men took up positions in dips in the terrain at the edge of the Plains, while the defensive army was installed in the trenches below the walls of the Citadel, with a few carabineers defending the towers. In the evening, a great banquet with two hundred guests rounded out the festivities.

The political meaning of this event did not escape the journalists. In *L'Opinion publique,* no mention at all was made of the great

gathering; insolently, the paper mentioned only the Saint-Jean festival the following month. On the other hand, *Le Canadien* provided a great deal of coverage, and the *Canadian Illustrated News* printed an etching illustrating the re-enactment of the military confrontation. The latter saw it as an opportunity for French Canadians to express their attachment to the English crown: "The mass of our population likes the Royalty because it represents stability, order, and liberty in the true sense of the word." The military review symbolized not only the British Empire, but English laws and institutions as well. And it stole a march on the great celebration planned for the following month—a celebration intended to spark the national pride of French Canadians.

The Festival of French Canadians of America

The grandest spectacle to take place on the Plains in the nineteenth century was, without doubt, the celebration of the *Fête nationale* organized by the Société Saint-Jean-Baptiste with "unaccustomed splendour," on June 24, 1880. Inspired by the programme of the first congress, held in Montréal in June of 1874, the organizers brought together for two days representatives of all French Canadians in North America, in order to "add to the excitement, the interest, and the usefulness" of this national festival. The essential goal was "to cement the union between French Canadians," in order to affirm their existence and preserve their nationality.

On the morning of June 24, the Archbishop of Québec, Monsignor Taschereau, celebrated a very solemn pontifical mass. On

The Field Day held on May 24, 1880, to celebrate the Queen's birthday, was intended to counterbalance the coming Saint-Jean-Baptiste festivities. It was an opportunity for large-scale military manoeuvres on the site of the Plains. (**Canadian Illustrated News**, May 24, 1880, NAC)

Octave Crémazie (1822–79). (AVQ)

the heights of Buttes-à-Nepveu, an estimated fifty thousand people participated in this "blessed national pilgrimage," a crowd larger than the entire Catholic population of the town of Québec, which was 46,444 at the time. The mass was sung by a six-hundred-voice chorus, accompanied by a number of bands conducted by the Basilica organist, Gustave Gagnon.

The Bishop of Sherbrooke, Monsignor Antoine Racine, pronounced a timely sermon that expressed the authorities' concern that so many French Canadians were emigrating to the United States. His superb eloquence brought tears to the eyes of the crowd; forgetting the holy nature of the ceremony, they applauded. After recalling the roots, intentions, and history of those who had created the country, the prelate spoke at length about the vocation that God had granted French Canadians: that of a Catholic, French, agricultural people. In fulfilling the faith of their forefathers, they would find nobility, strength, and salvation.

After the mass, forty-one divisions of representatives from various social groups, which had arrived on Buttes-à-Nepveu earlier that morning, moved into position for a huge parade. More than ten thousand people, most of them in costumes, marched in a pre-established order according to a rigorous protocol reflecting the social hierarchy. There was a procession of twenty imposing allegorical floats, representing scenes, historical characters, and trades, accompanied by numerous bands. Representatives from fifty Saint-Jean-Baptiste societies throughout Québec, Canada, and the United States marched alongside members of workers' associations, brandishing hundreds of banners, signs, streamers and multi-coloured flags. The parade made its way through the streets of the town onto Grande Allée and ended, four hours later, on Terrasse Frontenac. Before an enthusiastic crowd, orators gave patriotic and religious speeches. On that day, J.-J.-B. Chouinard, secretary of the national convention, recalled, "the battlefield of the Plains of Abraham shuddered under the feet of a people whose most pure blood it had swallowed one infamous day." For him, this "national procession" expressed "the peaceful forces of the French Canadian nation." By manifesting its strength and vitality, the Sociétés Saint-Jean-Baptiste took their revenge in the manner of their namesake: peacefully and serenely.

On the evening of June 24, the festival ended with a grand national banquet at the Skating Rink with the Governor General, the Marquis de Lorne, and his wife, Princess Louise, as guests of honour. The most prominent religious and political dignitaries were in attendance, and no fewer than eight hundred people paid $2.50 to "banquet" and listen to toasts that were speeches of ambivalent patriotic flavour in which national loyalties were juxtaposed without ever really blending.

The governor general made a speech in French which was intended to galvanize the "young Canadian nationalism." Delicately, he mentioned that English and French Canadians had a common ancestor,

the Normans, from whom the British Parliament had acquired and preserved the customs of liberty. Echoing the declared hope of French-Canadian religious and political leaders, he asked Franco-Americans to return to this country, where they would find "a perfect guarantee of their liberty and of all their citizenship rights." Then the governor general sketched a portrait of French Canadians designed to warm even the most tepid hearts. He spoke of a loyal people, a noble and valiant race, strong, devoted, dignified, and happy, and he repeated the guarantee of complete liberty with regard to French-Canadian institutions, language, and laws. In conclusion, he asked the French Canadians of Canada to use the strength bequeathed to them by their ancestors to "work in concert with the other races to consolidate and unify our great confederation, thus cementing a patriotism no less happy to take responsibility for than to share the glories of a country which is so important to the most powerful empire in the world." The British Empire offered liberty and safety—what more could one want?

The nationalistic duality emphasized in these two 1880 events, with their rivalling festivities and oratorial competition, degenerated into a war of words. What some reporters saw as shining and extraordinary, others were much more critical of: "Because of a lack of rehearsal among the volunteers, the military review was full of mistakes." The Saint-Jean festival did not attract as many representatives as hoped, and the speeches were nice, but flat and meaningless.

O Canada

*D*uring the national banquet celebrating Saint-Jean-Baptiste Day, held at the Québec Skating Rink in 1880, O Canada was sung for the first time in public. The words were written by Judge Alphonse-Basile Routhier, and the anthem was set to music by Calixa Lavallée at the request of Lieutenant Governor Théodore Robitaille. In 1980, the federal government made it Canada's official anthem. ❧

**LA SAISON DU JEU DE GOLF EST DEFINITIVEMENT COM-
MENCEE SUR LES COVE FIELDS**
(Le nombre des membres du club est presque doublé cette année)

A Playing Field

AS WELL AS BEING A VESSEL OF MEMORY and a venue for events, the Plains were a favoured spot for sports in the nineteenth century. Sport as we know it today is a very particular form of physical activity, which was invented by the English at the beginning of the seventeenth century. Both entertaining and competitive, it is practised with a view to winning a game according to written rules and a "sporting" spirit inspired by the notion of chivalry, and with the ultimate goal of determining which of the participants is the superior. This constant search for performance expresses the progress made not only by individuals but also by humanity. With its roots in the philosophy of the Enlightenment, this concept of excellence places its confidence in man, who is infinitely perfectible through his own efforts, channeled through a philosophy and discipline of life.

These physical activities, and the spirit of challenge and fair play that accompanies them, were introduced to Canada by the British soldiers of the Québec garrison. Horse races, foot races, cricket, boxing, athletics, and golf were all unknown in Canada at the end of the eighteenth century. The Plains of Abraham, near the Citadel, quickly became the favourite playing field for the military and for the English-speaking upper class of Québec.

Horse Races

As the first traditional physical activity to be transformed into a sport by British aristocrats, in the sixteenth century, horse racing was an integral part of the gentleman's way of life. Monarchs lent their patronage to this diversion, whence its name "the sport of kings." Thus, it was not surprising that in 1767, or perhaps in 1764, the military men of the Québec garrison had organized a horse race on the Heights of Abraham. The winner, Captain Prescott, mounted on a mare ironically named "Modesty," won the forty-dollar prize. Although it was an isolated event, it was nevertheless the first advertised horse race in Canada.

Twenty years later, horses were again galloping on the Plains. The Québec Turf Club was formed in 1789, but it did not hold regular races, for there were not enough competitors of even calibre. After a

A pair of late-nineteenth-century golfers. (**Le Soleil**, May 14 and June 2, 1900)

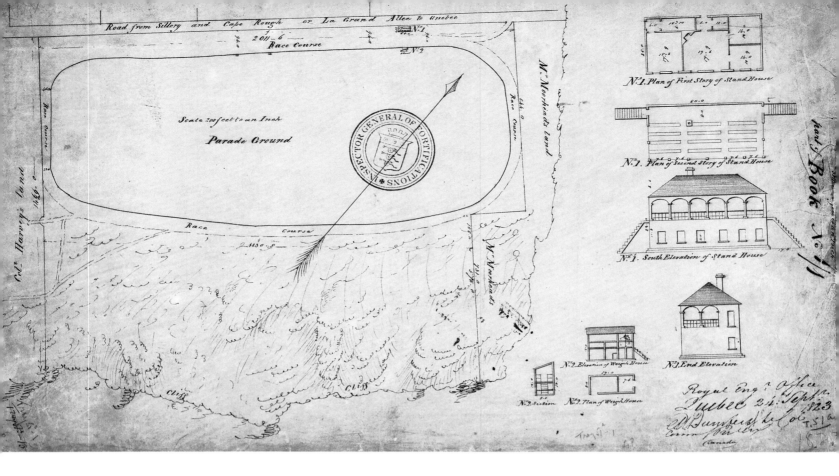

The Ursulines' land, at the western end of the current site of the Plains, was rented to the military on a hundred-year lease in 1808. It was used as a race course and parade ground. (1823 plan, NAC)

number of fruitless attempts between 1800 and 1807, a programme of races was presented at the beginning of July, 1808. Placed under the patronage of the governor, Sir James Craig, this competition was extraordinary not only because the dignitary graced it with his presence, but also because of the importance and the exceptional pomp the English accorded the occasion. Brightly coloured jockeys' caps had even been sent from England. The *Québec Gazette* estimated that a crowd of three to four thousand attended the meet, even though it was held on two weekdays, Monday and Tuesday: almost a quarter of the population of Québec and most of the two thousand soldiers of the garrison were there. It was said that never in the country had there been more people gathered in one place for this kind of entertainment.

Observers attributed the extraordinary turnout to "the novelty of races conducted in a style that surpasses anything we have seen in this country." They were not at all like the traditional horse races that French Canadians had been holding since the beginning of the seventeenth century. The English-style races were held in one precise spot, and according to an order rationally based on a measured performance. The competing horses were placed in categories according to objective criteria (age, performance, etc.), and they had to respect the rules established by an outside body and an intricate handicapping system. The goal was to make all of the competitors equal at the starting line, so that the victory would go to the fastest.

French Canadians were unfamiliar with such complex rules for racing and did not possess horses of the quality of the English thoroughbreds. In an attempt to mollify them, Governor Craig offered a purse of fifteen guineas for a race of three times two miles. In contrast to English sporting values, this race was open "to all horses and mares bred in the country, of any age or size, as long as the horse is in good faith the property of a Canadian farmer." However, very few French

Canadians took part, since these were mounted races, in the purest British tradition, and not harness races; Québec farmers preferred driving to riding.

In the summer of 1808, four days of horse racing were held on the Plains of Abraham. The following years were not as opulent, but up to 1830 the Québec Turf Club organized at least one day of races per year, encouraging French Canadians, without great success, to take part in them. This attitude was not shared by all Anglophones. The *Québec Mercury* felt that the governor and the directors of the Québec Turf Club were very mistaken to encourage French Canadians to participate in the races, for this would encourage their natural laziness and keep them from their work. For his part, Governor Craig wanted to make peace with the French Canadians and engage them in "taking care of their horses and improving the race, both for riding and for work." This initiative, the first in Canada, also flowed from the imperial politics of England, which had a great need of horses for maintaining order and conducting wars in the Empire.

In 1829, the Québec Turf Club created, for French Canadians, the Jean-Baptiste Plate, with a purse of twenty *piastres*, a sum about equal to the monthly salary of a labourer. The horses of British gentlemen raced for purses two, three, or even five times higher; however, the English had to pay an entrance fee of ten dollars, from which French Canadians were exempt.

The race course on the Plains became the Epsom of Québec, as Tolfrey called it. Americans and English Canadians from Upper Canada and the Montréal region came to race their horses, and racing fans came in droves. In 1829, for example, about a thousand Montrealers, most of them middle and upper class, embarked on the steamboats *Hercules, Lady of the Lake, John Molson,* and *Waterloo* for the trip to Québec to see the races on the Plains.

The Jean-Baptiste Plate was short-lived, disappearing in 1830. The turbulent political times were mostly to blame. French Canadians were going through a particularly agitated time in their history: the revolutionary troubles. With Louis-Joseph Papineau at their head, French-Canadian nationalists made a radical critique of the English administration, and tensions between the two groups grew to the point that it was impossible to organize sporting events on the Plains. Violent confrontations between Redcoats and French Canadians multiplied, in both Québec and Montréal, feeding into existing strong feelings of mutual distrust. The slightest manifestations of British culture were railed against, and sport did not escape public vindictiveness. A reporter in the newspaper *Le Canadien* denounced these annual diversions as alien to French-Canadian customs. He accused the English of valuing their race horses, and even their dogs, more highly than all the institutions and all the men in the country. In such an explosive political context, the Québec Turf Club stopped holding races on the Plains.

In 1837, when the Patriotes rebellions were at their height, the new governor general, Lord Durham, who had many other preoccupations,

Soldiers' Pastimes

Although the military took an active part in organized sports, they also created, in the 1830s, athletic games for the garrison alone. These field days, which took place on the Plains, included physical, sporting, military, and folkloric activities, including a tug of war and a "smoking race," which consisted of running with a pipe, a tobacco pouch, and matches—the first to arrive with a lit pipe won the prize. ✑

organized horse races at Québec. When he arrived, Durham had noted a strong incompatibility of national aspirations between French and English Canadians, which was expressed throughout colonial society, including the horse races. In spite of his desire to endow Lower Canada with an entirely British character, he offered a purse of fifty pounds for a race between French-Canadian horses, belonging to and ridden by French- Canadian settlers, and another for a race in which the horses were the property of English subjects. This was an acknowledgment of the socio-ethnic cleavage.

After the double defeat of the Patriotes, there was a change in attitude among French Canadians, and the calls for revolt gave way to compromise and mimicry. They agreed to compete against the English, hoping to beat them at their own games. In 1842, the mayor of Québec, E.R. Caron, even became one of the directors of the Québec Turf Club. However, French-Canadian nationalism was not yet extinguished. A horse called La Belle Canadienne, belonging to M. Laframboise of Saint-Hyacinthe, won the Queen's Plate, the most important race in Lower Canada, which was held on the Plains in 1857. *Le Canadien* asked whether "the beast was of an inferior race," referring to an insulting remark made by the governor, Sir Edmund Head, a few years earlier, that the English "race" was superior to French Canadians.

After Confederation, in 1867, relations between French and English Canadians improved, and this extended to the horse races and other forms of recreation. According to Hubert La Rue, the socio-political climate was "all rosy." By the end of the century, a third of the directors of the Québec Turf Club were French Canadians. Given that only 15.7 per cent of the population of Québec was English-speaking at the time, this illustrates the extent to which the sport of horse racing remained the preserve of the English.

The horse races also provoked moral problems and created other social cleavages. For each show, thousands of people were drawn to the Plains from the pubs. With alcohol in their veins, "the rowdies are given to bloody fights and causing numerous disruptions that are more likely to demoralize the people than to let them enjoy innocent recreation." The moment the police left the Plains, the brawlers, regular customers at the pubs, immediately turned back to drink, then to fisticuffs which, at their worst, injured even innocent bystanders. At this point, garrison soldiers had to be called upon to disperse the rowdies, not without taking their share of blows and punches. In the tumult, the soldiers often suffered reprisals from French Canadians who were attending the races. Witnesses claimed that "brutes in red coats" had made murderous assaults on tranquil spectators.

These disruptions gave rise to protests by certain Québecers, notably residents on Chemin Saint-Louis, close to the race course. In 1854, thirty-nine people, including three Francophones, petitioned the municipal council for the Plains to be transformed into a site for recreation and relaxation, where respectable families could benefit from the pure air and the view of the St. Lawrence. The petitioners

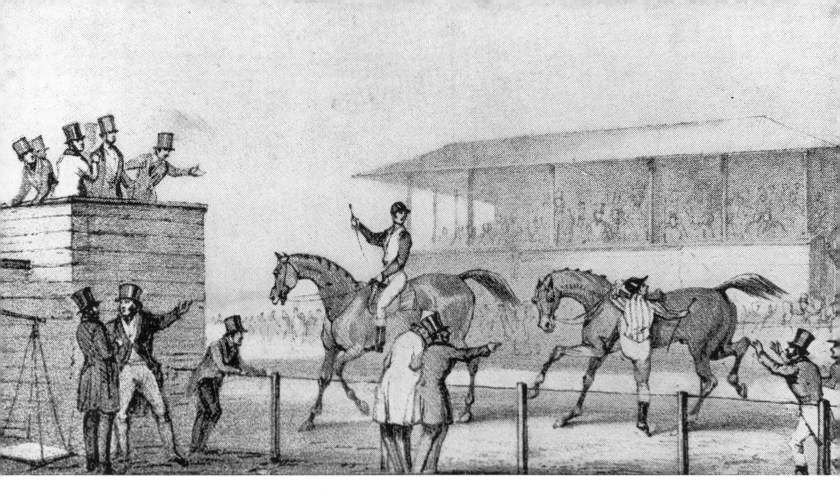

respectfully suggested that the race course be moved to relieve the citizens of the great inconvenience it engendered. The idea of making the Plains into a park became reality fifty years later.

The episodes of disorder and violence were not attributable to the horse races alone. The years between 1830 and 1860 were times of great upheavals—some of them mortal—for both Québecers and Montrealers. Terrible epidemics of typhus (1847–48) and cholera (1832, 1834, 1849, 1851, 1852, 1854), and a series of fires (1836, 1840, 1845, 1846, 1849, 1861) ravaged hundreds—thousands—of households. Fights erupted among the soldiers of the garrison, and between them and the townspeople. Workers' strikes turned violent, and rabble-rousers continued to cause disruptions of all sorts. Urbanization was no stranger to deterioration in living conditions, both sanitary, moral, and social.

All of these disruptions made a frank mockery of Christian morals. The Catholic clergy, though given to quick condemnation, did not attack the sport of kings directly. It was only in 1859, once social and police control were consolidated, that Monsignor Bourget, in a clerical circular, fulminated "against the Opera, the theatre, the circus, and other profane entertainments," which were, in both town and country, "a true subject of scandal." The bishop did not dare to denounce the horse races directly. Placed under the high patronage of the king of England and presided over by the governor general, whose duty and pleasure it was to attend them, the races on the Plains had gained a well-established respectability through attendance by upper- and middle-class English Protestants. The sport belonged to the top echelon of the social hierarchy and the political power associated with it.

The élites observed that it was people of the "lower classes" who caused the disturbances during the horse races on the Plains. Although they recognized that these people needed entertainment, they did not

Race horses on the Plains in the nineteenth century.

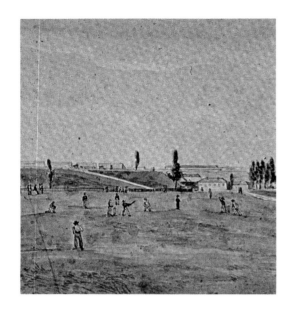

really want them to attend races designed and organized for and by the Québec upper crust and the officers of the garrison. According to *Le Canadien*, the presence of lower-class people kept self-respecting people away. To counter the annoying presence of the "industrial population," the upper-class Québec Turf Club took a radical measure. In 1847, it moved the race course to Ancienne-Lorette, onto land owned by M. Hough, hoping that the distance would suffice to keep labourers away. *Le Canadien*, no longer the revolutionary liberal newspaper of the 1830s, rejoiced in this initiative and hoped "that we will see at the races only the small number of people who can take part in this recreation without harming their families, their fortunes, or their duties."

In short, the upper classes felt a social responsibility to set a proper tone and a good example. They felt that if labourers skipped work to go to the races, the country would suffer irreparable loss. In their opinion, the horse races should be reserved for "rich people." Only those with "the taste, the leisure, and the money" could and should breed race horses for their pleasure and preserve fine equine bloodlines in the country. However, the Ancienne-Lorette race course, small and far from the town and the garrison, was not a success. In 1851, the Québec Turf Club decided to return to the Plains, where it continued to raise interest among large numbers of the "lower classes."

Entrepreneurs quickly realized the potential of horse races as a popular entertainment. At the beginning of the 1860s, Peter Morris constructed a hippodrome near the St. Charles River, ending the monopoly held by the Québec Turf Club for sixteen years. The race cards at the St. Charles hippodrome were much more varied than those offered on the Plains, where there were only mounted races for gentlemen's horses. Most French-Canadian owners entered their horses in the harness races. Men had to pay fifty cents to get in; ladies, who gave the event respectability, got in for free. Bookmakers took wagers and the owner of the hippodrome sold pools, both commercial practices frowned upon by the gentlemen of the Québec Turf Club.

Because of their preference for trotting races, French Canadians were steady customers at the St. Charles hippodrome. Trotting races, American in origin, were more democratic and related to the traditional races known and practised since the seventeenth century. Given their popularity, entrepreneurs built many more hippodromes; in 1900, the Québec region had four, and the sport was well organized. As for the Québec Turf Club, the departure of the garrison, in 1871, and the declining British population deprived it of its main clientele. The maintenance of entrance requirements for the club and the racing rules did not respond well to the new expectations of mass culture. A riding school opened in 1872 to perpetuate the ideal of a select club, but it had a troubled, episodic existence until 1887.

Cricket party on the Esplanade (J.P. Cockburn, 1829, ROM)

Cricket and Lacrosse

Cricket, the English national sport, was the first team sport practised in Canada. In Québec, the first matches took place in the 1830s, played on the Plains by garrison soldiers. The game required eleven players of similar calibre, which often made it difficult to put together truly competitive teams; on top of this, the mobility of the military men limited the opportunities to play. Occasionally, the members of the garrison challenged sailors on English military ships passing through Québec to a match. French Canadians were indifferent to the game, and never played it in significant numbers—that is, in sufficient numbers to form clubs. In fact, cricket was one of the few sports from the British Isles that was not a successful export. Even English Canadians preferred to play lacrosse, an aboriginal game, by the second half of the nineteenth century.

Although they did not introduce lacrosse to Canada, the British transformed it into an organized sport in the 1850s. Doctor George Beers wrote the first rules in 1859, and at the beginning of the 1860s a number of clubs were organized (Thistle, Stadacona, Crescent, Shamrock, St. Lawrence). The first French-Canadian lacrosse club, Champlain, was organized in Québec in 1868 and adopted a very sporting motto: *Celer et Audax* (Rapid and Brave). It practised on a lot on Grande Allée beside the Skating Rink and challenged the best English-speaking teams, winning a number of matches.

Most of these clubs played their first matches on the Plains, where English, Irish, and French Canadians tested their skills against each other. In these confederative times, both sides avoided making a point of "the national fibre"; although the sporting rivalry was great, there was a civility that left no doubt about the feelings of "harmony and friendship" between the players, who were aged between seventeen and twenty. After the games, the sociability continued through a good meal at Fréchette's restaurant on Côte de la Montagne or the Imperial Hotel.

The lacrosse players also organized athletics competitions (racing, jumping, throwing) on the Plains, inviting sports fans to join them. These days ended with a banquet and the awarding of prizes to the winners at the Skating Rink, always before a large crowd.

However, it seems that lacrosse matches took place on the Plains only if the Esplanade, a busy street, was not free. The space on the Plains did not lend itself to making the show a profitable one: because it was open on all sides, the organizers could not charge admission. In 1878, Anglophone lacrosse clubs acquired their own land on Chemin Saint-Louis, which were financed through charging spectators twenty-five to thirty-five cents a match. As was the custom at the time, ladies were admitted free, since they added respectability and sociability to the occasion.

An Aboriginal Practice

In the seventeenth century, when the French settled in Canada, the aboriginals had a practice that the Jesuits called "the game of the cross." It was a religious practice used to cure disease, influence the weather, or remember a great chief who had died. In the mid-nineteenth century, Anglophones began to practise this physical activity for pleasure. They made a sport of it, with precise rules; it became so popular that, by the 1860s, they considered it their national sport. ❧

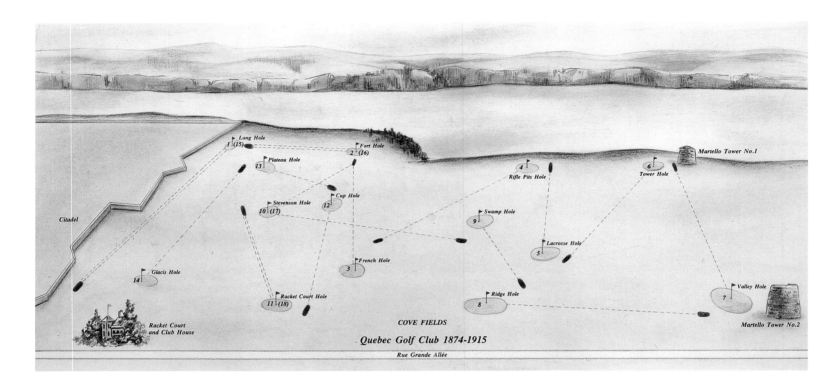

The golf course on the Plains between 1874 and 1914. (NBC)

Golf

Although the British, especially the Scottish (for whom it was a national sport), had been playing golf since the fifteenth century, it was some time before the sport was introduced to Canada. The Royal Montréal Golf Club, the first club in North America, was opened in 1873, a hundred years after the first Scottish club, St. Andrews. The following year, Anglophones formed the Québec Golf Club. Because the course, at a place called Cove Fields on the Plains of Abraham, had only fourteen holes, golfers had to play four extra holes to complete their game. At first, farmers' cows kept the grass short, although they also left their particular mark on the greens. By the 1880s, a mechanical mower, drawn by a horse, performed this indispensable task.

Starting in 1877, the members of the Québec Golf Club organized an annual tournament with the members of the Montréal club. In the 1880s, golfers came from all over Canada and even the United States to play the course on the Plains. Connoisseurs also appreciated the great historic interest of the site, its incomparable beauty, and the exceptional view on the river and Île d'Orléans. The members of the Québec club upheld their reputation for being very good golfers by winning the Interprovincial Cup in 1882, 1887, 1892, 1894, and 1896.

Who were these golf aficionados? In 1899, when the club celebrated its twenty-fifth anniversary, it had fewer than a hundred members. Among the forty-one identified, there were eighteen ladies, among them two French Canadians, the Misses Casault, and twenty-three men, including six French Canadians, among them George

Garneau, mayor of Québec from 1906 to 1910 and first president of the National Battlefields Commission. The members of the Québec Golf Club played on the Plains until 1915, although it was converted into a park in 1908.

Ice Hockey

The first publicized ice-hockey matches were played in Montréal during the winter of 1875. There is no evidence of the game being played in Québec before 1878, the year the Québec Hockey Club was founded. In fact, when the Québec Skating Rink was built, in 1877, in front of the current site of the National Assembly, on the north side of Grande Allée, ice hockey was not a consideration; there were neither boards nor permanent seats for spectators. Although several dozen young men practised the new game there, there were not enough of them to put together several teams of similar calibre, especially since hockey was played with between seven and nine players per side. To find a suitable adversary, challenges had to be launched to clubs in Montréal. However, there was another obstacle: the rules were different from one town to another; it was not until the beginning of the 1880s that there were hockey games between teams from the two largest towns in Québec, using the Montréal rules. The Québec Hockey Club beat the Montréal Hockey Club and the Victoria Hockey Club, two of Montreal's strongest teams, fanning the rivalry between the two towns.

In 1889, three years after it was first invited, the Québec team joined the Amateur Hockey Association of Canada. It played four or five

Golfers on the Plains in 1909. (NBC)

The Royal Club of Québec's John Hamilton Golf Trophy, made in 1898.

161

The Ladies Golf Club

In 1892, "Ladies Golf Clubs" were organized in Montréal and Québec. Lady golfers played wearing heavy ankle-length skirts. Although it impeded their performance, this attire met the requirements of Victorian morality and elegant good taste.

Like the men golfers, the women of Québec met their counterparts from the Montréal club, though the rule of sexual separation was rigorously respected, as sporting tradition and custom dictated. As well as physical activity, golf was a cultural practice that promoted sociability beyond the greens. The club members all knew each other, and men's games usually ended with a good meal at a member's home, or at the restaurant of the Garrison Club, while the women met at a friend's house to drink tea. ✍

games during the winter season against the Montréal clubs (M.A.A.A., Victoria, McGill, Crystal) and the one in Ottawa, and also hosted teams from Dartmouth and Halifax. Four years later, the Association adopted an eight-game schedule, starting on January 6 and ending on March 7. The cost of joining the Association was ten dollars.

These amateur players played for the pleasure of it. Although they were determined to win, and fought ferociously for the championship, they were gentlemen first. However, the rivalries continued off the ice. For example, at the annual meeting of the Association in 1893, Québec and Montréal representatives clashed over the issue of the presidency. The Québecers wanted one of their own finally to hold the position, but the Montrealers argued that their city was at the centre of Canada and that the game of ice hockey had been born there. As they were in the majority, they elected their candidate, and the Québec Hockey Club's candidate had to be satisfied with the vice-presidency.

Spectators also got involved in the game. When tempers flared in the stands, the fans tried to intimidate the referee by threats "to the point of keeping him from fulfilling his duties as referee effectively." Repeated complaints by referees Lang, Hamilton, and Young led the A.H.A.C. to suspend the Québec Hockey Club in 1895, to the great displeasure of the players, who had done nothing, or little, to deserve this. At the end of the century, in Québec and elsewhere, hockey was invaded by violence. Among the players and the fans whose team aspired to top rank, partisan spirit was at a fever pitch. Any means was fair to avoid defeat: hitting with the stick, tripping, brutal tactics, fisticuffs, and so on. Some players did not hesitate to use their hockey sticks "like a butcher would use an axe." There were injuries during every game. Finally, the Montréal Hockey Club threatened not to play in Québec any more unless the players and spectators stopped hitting and intimidating its players. The directors of the Québec Hockey Club cried foul and managed to avoid a second expulsion from the Association. These frictions only made relations between the Montréal teams and the Québec team more venomous. They raised the ire of sports reporters and the enthusiasm of the fans, who went in great numbers, more than two thousand spectators per game, to the Grande Allée rink. The violence, the source of a fairly bad reputation in sporting circles, lasted only a few years. Heeding the warnings of sports commentators, who counselled that success on the ice required better discipline, the Québec players paid attention to the rules. The ultimate goal was reached ten years later: in 1911–12 and 1912–13, the Québec club won the Stanley Cup in the Skating Rink on the Plains.

The Skating Rink was not reserved for the use of senior hockey players. Université Laval students and teams from the intermediate and junior leagues played their games there too, facing teams from Montréal, Ottawa, Sherbrooke, Trois-Rivières, Lévis, and sometimes the Maritimes and New England.

The directors of the Québec Hockey Club made an important contribution to the game. In 1899, they suggested putting a net behind

the goal posts in order to avoid interminable discussions on the validity of goals. Other sports later adopted this innovation.

By the beginning of the twentieth century, hockey, like other sports introduced to Québec by the British, had become so much a part of French-Canadian leisure that it was considered Québec's national game. Québecers encouraged young men who wanted play, seeing the game as the best way to keep them from the evils that led them astray.

The Stanley Cup

The emblem of hockey supremacy in North America has a direct connection with the Plains of Abraham. In 1893, at the annual general meeting of the Amateur Hockey Association of Canada, the governor general, Lord Stanley, officially submitted to the league directors a plan to create a cup to award to the winning team at the end of each season. This meeting took place in the new Québec Skating Rink building erected on the Plains in 1889, where the Québec Hockey Club played its games. ℅

Recreation and Relaxation on the Plains

I N THE NINETEENTH CENTURY, ICE SKATING was the most popular recreational activity among residents of upper-town Québec City, followed by tobogganing and snowshoeing. During the summer, strollers frequented the Plains, a favoured spot for romantic interludes. And children always went there to play, summer and winter.

Snowshoeing and Tobogganing

With lacrosse and canoeing, snowshoeing and tobogganing were the most visible European borrowings from aboriginal peoples. The aboriginals and French Canadians used snowshoes and toboggans for practical purposes; the British used them for leisure and sport. At the beginning of the nineteenth century, the Anglophone upper class of the town of Québec and the garrison military men, especially the officers, liked to snowshoe on the Plains, in pairs or small groups.

In 1845, the Anglophones founded the Québec Snowshoe Club to organize snowshoeing outings and races. This activity was so popular that the editor of *Le Canadien* suggested, in 1854, that it be made "a national Canadian pastime." Snowshoeing parties organized on the Plains usually ended with a hearty meal, well washed down, in a local restaurant. The Québec clubs sometimes hosted groups from clubs in Montréal and even Ottawa. In 1885, the snowshoers from the Frontenac Club, in Ottawa, joined Québec City snowshoers to pay their respects to Lieutenant Governor L.-F.-Rodrigue Masson at Spencer Wood. The reception was magnificent and the speeches vaunted the benefits of snowshoeing. Lieutenant Governor Masson recalled that the country had been opened by the axe and the snowshoe, then suggested that the latter become part of the national arms. This physical exercise, he said, looks like child's play, but it makes men. In the act of snowshoeing, man must master work, must struggle, and, when the time comes, he will do honour to his quality as a man and a patriot. Thus, snowshoeing serves not only sociability, but the country.

With some of the slopes at a 70 per cent pitch, the Plains and the glacis of the Citadel were the site of another very popular nineteenth-century recreational activity: tobogganing. Québec "highlifes" went sliding on ash-wood sleds three metres long that easily held three people.

The Hare and the Snowshoes

T here were sometimes small inconveniences involved in recreational snowshoeing on the Plains at the end of the nineteenth century. Since there were no washrooms, precautions had to be taken before going out. A certain Lieutenant-Colonel B__ had first-hand experience of this: during an outing with a group of friends of both sexes, he suddenly found himself overtaken by a too-rapid digestion. He pretended to chase after a hare to escape to a discreet thicket. Unfortunately, when he returned, the ladies noticed that he had brought some traces of his "hare" on one of his snowshoes, and this provoked general hilarity. ☙

The Plains of Abraham in winter. (D. Gale, 1860, NAC)

There were various sliding techniques, but the sitting position was the favourite. The most talented sliders descended the slopes standing on the back of the toboggan, keeping their balance with the help of ropes that enabled them to guide the toboggan as one would a horse. The frequent swerves added to the fun, since they allowed the physical proximity that was usually not acceptable in "good society," for etiquette demanded that everyone keep his or her distance. The Catholic clergy fulminated against this physical closeness, which created opportunities for intimacy.

At the end of the century, a man named Fitzgerald had a public slide constructed on the flank of the Citadel glacis. Tobogganing thus extended beyond the closed circles of the bourgeoisie to the new middle class composed of merchants, small storeowners, and store and bank clerks, who could afford such entertainment. The inevitable democratization of this form of diversion did not, however keep the governor general and his wife from sharing the pleasure of a rapid descent on a toboggan. Children also went to slide on the Citadel glacis or on the ridges of the Plains. In general, though, they preferred to slide on the streets of the town, even if they risked a fine of five dollars or, worse, a fifteen-day stay in prison.

The Skaters' Pavilion in Québec City around 1890.
(Photo: J.-E. Livernois, NAC)

Tobogganing on the Plains in 1869. (Horatio Walker, NAC)

166

Skating

It is known that skates were present in New France as of 1669. Father Charlevoix, who visited Québec in 1720, reported that skating was one of the ways French Canadians entertained themselves. The intendants tried, unsuccessfully, to dissuade children from skating in the streets of Québec. Young boys in particular were taken with this activity, and it was a novel way to get around when the ice conditions on the rivers, lakes, and the St. Lawrence permitted. In the mid-nineteenth century, English Canadians used it as a high-society entertainment. Because the often rigorous Québec winters made skating a risky activity, they designed and built places where they could skate in shelter, with a degree of comfort that expressed their station in and way of life. In the 1850s, a warehouse on the Quai de la Reine became a covered rink: at the beginning of winter, the floor was flooded with a foot of water, which froze into a thick sheet of ice. This covered rink was probably one of the first, if not the first, in North America. At the beginning of the 1860s, the Québec Skating Club set up a covered rink at the corner of Rue Saint-Eustache and Grande Allée, opposite where the National Assembly is today. Members could skate there every evening from eight o'clock to ten o'clock to music provided by a military band from the garrison.

Experts provided advice intended to "reduce the pernicious effects of skating." For instance, the laces should not squeeze the foot in such a way as to impede circulation of the blood, exposing the feet to freezing without the skater noticing. When it was very cold, the ladies were to wear a veil over their faces "to avoid an inflammation of the lungs." When the temperature dropped to 30 degrees below zero, ladies were not allowed to skate; it was believed that men's constitutions were more resistant to cold. Finally, both men and women skaters were exhorted to skate with grace, rather than with speed.

An Artistic Skater in 1864

In 1864, American Jackson Haines, the greatest "artistic" skater in the world, visited the Québec Skating Rink as part of his Canadian tour. Before an enraptured audience of Québecers, Haines performed "stunning leaps" and extraordinary "tours de force." He had started as a ballet dancer, and he never conformed to the classic figures; he performed dance, and not sport. Québec skaters greatly admired Haines, and they enthusiastically attempted to imitate him. After his marvellous performances, skaters exhibited their expertise, gliding on "the ice with admirable talent and elegance." The authorities encouraged skating, which they saw as good, healthy exercise, and an agreeable, innocent pastime. ✌

A masquerade at the Skaters' Pavilion at the end of the nineteenth century. (ANQ)

Executions on the Plains

Between 1763 and 1810, some ten executions took place on the Plains, before large crowds. They were carried out by hanging on the Buttes-à-Nepveu or, in the case of deserting soldiers, by firing squad near the fortifications. The crimes of murder and sacrilegious robbery garnered this terrible sentence. Often, the criminals addressed the crowd before suffering the punishment society had imposed upon them. They asked for pardon and told young people not to follow their example.

The spectacle was sometimes macabre. On July 7, 1797, David McLane, found guilty of high treason, was sentenced to "be hanged by the neck, but not until death. You must still be alive, while your entrails are cut out and burned before your eyes; then your head will be separated from your body, which will have been quartered; and your head and limbs will be at the disposition of the King." There was also the case of the "Negro," Alexander Webb, who, on 15 June 1784, obtained a pardon at the very foot of the gallows. It is no great surprise that, one day, the executioner was found hanged in the prison. ❧

The opening of the skating season was a festive occasion attended by the high dignitaries of the town. For a subscription of a few dollars, or for ten cents per visit, people could spend their evenings skating to a musical programme which was published in the newspapers. Promenades, cotillions, military marches, quadrilles, waltzes, and reels succeeded each other in a predetermined order, and the two final tunes of the evening were always the nationalist *Vive la Canadienne* and the Loyalist *God Save the Queen*.

The Québec Skating Club also organized skating races each year under the patronage of a notable such as the governor general. On the Mardi Gras holiday there was a masquerade, or "masked ball." Hundreds of women, men, and children scoured their imagination to come up with colourful costumes, and original shows were presented, such as card games played on ice with living cards. In 1894, the programme of the Québec *Carnaval* listed a number of activities at the Québec Skating Club's Rink, including the "Grand Curling Bonspiel," the "Grand Fancy Dress Masquerade," the "Fancy Skating Contest for the Championship of Canada," and the "Grand Hockey Tournament."

Promenades and Get-Togethers

For the citizens of the town and the garrison soldiers, the Plains were also a place for promenades and get-togethers. In the mid-nineteenth century, residents of Grande Allée began to request that the Plains be reserved for walking and relaxation, so that people could enjoy the pure air and exceptional lookout points. The municipal authorities were convinced that this would "greatly contribute to the health and morality of the citizens and the garrison." Québecers had to wait half a century, however, before this dream came true.

From the Heights of Québec, strollers and the curious watched the launching of the **Royal William**, in 1831. It was the first ship designed to sail across the Atlantic powered exclusively by steam. (J.P. Cockburn, NAC)

Strolls on the Heights of Québec. (Francis G. Coleridge, NAC)

A walk on the Plains. (J.P. Cockburn, 1830, NAC)

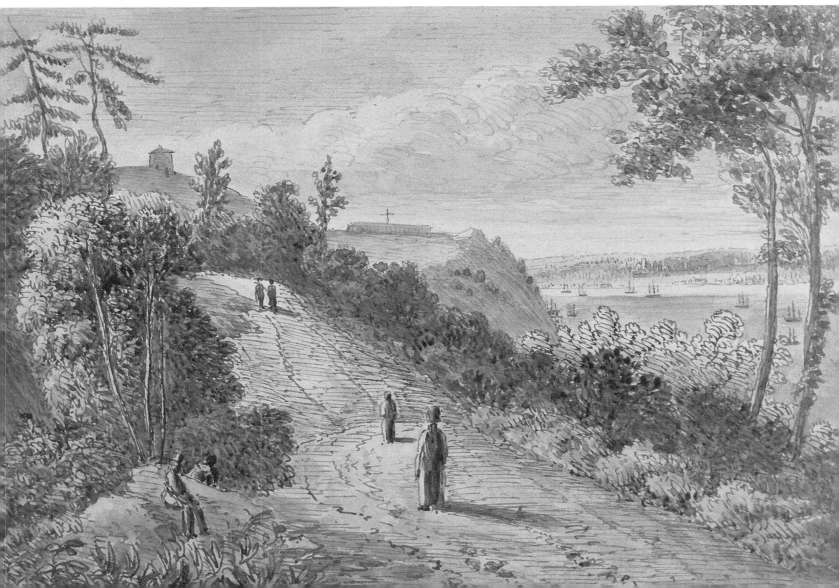

"La Corriveau"

The story of Marie-Josephte Corriveau is legendary in Québec. She was accused of the murder of her second husband, Louis-Étienne Dodier, of Saint-Vallier de Bellechasse, who was found dead on January 27, 1763, apparently trampled by his horses. However, his fights with his father-in-law were well known. At a first trial, Corriveau's father was condemned to death and she to a public flogging. But, since he had not testified, a second trial was required. This time, Marie-Josephte pleaded guilty, absolving her father: she had wanted only to avenge herself for the bad treatment inflicted upon her by her husband. The Crown pronounced that the sentence held and ordered the execution. She was hanged three days later, on April 18, 1763, on the Buttes-à-Nepveu.

Corriveau's hanging, like those of the most notorious criminals in England, took place "in a cage." This dismal apparatus shackled the person in an iron yoke in the shape of a human body. The gallows was constructed in plain view, and the body was left so that the remains would inspire a healthy terror in passersby. The cage probably remained on the Plains only a short time. Then she was taken to Pointe Lévy, to a crossroads where all travellers passed on their way from Côte-du-Sud or Québec. She stayed there for forty days, but she fed imaginations for two centuries.

When Governor Murray permitted the burial of Corriveau, on May 25, 1763, he uncovered another motive for the severity of the sentence: "Peace has been made [between England and France] and since the country belongs to his British Majesty, His Excellency, to encourage the settlers to do their duty, is trying to impress them with the benevolence and kindness of the Government." ‹›

Courtly encounters on the Plains. (**Canadian Illustrated News**, June 5, 1880, NAC)

Although the Plains were not public property—until 1908, some lots were privately owned and others, belonging to the federal government, were rented out—Québecers went there to stretch their legs and observe the ships on the St. Lawrence or activities in the shipyards at the bottom of the cliff. The Plains and the terrace were a favourite spot to watch the launching of ships, such as that, in 1831, of the fifty-metre *Royal William*, belonging to the Cunard brothers, the first ship built in Canada to cross the Atlantic powered exclusively by steam. Each launching was like a party, with a great number of ladies and gentlemen dressed in their best finery gathering to watch.

Children were interested in different pastimes, including "prisoner's base," a very popular game in the first half of the nineteenth century, as the mayor of Québec in 1856, Olivier Robitaille, mentioned in his *Mémoires*. In the winter, they skated on the ice of a small pond, near Colonel Ferguson's property.

On holidays and Sundays, girls from the town went out to the Plains, near the Citadel, to meet soldiers. The uniforms, especially those

of the officers, were very seductive. But gallantry did not always attend these trysts. In 1806, the Ursulines announced in the *Québec Gazette* that they intended to prosecute vigorously in the courts delinquents who had damaged their property. In 1833, the residents complained to the governor general, "People given to drunkenness and women of poor repute find refuge on this land, carrying on the most unrestrained debauchery, and every night they make a noise so terrible that it is alarming." Hôtel Wolfe, at the entrance to the Plains, was known to be a bawdy house in 1867. In Québec, as in other cities, the urban park served as a refuge for marginal people who were more or less well tolerated. They did not keep most of the population, however, from finding pleasurable relaxation there.

* * *

If the Plains of Abraham played a decisive role in the history of Canada on the military level, they also had a profound and long-lasting influence on French-Canadian life. Sports and entertainments introduced to the country by the British, first played on the Plains, profoundly penetrated French-Canadian culture, first through the bourgeoisie who lived beside the Anglophones in the town of Québec, with whom they shared certain class values, then through the middle classes that emerged at the end of the nineteenth century.

It is fascinating to trace the evolution of the diversions that the Plains of Abraham were host to in the nineteenth century. They show how mentalities changed and different and changing ideals were promulgated. From a leisure activity, certain diversions were turned into sport, expressing the ideal of a disciplined life, beyond the search for pleasure and spectacle. At first reserved for a social élite, the Plains became open to mass culture and American influences in the twentieth century. But throughout time, and throughout the seasons, they have provided a unique place to relax and to regenerate body and spirit—and heart.

La Corriveau (Bronze statue by Alfred Laliberté. Musée du Québec)

CHAPTER SIX

❧

A Park
in the City

1830-1910

Guy Mercier and Yves Melançon

The Villa: a New Art of Living

BATTLEFIELDS PARK, which dominates the southern flank of the Heights of Québec, belongs to the prestigious family of English-style public gardens that grace many cities around the world, including London, Paris, and New York. Situated in the very heart of urban centres, these large spaces preserve an area where the beauties of nature are displayed. Their elegance resides in a careful arrangement of natural elements; in their turn, the plain and the hill, the tree and the forest, and water, calm or moving, are laid out for contemplation. The whole forms an attractive tableau that draws the viewer's eye to the distance, a picturesque panorama. Often, the bucolic vocabulary is completed, as is the case in Battlefields Park, by ruins and historic monuments that reinforce the evocative power of the place.

By highlighting nature and the past, the English-style public garden constitutes an original, idealized territory. It somehow carves a space out of the daily rhythms, the obligatory modernity, and the social constraints of the city. People can go there to be alone, outside of time, to renew their relationship with nature.

The Homes of a Prosperous Élite

This search for self-reflection and an intimacy with nature, as evidenced in English-style public gardens, is part of a larger movement of transformation of urban life. In Québec, at the end of the eighteenth century, the construction of sumptuous villas erected in the countryside on the periphery of the town presaged this new way of living, advocating a reconciliation between urban dwellers and nature. The notion of creating, around the city, an residential environment separated from social life and close to nature gained momentum in the next century. Thus were born suburbs, wealthy or less opulent, with varied architectural styles, but always more or less representative of the notion of the home as a refuge for the individual and a means of enjoying the spectacle of nature.

The creation of Battlefields Park was part of an urban-development movement that got underway when the British authorities appropriated properties on the outskirts of Québec, where they had

Country house of a military officer, near Québec.
(C. Krieghoff, 1857. Musée du Québec)

The Comfort and Elegance of the Villas

Through the residential form of the villa, the nineteenth-century élite exhibited its taste for comfort, art, and science. The interiors, notably, carried the imprint of this refinement, as we can see in this 1882 description by Dr. Prosper Bender of Asyle champêtre, the villa belonging to his grandfather, Joseph-François Perrault (1753–1844), protonary of the King's Court, educator, philanthropist, horticulturalist, and writer in his spare time:

On entering, the visitor found himself in the reception room, which was about twenty-four feet square, with a large bay-window towards the north and used as a drawing-room and study. . . . The parlor in the Asyle Champêtre, well known to the élite and leaders of society of that day, was elegantly, but not luxuriously, furnished; the carpet was made of flax sown and grown on the grounds adjoining his schools, and woven by his pupils; the walls were hung with valuable paintings and ornamented with objects of virtu, artistically arranged. From the centre was suspended a lustre of candles; at the two rear angles were large circular mirrors, one concave and the other convex, with lights on each side, reflecting every object, or movement in the apartment. Two bronze statues, or candelabra, with lights, guarded either side of the hall door, in keeping with the surroundings; the hangings and furniture were in the style of Louis XIV, in which the colours [were] harmoniously blended. On the left side of this apartment was Mr. Perrault's library, in which was a choice collection of Greek, Latin, English, French, and Spanish works, on philosophy, history, and les belles lettres. . . . On the right was another room with a piano and an organ, to which the family devoted much attention. ✑

huge mansions built in the style of the "country houses" that were very much in vogue among the English aristocracy and bourgeoisie. Rural but not agricultural, these mansions created a clear separation between the place of work and activity (the town) and the place of residence (the countryside). Nestled in the woods or the fields, they offered their owners the privilege of a comfortable refuge away from the hustle and bustle of urban life. In 1780, governor Frederick Haldimand was one of the first to have an elegant residence built right beside the Montmorency Falls; between 1791 and 1794, it was occupied by the Duke of Kent, father of the future Queen Victoria. Judge Adam Mabane acquired an immense property on Chemin Saint-Louis in Sillery in 1769 (today the land is shared between the Saint-Patrick Cemetery and the Montmartre Canadien) and had the Woodfield Villa erected there; it was occupied between 1795 and 1802 by Jacob Mountain, the first Anglican bishop in Québec. Farther north, on Chemin Sainte-Foy, the land that had belonged to Jacques Lafontaine de Belcourt, member of the Superior Council, before the Conquest was taken over in 1767 by Major Samuel Holland, surveyor, who had a large residence built there.

In the first half of the nineteenth century, the number of suburban villas multiplied around Québec, springing up in Limoilou, Charlesbourg, Cap-Rouge, and Beauport. The promontory, however, was the site of choice. Among the seventy-three villas catalogued by France Gagnon-Pratte in 1980, forty were along Grande Allée, Chemin Sainte-Foy, and Chemin Saint-Louis. They belonged to rich merchants, highly placed civil servants, officers, and dignitaries, most of them British. As well as being the seat of the legislature and of the civil and military administration of Lower Canada, Québec was in the middle of an economic boom. As a port town, it was host to a thriving business in naval construction and timber sales. When the British parliament adopted a policy of preferential tariffs for importations from its North American colonies, in 1795, exports from Québec to England leapt in volume. The privileged trade with the home country expanded again starting in 1806. At war with France, England faced a naval blockade that deprived it of its traditional sources of wood supply. To remedy this, it turned to its colonies, which greatly favoured the prosperity of Québec. The multiplication of villas thus took place during a period of strong economic growth, and the élite took advantage of this to advertise its success through the magnificence of its homes. Extravagant expenditure became the very symbol of power.

Country Retreats with Their Back to the Unsanitary City

While high society withdrew to this nearby bucolic suburb, Québec suffered the effects of prosperity. The economic boom caused an upheaval in the appearance of the city. The shores of the St. Lawrence and St. Charles rivers were covered with shipyards, ships, and piers; close by, factories of all sorts went up. This activity required a great deal of labour, which drew young men from the surrounding countryside. To this rural exodus was added the arrival of a great number of immigrants from Europe, notably Ireland. The population of the town and, in particular, the *faubourgs*, exploded. In Saint-Roch alone, the number of residents swelled from 829 to 10,760 between 1795 and 1845. To respond to new housing needs, the large landowners, including the religious communities, subdivided some of their lots, creating tightly woven *faubourgs* with narrow streets. For some, this landscape was thrilling and synonymous with progress. On December 14, 1874, the Saint-Roch newspaper nostalgically recalled the wonderful era of the 1850s:

> You must remember the great days of 1854, when shipbuilding was at the apogee of success. St-Roch was beautiful then! It did the soul good to see, when the midday bell rang, the long files of workers, shouldering bags of wood chips, content and happy to contribute hours of peace and sweet prosperity to their hearths.

But economic progress had a significant side effect: insalubrity. In the *faubourgs*, houses sat beside various trade and manufacturing

The Marchmont villa, west of the site of the Plains, in 1865. (Musée du Québec)

177

Urban Insalubrity

At the beginning of the nineteenth century, the rapid population growth and the lack of organized urban development caused a serious deterioration in living conditions in Québec. Public health, as William Kelly noted in 1837, was particularly threatened by the absence of a sewer and drainage system, as well as by the accumulation of garbage:

> The public sewers are in such a state that some houses, in one of the principal streets, are scarcely habitable at times, in consequence of the stench proceeding from the sewers. . . . The suburbs, with few exceptions, beyond the streets that form thoroughfares or avenues to the country, gave neither the advantage of sewers or paving. . . . After the melting of the snow in April and May, several streets in the flat suburb of Saint-Roch are no better than slough; and very offensive sloughs too, from the accumulation of filth that was hidden by the snow in winter. Such places, when acted on by the summer's sun, must give out very noxious effluvia.

W. Kelly, «Medical statistics of Lower Canada», Transactions of the Literary and Historical Society of Québec, 1837, no. 3, p. 210-211. ✑

commerces. The dark and poorly drained narrow streets, the absence of a proper water-supply and sewage infrastructure, the open-air dumps by the river, and the butchers, tanneries, and other businesses that dumped their waste in the river all combined to make these neighbourhoods unhealthy places. The filth left residents vulnerable to a range of diseases that the ships brought with them. In 1832, a cholera epidemic killed some three thousand Québec residents, and five more epidemics had swept the population by 1854. As well, urban crowding exacerbated the risk of fire. In 1845, 1866, and 1870, conflagrations razed entire sections of the Saint-Roch and Saint-Jean *faubourgs*.

What with the dirt and disease, the town became an object of revulsion. The 1832 cholera sowed panic and prompted many citizens to take refuge in the countryside, confirming this negative image. To remove their families from the dangers of the urban milieu, the wealthier residents fled ever more quickly to villas. Many imitated William Price, a rich wood merchant who, "seeing the terrible state of public hygiene in Québec and the defective drainage in the town . . . hastened to obtain a residence far from the miasmas of the town."

Two factors thus favoured multiplication of the villas on the periphery of Québec: an economic boom that ensured the prosperity of the local élite and increasing anxiety with regard to the degradation of sanitary conditions in the town. To grasp the full significance of this type of housing and its role in the slow but progressive transformation of the urban space of Québec, we examine how the villa, through its intrinsic qualities and the values it symbolized, introduced a new way of urban life which had direct, profound repercussions on future urban development.

The Cult of Comfort and Elegance

The villas constructed during this period were distinguished by their large size, their elegance, and their huge gardens. These luxurious houses bore witness to the primary desire for comfort and for a healthy, active, and pleasant family life. To allow the mind to blossom, villas had libraries, studios, music rooms, and sometimes art galleries. There was also room for social life, since these sumptuous family retreats were host to society get-togethers: the entrance hall, the salon, and the dining room, the areas open to guests, were spacious and richly decorated.

The exterior appearance of the villas was very important. Depending on the time of construction, they had different architectural styles, always corresponding to the fashion of the day. The first villas were inspired by the sixteenth-century Neoclassical Venetian architect Andrea Palladio; neo-Gothic and eclecticism also had their day. Whatever its look, the villa was a unique product with a cachet that,

beyond charm, sought to transmit the nobility and distinction of its owner. Evoking the beauty of the villas of Québec, Dr. Prosper Bender, grandson of Joseph-François Perrault, protonary of the King's Court Bar, was very aware of this dimension when he noted, "In these days of ambitious, showy villas and grand mansions, whose lofty and imposing proportions, elaborate architectural ornaments, conspicuous verandas, and prominent sites are all designed, not only to gratify the taste and pride of their owners, but to excite the wonder and admiration of the ordinary observer."

Elegance extended to the landscaping of these estates, a cherished aspect from the start on the Heights of Québec. More than simply a setting for the beautiful residence, the garden expressed a profound attachment to nature. Thanks to horticultural art, nature was carefully arranged and offered for admiration: flower beds were seeded with flowers and fruit trees, or rare varieties. Paths snaked through a forest, belvederes dominated picturesque sites, and kiosks awaited strollers beside a stream or close to a pond or a fountain. The wealthiest owners built greenhouses and hired gardeners from England or Scotland to cultivate plants and exotic fruits. In spite of the effort and money invested, the magnificence of the celebrated English gardens that served as models—for instance, Hampton Court, Stowe, and Chatsworth—was never, or rarely, achieved. However, some gardens were undeniably of high quality, if one believes the descriptions of a memorialist who observed Québec high society in the last century, James Macpherson Lemoine. With regard to Spencer Wood,

The Woodfield estate on the Québec promontory, west of the Plains, in 1830. (J.P. Cockburn, NAC)

179

owned by his father-in-law, Henry Atkinson, before becoming the governor's residence in 1849, Lemoine wrote,

> It was to a landscaping gardener, M.P. Lowe . . . that the Spencer Wood garden was indebted for being cultivated in such exquisite taste and for being an object of curiosity for all foreigners who visit Québec. . . . It was an estate of more than a hundred acres . . . bordered to the east and the west by two streams; isolated from the main road by a thick grove of oaks, maples, pines, and elms—that is to say, virgin forest, dappling light here and there through the labyrinth of its pathways; a breathtaking countryside, with shadows blurring the gentle shades of the carpet of green. . . . A magical flower garden was situated behind the château to the north; it once drew much attention. There was also a large fruit garden and a well-maintained orchard dotted with borders of flowers; the centre was adorned with the most charming circular fountain of white marble. . . . Balconies and belvederes were erected in exposed places over gaping precipices and on two points, one overlooking Sillery, and the other Île d'Orléans; this was the spot for many gay teas, where much champagne was drunk.

The Individual and His Kingdom

The villas in the Québec countryside provided a new way of urban life for a small number of wealthy people, who lived in comfort a short distance from the city. This gave rise to a protected, privileged milieu that favoured the arts, the sciences, and nature, brought pleasure to the senses, and raised the spirits. Individualism, romanticism, and scientism, the dominant values of the time, strongly imbued this new élite way of life.

The physical and psychological distance that the villa established between residence and city represented an adherence to the individualistic concepts staked out in philosophy and politics by John Locke in England and Jean-Jacques Rousseau in France. Individual liberty was fundamental and unalienable. Even the state could not suppress this "natural" right; on the contrary, it was bound to guarantee liberty and see to it that life in society was not a constraint to its expression. The villa fit with this philosophy; it was to reinforce the liberty of the individual by reserving, within society, a large space in which he was utterly sovereign.

The influence of romanticism in the nineteenth century was manifested in the attention paid to art and nature. This movement militated for a revolution in individual sensibilities, which would have been atrophied by the empire of reason, conventions, and academe. Repulsed by societal constraints, it promulgated a search for the true self. Each person had to discover within himself the "Noble Savage," closer to the authenticity of nature than to the artificiality of social life. He must also heed his emotions and the messages his senses brought him, so that his imagination was constantly at work.

Bois-de-Coulonge at the end of the nineteenth century. This estate, which was part of the Chatellenie-de-Coulonge, was subdivided a number of times in the nineteenth century. In 1849, it became the residence of the governor general of Canada; in 1870, that of the lieutenant-governor of Québec. (Ursulines de Québec monastery archives)

Above all, passion must rule, even at the cost of suffering, torment, and chaos. This confusion mattered little, since desperate love and effusiveness before beauty were always more sincere than conventions. As it did in England, this bold romanticism had a profound influence on the design of villas in Québec, which were intended to provide the individual with all he needed to awaken his sensibility and free his imagination. Protected from the outside world and its constraints, nature and art offered an infinite horizon; the sensations and images it offered led the way to the true soul.

For the romantic, nature hid a trove of mysteries to which intelligence held the key. Villa owners were sensitive to this appeal. They examined nature meticulously in an attempt to understand how it worked, and many pushed the art of gardening toward the natural sciences. One of the first, Pierre-Joseph Perrault, turned the garden at his villa, *Asyle champêtre*, into a veritable laboratory. The Horticultural Society of Québec, created and long presided over by Henry Atkinson, owner of Spencer Wood and then of Spencer Grange, recruited many members from among the villa residents, a number of whom were also interested in ornithology. Some, like James Macpherson Lemoine, became accomplished and reputable naturalists. This sustained interest, much more than a simple pastime, was due to the marked growth in the natural sciences in the nineteenth century. Scientism was gaining momentum. Considered one of the principal factors in social progress, science was also seen as the best way to penetrate the secrets of nature and uncover its laws. It provided man with the tools for mastering his environment, making the most of it, and improving his situation. It made sense for honest men to put their intelligence and resources, however modest, at the service of such a noble mission.

In the first half of the nineteenth century, the escape of part of the Québec élite to the nearby countryside was thus much more than simply a reaction to a favourable economic context and urban insalubrity. It was the expression of a new way of urban life based, in the name of individualism, on comfort, contact with nature, and aesthetic qualities. This new life style, which required significant financial resources, was the lot of a minority. However, it contained the seeds of a new conception of the city, which was to mark urban development in later years.

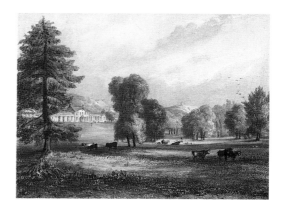

Villas, built in a rural setting away from the city were the privilege of the wealthy. (**Le Bois-de-Coulonge ou Spencer Wood**, Musée du Québec)

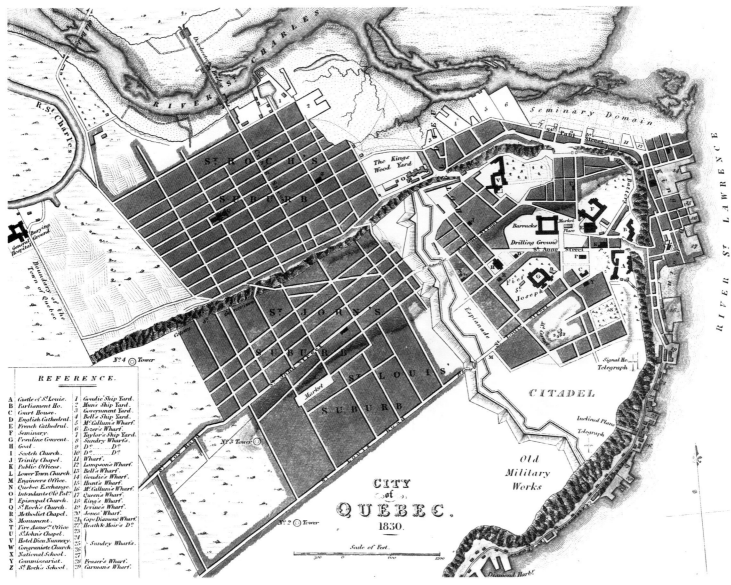

CITY
of
QUEBEC.
1830.

Scale of Feet.

Modernizing a City of the Past

B Y THE BEGINNING of the nineteenth century, rapid population growth and the lack of organized urban development had resulted in a serious deterioration of living conditions in Québec. The sanitary state of the city was so deplorable that some local notables hoped that the authorities would quickly undertake the corrective measures required, using as their inspiration reforms already underway in England and elsewhere.

In Europe, the question of urban hygiene had been on the agenda since the mid-eighteenth century. Under the pressure of the industrial revolution and the rural exodus it triggered, the cities swelled without any sort of real control over their development. Precipitous growth and the absence of planning caused disordered overcrowding, especially in working-class neighbourhoods. The absence of means to evacuate trash and wastewater and the lack of air circulation created breeding grounds for pestilence, causing epidemics. To fight this insalubrity, a "hygienic offensive" was launched with the cooperation of the government.

Urban Hygiene

The hygienic intervention was based on recent scientific discoveries in the areas of chemistry and the physics of air. Researchers had demonstrated that air, more than a simple element, was indispensable to living organisms, and that its quality had an effect on the normal functioning of such organisms. In 1771, the English chemist and theologian Joseph Priestly had proved that both breathing and combustion are impossible in tainted air. He then discovered that, in the presence of plants, oxygen-poor air once again permitted combustion. This demonstrated the balancing function played by vegetation in the recycling of air and provided scientific proof that crowding and the lack of greenery in the cities upset this natural equilibrium. The stagnant air and water in the poorly drained and ventilated cities were then identified as vectors of contagion, capable of spreading disease.

Based on these indisputable scientific discoveries, the authorities accorded priority to a topographic clean-up of the city. They adopted

Beside the large villas, the town's often filthy **faubourgs**. In the nineteenth century, the workers lived there, crowded together. Narrow, dark, poorly drained streets and accumulated garbage were the flip side of economic prosperity. (NAC)

Québec City in 1830. The **faubourgs** are taking more and more space on the promontory. (NAC)

183

various measures to get rid of overcrowding and encourage ventilation of the neighbourhoods. They began to install or improve drainage, sewage, and aqueduct infrastructures, and made plans to level the old walls and widen the streets for better aeration. Finally, it seemed necessary to introduce, right in the heart of the city, green spaces to ensure regeneration of the air.

Sanitary Reforms

In Québec, sanitary reforms really began in 1832, when the city government was reorganized. Up to then, justices of the peace, named by the governors, had managed municipal affairs, but these part-time administrators were incapable of effectively controlling the rapid expansion of the town. Although their numbers grew from nine, in 1814, to forty-one, in 1831, the *faubourgs* remained underrepresented. In spite of complaints by *faubourg* residents, essential services were inadequate and public funds were used primarily to improve hygiene conditions in the upper town.

As well, the military vocation of Québec and the constraining presence of the army complicated any reorganization of the town. The confining of the upper town within the fortifications and the military presence on many lots, both inside and outside the walls, hindered management and development of the municipality.

In 1832, a municipal council replaced the judges. It set in motion major reforms to combat unhealthy conditions. In 1833, the municipal council created a sanitation committee to prevent a repetition of the catastrophe of the year before, when the town had been hit by a serious cholera epidemic. Regulations were also written regarding the cleanliness of houses, yards, and streets, but these precautions were not sufficient. With the arrival of immigrants, cholera was unleashed on the town again. Installation of a network of aqueducts and sewers, starting in 1852, reduced the threat.

This infrastructure, a prime feature of sanitary reform in Québec in the nineteenth century, put a serious hole in the public purse. Paving and widening the main streets and moving the cemeteries outside of the city also improved the urban framework. In addition, the municipal authorities planned to extend the town beyond the walls. In 1858, the mayor of Québec, Hector-Louis Langevin, proposed to widen Grande Allée and De Salaberry Avenue. Inspired by the huge urban-renewal projects undertaken by Prefect Haussmann in Paris, he wanted to create wide boulevards, airy, clean, and bordered by sidewalks, lining trees, and elegant houses. In this case, hygiene was married to a concern for aesthetics which involved integration of greenery into the urban context. The project was thus descended from the concept of urban life that had created the villas,

although it proceeded from a municipal programme and not an individual initiative. Mayor Langevin's plan was not acted upon immediately, for the economic context was not favourable: the loss of preferential tariffs on English markets, the decline of sailing ships, and competition with Montréal, which was in full industrial expansion, cut into Québec's prosperity. But the main obstacle remained occupation of land by the army, which blocked any significant attempt to expand the town.

The British Army's Occupation of the Land

In the nineteenth century, Québec was England's main stronghold in North America. Major fortification work had culminated in the construction of Martello towers and the Citadel. Between the towers and the wall, the military authorities wanted to establish a zone free of housing, to make it difficult for enemy troops to approach the town; however, the Saint-Jean and Saint-Louis *faubourgs* sprang up anyway. On the south side of Grande Allée, the army managed to maintain an area that was open and had few structures on it. To preserve this safety corridor, the British authorities had to out-manoeuvre certain profit-hungry land speculators. For instance, in 1840 the shipowner William Lampson bought up the lease for a property situated immediately to the east of the Martello Towers, belonging to the Ursulines. To increase its value, he subdivided the lot, intending to sell it for housing. This tactic obliged the army to reward him for his initiative: "The Engineering Department, fearing that houses, which were on the point of being constructed on this piece of land, would interfere with the town's fortifications, took it by force . . . and paid Mr. Lampson in 1843."

An Institutional Vocation

Although military constraints impeded urban expansion toward the west, buildings dedicated to charity or public service went up in the area. In 1860, the Irish erected the Sainte-Brigitte Asylum to lodge their community's old people and orphans at the corner of Grande Allée and Avenue De Salaberry. A year later, the English community built the Finlay Asylum on Chemin Sainte-Foy. Also in 1861, a military asylum was constructed beside the Martello tower on Grande Allée; when the garrison departed in 1871, this became the Female Orphan Asylum. In 1862, the Ladies Protestant Home, a retirement home for women, went up on Grande Allée near Avenue Cartier. The provincial government built a prison in 1867—today used as a museum—on a lot acquired from John Bonner, who had obtained it from the Hôtel-Dieu nuns. A little later, in 1874, the federal government installed an astronomical observatory near the prison, the data from which was used for navigation on the St. Law-

Québec

O Fortress city, bathed by streams
 Majestic as thy memories great,
 Where mountains, floods, and forests mate
The grandeur of the glorius dreams,
Born of the hero hearts who died
In founding here an Empire's pride;
Prosperity attend thy fate
And happiness in the abide
Fair Canada's strong tower and gate!
Marquis de Lorne, 1884.

The military garrison left Québec in 1871. (**The Canadian Illustrated News**, December 1871, NAC)

rence River. In 1865, the municipality granted the Séminaire de Québec a lot situated south of Grande Allée, immediately west of the Martello towers, to build a new small seminary—the old one, within the town walls, had just burned down—a forestry school, and a botanical garden. The Séminaire authorities wanted to contribute to the dissemination of horticulture and sylviculture, fashionable sciences of the time. However, the project was never realized.

Departure of the Garrison and Urban Modernization

The weakening of Québec's strategic position, the evolution of military technology, and the desire of the new Canadian confederation to see to its own defence led to the departure of the British garrison in 1871. Although a civil administration had been managing the town for almost forty years, the military function had severely constrained its development; the army's land holdings and the fortifications comprised an obstacle to urban expansion. Abutting the ramparts, the town turned its back to the *faubourgs* and the large real-estate reserves of Cove Fields and the Plains of Abraham. As well, the narrow gates to the town impeded traffic and inhibited trade. Once the garrison departed, the municipal authorities asked the federal government to raze the fortifications. The goal was simple: to free the town from the barrier to its modernization. Faced with petitions and repeated requests, the government consented, first, to demolition of the gates. The Saint-Louis gate was soon destroyed, but the newly renovated Saint-Jean gate was saved. At the same time, the city councillors created a Special Committee on City Improvements. Members

of this committee went to Ottawa in October, 1874, to obtain permission to tear down part of the walls.

As the defensive function of Québec faded, the town expanded westward to a sector which had been distinguished by "peri-urban" occupation. The villas and institutions there represented more a separation or rupture from than a connection with the city; now, integration of this territory into the city itself was possible, even desirable. In 1871, the widening and embellishment of Grande Allée was put on the agenda. At the same time, following the principles of urban hygiene, a public park was planned for Cove Fields. The municipal authorities then proposed, in 1874, a plan to expand the upper town westward. Designed by Charles Baillairgé, the city engineer, this plan reserved land for a park and called for the widening of Grande Allée and subdivision of the lots on its south side. To the north, the old Garnison Cricket Field, where the Québec parliament buildings were later built, was also to be subdivided.

In an extension of this municipal project, the promoter Léonard-Irénée Boivin subdivided a piece of land close to the Guénette *faubourg*, between Grande Allée and Chemin Sainte-Foy, and put three hundred building lots up for sale. This step was innovative, in Québec at any rate, since it offered a middle-class clientele the possibility of acquiring a property in a clean, pleasant neighbourhood, served by the horse-drawn tramway service. In its issue of October 6, 1874, the newspaper *Le Canadien* hailed the enterprise as indisputable progress for Québec City:

> For many years, the trade in plots of land has been a common thing in Montréal. But this is the first time that citizens of Québec have seen a sale of this type. It is an unequivocal sign of progress; our city is coming out of the rut it has been in for such a long time. . . . The site is undeniably one of the most beautiful and cleanest in the Québec area. . . . We are convinced that bank and store clerks, government employees, etc., etc.—in a word, all who want to have a home of their own—will profit from this exceptional opportunity.

In spite of this encouragement, Boivin had to abandon his project. Although his idea presaged the growth of the suburbs, his plan was stalled by the poor economic times. Affected by the decline in the wood trade and naval construction, Québec had not yet had its industrial conversion. As well, Boivin's plan perhaps depended too much on the capacity and desire of the still embryonic middle class to confirm its social distinctiveness through a specific type of housing.

Reconciling the Glorious Past and Modernity: Lord Dufferin's Mission

Although modernization projects for the city had many boosters, some citizens remained nostalgic. Among them was James Macpherson Lemoine, who, secluded in his Spencer Grange villa,

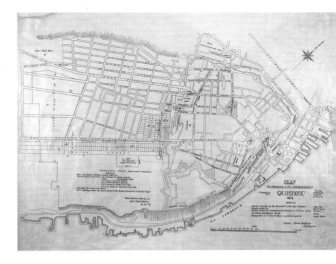

Municipal urban-development project in 1874. (Plan by Charles Baillairgé, AVQ)

remained a lover of the old stones of the capital. All the changes upset him, and he lamented that, as ineluctable and beneficial as it may be, the metamorphosis of the city was taking place to the detriment of its past:

> Obviously, the time for change, demolition, and improvements is upon us. When a sacrilegious hand tears down our massive, venerable walls, when the secular gates of our historic city are torn from their hinges, without one single voice, not even that of the antiquarian, defending them, one feels that there is something to be said for our venerable walls, the knowledge and safety of those they had the mission of protecting, and that convenience and public health must prevail over the desires of the antiquarians. And, in truth, where will it end?

For the sake of modernity and hygiene, the Québec fortifications in fact seemed doomed to disappear. The intervention of Lord Dufferin, governor general of Canada since 1872, changed the course and the direction of the projects. This well-read aristocrat felt that the walls had great historic value and that it would be a pity to destroy them, for the old capital, the cradle of French America and the seat of a decisive, heroic victory by the English army, was the very embodiment of the history of this new country, Canada. It was therefore essential, in Dufferin's opinion, to preserve this symbol to stimulate and strengthen the patriotism of its citizens, and so he pressed against demolition, which he considered sacrilegious. He won out: the walls were to be preserved and restored. The municipal council approved the project, and Dufferin ensured the support of the prime minister of Canada, Alexander Mackenzie, and of the Secretary of State for War in London. The queen herself contributed by financing the erection of a new gate, which she dedicated to the memory of her father, the Duke of Kent, who had once lived in Québec.

As well as protecting the walls, Dufferin's plan aimed to reconcile conservation of the fortifications with an improvement and beautification project for Québec. Recognizing the need for modernization, he agreed that new openings should be pierced through the walls and that the old gates and some streets should be widened. This concession to the imperatives of the time was associated with a series of proposals to develop the historic and aesthetic treasures of the city, including the creation of a promenade along the ramparts, offering a view of a city and of one of the world's most scenic locations. West of the walls, between Rue Saint-Louis, Rue Saint-Eustache, and Rue Dauphine, an ornamental park was to be linked to another park within the walls, on the Esplanade, increasing the cachet of the area. At Dufferin's request, the Irish architect William H. Lynn designed various projects for reconstruction and construction of gates. His intention was to reinforce the reference to history with the help of an architectural vocabulary that echoed the past: turrets, watchtowers, loopholes, machicolations, embrasures, archways, and so on. The

Lord Dufferin (1826–1902) (NAC)

plan also called for the erection of a grandiose residence for the governor general at the Citadel. This new "Château Saint-Louis" would be better placed on the promontory, liven up the silhouette of the capital, and add to the visible symbols of prestige and power.

In 1873, Dufferin approved the municipality's proposal to widen Grande Allée to the west, outside the walls. The government's plan to subdivide Cove Fields in 1876 lent urgency to this project, for Ottawa was planning for major residential developments in this sector. The federal project ran counter to the idea of creating a public park on the site; all that remained was a square bordered by a grid of wide streets. Like many others, this project was never realized.

What Dufferin had in mind was a true urban-planning project, which would accentuate Québec's historic, picturesque character, while adapting the city to the requirements of modernity. This desire to link progress and tradition evidenced a romantic vision that refused to sacrifice beauty to efficiency. Defenders of the project also argued that this attitude was indispensable for tourism, which was already important to the city's economy.

The Plan of Improvements of the City of Québec advanced by the governor general was never realized in its entirety. However, the extension of Terrasse Durham (later renamed for Dufferin), the piercing of the walls, the widening of main streets, and the reconstruction of gates gave impetus to major works that flowed directly from the urbanistic and architectural choices suggested by his project. Construction of the parliament buildings (1877–84), the courthouse (1883), the city hall (1892), and Château Frontenac (1892), notably, created the profile that Dufferin had wanted the city to have.

The Good Times on Grande Allée

In the wake of the expansion projects to the west after 1871, the government of Québec decided, in 1876, to erect its new parliament buildings on the old garrison cricket grounds. This choice had a major effect on the development of the sector. When the parliament buildings went up, occupation of Grande Allée quickly intensified. The artery was soon bordered by the architecturally refined residences of the élite, generously ornamented and presenting a seductive façade of gardens and lawns. In 1886, the municipality reinforced this distinctive character by widening and beautifying Grande Allée. Drained and paved from the fortifications to Buttes-à-Nepveu, the avenue lacked only the tramway, which was installed at the turn of the century. Sidewalks and lining trees added to the pleasure of residents and pedestrians. As the twentieth century began, Grande Allée was the pride of all Québec; it embodied the long wished-for "new city."

The infatuation with Grande Allée had a direct effect on the value of land. Lots were very expensive, which encouraged a high occupation density; the houses were built close together and

A Threat to Grande Allée

At the beginning of the twentieth century, some promoters erected apartment buildings on Grande Allée. These buildings displeased area residents, who saw them as a threat to their quality of life. When the first high-rise, Les appartements Grande-Allée, went up in 1911, a petition of protest was addressed to the mayor of Québec City:

The building that is currently being constructed . . . will have the effect, given its character and disproportionate size, of changing completely the regular and natural physiognomy of this place, and will diminish . . . the value of neighbouring properties. This entire part of Grande Allée, from Parliament to the Franciscan church, is an area of essentially private residences. The houses on this stretch were constructed with symmetry, set back and at an equal distance from the street. Those erected over the last ten years have followed the aesthetic and hygienic rules observed today in all recently created cities . . . all of which makes our Grande Allée a harmonious, pleasant, tranquil whole that adds to the beauty of the location and the value of the properties. All of this will now be destroyed by this disparate structure, a sort of hotel, which a Montréal company is building and which, given its double character as a public and speculative establishment, should never be tolerated by municipal authorities. The proportions of the building alone, of which we had no idea, built right to the street, form such a contrast with the neighbouring properties that the effect of this harmonious, distinguished ensemble, mentioned above, so appreciated by local residents and admired by strangers is now completely annihilated. . . . It is not just the view, the air, the space that we enjoy, for example, in back of our houses, that no longer exists, but the sunlight will be interrupted for a good part of the day by this structure.

Archives of the City of Québec, Séries Conseil, Comité dossier, rue Grande Allée. ✑

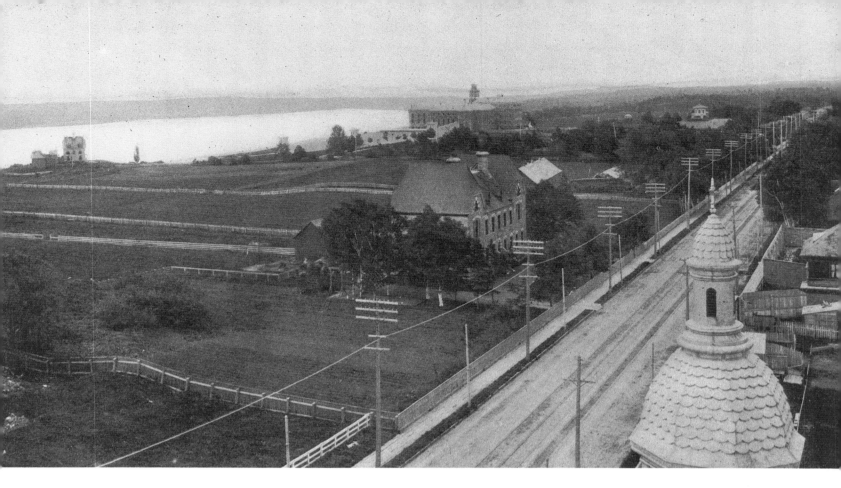

Sacrilegious Urban Development

During the 1870s, the citizens of Québec, including the mayor and other well-known personalities, began to worry about the future of the site of the famous battle on the Plains of Abraham. The site, or a large part of it, belonged to the Ursulines, who had rented it to the army; when the garrison departed, in 1871, the federal government became a tenant. Thus, an association was formed with the goal of creating a commemorative park there. In 1883, a design for the future park was even proposed by someone called J. Horn of Montréal. In the name of Canadian patriotism, the author of the plan launched a solemn appeal—and a warning:

> The Plains of Abraham, enveloped by the memory, like a glorious nimbus, of the two heroic generals, must be considered a national property—the meeting place of all Canada—the sacred shrine to a united people. . . . All of Canada has an interest ▶

Grande Allée at the end of the nineteenth century. Fences and paths; far left, the Observatory, the prison, and some villas on the edge show how the site of the Plains was used. (**Mémoires de la Société royale du Canada**, section 2, 1899)

promoters began to construct apartment buildings. Appartements Grande-Allée, erected in 1911 on the corner of Rue De La Chevrotière, was the first in a series that extended up to the recent Saint-Patrick project, erected on the site of the church of the same name. The establishment of these multi-dwelling buildings marked the end of an era in which individual upper-class houses dominated Grande Allée. The residents were very unhappy about these buildings; it was said that they were in poor taste and marred the beauty of the area.

Reconciling the Past and the Future: A Commemorative Park

The residential push toward the west encouraged large land-owners to allow their lots to be developed. The Ursulines, owners of lot 165, the "Plains of Abraham," were in a choice position in this regard. The long-term lease granted to the federal government expired in 1902, and the religious order considered subdividing the huge lot for residential construction. This raised an outcry, for no one wanted the thirst for land that accompanied urban growth to swallow up the site of so memorable a battle. Suddenly, public opinion mobilized in favour of preservation of the site. Letters from all over Canada pleaded with the federal government to enshrine this historic site in a commemorative park.

At the request of the federal authorities, the nuns agreed to let their land go to the municipality. After lengthy negociations, the nuns acquired the Marchmount property in exchange for the Plains. They also sought, and obtained, a number of conditions: the property would be incorporated into the municipal territory of Québec

City, connected to public services (water drainage and supply) at the city's expense, served by a paved and lit road eighteen metres wide and by a tramway, and exempted from taxes in perpetuity. These provisions were made in anticipation of a subdivision into lots which, according to Monsignor Marois, who counselled the nuns in this affair, "the wealthy class would be naturally the one on which we would count" to purchase.

It has become a commonplace to consider this episode as an example of speculation by large landowners. The nuns profited from their real-estate holdings by selling off a coveted lot, while holding on to land of even greater value, neighbouring a future park, which they could later subdivide. But it was not simply a question of profit. This deal caused the value of the real estate to rise, and also fixed the future conditions of occupation for a large area in Québec's upper town, establishing the tone of development for the sector and creating balance in urban development. While upholding the historic value of the site and the impressive idea of a park, this path opened the way to selective urban development in the environs. An urban project took shape beyond the lucrative financial prospects. Privileged actors, in this case the state and a large landowner, thanks to their control over the space, were planning a project with an urbanistic intention, but the conditions for its realization were not yet all in place. It would be another few years before the park was created and the consequent urban development took place.

in seeing this sacred site, once drenched with the blood of the heroes of two great nations, preserved intact and inviolable. To the nationalities that occupy the land of Québec, this battlefield is holy ground. . . . It goes without saying that if anyone ever sets himself the task of diverting this cherished site from its present function, all of Canada, in a single voice, will denounce this outrage. All the efforts of our compatriots who wish to convert the Heights of Abraham into a great public park should be completely successful—this is the wish of your humble servant.

L'Électeur, *October 2, 1883.*

All of this patriotic fervour did not, however, move the Ursulines, owners of lot 165, "the Plains of Abraham." The nuns were so deaf to exhortations that they were planning to subdivide their land. Scandalized at the idea of seeing this noble site thus profaned, Canadian public opinion—as predicted!—mobilized to preserve the site from the sacrilege of urban development. To honour this glorious site, they called for the creation of a park that would be the pride of all Canadians:

> *We cannot regard the Plains of Abraham as being of merely local interest. There is not a Canadian from the Atlantic to the Pacific who does not share in its significance. Nor is that all! Wolfe's victory was the harbinger of the ultimate triumph of the British arms by which Canada became what, in spite of perils and temptations, it has ever since remained.*

Montréal Gazette, *December 7, 1898.*

Montcalm: Planned Comfort

I N 1908, WHEN THE NATIONAL BATTLEFIELDS Commission was created, a decisive step was taken in development of the upper town. From the start, the Commission possessed a large lot, which it later expanded. As a real-estate reserve, the park removed from residential development most of the southern portion of Québec City that overlooked the St. Lawrence River, thus helping to define the layout of the upper town. It was associated with the planning and placement of a nearby neighbourhood that was essentially residential and responded to very precise urban standards: the Montcalm district.

The Urban Function of the Park

The creation of a park on the Plains of Abraham was not aimed simply at preserving a place beyond the grasp of invasive urbanization in the Grande Allée sector. The park was part of a directed urban-development process responding to a current model found elsewhere. It carried in itself the conception of and plan for a city. Thus, the reservation of a space for a park was accompanied by urban development on its periphery.

In the year that the park was created, the municipality of the Notre-Dame-de-Québec parish, which extended west from Avenue De Salaberry toward Sillery and Sainte-Foy, became the town of Montcalm, and joined with real-estate promoters to encourage planned development of the area. The town they wanted to build had to respond to strict criteria with regard to hygiene, tranquillity, and comfort. This was regarded as progress over the old city and the *faubourgs*, which were associated with filth, overcrowding, and discomfort. A certain aesthetic quality was sought in the new town's architecture, and greenery was an important component of its overall composition. The creation of a large park nearby was very important, but the entire landscape was to be imbued with the presence of nature.

Advertisement showing the importance of the park to urban development. (**Le Soleil**, May 24, 1914)

Avenue des Braves after it was refurbished at the beginning of the twentieth century. At its end, the monument installed in 1855. (NBC)

Planned and Standardized Urban Development

At the turn of the century, the westward urban thrust had only just reached Avenue De Salaberry, which was the city limit. Up to Avenue des Érables, the land was divided into lots for building, but only three small streets in the Guénette *faubourg* had been laid out and paved. Some fifteen villas belonging to wealthy residents and some institutional establishments occupied the rest of the area. Now, the time was right for intensive urbanization of the sector. The creation of a public park on the Plains of Abraham had been confirmed, and a tramway served Grande Allée, which was now paved and lit. To complete the preparation for this urban expansion, the town councillors of Notre-Dame-de-Québec set up solid institutional bases. In 1908, the municipality became a town (Montcalm), and created the infrastructures and by-laws it needed to ensure an environment that respected the new, hygienic, romantic way of urban living.

The highest priority for Montcalm's leaders was to install a proper water-supply and sewage system, to provide the future town with the best possible hygiene conditions. Since 1887, the parish had been connected to Québec. Later, in 1904, work had been ordered to improve water conveyance and sewer drainage. In spite of the improvements, public hygiene was below expectations—so much so that in 1907 a number of citizens complained to the town council about the odours emanating from the canalizations. The situation became of even greater concern when the town council received a notice from Jos. A. Beaudry, public-health inspector for the province of Québec, rejecting the municipality's proposal to get rid of its wastewater in the St. Charles River. According to Beaudry, the river was already an

"open sewer" and a danger to public health. To provide present and future residents with a salubrious environment, the new town thus undertook, in 1908, to install its own sewer and water-distribution system. It was an ambitious plan, and it resulted in a heavy debt load; in 1913, the town owed $450,000. As well, the system was not a model of efficiency: the aqueduct had a limited capacity and the problem of draining into the St. Charles river had not been solved. In 1913, faced with these financial and technical difficulties, the citizens of Montcalm decided to be connected and annexed to Québec City.

Montcalm had had a development plan from its beginnings. From 1909 to 1913, a series of by-laws aimed at regulating and defining urbanization shaped the landscape of Montcalm more or less as we know it today. The norms covered all aspects of urban development with regard to use of the ground, subdivision of lots, laying out of streets, and construction of buildings. This administrative rigidity no doubt contributed to the homogeneity of the architecture. A high-quality residential vocation was imposed even before development began. To ensure tranquillity and the comfort of its citizens, the town of Montcalm kept outside its borders the manufacturing, industrial, and commercial activities that were flourishing elsewhere in Québec. One by-law stipulated:

> Factories and other establishments that use steam, electricity, natural gas, or other inflammable substances, breweries, livery stables, forges, and foundries may not be constructed or operated except with permission of the Council. . . . It is forbidden to establish, construct, or administer within the town limits cattle yards, canning plants, tallow-melting establishments, candlemakers, warehouses for raw skins, establishments for burning or boiling bones, glue factories, natural-gas plants, soapmakers, dyemakers, tanneries, and other unhealthy establishments, without special permission.

The desire to ensure a healthy neighbourhood went as far as requiring residents to respect cleanliness. Every owner "must keep his house in a state of cleanliness and allow no garbage that will inconvenience the neighbours or other persons." The concern for hygiene was matched by very careful attention to the presence of greenery. The alignment of houses set back from the street was prescribed in order to leave room for shrubbery and flower beds. In many places, lining trees separated the sidewalks from the streets. These measures left room for small gardens to embellish the façades. To stress the importance of introducing nature into the city, the municipal council organized a "tree festival" in 1913, to encourage owners to plant ornamental trees.

As well as promoting the residential function, health, and a naturalistic aesthetic, the city council required that housing development follow a regular geographic distribution. A 1909 by-law defined

Montcalm: The Ideal Town

Founded in 1908 and annexed to Québec City in 1913, the town of Montcalm symbolized the triumph of a new conception of the city in which hygiene, comfort, and contact with nature were valued very highly. This sought-after "urban quality" was largely exploited by real-estate promoters, such as, for example, the Montcalm Land Company:

> The division of our lots, made according to plans by one of our most famous architects, offers the most perfect symmetry. The streets are straight, wide, and spacious. Trees are not a rarity on our lots. You will find air and space, and yet you will be in the city. . . . All that you desire in terms of services is found at Montcalm: water and aqueducts are superior to those of the city. Lighting is provided by the Jacques-Cartier Company. The sewer system is perfect. The tramways cross our land.

L'Événement, *February 18, 1911.*

Others, such as the promoters Tourigny et Marois, proclaimed that Montcalm was "a prized residential area" since it offered the conveniences of the city with the advantages of the country: sun, air, and shade. The proximity of a large urban park was presented as a major asset: "One fact that will interest those in search of an ideal location is that our property neighbours Battlefields Park, which, once finished, will be one of the most beautiful in the entire Dominion."

Le Soleil, *May 23, 1914.* ❧

lot sizes, no doubt to avoid exaggerated real-estate speculation that would create a density in Montcalm comparable to that on Grande Allée. Real-estate promoters had to have their cadastral plan approved by the city, which then had to construct new roads and avenues. The size of lots could vary up to a limit of twenty feet (6.5 metres) wide by one hundred feet (30 metres) deep. The division of territory into such small lots impeded the construction of large buildings. Finally, the municipality referred to standards in the revised provincial statutes that required any new street to be sixty-six feet (20 metres) wide.

The planning authority of the town of Montcalm also extended to construction of buildings. Every design had to be submitted to the town engineer, who ensured that the project conformed to municipal regulations with regard to alignment, height, and materials. In order to reduce the risk of fire, one of the scourges of urban life in the recent past, the town required that houses be faced with bricks. Even more significantly, the minimum value of buildings had to be five thousand dollars for a detached house, and three thousand dollars for a building containing flats. These thresholds corresponded to the cost of a wealthy residence or a well-appointed apartment building.

The National Battlefields Commission had similar prerogatives on the immediate periphery of the park and on Avenue des Braves, which fell under its aegis. The Commission wanted high-quality residential development to enhance the park's attractiveness. First, Avenue des Braves was to become a majestic drive with the solemn mandate of reuniting two battlefields. At the Commission's request, the town of Montcalm decreed, in 1913, that buildings on this avenue "must stand alone or be semi-detached, be constructed at a distance of no less than twenty feet from the alignment of the avenue, be of a value of at least six thousand *piastres,* and be occupied exclusively as private residences." The commission also exercised control over the borders of the park. The charter of Québec City (modified in 1927) stated that a zone of one hundred feet (thirty metres) bordering the park could not be built on, "except if it is a house exclusively for residential purposes, of a value of at least nine thousand *piastres,* standing alone, constructed for a single family." The erection of such a house would be authorized only if the plans and specifications "as regards its general exterior appearance and the position that it occupies in respect to the park are previously approved by the Commission."

All of these regulations, most of them enacted during the brief existence of the town of Montcalm and reaffirmed after its annexation to Québec, left an indelible mark on developments in the area. Through the actions of their trustees, the city and the park complemented each other. The objectives were always the same: a new urban ideal in which the watchwords were public health, tranquillity, and contact with nature.

The green spaces and trees embellish the urban fabric.

A luxurious residence on Avenue des Braves.

The landscaping of the town of Montcalm was designed in relation to nature.

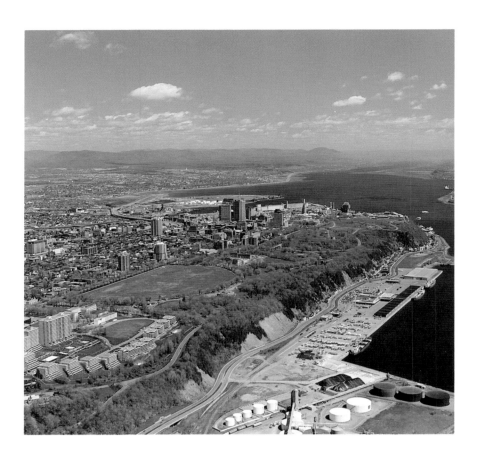

The idea of sharing a new, progressive way of life was quickly adopted by the population. Although acquisition of a villa was reserved for the privileged few, the project of the town of Montcalm bore the promise of a certain democratization of residential comfort, and many responded to the call. Civil servants and other middle-class city-dwellers were happy with the flats in the spacious triplexes. The wealthiest could obtain a single-family house, the elegance of which bespoke their superior status. This was not simply flight from the city, as had previously been the case, but a wider variety of people moving to an area corresponding to a new concept of the city. In other words, Montcalm was one of the first suburbs of Québec City. According to this logic, urban expansion was less a result of demographic growth than of the desire of individuals to enjoy a comfortable, satisfying, and pleasant domestic life.

Two Faces of Modernity

The intense residential development that accompanied the creation of Battlefields Park in the first half of the twentieth century confirmed that the new concept of urban housing, modeled in the last century on the notions of individualism, hygiene, and romanticism, had taken hold. The Québec promontory thus stood out as a privileged, protected urban area. After the Second World War, however, intensification of administrative and commercial functions in the sector threatened this urban fabric. The proximity of the park continued to provoke envy and attract power brokers.

Government and business began to show an interest in the area between 1910 and 1937, once the four parliament buildings were completed, and this was intensified in the postwar years. First, the

The park enclosed on all sides by urban development.

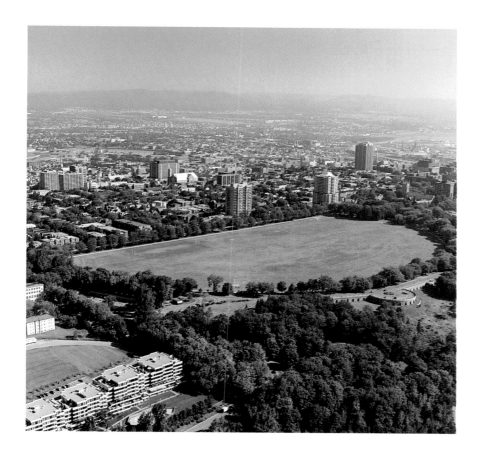

head offices of insurance companies appeared on Chemin Saint-Louis. The building of the Female Orphan Asylum was torn down in 1961 to make way for construction of the new Ministry of Cultural Affairs. In 1965, several old houses were demolished to make way for the La Laurentienne office tower. In the 1970s, the number of office buildings reached a critical threshold, causing a profound upheaval in the sector's urban composition. The government of Québec led the way with the erection of two imposing towers, the G and H buildings, in a resolutely modernistic style. Driven by the rapid increase in government bureaucracy, the refurbishing of Parliament Hill required destruction of a large part of the Saint-Louis *faubourg* and of a number of houses on Grande Allée. Construction of a number of other, similar buildings for hotels, offices, shopping centres, and deluxe apartments amplified the urban-renewal movement. To this was added the widening of Boulevard Saint-Cyrille and construction of a highway that penetrated the city from the Beaupré coast as far as Parliament. The end of the 1970s saw a slowdown in urban development, which had cut a wide swathe through the historic neighbourhood. A number of large houses on Grande Allée were renovated to house chic restaurants, fashionable bars, and professional agencies. As for the Montcalm district and the Saint-Jean *faubourg*, they took on new life as a young and active population rediscovered them.

Today, Battlefields Park is rooted in a sector in which urban development followed two distinct trends. Urban residential forms that bore witness to the search for individual comfort and a close relationship with nature first appeared on the periphery of the *faubourgs*. The park itself was the fruit of this new way of urban life, created in the last century and disseminated throughout upper-town

The city at the edges of the park; below, the Mérici buildings.

Québec in the twentieth century. Various functions were added later. Commercial, tourist, and cultural jobs and activities were massively concentrated in the area, making it very central. In most cases, the new functions were imposed on the landscape through urban forms that contrasted greatly with the existing urban fabric as much by their styles and volumes as by their elevations.

At first glance, the coexistence near Battlefields Park of these two types of urban development seemed contradictory. Instead of being protected and featured, the urban patrimony forged in the nineteenth and early twentieth centuries was abandoned to the bureaucrats and promoters. The upper town then saw its urban fabric torn apart by demolitions and by construction of overwhelming, gigantic structures, motivated by plain economic viability rather than quality of life. The reinforcement of the centralizing administrative function destabilized an area oriented to domestic comfort, architectural aesthetics, and contact with nature. Beyond this apparent contradiction, a common logic seems to have sustained urban development in the Battlefields Park district.

Whatever one thinks of the encumbering presence of the bureaucracy, it has a connection with the history of Québec's upper town: in fact, the area's residential vocation would never have come into being without government intervention. As well, the apparent contradiction between different functions and occupations in the area around the Plains conforms to a long tradition, stretching back to French and English royalty in the colonial era. From the beginning, indeed, the best space on the Québec promontory has been reserved for the representatives of power and the well off. Even today, the site, thanks especially to the park and its attractions, bespeaks the permanence of this distinction.

Grande Allée bordered with trees.

The widening of access to the park's attractions did not always please the old residents.

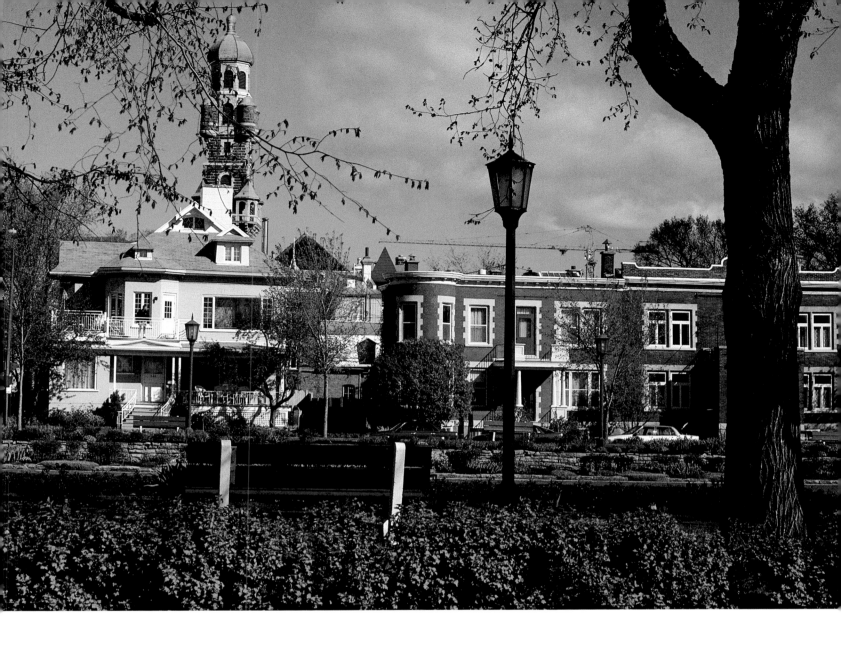

Residences bordering on Jardin Jeanne-d'Arc. As one crosses the street, one enjoys the sight and the scent of the flowers.

CHAPTER SEVEN

∞

The Natural Park: A Romantic Garden

Claude Paulette and Jacques Mathieu

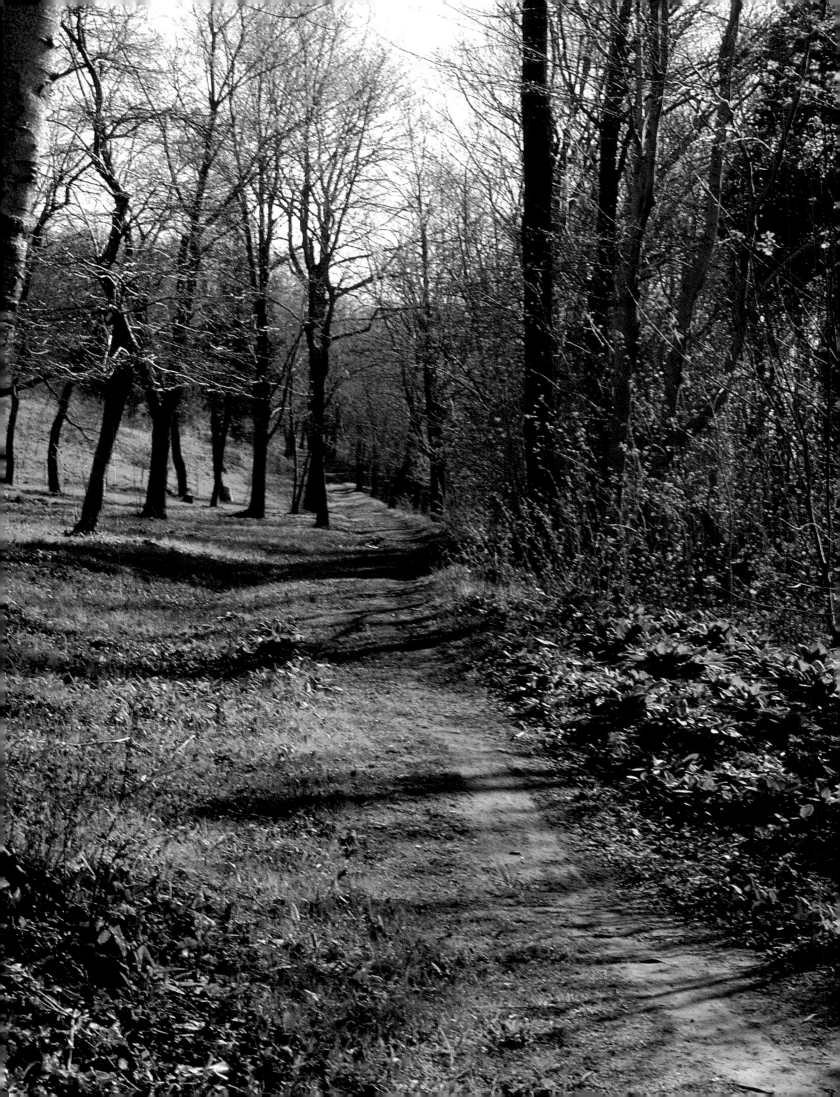

Gardens of Other Times and Other Places

T HE CREATION OF NATIONAL BATTLEFIELDS Park in Québec City at the beginning of the twentieth century went well beyond the political and cultural circumstances and debates that governed its establishment. Both nature and history influenced the choice of vocations for the park, its landscaping, and the activities that took place there. Thus, it was to be natural and commemorative. Like public green spaces elsewhere, the park also responded to the needs of a growing city. Its creation was part of a larger trend that had originated in Europe, particularly England, but had been realized most fully in the United States starting in the mid-nineteenth century. As an urban park, it fulfilled the need for green space and clean air in the city centre. Because of its hygienic functions, it was part of the new concept of the city and was taken into account in urban planning. It was also part of a Romantic trend, which aimed to humanize and beautify the human environment.

As a natural lung, historic garden, and jewel at the centre of Québec City, it also had to be *the* perfect park. To preserve and enhance the natural beauty of the site, add to its aesthetic value, and increase its attractiveness, the National Battlefields Commission engaged the services of a well-known landscape architect, Frederick G. Todd. The challenge was enormous; the task, immense. The park had to please residents and visitors, respond to their expectations, satisfy their aspirations, appeal to their senses, rouse their emotions.

In the seventeenth and eighteenth centuries, cities such as Boston, New York, Montréal, and Québec were above all places of trade, neither large nor well populated. Narrow streets, houses crowded cheek by jowl, and a lack of open spaces characterized the urban fabric. Certain spaces had well- defined community functions, such as the marketplace and the parade grounds, but there was no park available to everyone. The art of gardening was known, but it was reserved for the privileged few, particularly on the heights of Québec.

Toward the end of the seventeenth century, when the small town of Québec was beginning to stake a claim to being the capital of French America, King Louis XIV had the Versailles palace built and its gardens landscaped by architect André Le Nôtre. The colonial administrative and religious élite wished to imitate in the colony the

The winding paths bordering the cliff give the impression of untamed nature.

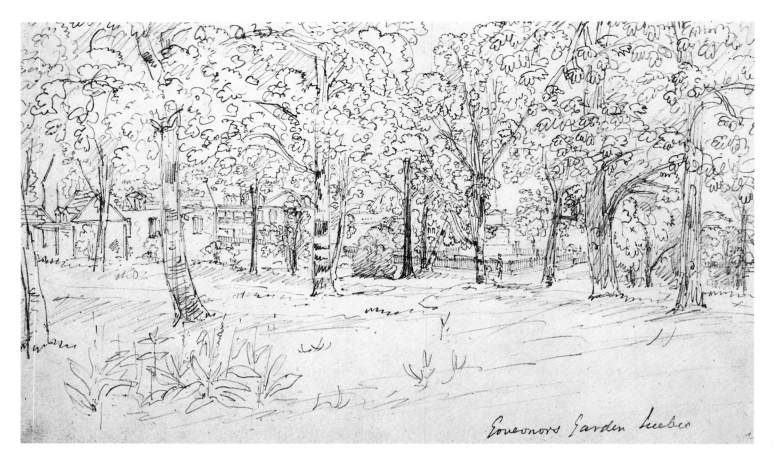

Governors Garden Quebec

Jardin des Gouverneurs in Québec City in the nineteenth century. (J.P. Cockburn, 1831, NAC)

All over the world, urban expansion has heightened the desire to preserve green spaces. (Photo: W.B. Edwards, 1937, NBC)

pomp of the home country. Although grand projects were quickly reduced to a more modest scale, the governor still possessed his château, the bishop and the intendant their palaces, the religious communities their convents.

As in Europe, the residences of these holders of power were graced with gardens, often designed in the French style—that is, using rigorously geometric forms. When the first Château Saint-Louis was built, in 1647, the Jardin des Gouverneurs, which was a king's garden, was created. In it were kept, before they were sent to France, plants that were unknown in the home country. The priests of the Seminary, the Jesuits, and the Ursulines also possessed vast green spaces. Magnificent trees adorned the Jesuits' garden; according to the Swedish naturalist Pehr Kalm, "vegetables of all species, as well as numerous apple trees . . . and other similar trees" filled the garden of the Hôtel-Dieu nuns. Only the intendant, residing on the shore of the Saint-Charles River, did not have a garden to start with. In 1726, however, when his palace was ravaged by fire and rebuilt, intendant Claude Dupuy had a French-style garden created, with geometric flower beds, canals, basins, and fountains. He drew much criticism from the king's engineer, Chaussegros de Léry, who doubted the utility of ornamental waterworks in a country where the ground was frozen and covered with snow for six months of the year. As well, some prominent private citizens, such as Rouer de Villeray, land-scaped their estates in rustic style.

These gardens existed for the pleasure of their owners, and many also included a vegetable garden for their benefit, but they were not open to the public. The only open spaces in Québec were the two marketplaces, in front of the churches in the upper and lower towns, and Place d'Armes, in front of Fort Saint-Louis. The change in re-

AAA *terrain du Palais.*
B. *Le Palais*
c *les Magasins*
D *Bureau des Magasins.*
E *Prisons.*
F *Basse Cour.*
G *Jardin des Couches.*
H *La Potasse.*
I *Ecuries.*
KKK. *hangars.*
L *Chapelle S.t Roch.*
MM. *Nouveau Quay, fait cette année.*
N *La digue ou Molle.*
O *Redoute S.t NiColas.*
P. *quille du vaisseau du Roy*
Q *Parc au bois*

fait a québec le 4.5 1739
Chaussegros de Léry

gime, in 1763, did not improve things. The Jardin des Gouverneurs was not opened to the public until 1892, and to convince the authorities to grant this access students from Université Laval had to storm the gates. In short, it was centuries before everyone had an opportunity to commune with nature for leisure and relaxation.

Nostalgia for Nature

Toward the middle of the eighteenth century, England underwent a revolution in tastes. Geometric gardens suddenly seemed very boring. The expanding romantic movement promoted a closer relationship with nature. Poets proclaimed its charms; for the first time, painters presented landscapes as subjects in themselves, rather than simply as backgrounds. Revolting against "the dictatorship of the rule and compass," garden designers, inspired by painters, sought to reproduce natural settings. Since nature abhors a straight line, gardens were full of undulating curves and sinuous paths, shrubbery, streams and pools, all enhanced by ornamental structures. This was the picturesque or landscaped garden.

The love for the picturesque was transplanted to North America, where rich merchants and dignitaries began to build large villas surrounded by landscaped garden-parks on the outskirts of town. In 1796, one of the founders of the United States, Thomas Jefferson, remodeled his garden at Monticello in the natural style. Near New York, on large properties situated beside the Hudson River, a number of landscaped gardens were created around 1825 by André Parmentier, a Belgian professional gardener. Artists and writers celebrated the beauties of Mother Nature and went into raptures over the splendid countryside, where dreams abounded. On holidays, families went on excursions in search of bucolic scenes.

In English America

*M*ost cities in the United States showed no more concern than did Québec City to provide green spaces for the public. However, there were two remarkable exceptions. When William Penn laid out the plan for Philadelphia, in 1682, he pictured a sort of garden city with five vast open spaces. In 1733, General Oglethorpe planned the city of Savannah, Georgia, with a public garden and twenty-four small squares, which still exist. The South also had some large classical-style private gardens, notably those at the governor's residence in Williamsburg, Virginia, created in 1699 and reconstructed when the city was restored. ↩

In the 1730s, the intendant of New France had his own garden, near his château in the lower town. (Plan of the Palace quarter, 1739, NAC)

207

A Commemorative Park

The idea of preserving a battlefield was born in the United States some thirty years before it emerged in Québec. The Americans wanted to transform the sites of bloody confrontations of the War of Secession (1861–66) into symbols of reconciliation and national unity. In Québec City, the Plains of Abraham lent themselves admirably to the noble vocation of cementing the friendship of the two founding peoples. The governor general himself went to the Gettysburg battlefield in 1907 to study how it had been developed. ↩

The first spaces arranged in the picturesque style near cities were cemeteries. For centuries, Christians buried their dead in hallowed ground beside churches. As towns grew, these spaces became so crowded that they were considered dangerous, for it was believed that the graves released noxious gases. In Paris, four large cemeteries were created at the beginning of the nineteenth century. The most famous, Père-Lachaise, both a memorial to well-known people and a public park, quickly became a tourist attraction.

Around 1830, a private club near Boston, the Massachusetts Horticultural Society, created the first cemetery on the Parisian model, Mount Auburn. Trees, shrubs, and flowers separated the graves, in conformity with eighteenth-century aesthetic theories. The designers avoided straight lines and respected the topography of the site in order to create the "picturesque" effect. This cemetery was an extraordinary success. Soon, it was imitated all over the United States. In New York, the Cypress Hill Cemetery became a meeting place for those who wished to leave the city behind for a moment to contemplate the undulating lines of a natural countryside. In 1855, when Montrealers decided to create Notre-Dame-des-Neiges Cemetery, on Mount Royal, they also wanted to reproduce a natural garden. "All is laid out like a public park, and both the administration and the families have neglected nothing in making it a place of pious attraction," wrote Siméon Mondou.

The Art of Making the Natural

Some people deplored the fact that citizens had to go to cemeteries to satisfy their need for the quiet pleasures of the countryside. Around 1840, the well-known landscape gardener Andrew Jackson Downing, designer of the gardens at the Capitol and the White House in Washington, criticized the absence of public parks in the cities of the United States. The numbers of people visiting the cemeteries, he wrote, showed that citizens would appreciate public parks along the same model. Downing began to crusade for creation of a park in New York.

Americans who visited Europe discovered that the old royal parks in London were now open to the public. In Paris, they saw the work undertaken by Emperor Napoleon III to transform the old Boulogne Royal Forest into a picturesque park with ponds, rocks, waterfalls, and grottoes. Frederick Law Olmstead, a young Staten Island horticulturalist, was among these travellers. Like many of his fellow citizens, he found it unacceptable that the largest city in the United States had only a small park beside City Hall to offer its residents. In 1850, the question became an electoral issue. After discussion on the choice of site, the city finally obtained authorization from the state legislature to acquire the land necessary to make a park in the centre of New York. When the site was cleared in 1857,

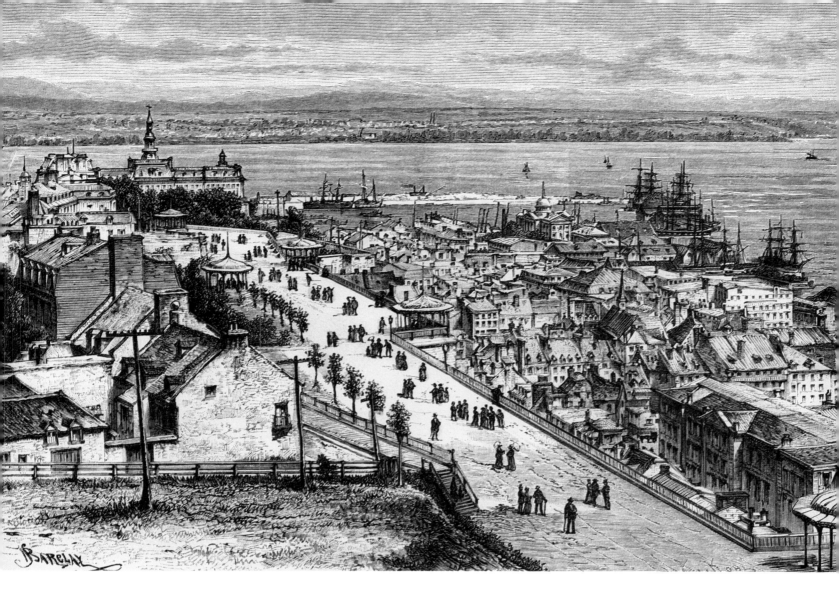

Olmstead was hired as superintendent. At the same time, the commissioners launched a contest for a landscaping plan. The young English painter and architect Calvert Vaux, who had been Andrew Jackson Downing's assistant, proposed to Olmstead that they prepare a project together. Their entry, "Greensward," won first place. The two associates quickly got to work, and soon the first tree of Central Park was planted.

The designers of Greensward wanted to "provide citizens of all classes with the best means of healthy recreation." To accomplish this, they constructed a piece of the country in the middle of the city, creating an artificial environment that appeared natural. They modified as little as possible the slightly rolling relief and rocky surface, while accentuating its picturesque aspects. To satisfy romantic spirits, they built a few rustic structures here and there—a small building, a bridge, a gate—following the principles of the English garden. Olmstead, however, distinguished himself from the landscape gardeners; he felt that what he was doing combined the art of the architect, the painter, and the poet with that of the garden designer. The result was a work of art, not simply an imitation of nature. In 1856, he began to call himself a landscape architect, and a new profession was born.

Under the direction of Olmstead, assisted by Vaux, the work on Central Park stretched over twenty years; the main work was completed in 1876. From the beginning, the public reacted enthusiasti-

Terrasse Dufferin in 1883. From the Heights of Québec, it dominated the city, the river, and the surrounding countryside, a view admired by travellers passing through. (Private collection)

The creation of Battlefields Park in Québec City in 1908 was based directly on the discourse set out by Olmstead and Vaux. Many people had wanted an urban park in the capital. For example, as early as 1871 James Macpherson Lemoine asked the municipal authorities to support such an initiative. A fervent and romantic defender of the project, he wanted Québec to have "a beautiful park with shady avenues and limpid pools, where both the working class and wealthy citizens could, on holidays and in the soft moments of dusk, go each evening to regain strength and refresh themselves under the green umbrella of pines and maples." Such an innovation was justified, he felt, as much as the installation of the aqueduct and sewers, by public hygiene:

> If the people, as well as the millionaires, could go and fill their lungs with the revitalizing salt air of the ocean at Cacouna, Rimouski, or Gaspé, a shady park would perhaps be a luxury item. But . . . a park in Québec City during the dog days is not a luxury item, it is a principle of hygiene, a source of health for the working class.

L'Événement, *August 2, 1871.* ❧

cally; fifty thousand people went to the park on pleasant summer days. This success gave impetus to what was called the park movement, and most large American cities and many medium-sized cities wanted their own natural park. Olmstead and Vaux's company designed a series of large landscape parks between 1865 and 1872, notably for other boroughs of New York City and for Boston, Buffalo, and Detroit. Throughout the United States, other landscape architects did similar work.

The park movement rapidly crossed the border, reaching Montréal, which was endowed with an exceptional attribute: a mountain overlooking the city. By 1858, city authorities were planning for a panoramic boulevard there. Ten years later, they acquired about two hundred hectares of untouched land; in 1874, the commissioners of the Park of Montréal hired Olmstead "to supply plans and direct the work for Mount Royal Park." His plan, approved in 1877, proposed to "create a harmoniously beautiful mountain," featuring the natural characteristics of the 230-metre-high rise, which was "royal only by custom." There was to be a network of winding roads and paths, following the topography and laid out to provide panoramic views. It took almost a quarter of a century to complete the work.

Romantic Québec

Québec City did not escape this movement, the goal of which was to put nature within reach of city dwellers. Like many North American cities, Québec underwent a metamorphosis in the mid-nineteenth century. Its population was growing rapidly, and its architects were giving it a new image with construction or transformation of many buildings, public and private. There were also epidemics, and fires razed the Saint-Jean and Saint-Roch districts. Like other city-dwellers confronted with the challenges of the industrial era, Québecers felt the need to embellish their city.

In 1854, to satisfy the need for clean air and create a promenade for residents of the upper town, the small terrace established sixteen years earlier on the ruins of Château Saint-Louis was expanded. In 1858, the possibility of creating a park around the Martello tower on Coteau Saint-Geneviève was discussed, but the project was never realized. A first public garden appeared within the walls in 1865, when trees were planted and a fountain installed at the *rond de chaîne* of Place d'Armes. The neighbouring land of the Citadel was also being considered. On December 29, 1852, the roads committee of Québec City asked the military authorities to sell it Cove Fields so that it could establish a romantic garden. The military refused.

Creation of a Park on the Plains

The idea of a park on the Plains of Abraham had been proposed by Lord Dufferin and by Charles Baillairgé, and it quickly gained

popularity. The situation was urgent. Already, north of Grande Allée, residential neighbourhoods had invaded much of the 1759 and 1760 battlefields. The military had preserved the large fields bordering the cliff, but its hold on part of this area was coming to an end. Many coveted the land; a number of promoters would have liked to grab it for housing. As early as 1876, a proposal had been floated to subdivide all the land to the foot of the Citadel. At the end of the nineteenth century, anxiety was fed by the fact that the lease granted by the Ursulines to the army for the land between Marchmount and the site of the present-day Musée du Québec was to expire in 1901. A considerable symbolic weight was borne by this relatively small space: it alone still carried the name "Plains of Abraham."

In 1901, after some equivocation, the federal government, headed by Wilfrid Laurier, finally agreed to purchase the Plains from the Ursulines for eighty thousand dollars. The parties signed the deed of sale on September 20, 1901; on that very day, the Government of Canada ceded the Plains to Québec City on a long-term lease. The Ursulines had stipulated in the deed of sale that the municipality was to make a national public park there, permitting no construction except that for use in such a place.

Now it was time to transform the Plains into a park. The municipal administrators showed no great enthusiasm for the task; they planted a few trees, laid out a few paths, but did nothing more. They even authorized the military to continue using the site for its parades and manoeuvres. The questions asked by the municipal roads committee in 1905 give a good illustration of the prevailing feelings at City Hall: Do we really have to proceed with landscaping the Plains? Couldn't we leave them as they are?

The tricentennial of Québec City was now three years away, and J.-B. Chouinard had proposed a few months earlier that major festivities be organized to mark the occasion. To investigate this possibility, the mayor of Québec City created a Commission of History and Archaeology, composed of Judge François Langelier, architect Eugène Taché, and historian William Wood. In its report, submitted in 1907, the committee urged the municipal authorities to "beautify the city, preserve it, and bring out the historic cachet of its monuments, buildings, and illustrious pieces of land . . . without altering the natural beauty of its site." It recommended the immediate creation of a park extending from the walls of the Citadel to the Ursuline land, encompassing the Monument des Braves on Chemin Sainte-Foy and following the edge of Coteau Sainte-Geneviève back toward the city—in short, "a promenade unrivalled in the world." The commission members stated that this site had been selected "out of the respect due to our courageous ancestors and in the name of public health."

Flower beds.

Lord Grey's Great Dream

Québecers were not the only ones interested in tricentennial festivities and the creation of a park on the Plains. The publication of the Commission of History and Archaeology's report coincided with the appearance on the scene of Lord Grey, governor general of Canada since 1904. Wanting to preserve the site of Wolfe's victory, he became an ardent promoter of the creation of a battlefield park that would honour the memory of the English and French combatants of 1759 and 1760. The organization of the tricentennial provided an ideal opportunity for him to advance his plan. Far more than a municipal celebration, it was to assume a Canadian—even an imperial—dimension. It was Lord Grey's dream to forge a closer link between the British mother country and its colonies, and he thought that financial assistance from the entire Empire was in order. In Canada, he pressed both governments and private individuals to contribute, even suggesting that a small donation be asked of each student in Canada and throughout the Empire. He submitted a beautification plan with a price tag of more than two million dollars. Aside from the purchase of land around the Plains, the project included demolition of the Ross-rifle factory and the prison, creation of a promenade around the park, construction of a museum, and erection of the Angel of Peace, a colossal statue, taller than the Statue of Liberty by thirty centimetres, with an interior elevator so that visitors could admire the panoramic view through the eyes of the celestial creature.

Lord Grey (1851–1917) (NAC)

Project submitted by Sébastien Siné for landscaping the Plains park in the shape of an imperial crown. (**Le Soleil**, September 28, 1901, NBC)

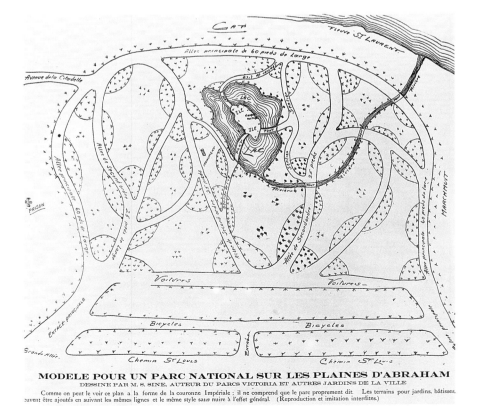

MODELE POUR UN PARC NATIONAL SUR LES PLAINES D'ABRAHAM
DESSINÉ PAR M. S. SINE, AUTEUR DU PARCS VICTORIA ET AUTRES JARDINS DE LA VILLE

Comme on peut le voir ce plan a la forme de la couronne Impériale ; il ne comprend que le parc proprement dit. Les terrains pour jardins, bâtisses, peuvent être ajoutés en suivant les mêmes lignes et le même style sans nuire à l'effet général. (Reproduction et imitation interdites.)

The National Battlefields Commission

After much debate, the law creating the National Battlefields Commission was finally tabled on March 3, 1908 and passed on March 17. The Commission was composed of five members, increased to seven in 1914. It was authorized to acquire the land on which the great battles had taken place, remove any structures, erect a museum and various monuments, and embellish the land. Its budget was three hundred thousand dollars, part of which was to defray the cost of the tricentennial celebrations. The first commissioners were Québec City mayor George Garneau, who was the chairman, Adélard Turgeon, George Drummond, Edmund Walker, and George Denison. They had four months to prepare the inauguration day, for the guest of honour, the Prince of Wales, was to arrive on July 22.

Meanwhile, the governor general was trying to gather the funds necessary to purchase the land: he hoped to amass two million dollars. But his enthusiasm did not find much of an echo beyond Canada's borders. With the exception of New Zealand, the Empire remained mute and the home country turned a deaf ear. The king saved his honour by sending five hundred dollars. The law creating the park provided that the government of a province that contributed at least one hundred thousand dollars could be represented on the National Battlefields Commission. Only two provinces were this generous, Québec and Ontario; to the latter went the honour of having its name attached to the most handsome avenue in the park. Altogether, with contributions from municipalities, various organizations, and individuals from Canada and abroad, Lord Grey accumulated a little more than $550,000, not enough to pay for demolition of the prison and the rifle factory, and obliging him to put aside plans for his Angel of Peace. At the site where it was to stand, one can instead read Lord Grey's name spelled out in flowers.

The logo of the National Battlefields Commission when it was founded. (NBC)

Creating the Perfect Park

*T*HE CREATION of the National Battlefields Commission was the first step toward realization of the park. There were three major tasks left to accomplish: completing acquisition of the land, demolishing the structures encumbering the site, and above all devising a development plan for all of the Plains.

Acquisition of the Land

When it was created, the Commission possessed only the Ursulines' land endowed to it by Québec City. From the federal government it expected to obtain Cove Fields, which had belonged to the Ministry of War (today the Department of National Defence). George Garneau also asked Québec premier Lomer Gouin to grant a concession for the provincial land on which the prison stood. His request was granted in 1911, with a reserve for the building and part of the land.

In 1909, the Commission began to acquire private properties, including the old Seminary farm, between Cove Fields and the prison, and a lot enclaved in the farm that belonged to the Dominicans; the price had to be fixed by the courts. It was much more difficult for the Commission to obtain the space it needed to create the other part of the park, around the Monument des Braves, for the land was already subdivided. Since the owners refused all offers, the Commission had to resort to the courts. From 1910 to 1912, it completed a number of acquisitions. The provincial government donated the site of the Monument des Braves; the municipality of Montcalm offered land for an avenue leading to the monument; then, the federal government ceded the land on which the Observatory stood. The Commission had no difficulty obtaining a few private properties bordering on the Plains, but this was not the case for acquisition of the Skaters' Pavilion, an enterprise undertaken in 1912 and settled only in 1933.

Appropriation of Cove Fields, a major element of the future park, proved the most difficult problem. The Minister of War invoked a number of arguments (and the First World war supplied him with others) not to demolish a series of buildings that completely

F.G. Todd, landscape architect, designer of the landscaping plan for the Plains of Abraham. (McCord Museum)

The architect respected the natural unevenness of the terrain. The layout of avenues played a primary role in creating the effect of surprise and enhancing the beauty and diversity of the park's landscapes.

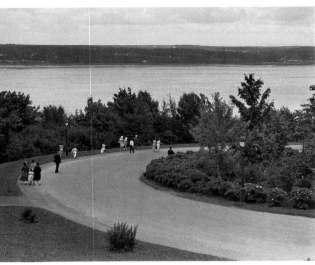

For F.G. Todd, the view, the gentle landscape, and the horizon were aspects to preserve. Avenue Garneau and Avenue George VI in August, 1935. (NBC)

spoiled the ambience of the spot: the Ross-rifle factory, a powder factory, a cartridge factory, and barracks. In the end, they disappeared, one after another, but the situation considerably delayed completion of the park.

The Commission also hoped to acquire part of the Ursulines' land (Mérici), in order to lay out an avenue extending Côte Gilmour and linking Chemin Saint-Louis to Anse-au-Foulon. Negotiations dragged on from 1912 to 1926. The following year, the federal government donated the land on either side of Côte Gilmour, then the municipalities of Sillery and Québec ceded the property of the road itself. All of these acquisitions extended the area of the park to about one hundred hectares, the equivalent of six hundred skating rinks or two hundred football fields. It was with this land that the landscape architect hired by the Commission would work.

Landscaping a Natural Park

In May, 1909, the Commission gave the landscape architect Frederick G. Todd the mandate to draw up a development plan, with the aim of transforming the battlefields "into a national park, in order to ensure their restoration and permanent conservation, without altering their beauty or historic aspect." Todd shared this vision. The spot seemed to him to be so intimately linked with the history of the continent that the future park had to perpetuate this memory.

Todd's plan was part of the larger urban-development trend that followed the creation of Central Park in New York and gave rise to large parks in many cities in the United States and Canada. These projects did not, however, obey common, predefined rules; on the contrary, the character of each place had to be developed, its personality enriched. Thus, Todd would not be content with sprinkling the Plains with shrubbery and ornamental water pools, interspersed with promenades and paths. Its natural beauty, its breathtaking panoramic views, its specific topography, its evocative value—in short, all of its symbolism—laid the burden of perfection on the site. The challenge was stimulating: how to wed space and time, the place and its history, into an integral whole?

Some operating principles guided the work of the landscape architect. The first involved his love and respect for nature, which obliged him to understand its laws. It was no less essential to incorporate a sense of time and change, since the work was designed to last. The first step was to get to know the area: "The better knowledge we have of every detail of our property, the better acquainted we become with, and the more love we have for our woods, the happier will be the results obtained." To become steeped in the spirit of the site took much time and consultation. The natural law of survival of the fittest had to be reconciled with the requirements of aesthetics, which meant that some trees had to be sacrificed for the good of the

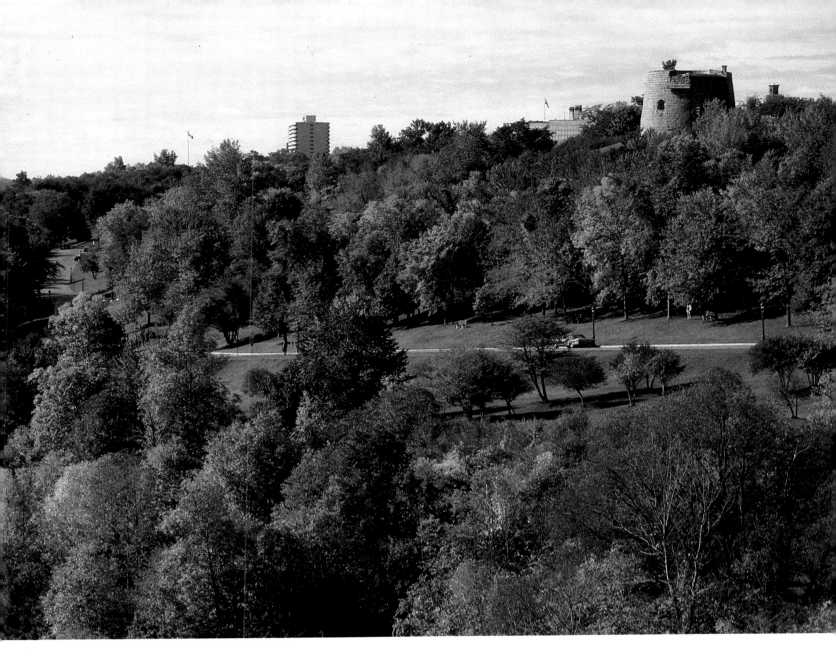

F.G. Todd felt that the historical remains in the park were very important, and planned to restore and refurbish them.

Frederick G. Todd

Born in Concord, New Hampshire, in 1876, Frederick G. Todd was educated in Boston and trained in the offices of Frederick Law Olmstead, the pioneering landscape architect and designer of Mount Royal Park in Montréal. However, Olmstead was in poor health and no longer working. Todd left Boston for Montréal in 1900, becoming the first landscape architect in Canada.

Three years later, he was hired by the commission responsible for the beautification of Ottawa to undertake a study on organizing parks in the capital. In 1905, he proposed to the city of Montréal a plan to refurbish the chalet near the belvedere on Mount Royal.

When he was hired by the National Battlefields Commission, Todd was already involved with park projects all over Canada, notably in Winnipeg, Regina, and Port Arthur. In 1912, he designed Bowring Park in St. John's, Newfoundland. In Québec, he later created parks in Valleyfield and Granby.

In 1936, during the Great Depression, the government of Québec undertook major work projects to combat unemployment. In this context, Todd realized two projects that he had submitted to the City of Montréal in 1931: he created Beaver Lake, on Mount Royal, and refurbished the park on St. Helen's Island, where, as in Québec, he highlighted remains symbolizing the country's military history. He then proposed to create a huge sports centre for the Olympic Games, to be situated in Maisonneuve Park (today Olympic Park).

From the beginning of his career, Todd was also known as an urban planner; in 1908, he worked on plans for the town of Point Grey, British Columbia, but he is best known for the "model city" he designed in 1938, which became the Town of Mount Royal. Between 1945 and 1948, when he died, Todd realized his last work, the Stations of the Cross garden near St. Joseph's Oratory in Montréal. ✧

Nature tamed.

The landscaping plan for the Plains submitted by F.G. Todd in 1908. It took fifty years to complete. (NBC)

whole. The sought-after effect was not to be spectacular or disproportionate. To endure, the ensemble must be harmonious, the treatment discreet, and the transitions gentle. The landscape architect's intervention consisted of assisting nature, emphasizing the best and most beautiful, bringing out the points of interest, and reinforcing the original character of the place. The goal was to bring the greatest pleasure to the senses, to produce feelings of well-being which, though subtle, were no less present.

This concept, based on sensitivity, is part of the search for the ideal and is connected with the painterly eye. Is there anything more beautiful than natural scenes? Yes, answered Todd: those shaped by the human hand, the hand of the artist. The great painters did not represent nature as they found it; they composed the most beautiful parts to form an eye-pleasing whole, a work of art. The art of making gardens was just as aesthetically minded. The most important thing was the angle from which the landscape was seen, studied, admired.

The landscape itself was the work of art, to be viewed as if it were a painting. Observers noted the different planes, appreciated the arrangement of shapes and colours, enjoyed a detail that caught their eye, were moved and astonished. The design was particularly sensitive to topography, and avenues and promenades were laid out to create an aspect of surprise. Each angle of observation revealed a new point of interest; each zone evoked new emotions. The transition from one to another had to be gentle. And all of this was living, growing, and changing through the hours of the day, the seasons, and the years.

The Main Features of the Park

This picturesque garden, characterized by its flexible layout, shows off all the configurations of the site to best advantage. As geographer Pierre Grenon described it, "by playing with indirect and rather intimate views, [Todd] varies and livens the dimensions and proportions." The impression is of wide vistas and freedom as much as of intimacy. This natural landscape is carefully designed: avenues and promenades, open spaces, buildings, plantings, and historic remains are significant down to the last detail. The landscape architect divided the battlefields into five large zones, each of which was treated differently, according to its nature and history. Sometimes he used a formal arrangement, submitted to a rigorous planimetry, but it was mainly on the model of the English garden that he redesigned the Plains.

Avenues and Promenades

Avenues and promenades are used to introduce the landscape and orient the views. They meander around the perimeter of the park, linking zones and levels; absorbed into the contours of the relief, they create a continuity in the diversity. Sinuous or steep, they

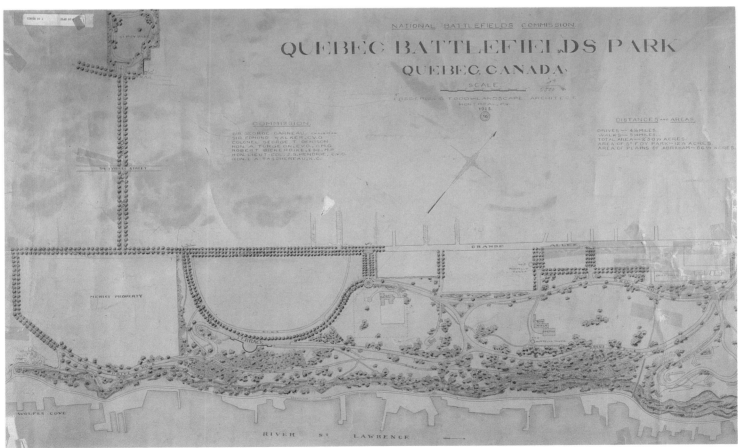

The Wolfe monument in 1935. A memory respected in F.G. Todd's plans. (NBC)

run along, skirt, or climb the dells, constantly revealing new scenes. They form two large loops, providing access to the places most invested with history and the richest vistas. These traffic lanes define a number of major zones of the park, but the delimitation is not apparent. In fact, every time one moves along them one's eye is drawn to an unexpected perspective, majestic yet simple.

The Major Zones of the Park

The first zone defined by Todd covers almost half of the area of the park, extending from the fortifications to the Museum building. An avenue runs beside the fortifications and the vestiges of the trenches, which accentuate the romanticism of the place, then leads to a high point near the Citadel, where there is an impressive view of the park, the St. Lawrence River, and the south shore. The architect's plans called for construction of a belvedere and a shelter here. Toward the west, a long dip in the land leads to a wide shoulder, created later when the Québec City water reservoir was built; on more distant rises on the promontory stand two Martello towers. In the vicinity of the Musée, the site of battles between Montcalm's and Wolfe's armies, the architect sought to preserve the natural landscape, featuring the remains of the fortifications and the Martello towers, and to recall the major historic facts, by erecting modest monuments. Near the Saint-Louis gate, he suggested that an entrance with a monumental gate be built, flanked by turrets and crenellated to harmonize with the forti-

fication wall. At the other end of this zone there was already an entrance leading to Wolfe's monument, but it was cluttered with houses. It was to be refurbished, lined with trees, and delimited by granite columns, and the monument was to be raised.

The second zone corresponds to the old race course in front of the Museum. The centre of the flat area, preserved as is, could continue to be used for military parades and physical exercise, and the large semi-circle would be lined with trees. Near the cliff, at the centre of a small terrace with a remarkable view, Todd proposed, in conformity with the wishes of Governor General Grey, to erect a statue, the Angel of Peace, which would overlook the area. Here, where heroes died on the field of honour, it would represent national reconciliation and the glory of the British Empire.

Just west of this terrace, a narrow strip of land links the promontory to Anse-au-Foulon. This small area held great interest for Todd, for it was where Wolfe's soldiers, led by Captain de Laune, climbed the cliff on the night of September 12–13, 1759. It was to be kept as intact as possible. The zone east of Terrasse Grey, a steep slope descending from the plateau to the cliff, was also to be preserved in its natural state, with its indigenous flora. Only a few paths would be laid through it, and dangerous cliff areas would be fenced off.

The last zone, Parc des Braves, is also of major historic interest. The Dumont mill had been the site of the fiercest combat during the French victory of 1760, and the remains of slain soldiers of both armies had been buried in a common grave there. The Commission already possessed the monument, conceded to it by the Société Saint-Jean-Baptiste. Todd wanted to link the two sites with a broad avenue, erect a belvedere there, and improve the quality of the area.

Of course, vegetation was an important element in the landscaping of the park, and it was also very dependent on the natural environment. From the start, Todd decided to limit plantations to the periphery of the park and to favour local species. He had a clear preference for deciduous trees: he loved their bushy crowns, and felt that their ornamental value was incomparable, for they are constantly changing. Their various shades of green, their seasonal colours, and their generous shade in the summer made them the planting of choice along certain avenues, and in some areas they protected the park against the outside world. Todd made one major exception. In his desire to make as authentic a historical reconstruction as possible, he planted cedars and white pines along the hill once climbed by Wolfe and his troops.

Refinements

Beyond the broad lines described above, Todd's plans included many details. He designed monumental entrances and a reconstruction of the blockhouse erected by Murray in 1760, and wanted to

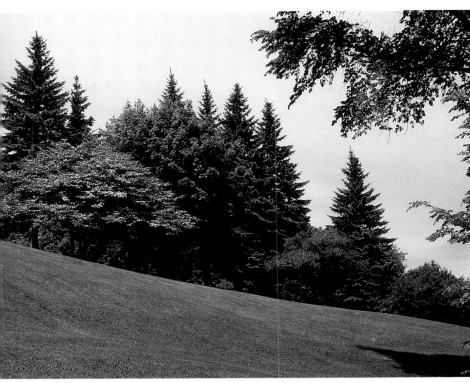

In this great tribute to nature, the majestic lining tree, in a bouquet of various species, growing skyward, is cherished.

mark the well where water was drawn for the dying Wolfe. Plans for belvederes and monuments were made up. Cannons were placed to recall strategic points. The wild cliff stood alongside regular plantations, the land rose and fell, and gracefully curved avenues wound through the park. Everywhere, the visitor's attention was delicately drawn to the beauties of nature and the historic remains. However, the grandiose architectural projects (statues, entrances), out of place with the restraint of the park, were never completed.

Todd's project was attractive. The commissioners adopted it without delay, making only minor modifications, and the federal government granted one hundred thousand dollars. The work, which the architect planned to complete in three years, ended up taking more than half a century.

An Encumbered Site

In 1910, National Battlefields Park looked very different than it does today. A number of buildings that were inappropriate, to say the least, for a natural park encumbered the site: the Ross-rifle factory and its laboratory, the cartridge factory, a target-practice range, and the prison. An astronomy observatory and a skating rink still stood where the main entrance to the park was planned. As well, houses bordered the road leading to the Wolfe monument.

In addition, the Commission owned only part of the land that Todd had been asked to develop; thus, nothing could be undertaken on Cove Fields. The gentlemen of the Royal Québec Golf Club continued to play on the fourteen-hole course, which they had created in 1874 between the Citadel and the Martello towers, until 1915.

A view, vestiges, a park within range of all city residents.

A Lengthy Undertaking

*A*LTHOUGH WORK ON THE PARK started right away, it stretched out over decades. Even today, finishing touches are being put on the initial plan. It is, however, remarkable to note that, after most of a century, the original design is still the source; the park has been shaped bit by bit.

In the summer of 1912, Todd began restoration of the entrance, of Avenue Wolfe, which led from Chemin Saint-Louis to the monument, and of Avenue des Braves. The Monument des Braves was cleaned and given a new coat of paint. Todd prepared a detailed work schedule for the following year. In December, he warned the commissioners that the estimate of costs had changed: labourers who had worked for $1.50 in 1910 now asked $2. Masonry work and transportation were also more expensive. Todd also complained of a general absence of energy and enthusiasm on the part of the workers and their foreman. In his opinion, the Commission was not getting its money's worth.

By autumn of 1914, when the First World War broke out, the terrace for the Parc des Braves, with its kiosks and balustrades, was finished. The old monument to Wolfe had been replaced by an identical copy placed on a new base. Granite pillars adorned the entrances to Rue Wolfe and Rue Bougainville (today Rue Montcalm). Over the next two years, Terrasse Grey was completed, though without the famous statue; one of the Martello towers, bordering Coteau Sainte-Geneviève, was restored; greenhouses were built; and an iron fence was erected edging the park along Chemin Saint-Louis.

In 1917, work on the park slowed, then was almost suspended completely. It was the third year of war and the watchword was thrift, except in the military. The return of peace did not much improve the situation, and this forced immobility was no doubt a reason for Todd's departure in 1918. For the next ten years, the only work done on the park was the leveling of the Plains and the installation of electric streetlamps. Thereafter, only maintenance was performed. Cove Fields, still military property, was off limits.

When no action had been taken by 1923, Québec City merchants protested. In a letter to National Battlefields Commission chairman Garneau, the Association of Retail Merchants insisted that

First landscaping of Côte Gilmour, April 22, 1931. (NBC)

Parc des Braves, behind the monument, around 1930 (NBC)

Avenue Wolfe, before and after landscaping of the
entrance in 1912 and 1916, respectively. (NBC)

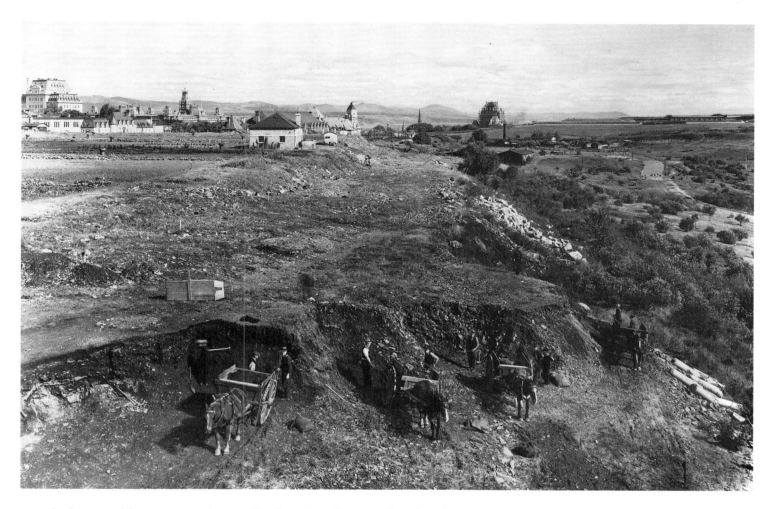

a park that would attract tourists to Québec City be completed with no further delay. The following year, the Croix du Sacrifice was inaugurated, and the greenhouses were completed in 1927. Things were still going slowly. The year 1928 started under good auspices, for the Ministry of National Defence finally promised to concede Cove Fields before the end of 1932.

Québec City's project to install a huge water reservoir under the Plains responded somewhat to the Commissioners' intentions and lobbying. Since 1925, the city had been having problems with its aqueduct system and difficulties in supplying the lower town. In August, 1930, Garneau approved the city's request, stipulating that "once the work is finished the site must look like a natural area, with varied contours that fit well with other parts of the park." In 1931, the Ross-rifle factory was demolished and the city began to dig the reservoir. Thus, a building that had been a blemish on the park was done away with.

A little farther west, the Québec government was also planning projects that matched the commissioners' aspirations. The idea of building a museum on the Plains, dismissed by Wilfrid Laurier in 1908, was taken up again by the provincial authorities, and a law on museums was passed in 1922. The Commission agreed to donate land for a building to house archives, works of art, and specimens of natural history, which fit with the spirit of the place; it reserved the right, however, to approve the choice of a site and the terracing and

Work in the Cove Fields sector in October, 1936. (Photo: W.B. Edwards, NBC)

Landscaping of Terrasse Grey in 1914. (NBC)

Terrasse Grey in 1916. (NBC)

The Québec Astronomic Observatory

Before the advent of modern navigation instruments, sailors needed to know the exact time in order to situate themselves and navigate on the high seas. To provide data to the commanders of the thousands of ships that dropped anchor at Québec each year in the nineteenth century, a small building (which still exists) was built on the Citadel in 1850, where the local time was determined through observing the movements of the stars.

In 1864, this observatory was expanded with the construction on the Plains of Abraham of a square tower with a crowning cupola, on which a refractor equatorial telescope was installed. Later, in 1873, the navy decided to transfer the entire observatory there. A house and three outbuildings were built around the tower, where the Centennial Fountain stands today.

For more than half a century, until 1930, the observatory supplied the exact time to ship captains and the public, a task to which were added meteorological observations and various astronomic work. By 1930, progress in communications technology had considerably reduced the utility of the astronomic station, which was then transformed into a simple meteorological station. Six years later, the observatory buildings were so dilapidated that they had to be demolished. The meteorological equipment was moved and the Ancienne-Lorette airport took over weather observation in 1954. ∞

The Observatory, when the park's avenues were being laid. (AVQ, Office municipal du tourisme)

beautification works to be undertaken around the museum, and to ensure that the design of the building conformed to the vocation of the site. As well, its location and the angle of its facade, not parallel to roads and thus at first surprising, would offer the advantage of almost completely hiding the view of the prison from the playing field. Finally, the Commission landscaped the land that had been conceded to it at the foot of Côte Gilmour.

During the economic depression of the 1930s, the landscaping work proceeded quite rapidly, since all levels of government encouraged large-scale projects to provide work for the unemployed—in Québec, more than one-third of the labour force. From 1936 to 1939, the Commission obtained supplementary budgets for "aid to the unemployed," which it used, notably, to level the terre-plein on top of the new reservoir. It also demolished the observatory building and restored Martello Tower 1.

Between 1936 and 1939, Battlefields Park really took shape. The federal government finally ceded Cove Fields, filling a request outstanding since 1908. Near the Saint-Louis gate, the entrance that Todd had designated as the main access to the park was created. The Commission also had Cove Fields levelled and proposed to complete this work once the old cartridge factory, near the Citadel, was torn down. Freed from all encumbrances, Battlefields Park would finally be in the image of its designers—with one exception.

In 1937, the Commission received an unexpected gift. An American artist, an admirer of Joan of Arc who had been won over by the charms of Québec City, donated to the Commission an equestrian statue of her heroine, who had been canonized in 1920. Accepting this donation was not without its problems. The Minister of Justice wanted the statue to be placed in Montcalm Park and the monument to Montcalm to be brought to the Plains. The difference in size between the two monuments made this solution untenable. The monument was inaugurated on September 21, 1938, and was dedicated "to the patriotism and courage of the heroes of 1759 and 1760."

To highlight the statue of Joan of Arc, the Commission decided to create a garden around it. Jean Perron proposed four magnificent entrances and reflecting pools on each side of the statue. However, the beginning of the Second World War obliged the Commission to reduce its landscaping budget, and so the design was inspired by a photograph of a private garden: rosebushes replaced the reflecting pools, and the entrances were more modest than planned. With its two levels of vegetation supported by a stone structure, it was called a "sunken garden." The English-style flower beds featured mixed perennials.

George Garneau, no doubt satisfied that he had brought to a conclusion the work begun in 1908, stepped down as chairman of the

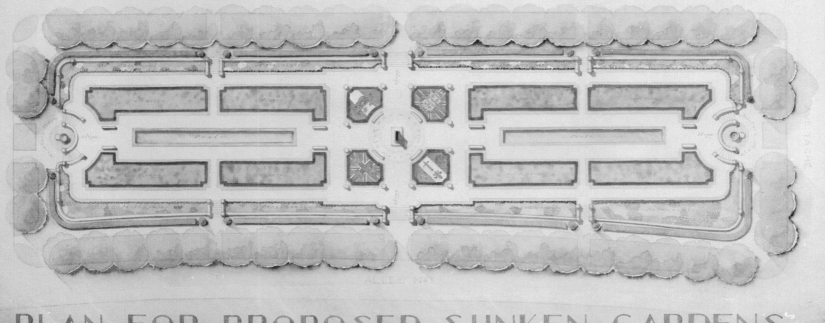

PLAN FOR PROPOSED SUNKEN GARDENS.
QUEBEC QUE.
SCALE–20 FEET TO THE INCH.
LOUIS PERRON C·S·L·A· 1938.

Joan of Arc on the Plains of Abraham

In March of 1938, during the House of Commons debate on allocating funds to the National Battlefields Commission, the minister of finance, Charles A. Dunning, spoke out against the statue of Joan of Arc. In response, on March 29, Commission chairman George Garneau saw fit to write him: "I confess that I fail to see how the erection of this statue can detract from the historical significance of the Park. Joan of Arc died over 300 years before the conquest of Canada and her statue symbolizes the valour and patriotism of the men of 1759 and 1760, which we commemorate in the Park."

Proposal to create a garden around the statue of Joan of Arc, by Louis Perron in 1938. (NBC)

Landscaping of Jardin Jeanne-d'Arc, September, 1938. (NBC)

Jardin Jeanne-d'Arc, completed in September, 1940. Note the old houses and young trees bordering the garden. (NBC)

The Musée du Québec

I n 1904, in the context of creating a park and a programme for the tricentennial celebrations, the clerk of Québec City, J.-B. Chouinard, proposed construction of a national museum or a public library. However, the design by landscape architect Frederick Todd, no doubt influenced by Wilfrid Laurier's rejection of the idea, had not reserved a site for such an institution, nor was it a consideration in the National Battlefields Commission plans. In 1922, the Québec government expressed its intention to erect a museum on the lot where the prison stood, part of which it had sold to the Commission in 1911. Through a simple exchange of correspondence, the Commission approved construction of the Musée du Québec, in large part on its land. In 1990, the governments of Canada and Québec, the National Battlefields Commission, and the Musée du Québec agreed to proceed with an exchange of land and services, and the property deeds were regularized to conform with current land use. In return for the landscape-maintenance services assumed by the Commission, the Museum gave it an exhibition space in the Baillairgé Building.

Many architects submitted projects for the museum, and that of Wilfrid Lacroix was selected. The Musée du Québec, a building in the Beaux-Arts style, opened its doors in 1933. Recent expansions have not modified its façade and respect the surrounding environment. The linking wing between the old and new buildings is hidden behind landscaping that harmonizes with the park. ∽

The façade of the Musée du Québec, inaugurated in 1931.

The Skaters' Pavilion

The Québec Skating Club constructed a covered skating rink in 1877 on the north side of Grande Allée, outside the ramparts. In 1888, when the parliament buildings were erected, the Québec government acquired this property and the Club obtained another lot from the federal government, across the street on the south side of Grande Allée, where it had another rink built in 1892. Today, the Croix du Sacrifice stands on this spot.

Twenty years later, creation of the park brought up the question of the future of the Skaters' Pavilion, since the main entrance was planned for where it stood. In 1912, the club directors offered to cede the land to the Commission on condition that they be given another lot right beside it; the proposal was turned down. In 1918, the Skaters' Pavilion was destroyed by fire, but the Commission did not acquire the land until 1933, when the Supreme Court confirmed the amount to be paid for the expropriation. The club was awarded $30,500 for a piece of land it had obtained for free. ☙

The Skaters' Pavilion stood where F.G. Todd had planned to create the main entrance to the Plains. (NBC)

The Arsenal laboratory on the Plains; background right, the Skaters' Pavilion. (NAC)

The state of the park before it was landscaped in 1907; left, the Observatory; right, the prison; foreground, fences. (NAC)

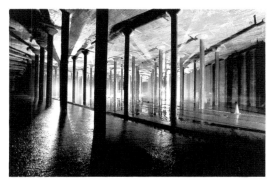

The Lake under the Plains

I t is strange to think, as one strolls on the soft green grass of the Plains near Martello Tower 1, that under one's feet are 136 million litres of water. In fact, two metres of earth separate the surface from an immense cavern that contains the largest potable-water reservoir in Québec City.

Once construction was complete, the underground reservoir left discreet but distinct clues to its existence on the surface: twenty large iron mushrooms (air vents) have sprung from the soil. To camouflage them, and to pay homage to the combatants of 1759, the founder of the Société nationale Jacques-Cartier, Maurice Brodeur, proposed in 1936 to create a "classic-style" commemorative garden. In the end, the ugly excrescences were hidden in clumps of shrubbery, in harmony with the rest of the landscaping. ✑

Construction of the municipal reservoir in 1932.
(Photo: W.B. Edwards, AVQ)

commission on March 13, 1939. On May 17 of that year, King George VI, accompanied by his consort, followed in Wolfe's footsteps up Côte Gilmour and across the park that his father had inaugurated more than thirty years before.

At the beginning of the war, the military received permission to build barracks on Cove Fields, which it agreed to tear down as soon as the war was over. These forty buildings, erroneously called "huts," sat on the most spectacular corner of the park for years—in fact, until 1952. The declaration of war in 1939 signalled the end of great works on Battlefields Park: no large-scale project was undertaken afterward. The only additions worth mentioning are the Centennial Fountain, installed in October of 1967, the sundial, erected twenty years later, and the creation, at the beginning of the 1990s, of nature paths.

Over the years, however, the Commission slightly increased the area of the park. In 1949, it obtained from the City of Sillery and the National Harbours Board the old public property on Rue Champlain (today Boulevard Champlain), the edge of which was modified at the foot of Côte Gilmour. The National Harbours Board also ceded, in 1988, the escarpment at the foot of Terrasse Grey. Finally, in 1989, the Department of National Defence transferred to the Commission a parcel of land abutting the Military Riding School for a parking lot.

Today, Battlefields Park corresponds well to Frederick G. Todd's vision. If one compares the design submitted by the landscape architect in 1909 with an aerial photograph of the site today, the similarity is obvious. For eighty years, the Commission has managed to respect the initial plan, adapting it to new circumstances and different needs. There have been some omissions and changes, affecting elements that were secondary in Todd's project. Except for the digging of the reservoir, none had an effect on the park's topography. Lord Grey's Angel of Peace and the monumental crenellated gateway proposed by Todd were left by the wayside; the museum that Wilfrid Laurier thought too onerous was built; and the prison that Todd wanted demolished remains.

The Commission has remained faithful to its mandate to dedicate the Plains to the double vocation of historic site and urban park. In recent years, to preserve and make known "the spot where the fate of a continent was decided," it has installed explanatory panels, hired guides to conduct guided tours, and created an interpretation centre on the ground floor of the old prison, on the very site of Wolfe's famous redoubt. To offer "to the public the means for healthy recreation," the Commission has also tried to provide leisure and entertainment to Québecers. Responding to popular demand, the park has also hosted sporting and recreational activities and cultural events, two elements that did not fit with the concept of a natural park at the beginning of the century.

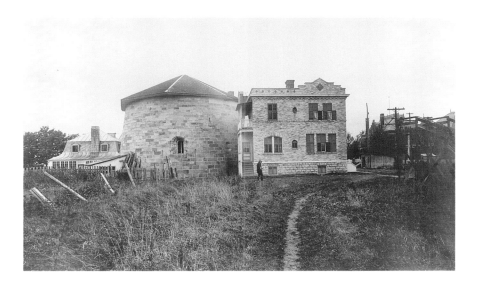

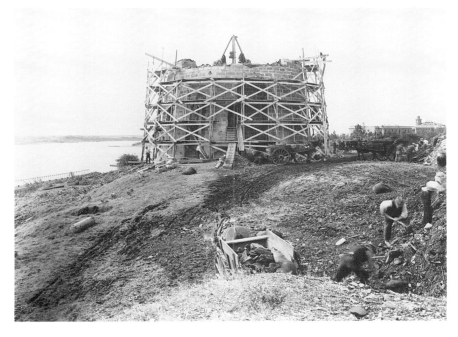

The Martello Towers

The Martello towers barred access to the town via the Heights of Québec. The three that survive today belong to the National Battlefields Commission.

In August of 1904 or 1905, Tower 3 was demolished. In September of that year, a petition was presented to the city council calling for the destruction of Tower 4, which overlooked the Saint-Charles valley on the edge of Coteau Sainte-Geneviève. At the time, the tower belonged to the Hôtel-Dieu nuns. The Société historique et littéraire de Québec, among others, denounced this "act of vandalism" and suggested that the federal government protect this element of the city's fortifications. The Hospital nuns, for their part, let Québec City mayor Simon-Napoléon Parent know that they were ready to give up the tower in exchange for a powder factory that the military had constructed in the Hôtel-Dieu gardens. An official request was transmitted to the Ministry of War.

In 1907, the new mayor, George Garneau, having received no response, took up the cause. He found out that the federal government would authorize the exchange of land. The ministerial decree was finally signed in 1910, transferring the property of the tower to the newly created National Battlefields Commission.

Tower 2, which rose from the highest point of the city, near Avenue Taché, remained military property. The Commission attempted to appropriate it in 1913, along with the right to acquire adjoining lots belonging to private individuals. However, the tower was converted to a munitions depot from 1914 to 1918. The Commission had to wait until 1923 to obtain satisfaction.

Tower 1, overlooking the St. Lawrence, on the edge of the cliff, capped with a water reservoir in 1902, was claimed in 1909. It was not ceded until 1936.

Martello tower 2. (NBC)

Restoration of Martello tower 1 in October, 1936. (Photo: W.B. Edwards, NBC)

If we take our aerial photograph and examine the areas surrounding the park, we find that here, outside the jurisdiction of the Commission, is where things have changed greatly. Like Olmstead in New York, Todd had thought that a curtain of trees on the periphery of the park would suffice to mask it from the city. However, in the 1960s, a series of skyscrapers went up right beside the battlefields, imposing their disproportionate presence on citizens who go to the park precisely to forget that they are there. Their omnipresence blocks certain views and constricts the harmony of the park.

If he were to return in the dark of night to climb the cliff with his soldiers, Captain de Laune would no doubt find the innumerable lit windows of the Merici apartment block robbing him of the element of surprise!

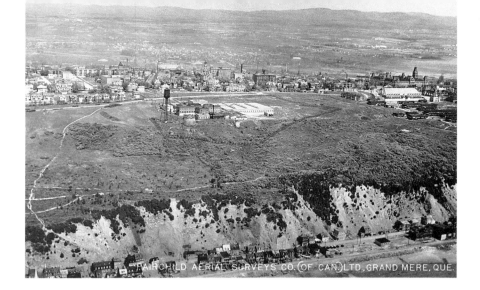

The Cartridge Factory

The Québec cartridge factory, which later became the Arsenal, was established in 1879 in Artillery Park, within the walls of the city. But the assembly and filling of cartridges carried a serious risk of explosion, and five years later, it was decided to move part of the workshop to the foot of the Citadel, to Cove Fields.

A series of wood buildings were built, surrounded by a palisade and separated from each other by earth ramparts, in order to limit damage if there was an explosion. There were many women employees; it was said that they were outstandingly patient when it came to checking the bullets and casings.

When the Canadian government sent troops to fight Louis Riel's Métis in 1885, the Québec plant supplied the cartridges—a million and a half in two months. A target range was set up beside the workshop to check the quality of the munitions. Residents on Grande Allée were not at all happy with this noisy neighbour.

In 1912, when Cove Fields were to be incorporated into the park, the Arsenal moved its target range to Saint-Sauveur. However, the manufacture of cartridges continued on the Plains until 1939. The decrepit workshops were then demolished, and production of munitions was transferred to Valcartier. ✧

The Ross Rifle

Ross rifles were used by Canadian soldiers during the First World War. The Ross-rifle factory on the Plains was established in 1902, not far from Martello Tower 1, on a part of Buttes-à-Nepveu belonging to the federal government, to fill a large order from the Ministry of War (today the Department of National Defence), just a year after the neighbouring property was purchased from the Ursulines to create a park. The installation of a rifle factory on this spot received a very cold welcome, since it took "the portion of the Plains of Abraham the most appropriate by nature for the establishment of a public park." The tricentennial committee, the architect Frederick Todd, and most of the residents of the upper town wanted this "blemish" to be razed.

When, in 1908, the National Battlefields Commission asked the Government of Canada to cede Cove Fields, it planned to exempt the rifle factory. But in the end, for this property, as for all Ministry of War properties, the Commission insisted that it be moved.

Starting in 1914, the war supplied the army with valid reasons to keep and use the properties on Cove Fields. In 1917, the rifle factory was expropriated by the government, which rented the buildings to another manufacturer, North American Arms, the following year. The army repossessed it at the end of the war for use as an arms warehouse. Rather than letting it go with its other properties, the military held on to the buildings until 1928. Two years later, Mayor Lavigueur complained to the federal government that the presence of the old rifle factory was impeding construction of the city reservoir under Buttes-à-Nepveu. A contract was finally signed for demolition of the buildings on March 16, 1931. ✧

Workers in the Arsenal in 1902. (NAC)

The Ross-rifle factory, in the heart of Cove Fields, in 1925. (AVQ)

Interior view of the Ross-rifle factory around 1905. (NAC)

The "Faubourg of Misery"

I n 1940 and 1941, the Department of National Defence built, behind the Riding School, some forty "temporary" buildings to be put to various uses, including a concentration camp for prisoners of war and a military hospital. Another barracks, erected along Laurier Avenue, lodged the members of the female army corps, the CWACs.

When the war was over, Québec City faced the double problem of unemployment and a severe housing shortage. Mayor Lucien Borne obtained permission from the federal authorities to rent twenty of the barracks as temporary housing for homeless families. In the autumn of 1945, with winter fast approaching, more than fifty families, about three hundred people, moved in. In January of 1946, the school authorities opened a small school in one of the barracks; another building served as a chapel. In May, fifteen more evicted families joined the seven hundred people who were now living in the faubourg of misery, which was in a painful state of deterioration.

Québecers were facing a dilemma: on the one hand, they wanted to get rid of the horribly dilapidated barracks that marred the Plains; on the other hand, the plight of these homeless people tore at their heartstrings. In the newspapers of the time, an editorial deplored that the Commission was unable to spend the budget available for beautification, while an article described the terrible living conditions in the faubourg of misery; elsewhere, there was a report on the efforts of the priest of the Saint-Cœur-de-Marie parish to provide assistance to the children.

Finally, in 1950, a small housing cooperative relocated the families in other neighbourhoods, freeing the commission to raze the barracks as they were evacuated. Some were bought and demolished by tenants' cooperatives, and the materials were used to erect some small houses on Champlain Street, near the Notre-Dame-de-la-Garde church. The last occupants were ordered to leave by May 1, 1951.

But the army, yet again, had the last word: it still occupied eight barracks, four of which housed military families. On August 19, 1952, General Bernatchez, commandant of the military region, wrote to Commission chairman Amyot, "We are building some two hundred houses at Sainte-Foy, and I am firmly convinced that, several months from now, the situation regarding these structures will finally be settled." ∾

The Prison

I naugurated in 1867, the prison was designed by Charles Baillairgé, of the famous family of Québec architects. It was, for its time, an avant-garde building in terms of prison architecture. Its location on the Plains of Abraham, enclaved within land used by the military, indicates to what point it was isolated from the city. With its austere look and its onerous function, this building seemed a poor match for the new vocations of the site at the beginning of the twentieth century, and the committee created in 1906 to plan a park project for the tricentennial of Québec City recommended that it be torn down. The architect Frederick Todd also called for the prison's demolition in his 1909 plan. Two years later, the Québec government ceded to the National Battlefields Commission part of the land around the prison, stipulating that the building not be demolished until a new prison could be constructed elsewhere. This did not occur until the 1960s.

Abandoned in 1970, the prison temporarily became the "Petite Bastille," a youth hostel, used during large popular celebrations. Finally, its future was assured as part of the Musée du Québec. Since the spring of 1991, it has hosted an exhibition on the history of Battlefields Park. ∾

The military barracks, a village for the poor on the Plains between 1945 and 1952. (NBC)

The prison on the Plains. (ANQ)

CHAPTER EIGHT

The Park
of Memories

Jean Provencher

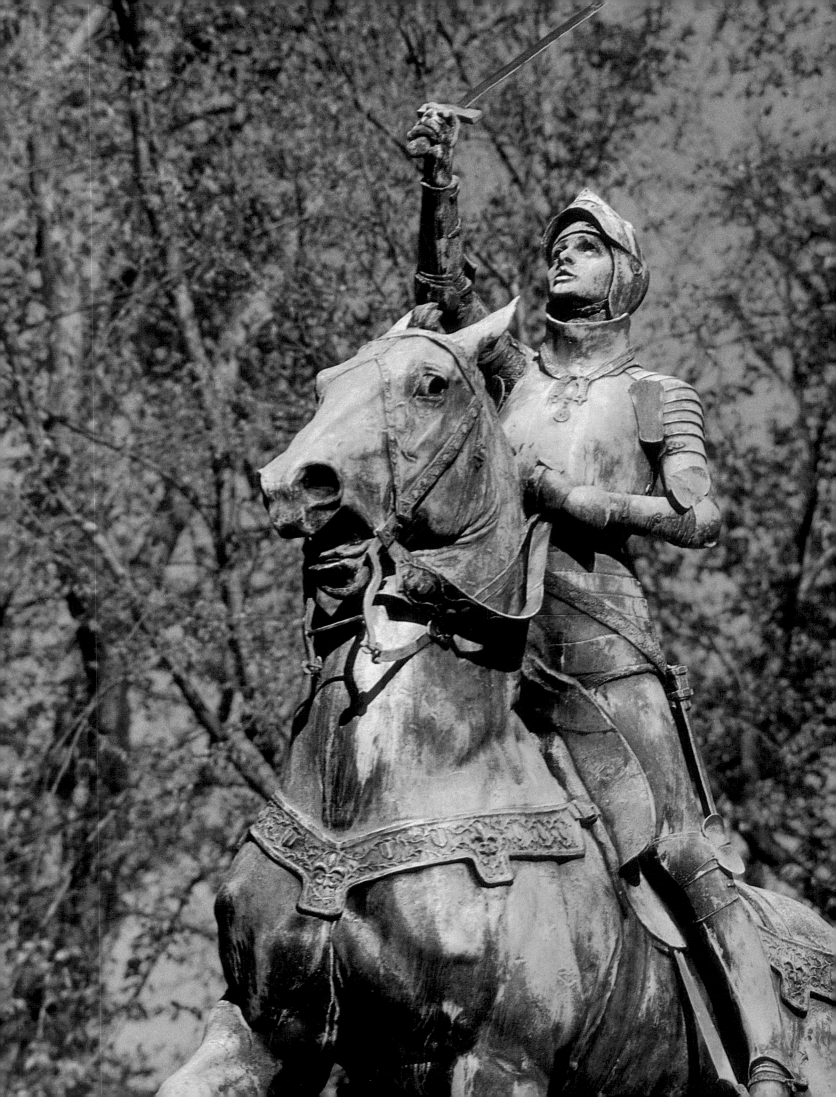

Inaugurating a Site

O N THE QUÉBEC PROMONTORY, time has lent value to space. It has shaped the spirit of the place, endowed it with character. Other eras and historic circumstances might have drawn a different image. If the southern part of the promontory became the Plains of Abraham, it was the work of the conqueror, the holder of power. He magnanimously proposed reconciliation, in memory of both generals who died as heroes. Through creation of the park, however, and in the stones of the fortifications and monuments, he indelibly inscribed the memory of his 1759 victory. He registered for time immemorial, in concrete and in nature, the event that legitimated and symbolized his power. By imbuing the site with meaning, he indicated where power lay and reinforced his own identity.

None of this was foreseeable. However, some hundred etchings have been published of the British victory of 1759; only one is known of the French victory of 1760, and it has never been published over the more than two centuries since. Nor is there a reminder that the Plains were used as a laboratory of the New World. In short, the symbolism presented on the Plains of Abraham follows only one of several paths; other meanings are possible. Over the years, depending on the situation, people have attempted to bend it to their advantage, in a variety of ways.

Festivities on the Horizon

This appropriation of meaning and character have been fixed in stone. However, they are manifested more openly during festivities or celebrations. In 1880, the Field Day on May 24 in honour of the queen and the Saint-Jean festivities of June 24 expressed the diversity of the issues played out on the Plains, illustrating the duality of aspirations with which the site has been invested. Through its impressive physical traits, the Québec promontory presents an image of strength that lends itself to embodying an ideal.

The inauguration of sites, monuments, or establishments is always accompanied by ceremonies and speeches that convey the meaning of the event. These manifestations can be more or less spectacular; in Québec City, in 1908, they aimed for the grandiose.

To justify the presence of a statue of Joan of Arc on the Plains of Abraham, the president of the Commission, supported by the historian Thomas Chapais, dedicated the monument to the courage of the soldiers of 1759 and 1760.

Invitation to the tricentennial of Québec City, 1908. (NBC)

242

At the beginning of the twentieth century, when the vocation of the Plains of Abraham had yet to be defined, a great anniversary was on the horizon, the tricentennial of the founding of Québec by Samuel de Champlain. The clerk of the city, a lawyer named Jean-Baptiste Chouinard, proposed a celebration of this anniversary, and invited the Société Saint-Jean-Baptiste de Québec, "which represents the founders of the French-Canadian nation," to plan the event. So that the moment would live on, he suggested that a park be created on the Plains of Abraham and that a museum or library be constructed. Convinced that the tricentennial of Québec City, the cradle of Canadian civilization, should be a national event, he hoped that all Canadians would take part.

The idea made sense: it was unthinkable that the three-hundredth anniversary of the founding of Québec City not be marked in a special way. The Société Saint-Jean-Baptiste de Québec asked the city's mayor, George Garneau, to convene a general assembly of the citizens of Québec, "to hand over to them the organization of said celebration." Some hundred people formed an executive committee and a sixty-member permanent committee with the mandate of drawing up a programme for the festivities as quickly as possible.

The executive committee formed a special committee the members of which represented the most prominent institutions: Monsignor Gagnon; Lieutenant-Colonel F.G. Scott, rector of St. Matthews Church; and the honourable Thomas Chapais, member of the provincial legislature. The committee was to prepare a request to the government of Canada, "asking it to take under its auspices the celebration of the three-hundredth anniversary of the founding of Québec as a national celebration involving all provinces of Canada, and requesting the support and assistance necessary to ensure its success." A five-member delegation, accompanied by a number of senators and provincial elected representatives from the Québec City region, went to Ottawa to present the request to the prime minister, Wilfrid Laurier, and his colleagues. Laurier was interested; he asked the committee to draft a bill, draw up a programme of the festivities, and submit a statement detailing the funds to be granted by the Canadian parliament. The delegates left this interview with the impression that their proposal had been favourably received.

The influential governor general, Albert George, the fourth Earl Grey, who had arrived in Canada in December of 1904, supported the proposal. An ardent imperialist, he had come to Canada very decided to nurture the blossoming of imperial sentiment and promote the development of closer ties between various parts of the Empire. Québec City was of great interest to him, particularly because he wanted to preserve the sites of Wolfe's victory. He encouraged the creation of a national park in memory of the victor of 1759; to mollify the local population, he suggested that it be linked it to another park, dedicated to the victors of 1760.

In January of 1907, a large delegation from Québec City went to Ottawa to meet again with Prime Minister Laurier and with members of parliament Fisher, Brodeur, and Lemieux, to request financial support from the federal government and to submit a plan for a major national exposition and construction of a national museum. Laurier promised a grant of at least three hundred thousand dollars, but he favoured the creation of a national park to preserve the historic battlefields of September 13, 1759, and April 28, 1760, over construction of a national museum. He pressed the delegates to promote, when they returned to Québec City, the idea of establishing a "truly national park with the goal of preserving for the public all the historic lands within its borders, and within which famous historic sites would be marked by inscriptions and monuments, in such a way as to create an open book that all who visit this place will find easy to read and understand." He also required the participation of the Québec government, which was ensured by premier Lomer Gouin.

In spite of these commitments, the idea of having the federal government involved in Québec's tricentennial celebrations seemed repugnant to Laurier. English Canadians would no doubt have preferred to celebrate the hundred-and-fiftieth anniversary of the victory of James Wolfe on the Plains of Abraham in 1909. At the end of March, 1907, just before he left for the imperial conference in London, Laurier explained to George Garneau, the mayor of Québec City and director general of the tricentennial executive committee, "the physical impossibility, given the lack of time, of presenting this motion to Parliament" before November. Laurier then asked Garneau to "delay the celebration to 1909" and reiterated his opposition to the creation of a national museum. When he returned home, Garneau

Monument des Braves in 1908. (NBC)

243

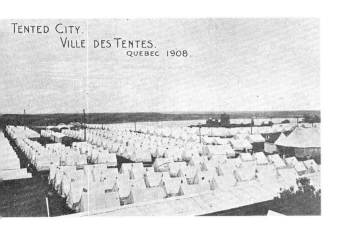

A "City of Canvas"

Québec City hotels could not lodge all the visitors who wanted to attend the tricentennial festivities, and so seven hundred and fifty white tents, which could hold thirty-two hundred people, were set up on the Plains of Abraham. This "city of canvas" faced Grande Allée, near the Protestant orphanage, and extended to the cliff. It had its own organization and institutions: information bureaus, post offices, railroad agencies, telegraph and telephone offices, a local market, convenience stores, and even police and fire stations. ❧

The tent city erected for the tricentennial of Québec City. (ANQ)

tried to convince the members of the executive committee that Laurier's position was well founded. Garneau was then invited to announce to the citizens of Québec City that the tricentennial was to be celebrated in the summer of 1909. . . .

Garneau tried to gain some time. In the autumn of 1907, he again approached Laurier. Two days later, invoking the inquiry under way into the collapse of the Québec bridge, the prime minister answered, "I regret to inform you that for the moment I cannot hold out hope that we will be able to continue with our project, and we will have to wait until the situation is clearer." Shocked, Garneau protested, "Have you asked yourself how this decision will be received in Québec, where the political situation is already so difficult? . . . Have you thought long and hard on what you are taking away from us now, after having justified and confirmed our hopes up to the last moment? . . . What reasons will the public find to explain this sudden change?" This letter must have been quite convincing, and additional pressure was undoubtedly applied by other prominent Québec citizens, for, in December of 1907, Laurier informed Garneau that the promised legislation would be submitted to Parliament "at the first free moment available to the government."

On January 10, 1908, in a major reversal, the representative of Governor General Grey, Colonel Hanbury-Williams, proposed that the festivities take place in August of that year. He revealed that both he and the governor general had always been in favour of commemoration of Québec's tricentennial in 1908, and that they had yielded before the formal wishes of the prime minister, "who felt that the major bridge should be inaugurated during the celebration of the tricentennial." With this strong support, the executive committee decided that Québec's tricentennial would indeed take place in 1908, and Garneau emphasized that a major part of these festivities would be the creation of a national park "in the care and under the auspices of the Québec Battlefields Association."

A Crowded Programme: Important Debates

Assured of the support of the governor general, certain that the budget for the celebrations would soon be adopted in the House of Commons, the executive committee had to work very quickly, for time was short. It was a large-scale project, and a complex task was ahead. The enterprise also had some particularly delicate aspects. The organizing committee had barely escaped having to hold the tricentennial of the founding of Québec in the year of the hundred-and-fiftieth anniversary of Wolfe's victory over Montcalm. As a compromise, it had agreed to use the tricentennial as a pretext for creation of a park evoking the memory of the 1759 battle.

The orientations of the festivities remained to be defined, and the committee wanted complete control. It had exclusive right of

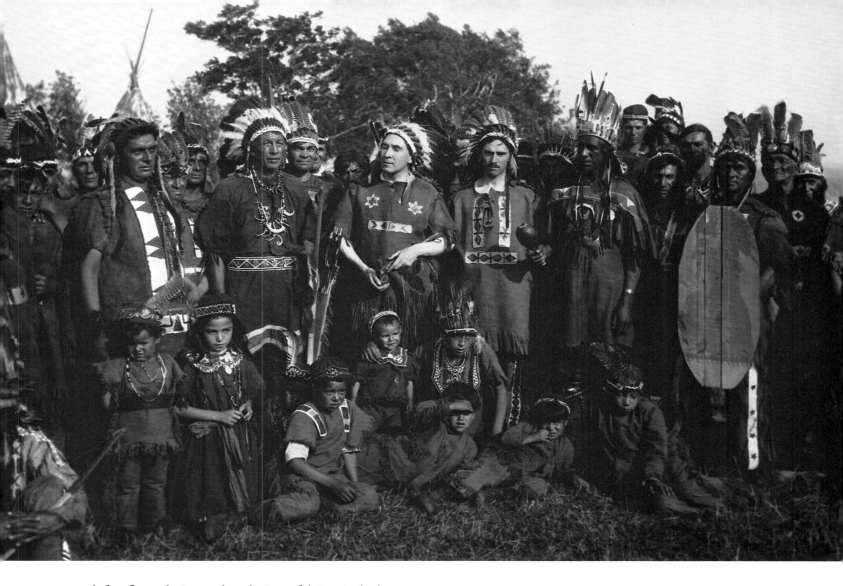

approval for float designs, the choice of historical characters represented, the costumes, the arms, the emblems, the banners. No float, no reminder of the past, no marching group could appear in parades, gatherings, or ceremonies without its approval. The main components of the programme of festivities was quickly put together. It was decided to strike a commemorative coin, and the issuance of eight commemorative postage stamps was requested, along with a great historical parade and a sail-by; the manufacture and placing of commemorative inscriptions and plaques was planned. There would also be an open-air high mass, a reconstruction of Champlain's *Abitation* in the lower town, guarded by soldiers in period costume, and a sail-by of warships in the port of Québec. Throughout the festivities, groups of sentries and heralds at arms would patrol the streets of the city. To top it off, there were plans for re-enactments of historic events on the Plains of Abraham.

These great displays had to be well orchestrated. The English director Frank Lascelles, a specialist in such productions, who had just organized a similar event in Oxford, England, was hired. For his show, he wanted the largest possible number of "savages." During this time, Governor General Grey ensured that the crown prince, the Prince of Wales, would attend the ceremonies, the king being unavailable. The festivities would thus take place in the presence of this concrete symbol of British power and majesty. Overflowing with enthusiasm, Grey wrote, "Québec is recognized as the cradle of an

The Aboriginals at the Québec Tricentennial

I n response to the wishes of director Frank Lascelles, who wanted aboriginals to take part in the historical pageants, the Canadian Pacific Railway agreed to transport to Québec City "a contingent of 100 Algonquin savages supplied with their war costumes, arms, tepees or tents, canoes, etc.," and to take charge of and answer for their good behaviour, for the sum of fifty-five hundred dollars. ༝

Aboriginal extras during the great historical pageants on the Plains. (NAC)

Recalling the Meaning of a Festival

O n 7 July 1908, journalist Omer Héroux wrote, in L'Action sociale,
 In this tribute by the young, it is the people of Québec, the entire French-Canadian nation, that will feel its heart beat and its soul quiver. . . . Before the tribute made by the great personages of the country and the English-speaking Canadians, before that of the Prince and ambassadors, will be the salute, affectionate and family oriented, of those who, through blood, traditions, and beliefs, hold the revered ancestors closest. . . . We will feel more clearly that although Champlain belongs to humanity, although he has the right to the homage of Canadians of all origins, he belongs first and foremost to men of his race and his faith. ✌

The mass on the Plains during the tricentennial of Québec City. (ANQ)

expanded Great Britain." On the other hand, during the debate on the bill, a young Québec nationalist, the lawyer Armand Lavergne, reminded the House that it was the tricentennial of Québec that was on the agenda; it was thus the memory of Champlain and not of Wolfe that should be honoured on this occasion. However, Lavergne voted in favour of the bill.

The Prince of Wales was due to arrive in Québec on July 22. It was now the beginning of April. There were only three and a half months to put together festivities that would last more than a week and do justice to this anniversary. It was a gargantuan task! A grand historical pageant had to be prepared, with forty-five hundred costumed actors; rehearsals had to be arranged; provisions for lodging fifteen thousand soldiers and hosting illustrious guests and thousands of spectators had to be made; official ceremonies had to be planned, visitors had to be housed, and so on.

For his part, Frank Lascelles scrambled to recruit actors and extras for his great historical pageants, but he was having a hard time. The French-speaking citizens of Québec City told him that they wanted no part of a show that they felt would only glorify the British conquest. With the organizers as his witnesses, Lascelles promised a completely French show, telling only the story of the French in Canada. Reassured by his words, people stepped forward.

The Catholic church also lent its support to the project. On June 24, 1908, Louis-Nazaire Bégin, the archbishop of Québec, addressed a pastoral letter to all of his diocesans, announcing that on July 3, the anniversary of the founding of Québec, "we will sing, in all the churches of the diocese, a grand mass of thanks in honour of St. Joseph, first patron of this country, to thank God for the protection He has granted us through the intercession of this great saint." On Sunday, July 26, as part of the tricentennial celebrations, a mass would be celebrated in the open air on the Plains of Abraham, and "We will sing in all the churches of the diocese, after the grand mass, or during the main mass in the community chapels, a *Te Deum* in thanks to God for the gift of faith and the prosperity of our country, and pray to Him to continue to accord to the Canadian people the protection they need to remain, as they have these last three centuries, faithful to the Catholic church and to its divine teachings."

Henri Bourassa, a journalist and political activist, remained skeptical. He was convinced that all of these festivities would serve to glorify the British Empire. He wrote to his friend, Goldwin Smith,

> In my soul, there is not a shadow of a doubt, knowing Lord Grey as I have learned to know him in Ottawa, that he decided, from the beginning, to transform the celebration of the birth of Québec and of French Canada into a grand historic reminder of the Conquest in order to show his imperialist friends in London that the new imperial religion has made progress among French Canadians. His second objective consists of affecting the spirit of French Canadians by rubbing their noses in the notion of imperial grandeur. Very adroitly, he has played on the sensitive cord or the weak spot of our political representatives: their vanity. He has thus managed to bring together a good number of people who never have been and never will be imperialists to take part in this great comedy.

The meaning of the festivities was a subject of debate up to the end. One group evaded the controls put in place by the Commission, and proclaimed the true significance of the event. The Québec-region members of the Association de la Jeunesse canadienne-française began celebrating two days early. Young people from Québec City and the environs came to pay homage to Samuel de Champlain, the "father of our country," by placing flowers at the foot of his monument. The crowd massed around the monument, barely contained by a platoon of cavalry and a police cordon, applauded long and loud, and *O Canada* was sung. According to the group's president, this "expression of legitimate pride that the memory of our heroes inspires in us" and "the solemn affirmation that their memory will never die in our souls" was well received. The next day, *l'Action Sociale* concluded, "In the next few days, Québec will perhaps see more carefully, richly organized festivities than yesterday's gathering; it will never see, we believe, a better event for its spontaneity, its profound significance, and its great symbolism."

The Great Festivities
of the Tricentennial of Québec

O N TUESDAY, JULY 21, numerous official guests were greeted
with great pomp. At the port of Québec arrived French
government representatives Admiral Jauréguiberry and fede-
ral judge Louis Herbette; they were accompanied by the
mayor of the town of Brouage, Samuel de Champlain's birthplace,
Count Bertrand de Montcalm, the Marquis de Lévis, and the
Marquis de Lévis Mirepoix. France's consul general at Montréal, Mr.
de Loynes, joined them that day. Vice-President Fairbanks of the
United States also arrived. From an English ship debarked
representatives of the British Empire: the Earl of Dudley, from
Australia; the Earl of Ranfurly, from New Zealand; and Henry de
Villiers, from the various provinces of South Africa. Making the same
voyage were George Wolfe, from General Wolfe's family; Arthur C.
Murray, from General Murray's family; Dudley Carleton, from the
family of governor Guy Carleton; and Lord Lovat, from the Fraser
Clan. Prime Minister Laurier arrived by train with an entourage of
members of his cabinet, members of parliament, and senators.

The forty-five hundred actors and extras in the eight great his-
torical pageants on the Plains of Abraham paid no attention to the
arrival of these dignitaries, for they were deep in preparation for their
first performance. Director Lascelles gave his final advice. Ernest
Myrand made sure that the dialogue was respected and stood in the
wings ready to prompt those who hesitated. It was too late to stop
now; everything had to be perfect. Joseph Vézina, responsible for the
music, gave his musicians a pep talk. After so many hours of work,
there was no room left for doubt. And now the public began to
arrive. The price of tickets was high; to Thomas Chapais, who had
expressed the hope that admittance would be free, Adélard Turgeon,
an executive-committee member, replied that if people were let in at
no charge, "the festivities would necessarily be less beautiful." A seat
on the large bleachers, capacity fifteen thousand, cost between one
and two dollars. Children were admitted for twenty-five, fifty, or
seventy-five cents. At first slowly, then rapidly, the seats were filled.
There would be a full house, that was certain.

At five o'clock in the afternoon, the most eagerly awaited event
of the tricentennial celebrations—but also the most costly and the
most difficult to produce—began: the great historical re-enactments

A tricentennial banquet. Standing: Colonel Turnbull,
Mgr. Mathieu, Lord Howick, Mr Borden, Sir Wilfrid
Laurier, Sir Charles Fitzpatrick, Lieutenant-Governor
Fraser, Mgr. Laflamme, L.A. Taschereau.
Sitting: Marquis de Lévis Mirepoix, Captain A.
Murray, Bertrand de Montcalm, George Wolfe,
Marquis de Lévis, Lord Lovat, Captain D. Carleton,
Lord Bruce.

The commissioners in front of
the Monument des Braves

Artist Charles Huot designed the costumes for the historical characters re-created to commemorate the history of Québec City. Jacques Cartier, a woman farmer, hunters. (Water colours, NBC)

on the Plains of Abraham. It had taken much tact and diplomacy to bring Frank Lascelles over, and the recruitment of players had been difficult. Finally, it was the big day! The spectators were impatient.

Silence fell: it was time for the show to begin! Here was the village of Stadacona under the lights. The aboriginals living there got busy, because a ship was arriving. It was Jacques Cartier, with his crew. On the river shore, the explorer planted a cross decorated with fleurs de lys, in the name of the King of France. Then, to the aboriginals gathered around him, he began to read the Gospel according to St. John and cured their illnesses by laying on of hands. Thunderous applause. Lascelles seemed to have kept his promise. Now, here were the Fontainebleau gardens; King François I, surrounded by horsemen, listened to Cartier's report on his discovery of Canada, which was so well delivered that fresh applause broke out. And so the first great historical pageant was a great success. But it wasn't over yet; seven others were still to come.

Soon, a goateed Samuel de Champlain made his appearance, to found Québec; the Iroquois welcomed him with the peace-pipe dance. The Ursulines and the hospital nuns arrived in their turn. Then, at Long Sault, here was Dollard des Ormeaux and his young companions fighting to save the colony. More scenes followed. Here was the reception that the bishop of Québec, François de Montmorency Laval, accorded the lieutenant-general of the French armies in America, the Marquis de Tracy, and his twenty-four guards. The costumes were beautiful! This was the work of artist Charles Huot. Now we travelled to the West, where Simon-François Daumont de Saint-Lusson took solemn possession of this land in the name of the King of France; the representatives of fourteen First

Nations pledged their fidelity to the King of France and the entire assembly chanted the *Te Deum*. Then it was back to Québec to see governor Louis de Buade de Frontenac give his proud response to William Phips's emissary. And so went the first seven great historical pageants, each as impressive as the next.

Now only one pageant was left. The story could only end with the fall of the French régime. Rumour had circulated that the last pageant would be the confrontation between Marquis Louis-Joseph de Montcalm and Colonel James Wolfe. A peek at the manual for participants revealed:

> Pageant eight, set thirteen: great parade of honour. Montcalm and Wolfe, Lévis and Murray, Carleton and Salaberry, at the head of their respective regiments, march to the boom of the cannon and fanfares. General salute by the troops, responded to by salvos from the warships anchored in the harbour. Gathering of all characters of the historical cortege and the pageants. Singing of the national anthems: *O Canada* and *God Save the King*. Salute the flag.

The French and English troops marched side by side, but the colours of the English flags seemed more lively, more flamboyant. Indeed, as the "souvenir-book" committee wrote of the jubilee festivities, this parade of honour put "in a splendid light Wolfe and the conquerors of 1759" and showed, "as was befitting, the brighter colours of the flag that will be our future." In short, this was a celebration of the victor without displeasing the vanquished. The writers added that this parade showed "that harmony is possible between the two races, French and English, through the bringing together of their flags." The crowds leaving the Plains were apparently satisfied.

Actor in the role of Samuel de Champlain. (NBC)

251

The Ships in the Port

Québecers could visit the port of Québec to admire six British warships: four combat vessels, the *Exmouth*, the *Albermarle*, the *Russell*, and the *Duncan*, and two cruisers, the *Venus* and the *Arrogant*. From the port, one could also watch two French warships, the *Léon Gambatta* and the cruiser *Amiral Aube*, arrive. The combat vessel *New Hampshire*, representing the United States, was also expected. ✄

The ships anchored in front of Québec City for the city's tricentennial festivities. (NBC)

The great military review on the Plains on July 24, 1908. (NBC)

Extras for the historical pageants. Montcalm's and Wolfe's soldiers. (NBC)

Grand Naval and Military Review
before H. R. H. The Prince of Wales
Quebec July 24th 08

On Wednesday, July 22, the representative of the King of England, the Prince of Wales, arrived. At two in the afternoon, his ship docked at the king's quay, escorted by the cruisers the *Indomptable* and the *Minotaure*. At the Citadel, there was a twenty-one-gun salute. In conformity with naval rules, the admirals greeted the prince first, followed by the governor general and the Canadian prime minister, accompanied by numerous dignitaries. Then he made his way to his quarters in the Citadel, escorted by a mounted troop.

Thursday, July 23, was the day dedicated to Samuel de Champlain. At three o'clock in the afternoon, a crowd massed on the shores of the St. Lawrence. A replica of Champlain's ship, the *Don-de-Dieu*, was sailing on the river in front of Québec. Champlain and his crew alighted on the Finlay Market quay, dressed in 1608 costumes. The crowd was jubilant: Samuel de Champlain had returned! Yes, he seemed to recognize his city, and he quickly made his way to the replica of the *Abitation*, the first building he erected in Québec. After visiting his first residence, he was escorted by Jacques Cartier and his men to his monument on the edge of Terrasse Dufferin. There, the Prince of Wales greeted him and his men and declared the festivities of the tricentennial officially opened. Cannons boomed at the Citadel. George Garneau welcomed his Royal Majesty and the representatives from France, the United States, and Canada, and then the telegrams exchanged between Garneau and the King of England were read aloud.

The great historical parade began to wend its way through the streets of Québec, with the sentries and the heralds at arms leading the way. Following the coat of arms of France, Jacques Cartier came next, accompanied by the 110 sailors of his crew and a great number

The historical pageants. Monsignor de Laval receives the Viceroy of New France, Marquis de Tracy. (NBC)

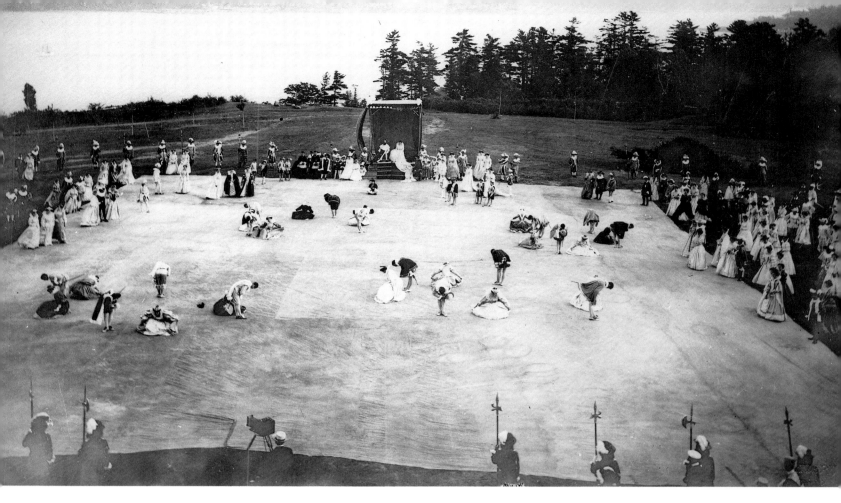

of aboriginals. And then came, in all his splendour, King François I, mounted on a steed, followed by Queen Claude, the King's beloved sister, Marguerite d'Angoulême, and the ladies and gentlemen of the court, all richly dressed in sixteenth-century costumes. Henry IV, his minister of finances, the Duc of Sully, Marie de Medici, and the knights followed in their turn.

The crowd applauded as they passed. Never had the streets of Québec been so adorned. "The city was literally enveloped in banners, draperies, and bunting." From almost every window flew the fresh, lively colours of the flags of Sacré-Cœur, Canada, England, France, the United States. Streamers softened the façades of public buildings and head offices of business and industry; they ran along ledges, framed escutcheons, floated around flag standards, and fell in elegant folds. At corners of main streets rose arches draped with fabric or decorated with inscriptions; Venetian masts flew a wide variety of colours along avenues and in public squares. All of this decoration gave the city an air of grace.

Now it was the turn of the true founders of the French empire in America: Samuel de Champlain, accompanied by François Gravé Du Pont and Sieur de Monts. They joyfully paraded, followed by the crew of the *Don-de-Dieu* and the first colonists: Guillaume Couillard de Lespinay, Pierre Chauvin, surgeon Florent Bonnemere, Captain Testu, Étienne Brûlé, Antoine Natel, Nicolas Marsolet, and Claude de Godet Des Maretz. After Dollard des Ormeaux and his sixteen companions came the discoverers and founders of cities: Sieur de Laviolette, Paul Chomedey de Maisonneuve, François de Bienville, Pierre Le Moyne d'Iberville, Antoine Laumet de Lamothe de Cadillac, René-Robert Cavelier de La Salle, Louis Jolliet, Jacques

Champlain receives his orders from Henry IV (NBC)

The Families of Old Stock

On the occasion of the tricentennial of Québec, a committee took a census of families to find those whose property had been transferred from father to son for at least two centuries. On September 23, a ceremony was held in Université Laval's auditorium, attended by the lieutenant governor, the premier of Québec, the auxiliary bishop of the diocese of Québec, the superintendent of public education, and Lieutenant H. Lanzerac, representing the old military and Catholic France, at which commemorative medals were handed out to 227 representatives of families of old stock.

In turn, each family member came forward to receive a medal from one of the dignitaries. The medal, of solid silver covered with gold, was shaped like a cross, the arms of which held a large golden wreath of maple leaves. In the centre of the cross, a green-enamelled shield bore the heraldic device of the farmer: Par l'épée, par la croix, par la charrue. On the reverse was inscribed the occasion—the tricentennial of Québec—the name of the head of the family honoured, and the year, 1908. The medal was attached to a soft-pink silk moiré ribbon, striped lengthwise with two bands of gold.

Several months later, forty-six more families were found to have a right to the cross of honour, and there was a second ceremony. ♥

Watercolour by Charles Huot (NBC)

256

Marquette, Jean de Quin, and Pierre Gaultier de Varennes et de La Vérendrye. Behind them, yes, it was indeed Marquis de Tracy and his counsellors, officers, and the rest of his entourage, composed of twenty-four guards, six pages, and four companies of the Carignan-Sallières regiment. And here were the *coureurs de bois* and their interpreters, dressed as if they were leaving tomorrow.

The characters from history succeeded each other for almost two hours. Here was Governor Louis de Buade de Frontenac, surrounded by members of the Conseil souverain, followed by the militiamen of René Robineau de Bécancour. Wild applause greeted the appearance of a young heroine, Madeleine de Verchères, dubbed the Joan of Arc of New France, surrounded by her brothers and followed by aboriginals. From afar, the military men were approaching in their bright uniforms, with Montcalm and Lévis at their head. Banners flapping in the wind, the regiments of la Sarre, Languedoc, Béarn, Guyenne, Berry, and Royal-Roussillon marched by. Wolfe and Murray were accompanied by their officers, Amherst, Anstruther, Lascelles, Kennedy, Bragg, and Otway. The Grenadiers of Louisbourg, the Royal Americans, and the Scottish Highlanders were also in the parade, as were Guy Carleton and those who defended Québec against Montgomery and Arnold in 1775. The parade finished with Charles-Michel d'Irumberry de Salaberry and his three hundred *Voltigeurs* who fought off the Americans at Châteauguay in 1812.

At the end of this beautiful summer day, people went home sated and satisfied. The historical procession, in the works for two years, had left no one disappointed. In the evening, spectators went to Terrasse Dufferin, Parc des Gouverneurs, and the Plains of Abraham for a formidable fireworks show set off from ships anchored in the port and the heights of Lévis. The next day, there was a great military and naval review, which drew a huge crowd to the Plains. No fewer than fifteen thousand Canadian, French, British, and American soldiers and ten thousand sailors, as well as a large contingent from the Royal North West Mounted Police, paraded before the Prince of Wales in his place of honour.

The festivities lasted for another week, with receptions, balls, military reviews, concerts, regattas, symbolic tree plantings, and parties for children. The departure of the Prince of Wales was marked by church bells ringing in full peal and cannons fired on the Citadel and by the British navy, signifying the official end of the tricentennial of Québec. The good weather had held the entire time. Praises were sung of the organizers of the event and the participants in the great pageant on the Plains of Abraham. Completely satisfied, Lord Grey wrote to the English prime minister, Lord Chamberlain, "We are justified in hoping that a new imperialism will blossom in Québec."

Such attempts to appropriate the meaning of festivities and of the place itself have continued, in various forms, up to the present. On the Plains of Abraham, celebrations of the Québec *Fête nationale*, which have been rife with wit and inventiveness, are a good illustration of this. Even some Americans have made their mark.

Lieux habitants 1865.

Other Commemorations

*I*N OCTOBER OF 1975, a few hundred Americans came to the Plains to re-enact Arnold and Montgomery's attack on Québec in 1775. They decided to do this during the pleasant days of Indian summer, rather than awaiting the frigid nights at the end of December. They came by car, but they followed the route the troops had taken two hundred years earlier. Once they crossed the bridge to Québec, "these strange Americans, dressed in period costume, marched to the Plains on foot, to the beat of a drum." On Saturday, October 4, "impassive but captivated, thousands of Québecers watched a simulated battle. Cannon and rifle shots echoed throughout the upper town, and the script was followed with the realism of the best war films."

The Americans . . . Two Hundred Years Later

This historical re-enactment had been organized by the Arnold Expedition Historical Society with the goal of rehabilitating the memory of Colonel Arnold. After directing a colonial army, Arnold had taken sides with England against the colonies, a move that painted him with the brush of treason in the eyes of the United States. This re-enactment, claimed to be the largest ever held, had been long in the preparation by several American historical societies. Paradoxically, it was presented as a "prelude to the bicentennial celebrations of American Independence"; the site was a natural, since Québec had been slated to become the fourteenth American colony. An organizer mentioned three other reasons for conducting this exercise: to recall the courage and bravery of the soldiers, to preserve the route taken by Arnold in its original state, and to celebrate two hundred years of being good neighbours with Canada. The expedition, its director added, would enable the participants to rediscover the spirit and values for which the troops had fought; this should not be seen as simple child's play.

The *Fête Nationale*

The *Fête nationale* for Québec, on June 24, and Canada's Dominion Day, on July 1, also had an inherently commemorative dimension. They marked the birthday of a community, let people ex-

In a natural setting, the monument to Sir George Garneau. Trees shade a stone laid in honour of an officer struck down on the battlefield of September 13, 1759.

In 1975, Americans came to Québec City to commemorate the expeditions of Arnold and Montgomery two centuries earlier. (NBC)

The Saint-Jean festivities, 1991: a bonfire that turned
into a tragedy.

press their attachments, reaffirmed the feeling of belonging, and re-
newed allegiances.

On the Plains, the *Fêtes nationales* have been celebrated with
variable regularity and intensity, but more frequently since the 1960s.
Almost every year, the traditional Saint-Jean bonfire is a counterpoint
to the fireworks of the first of July. One celebration features theatre,
popular, traditional, and children's music, puppet shows, and variety
shows. For the other there are hot-air balloons, kite-flying demonstra-
tions, parachute jumps, clowns, and open-air concerts. These per-
formances are always enchanting, though some spectators enhance
the experience by warming their hearts with alcohol and friends. The
crowds are not always large, even when the festivities have a particular
significance. The shows in a park on the edge of the city provide an
opportunity to cut loose, and they always draw a good number of
people. The great pitiless arbiter of this revelry, however, is most
often Mother Nature.

The Monuments

Another form of communication, more subtle than that of the
celebrations, expresses the spirit of the place: the objects that have
been placed on the Plains of Abraham. Commemorative monuments
and plaques tell the story of the site; the words they bear describe
personalities and express a facet of the identity of the Plains.

When Battlefields Park was created, there were already a number
of monuments attesting to the history of the Plains and of the
Québec community. Defensive military installations, constructed in
the nineteenth century, dominate the landscape. The Martello towers

Friendly rivalries.

261

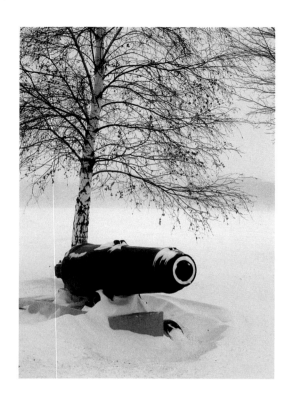

and the Citadel walls, the oldest vestiges, are impressively massive. But the strength of the stone itself is sometimes matched by the weakness of its significance. The most impressive remains are those of the temporary citadel at Cap-aux-Diamants, constructed between 1779 and 1783. However, by the mid-nineteenth century, the English military referred to them as old French fortifications; having forgotten their own work, they attributed it to others. The use of the towers has not always clearly expressed their purpose; one was used as an observatory, another as a residence, for a number of years.

In counterpoint to these imposing military remains are two other large buildings: the old prison, which is now the second wing of the Musée du Québec, and the main building of the museum itself. These two structures, architectural works reflecting their respective time and function, are today dedicated to art and culture. The museum's collections seem to have an inexhaustible eloquence, through works of art of various shapes, eras, and provenances.

As well, Battlefields Park has seven monuments marking major events or historical characters associated with the site. Four of them concern military history: the Wolfe Monument, the Monument des Braves, the Joan of Arc monument, and the Croix du Sacrifice. There are also a monument dedicated to George Garneau, chairman of the National Battlefields Commission from 1909 to 1939, the Centennial Fountain, and, on a smaller scale, the sundial.

The Wolfe Monument

The first monument dedicated to General James Wolfe was the boulder that his soldiers rolled to the spot where he fell in 1759. In 1832, governor Lord Aylmer had a small truncated column erected on the site. Soon after, however, this first true monument to the memory of Wolfe deteriorated, and in 1849 the British army replaced it with a column topped with an antique helmet and sword. Inscribed on the pedestal was "Here died Wolfe, Victorious, Sept. XII, MDCCLIX." In 1913, the National Battlefields Commission had a third monument to Wolfe constructed, preserving the top pieces and the inscription from the previous one. Fifty years later, on March 29, 1963, as the Québec nationalist movement was gathering strength, this symbol of the Conquest was destroyed "by vandals." In July, 1965, the Commission inaugurated a new one, a Doric column 11.5 metres high, topped with the same antique helmet and sword.

The Monument des Braves

In 1855, the Société Saint-Jean-Baptiste de Québec purchased the land where the remains of soldiers who died in the 1760 battle were resting. On July 18 of that year, there was a long funeral procession and several thousand people witnessed the laying of the cornerstone of a future monument to the memory of the soldiers of

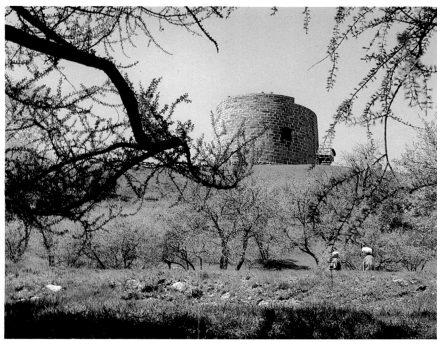

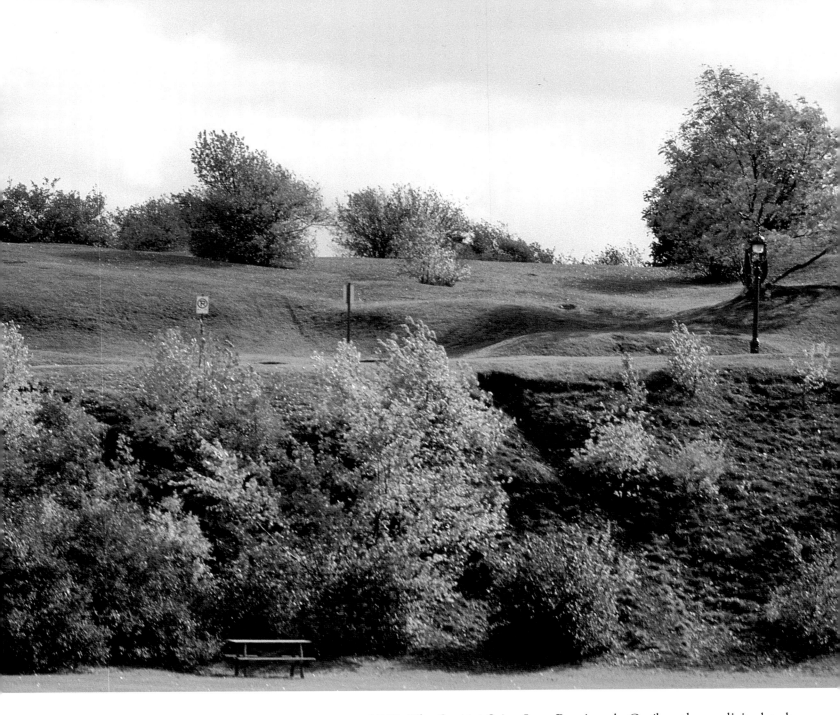

Autumn Landscape.

1760. The Société Saint-Jean-Baptiste de Québec then solicited public donations for realization of the Monument des Braves, designed by architect Charles Baillairgé. In 1860, on the centennial of the battle, the stone base of the monument, made of rock from the Deschambault quarries and carved by the mason Joseph Larone, was erected. A year later, a fluted bronze column, cast in Québec at John Ritchie's foundry, was put in place. After his visit to Québec, Prince Jérôme-Napoléon, uncle of Emperor Napoleon III, donated a statue of Bellona, Roman goddess of war, to crown the monument.

The Monument des Braves was officially inaugurated on October 19, 1863. It measures twenty-two metres; the statue itself is three metres high. Bellona carries her lance and shield and is turned toward the part of the battlefield that had been occupied by the French. On the cenotaph that serves as the statue's base, there are four bronze mortiers. Two plaques adorn the façades of the pedestal, one bearing Lévis's name and the other Murray's. On another façade is a repro-

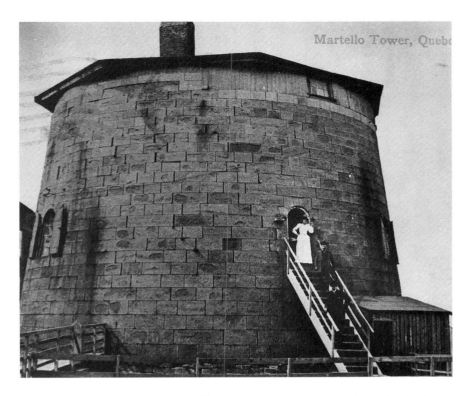

Martello Tower, Quebec

duction of the Dumont mill. On the opposite side, which faces Chemin Sainte-Foy, is the inscription "Aux Braves de 1760. Érigé par la Société St-Jean-Baptiste de Québec, 1860."

Rather than a tribute to the military superiority of one or the other nations once joined in battle, the Monument des Braves was intended as a symbol of reconciliation and peace. On this land rest side by side, without distinction, soldiers and militiamen, aboriginals, French and English, Catholics and Protestants. In 1910, the Société Saint-Jean-Baptiste de Québec donated to the National Battlefields Commission its land and its monument to create Parc des Braves.

The Joan of Arc Monument

The statue of Joan of Arc rests on a single block of stone weighing twenty-eight tons, cut from rock of the Notre-Dame mountain range in the United States. The donors wished to remain anonymous. The monument was inaugurated on September 1, 1938, and paid "homage to virtue, valour, and glory, on the very land that soaked up the blood of heroes fallen for the glory of their country." Historian Thomas Chapais, acting premier of Québec, explained the significance of this monument on behalf of the commission:

> Patriotism and courage! In other words, through bronze and granite, this monument is the glorification of heroism, embodied in one of the most radiant figures in history. Has heroism not written one of its immortal pages in this historic site? A few feet from here, a hundred and seventy-nine years ago, two illustrious warriors spilled their blood for their countries, and through their sublime devotion, Wolfe and Montcalm, conqueror and vanquished, entered the pantheon of history together. . . . This is the link that connects the two apotheoses, that of Joan of Arc and that of the two heroes of 1759.

Various Uses of the Martello Towers

Three of the four Martello towers erected on the "Heights of Québec" between 1805 and 1823 are still standing. Towers 1 and 2 are situated within National Battlefields Park; Tower 4 is on Rue Lavigueur. Tower 3 was demolished in 1904–05.

One of the towers served as a family residence for many years. Another was used as an astronomical laboratory and attracted thousands of visitors. In 1985, Tower 2 became a reception centre, with an exhibition on the history of the National Battlefields Commission and of the park itself. Towers 1 and 4 house memorabilia of the 1759, 1760 and 1775 battles, as well as documents on the origin and architecture of Martello towers. ✌

Martello tower 4 as a residence. (Photo: K. Elder, NBC)

The Parade in Honour of the Soldiers

The newspaper of July 20, 1855, reported that at least twenty-five thousand people attended this event. " A little after noon, an influx of people arrived from all points in the centre and faubourgs of the city to flood the heights of the Esplanade, in the middle of which was to form, at one o'clock, the funeral procession. Soon, these positions, as well as the lateral streets and Rue d'Auteuil, not to mention all the windows which, from the latter street, gave onto the square, were literally filled with people. . . .

The length of Rue St-Jean was filled from end to end by the brightly coloured parade. The street was decked out, and draped across it were painted streamers decorated with devices; it was bordered with two parallel lines of trees aligned on each side." ❧

Avenue des Braves and Monument des Braves.

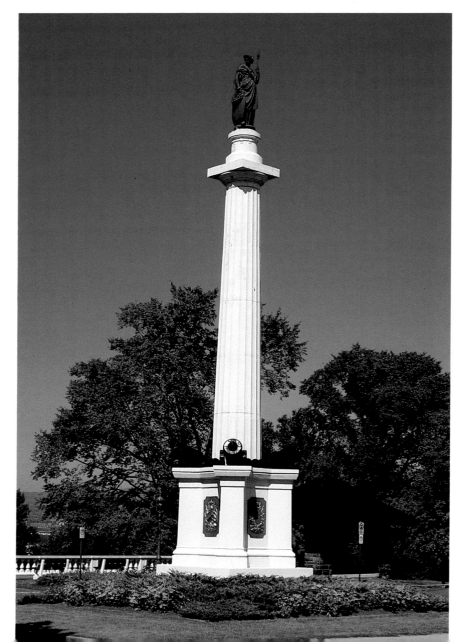

The Croix du Sacrifice

At the end of the First World War, monuments were raised to honour the war dead in many cities. In Québec City, prominent citizens donated funds for the Croix du Sacrifice, which was inaugurated on July 1, 1924. Erected on a small knoll at the entrance to the Plains, it paid tribute to the memory of sixty thousand Canadians, including two hundred and nineteen Québec City citizens, who died during the First World War. It was inscribed, simply, "À nos morts de la grande guerre. To the citizens of Québec who fell in the great war." At the end of the morning, in the presence of members of the Royal 22nd Regiment, H.M.S. *Valerian,* and a guard of honour composed of more than two hundred veterans, the governor general, Julian Byng Baron de Vimy, pulled away the flag that covered the cross. Silence was observed for two minutes, then the foot of the monument was covered with wreaths. In the autumn of 1947, a new dedication ceremony and blessing of the Croix du Sacrifice was organized to honour those who died in the Second World War. Finally, soldiers fallen during the Korean War received the same honour for their sacrifice.

Joan of Arc in her garden.

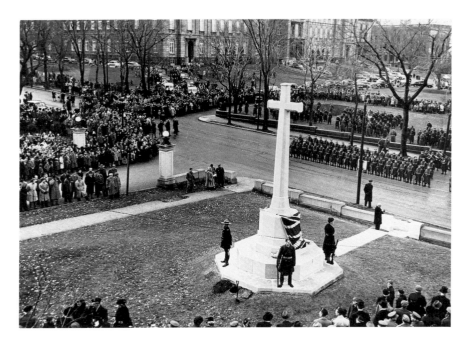

Each year on November 11, the anniversary of the armistice and Remembrance Day, war amputees, veterans, dignitaries, and military personnel pay homage to those who have fallen on the field of honour. After the general salute of the guard of honour, the bugler plays *Aux Champs*, while all the officers salute. Then there is a cannon volley and the bugle sounds the *Reveil*. After two minutes of silence, a guest of honour places the first wreath of flowers at the foot of the monument; after him comes the mother of honour, then the president of the Association des Anciens combattants. The honour guard plays appropriate music as the other dignitaries lay their wreaths, most of them made with poppies. After reviewing the veterans and war amputees, the guest of honour stands before the cross and the honour guard sings *O Canada*.

The Monument Sir-George-Garneau

The Monument Sir-George-Garneau was unveiled on September 7, 1958, by the National Battlefields Commission. To celebrate the fiftieth anniversary of its foundation, the Commission wanted to honour its first chairman, who had worked for more than thirty years, from 1908 to 1939, "to create and beautify a park that will ever be the pride of our lovely city." On this occasion, the president of the Commission, L.-J.-Adjutor Amyot, and two committee members, Monsignor Maheu and the representative Price, made speeches. George Garneau's son, Léon Garneau, expressed the gratitude of his family.

Monument Garneau

The Croix du Sacrifice, a tribute to Québecers who gave their lives during the wars of the twentieth century. (ANQ)

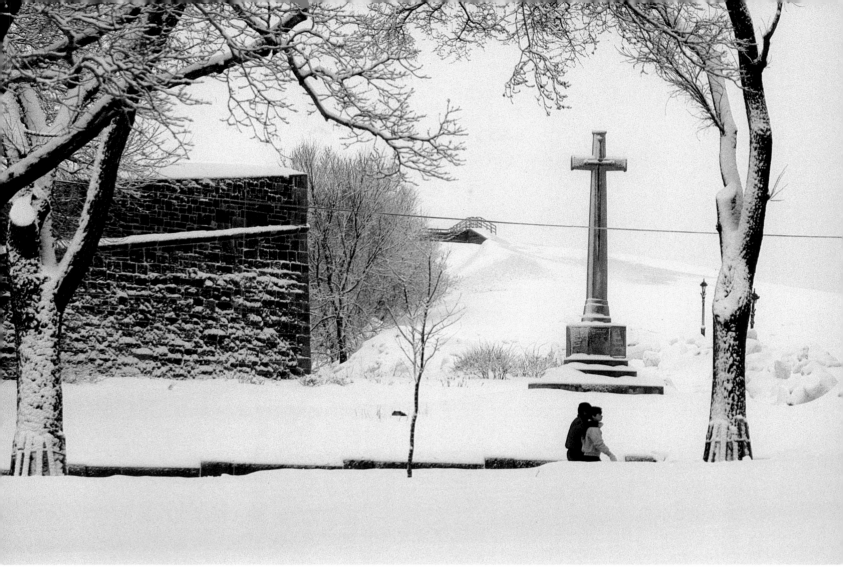

The Centennial Fountain

To commemorate the centennial of Canadian Confederation, a lit fountain was erected in 1967 on the land once occupied by the Québec Observatory. It has two basins, the larger of which is twelve metres in diameter, and seven water jets, one of which rises about nine metres. To respect the dignity and serenity of the Plains, only white lights illuminate the fountain. It has been placed at a spot where there are no important summer or winter recreational activities. Far from the road, it is more visible to pedestrians than to motorists.

The Sundial

The most recent monument is the sundial, which was erected in the summer of 1987. Designed by surveyor and geometer Rafael Sanchez, it is placed not far from the Centennial Fountain and sits on a table of pink granite. The sundial is different from most others in Québec because it indicates, almost to the minute, Daylight Savings Time—the time in Québec from April to October. To create the shadow, Sanchez replaced the traditional single metal wire with an aluminum prism, with two fins. The computer-manufactured shadow table is elliptical and has one thousand points corresponding to every ten minutes of the first and fifteenth days of the months from May to October. The months are marked by different colours. After iden-

The Croix du Sacrifice

Centennial Fountain

269

tifying the elliptical line of the current month, the observer notes the hour at the point of intersection created by the shadow.

The decision to install a sundial denotes an interesting change. Here is a monument that does not relate to war. It cannot help but recall the long-ago era when the site of the Plains was used as a laboratory of the New World. It also suggests the power that mastery of time has long symbolized, as represented in church clocks, plant sirens, and the sphere in the astronomical observatories. In this space of incomparable richness, the sundial evokes time and its infinite divisions.

Commemorative Plaques

In 1908, on the occasion of the tricentennial of Québec City, the National Battlefields Commission had twenty-seven commemorative plaques made, which were placed throughout the city to mark important historic sites. Over time, twenty more plaques have been placed within the territory under the Commission's jurisdiction. However, a certain number of them were destroyed and have not been replaced. Today, the Commission has fifty-two plaques, twenty-six of them on the Plains.

On the Plains, one of the most explicit and durable forms of communication is the inscriptions cast in the bronze of plaques attached to granite steles. These small steles fit with the sobriety of the park, respecting the primacy of nature and providing an intimate form of dialogue.

The inscriptions create a durable memory of the essence of the site's existence. The texts strike a balance between facts and their underlying ideologies. A large number, obviously, relate to the battles of 1759 and 1760, but there is also reference to the American attack of 1775, to the soldiers who died in twentieth-century wars, to the anthem *O Canada*, sung for the first time on the Plains, to the Hurons, to the 1938 Eucharistic Congress, and to Joan of Arc. The subjects of the death of Wolfe on the Plains, the English victory of 1759, and the French victory of 1760 take up an equal number of plaques, placed in different spots. The place where each general was probably wounded is indicated. The place of Wolfe's death is glorified in a monument somewhat set back; Montcalm has no such monument, as he was taken back to the town, where he died twenty hours later. Finally, the well where water was drawn to quench Wolfe's thirst during his last moments of life still exists, a moving testament to the tragic circumstances of the end of a life. The only extra British accents are indications of the landing in 1759 and the place where a reigning king first set foot in Canada, in 1938. Since the park was created, in 1908, those in power have been careful, following Lord Grey's inspiration, to inscribe in stone only conciliatory texts.

Still, sometimes the old discourse has been inscribed in concrete terms. Even the place names that designate the site as a whole, National Battlefields Park and the Plains of Abraham, refer to different powers: one official, the other popular. The widespread use of the latter clearly indicates the limits to official power as well as the feelings of attachment to the space and to its significance. In the spirit of a place name, usage creates power.

Heavy Artillery Pieces

In the park are about fifty old pieces of heavy artillery, among them a number of eighteenth-century cannons used by French or English warships during battles and from vessels that sailed between Louisbourg and Québec. There are also eight German cannons that were brought from France after the First World War. The most interesting in historical terms are without doubt the ten Price cannons, mostly because of their age. Acquired by the commission in 1913, they are lined up facing Terrasse Grey. ✑

The sundial.

Everywhere on the Plains of Abraham are
commemorative plaques.

Accounts of the history of the Plains.

CHAPTER NINE

&

A Citizens' Park

A Gathering Place

Jean Provencher

AS WELL AS HAVING A COMMEMORATIVE dimension, the Plains had uses that embodied debates, proposed ideals, and enriched the symbolism of the site. In opposition to the messages writ in stone by the authorities was the discourse of citizens, which took hold in their hearts. Memories contradicted the officially celebrated record. Whether it was individual or collective, spontaneous or organized, regular or occasional, this discourse expressed attachments and reinforced the sense of belonging.

On occasion, huge mass gatherings have proclaimed, loud and clear, the values shared by Québecers. Often, during national festivities, the significance was so obvious that the celebration became a performance. Art, history, nature, and sociability fill this jewel box of greenery, and each visitor chooses his or her preferred medium. Every state of mind can be found here, depending on circumstances, convictions, or sensibilities. Some come to surpass themselves in physical activity; others are transported beyond the human condition by their imagination. In short, physical and mental health and personal or societal aspirations are all expressed here. In these intimate surroundings, the pleasure of relaxation is often mixed with the pleasure of knowledge. Here again, the time of day, the weather, one's age and tastes, and the reasons for visiting influence one's perception of the place, at the same time enriching its character.

Battlefields Park is one of the most remarkable gems of Québec City. This garden, with an area of almost a hundred hectares, has become a favourite place for Québecers to meet—for their imagination to ferment, for their festivities—and an incomparable tourist attraction. The Plains of Abraham are an exceptional site for holding large gatherings: close to the city, in an enchanting natural environment, they can hold tens of thousands of people at a time.

The National Eucharistic Congress of 1938

Québec City was long seen as the cradle of the Catholic faith in North America. It is therefore not surprising that the church often held public gatherings there. One of the most remarkable events,

The immense temporary altar constructed for the eucharistic congress was forty metres high. It could be seen from the south shore of the St. Lawrence. (ANQ)

Finding a friend in nature.

277

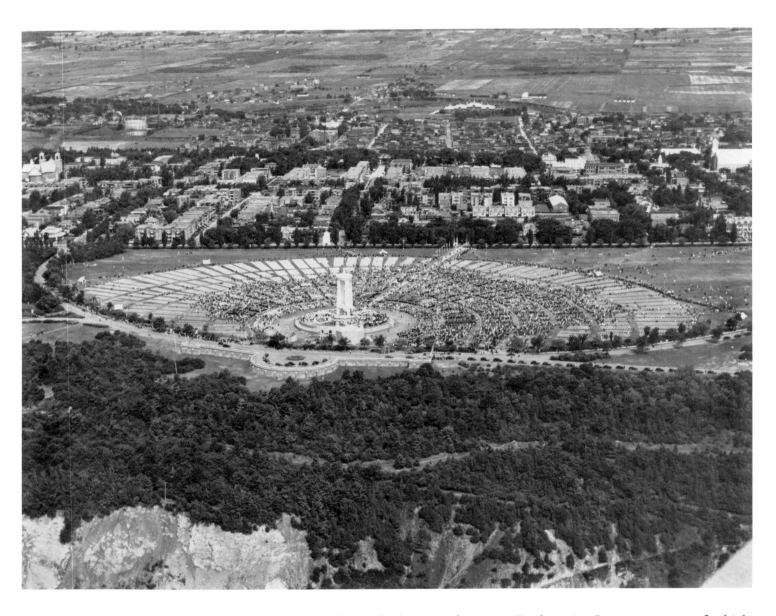

The circular bleachers and the temporary altar installed on the Plains for the Eucharistic Congress of June, 1938. (Photos: W.B. Edwards, NBC)

without doubt, was the 1938 Eucharistic Congress, most of which took place on the Plains. The church in Québec was very powerful at the time, counting 85.7 per cent of the population among the faithful. It comprised four thousand priests and some twenty-five thousand members of religious communities—one priest or nun per 87 people, an extremely high ratio. It was supported by a large number of agencies strongly committed to social action, such as leagues, crusades, Saint-Jean-Baptiste societies, farmers' societies, and family circles. Under its wing were the new movements of young workers and students, as well as the unions. It came by its triumphalist attitude honestly. However, the institution was having trouble making the transition to modernity. In the urban milieu, the parish organization was losing much of its effectiveness. The economic depression, the low success rate of colonization efforts, and the inability to capture the souls of Franco-Americans were showing that there were limits to its power. The messianic myth had run its course. To a certain secularization was added the rise of oppositional movements, including socialism and communism. The spread of new means of communication, in particular radio and movies, favoured the emergence of behaviours and ideas that the church deemed reprehensible. The catalogue of ills grew without end. The future seemed

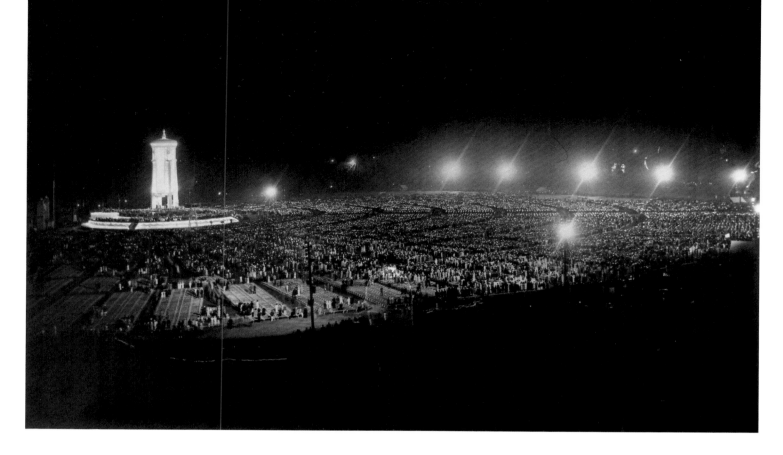

to have been mortgaged, unless a Christian solution could be applied to social issues.

As the second decade of the twentieth century began, the church adopted a new pastoral strategy based on mass gatherings, in the form of retreats, missions, leagues, and congresses. The plan that Cardinal Villeneuve, of Québec, wanted to put into action was along the lines of a dramatic public demonstration of faith. From the Heights of Québec, the cardinal was to proclaim the right of Christ to reign over individuals and exhort the population to pronounce an act of solemn, collective, and national faith.

The National Eucharistic Congress of Québec, held on June 23–26, 1938, was organized many months in advance. It touched all aspects of society and brought together all Catholic movements. In all the parishes of the diocese, and in others in Canada and the United States, prayers, fasts, special retreats, missions, assemblies, and regional congresses were held to prepare for the big event. The Congress of Québec had two aspects: study sessions on a series of themes and large-scale gatherings. The former aimed to define a plan of action to bring the ministry of the faithful into daily life. The public ceremonies were to be both dazzling and solemn, designed to inspire the imagination. The cardinal of Québec, who had been named a papal legate for the occasion, wanted to make Battlefields Park "the Field of Peace of peoples united around the altar, in the most moving communion of faith that we can conceive."

And the people came. The city was decked out in the papal colours, yellow and white. The large poster of the Eucharistic Congress, showing a chalice suspended over a great host, with rays crossed with stars, was up all over Québec City, and the red-white-and-yellow flag of the congress hung from windows. On streets where the grand procession was to pass, twelve triumphal arches representing the

The night mass on the Plains, June 23, 1938. (Photo: W.B. Edwards, ANQ)

279

Canadian Eucharistic Congress

The climax of this first Canadian Eucharistic Congress took place on Sunday, June 26. In the morning, after a night of thunderstorms, the cardinal legate, Rodrigue Villeneuve, surrounded by fifty-five bishops and archbishops, celebrated a pontifical mass before five thousand clergy and more than one hundred thousand people. The members of the Apostolat de la prière offered 31,421,717 prayers, communions, and sacrifices to Christ the King; those of the Eucharistic Crusade, 25,415,696; the Archiconfrérie du Très Saint Sacrement, 20,000,268 masses, sacramental communions, adorations, and diverse works. After the mass, Cardinal Villeneuve gave a speech; then, at his invitation, the crowd sang Nous voulons Dieu and Christus vincit, Christus regnat, Christus imperat. Then there was a solemn moment: a live retransmission of an address by the pope, direct from Rome. "Above all," he said, "we cordially salute you for having supplied us with the opportunity to see flowering once more among you, and so splendidly today, the faith that you have received from your ancestors, and to see you practising their Christian piety." ∽

twelve principal cities of Canada were raised. A particular emphasis was placed on the Eucharist within the general theme of the mass. In fact, the four large public ceremonies—the night of light, the Ghéon mass, the pontifical mass, and the grand closing procession—celebrated these mysteries.

For the mass of light, an immense temporary altar, forty metres high, was built on the Plains of Abraham. An openwork pylon crowned with a diadem-shaped calotte soared toward the sky: this was the main altar of the congress. The rallying point of the congress attendees, the triumphal altar, a gigantic eucharistic Mount Tabor, it could be seen even from the far shore of the mighty St. Lawrence River. The temporary altar was surrounded by a giant circle of banked bleachers that could hold 105,000 of the faithful. A wide, carpeted central walkway led to it. The Eucharistic Congress began there on June 23, at midnight. At the first mass celebrated at the temporary altar on the Plains, some 150 priests gave communion to more than sixty-five thousand of the faithful.

The next day, before an audience of more than fifty thousand children and thirty thousand adults, a hundred young people performed Henri Ghéon's great drama, Le Mystère de la messe. To get away from the usual customs, the young people presented a modern programme, pulsing with life: a dialogued mass, then a play. Inspired by dramatization from olden times, which they adapted to Ghéon's script, they created a living fresco of the mysteries of the mass. Father Émile Legault, director of a new theatre company, Les Compagnons de Saint-Laurent, directed the show. A brilliant seven-trumpet fanfare announced the start. In the first scene, the fore-mass, a young woman, dressed in white and wearing a diadem, slowly advanced to the microphone: "I am Supreme Wisdom. I have come to introduce you to the work of love, the great work of the living God, the mystery whose source is Adam's sin." Her monologue continued with a long lament over what seemed an irretrievable fall. In the second scene, Moses presided over the assembly of Jews, serving as mediator between Yahweh and the Israelite people. This part ended with a chorus singing the Kyrie Eleison and the Gloria. The third scene, the assembly of the Christians, opened on John the Baptist crying in the desert. But the chorus of Jews answered him with a blasphemy. Christ then appeared, flanked by the apostles St. John and St. Peter. St. Paul fell prostrate before him, but then rose again and began to read one of his epistles. John followed with a reading from the Gospels. And the great drama ended with Christ, surrounded by the twelve apostles, celebrating the divine mystery. The event, performed again the following evening, was a great success.

The spectacular closing procession followed a very precise order. The manual specified that the pontifical honour guard must lead the march, followed by the Croisés, the Scots, the Routiers, the Petit

Vendeurs de journaux, the members of Jeunesse agricole catholique, Jeunesse ouvrière catholique, Jeunesse étudiante catholique, the Société du Saint Nom, the Ligues du Sacré-Cœur, the Congrégations de la Très Sainte Vierge, the Confrérie du Très Saint Sacrement, the Adoration nocturne, the Adoration perpétuelle, the Tiers-Ordre, the religious orders, and the secular clergy. Then came the Blessed Sacrement carried by Cardinal Villeneuve, under the canopy, surrounded by the prelates. Behind them were the nonfrocked prelates, magistrates and prominent citizens, and, finally, the people.

The procession started slowly before the Québec basilica, descended Côte de La Fabrique, and turned onto Rue Saint-Jean, under a first triumphal arch. Piously, the rosary was recited, accompanied by joyous, painful, and glorious mysteries. The assembled crowds prayed for the organizers of the congress, the triumph of Catholic action in Canada, the pope and his representatives, the conversion of the infidels, the work of closed retreats, propagation of the faith, and the disappearance of the scourge of communism. Then the cortege took Chemin Sainte-Foy. Banners in the papal colours were hung from the windows and draped between lampposts. The prayers were interspersed with songs everyone knew: *Tantum ergo, O Salutaris Hostia, Adoro te devote, Louis soit à tout moment, Prions le Sacré-cœur, Ave Maria Stella, Ave Maria,* and *Nous voulons Dieu.* As they turned onto Avenue des Braves, they recited the litanies of the Blessed Sacrament. They passed under three triumphal arches before turning onto Chemin Saint-Louis. Soon, the pontifical honour guard led the procession onto the Plains of Abraham. Little by little, the rest of the crowd arrived, and everyone took his or her place. The Blessed Sacrament was placed well in view on the temporary altar, and the closing of the great event took place. After a speech, the blessing, and cheering, the Sacrament was blessed and, finally, the *Te Deum* was intoned.

Cardinal Villeneuve was very happy with his congress. The letter of thanks that he sent to George Garneau, chairman of the National Battlefields Commission, was ample evidence of this.

> Our *Premier Congrès Eucharistique National* took place in an incomparable natural setting, and around the temporary altar of the Blessed Sacrament. For four days, thousands, even hundreds of thousands of the faithful assembled to take part in the Congress. And it is to you, Sir George, whom we owe use of the plain on Battlefields Park for the Congress ceremonies. I therefore want to express to you my personal gratitude as well as that of all the Catholics who came to Québec for this purpose.

For a time, the battlefield was transformed into a Field of Peace for those united around the altar. Once again, the symbolism of the promontory of Québec played a part, as host to the expression of the highest ideals.

The huge outdoor stage was built close to Village des arts, in the courtyard of the old prison. The shows by artists and troupes from different nations attracted large crowds. (Photo: J.-M. Villeneuve, ANQ)

People arrived early to see the shows presented on the Plains during the Superfrancofête. (Photo: L. Chartier, ANQ)

Other, more secular festivals, have obtained comparable success using the Plains as a venue. Starting in the 1960s, given the lack of places to go and relax, green spaces, and public squares in the heart of Québec City, especially in the upper town, many organizations wanted to use the Plains of Abraham to hold mass gatherings for recreational, social, or cultural purposes. As soon as an activity was planned involving a large number of people, the Plains were proposed as a site; requests for permits flooded in to the National Battlefields Commission. The Commission was receptive to requests that seemed to it to fit well with the spirit of the place.

The "Superfrancofête"

In recent years, the largest event to take place on the Plains of Abraham was the Festival international de la jeunesse francophone. In 1971, during its second general conference, the Agence de coopération culturelle et technique decided to hold a festival for French-speaking young people from all over the world, and it had to choose a host country. The aim of this great gathering was to provide closer connections between French-speaking countries in a spirit of international fraternity. For Québec, this would obviously be an exceptional opportunity to raise its profile. The event was planned for 1974, an election year. Québec premier Robert Bourassa hesitated to give his endorsement, for the nationalist current seemed to him to be strong enough already. Nor was the Canadian government particularly happy about all the ways in which Québec was becoming well known. In June, 1972, using every trick in the book, the two Québec City delegates managed to have their city selected as the site for this first world congress. The Plains were expected to provide participants from all over the world with an unforgettable memory of their stay in Québec.

The festival, popularly known as the "Superfrancofête," took place on August 13–24, 1974. It "brought together athletes, artists, and researchers aged eighteen to thirty-five, wanting to show off the creative spirit, wealth, and complementarity of their respective cultures." Fifteen hundred participants from twenty-five Francophone countries gathered for the cultural and sporting activities. For twelve days, all of Québec City and the surrounding area rang with the voices of French-speaking young people.

On the opening day, the delegates, dressed in their national costumes, paraded down Grande Allée toward the Plains of Abraham. The Nigerian tomtoms resonated, attracting onlookers to the curbsides. Perched on their stilts, the Belgian delegates delighted the children, while the disciplined Vietnamese sang songs from their country. The crowds on the sidewalks applauded the delegations, some of which stopped to improvise a dance or a piece of music. On the playing field, the crowd watched six parachutists jump from an

altitude of seven thousand feet. Then there was a country-style supper, while an accordionist entertained the diners with traditional folk tunes. As more people arrived, the crowd grew denser. To mark the opening, Félix Leclerc, Gilles Vigneault, and Robert Charlebois performed before more than 125,000 people. Even Premier Bourassa and the prime minister of Canada, Pierre Elliot Trudeau, were there, sitting on the ground, surrounded by police officers. A journalist was surprised to see a police officer who had been guarding the dignitaries' platform with his walkie-talkie and formal uniform now standing in front of the big stage, wearing a Moroccan shirt.

One thing was certain: never had these three Québec singer-songwriters had such an audience. Sometimes alone, sometimes two or three together, sometimes leading the crowd in a chorus, they sang each other's songs on the themes of justice and fraternity. The enraptured spectators clapped their hands to the best-known songs and all of the great hits. The three stars finished the concert by leading the crowd in a rendition of the Raymond Lévesque song *Quand les hommes vivront d'amour*. On this ex-battlefield, it was thrilling to hear the words of the songwriter ringing prophetic: "Soldiers will be troubadors." The crowd was on its feet. Everyone lit a candle in the darkness, even the performers. A spectator threw a fleur-de-lys flag onstage, but none of the three held it up, perhaps a little scared that the cheers of this crowd, expecting such a gesture, might be transformed into delirium.

Now the show was over and it was time to go home. The Superfrancofête had started with a bang. People climbed down from the trees, the monuments, the sculptures, and the walls of the courtyard of the old prison. As they made their way out of the park, they stepped on pop cans and garbage of all sorts. The next day, the newspapers called the show the "Woodstock of Francophone youth." The reporter from *Le Devoir* admonished readers who hadn't been there that they had missed the party and the show of their lives.

"Of course," the *Soleil* reporter wrote, "there were a few dozen 'bad trips' among the several thousand smokers. There were also cases of fainting, sprains, minor injuries, children lost then found, and all the to-do." "From the public-security side, however, it was a success such as has never been seen within the walls of the Old Capital," remarked a spokesperson for the Québec Provincial Police. A starry night, humid weather, and crushing heat also kept the 125,000 Francophones calm.

The heart of the festival was the Village des arts, in the courtyard of the old prison, the "Petite Bastille." Here, according to many visitors, was "the most beautiful part of the festival." This village was the temporary home of more than a hundred artisans from four continents, who plied their crafts before the public until nightfall in the five pavilions at their disposal. They wove, made pottery, painted,

sculpted, made baskets; they worked metal, wood, ivory, stone, and leather. Visitors learned about European, African, Asian, and American crafts.

If we had visited the Village des arts on the afternoon of Wednesday, August 14, this is what we would have seen: on the large outdoor stage near the village, eighteen metres wide and fifteen metres deep, are artists and troupes from different countries. Incredible acrobats from Dahomey improvise a performance, dancing to the frenetic rhythms of the group's singers and musicians. A group of fascinated Africans watch Michel Gros-Louis, the son of Absalom, making a snowshoe and they wonder what it could be used for. In his corner, Antoine Manirampa, from Burundi, sculpts reliefs of traditional life in his country. Beside him, artists from Dahomey create a painting using pieces of banana-tree bark. The large mural on the walls of the prison, before which Paul Bilodeau, from Sept-Îles, is standing, was made by the Petits Soleils de Québec, a group of fine-arts students. This vast sweep of air or water, where comets streak and balloons float, is "the largest mural in North America." Kimchombe Kola, from Mali, weaves tirelessly from morning to night. Nicolas Gbaguini explains to a visitor that the important thing is not to label Africans blacks or Negros, but to like them. Jules Ralantomahefa, from Madagascar, a specialist in marquetry, chats with Montrealer Roger Leblanc, a cabinetmaker who knows this art well. In the evening, thirty thousand people watch a show from Cameroon and the Ivory Coast. The next day, a *Le Soleil* reporter wonders,

> Is there not, in some ancient ancestry, a family resemblance between Québecers and people from Cameroon and the Ivory Coast? One would have believed it, watching the physical reaction of this crowd to the exotic accents of the music from these two countries. . . . From ebony to pale skin, the difference was only in costume and place, since the show . . . took over the audience so that they danced as much to the rhythm as the people onstage.

The rest of the week featured similar shows. Jugglers, minstrels, dancers, storytellers, mimes, singers, and musicians left audiences spellbound, mesmerized by a panoply of colours, rhythms, and chants. A great outdoor party, a "super-picnic" on the Plains, marked the festival's closing. The entire population of Québec City was invited to bring a food basket, and between fifteen and twenty thousand people responded. The farewell evening, an "international" show on the big stage, drew at least a hundred thousand. In total, more than a million visitors attended the Festival international de la jeunesse francophone. This extraordinary manifestation of international fraternity between Francophone countries surpassed all hopes. The magic of the site may have enhanced the magic of the artists.

The Festival de la chanson québécoise

The success of the Superfrancofête led organizers to a repetition of the experience. This time, the Québec department of cultural affairs put together a week of Québec music, to be held on the Plains on August 10–17, 1975. The objective, defined in an excellent example of bureaucratic language, was to "stimulate the rise of Québec music by organizing a mass movement based on information and promotion of support for this music, as well as those who perform it." The goal was "to enable Québec music and its agents to be recognized within the Québec community." The festival thus addressed itself to "professional and other music performers, distributors, private and public institutions that may play a role in the music industry, and the general public." It was hoped that everyone involved in the industry would come together for eight days to give new impetus to Québec music. Four months later, it was announced that 525 artists would participate: 200 professionals and 325 amateurs, including all the great names of Québec music. The concerts were arranged to group together, within certain compatibility criteria, artists of different styles.

Although it was less spectacular than the Superfrancofête, the Festival de la chanson québécoise still managed to attract more than a hundred thousand spectators over the week. The "Chant'août," as it was called, was not truly a popular festival; rather, according to the organizers, it was intense.

Québec City 1534–1984

The Plains of Abraham are an excellent spot for watching ships on the St. Lawrence River. On Saturday, June 30, 1984, during the parade of the tall ships, as part of the "Québec 1534–1984" celebrations, a crowd estimated at eighty thousand went to the top of the cliff on the Plains to watch the great sailing ships. ✑

Leisure activities for everyone.

The Festival d'été international de Québec

Since 1974, the Festival d'été international de Québec has held some of its activities on the Plains of Abraham. In 1974, a few hundred young people from the Québec region gathered to fly kites they had made. In 1975, a painting "happening" was held in front of the Musée du Québec, and Théâtre en Vrac and Théâtre Parminou performed. The following year, the National Battlefields Commission authorized the holding of family picnics, parachute-jumps, a bicycle rally, a play by the Théâtre Bonne-Humeur, and fireworks. In 1977, there were a fifty-eight-kilometre bicycle criterium, a skateboard competition, parachute jumps, a twelve-kilometre foot race, called "La Galipote," and an exhibition of antique cars.

On July 12, 1980, the festival organized "a great crazy day for kids," and the event wrapped up the next morning with an outdoor picnic concert in the afternoon and a show of Québec, European, and African artists in the evening. In 1981, near the Bastion du Roi, on a sunny day, fifty thousand people attended the festival's closing show. This gathering, hosted by Léo Munger, brought together fifty artists, including performers from the Upper Volta, Gabon, Mauritius, Vietnam, Vanuatu, and the Dominican Republic; Québec artists included Mama Béa, Richard Séguin, les Ballets jazz de Montréal, and Zacharie Richard. With the rhythms of their music, they kept the crowd singing and dancing. The Festival d'été international de Québec continues to hold events on the Plains every year.

The Carnaval de Québec

The organizers of the Carnaval de Québec, Québec City's winter carnival, were the first to knock on the door of the National Battlefields Committee. From 1965 to 1970, as part of the Carnaval's activities, the Commission allowed a bonfire, made with the Christmas trees the organizers gathered after the holidays, to be lit on the Plains. The director of the firefighting service of Québec City, J.-B. Voiselle, saw no problem with this activity, "unless there is an excessively strong wind (like a squall), in which case the event will have to be cancelled." Some years, the Bonhomme, the Carnaval snowman mascot, has made his appearance on the Plains via helicopter. In 1968, as part of the interregional games, a slalom race was organized on Côte Gilmour. A new sporting attraction, a four-kilometre cross-country-ski race, was opened to the general public in 1974. In February, 1976, also as part of the Carnaval, spectators watched parachute jumpers land on the playing field. Over the ensuing years, snow-sailboarding and ski races have been featured. Since 1988, Place de la famille, situated at the entrance to the Plains, bedecked with ice sculptures, has drawn some 125,000 visitors.

All of these gatherings bear witness to the lasting and changing uses and meanings of the Plains. They remind us that the site has

hosted various aspirations, sometimes ones that are hard to reconcile. Like all urban parks, the Plains present contrasting images—the official and the marginal, the real, controlled space and the fabulous, imagined space—that exist side by side. The city presses in on all sides, while its residents flee to the Plains to free themselves from urban conditions. The Plains of Abraham, so rich in nature, history, and culture, have multiplied these symbolic aspects. In the spirit of Québecers, the imaginary overtakes reality on the Plains.

A Place to Talk

Jean Du Berger

T O SOFTEN THE BLOWS OF LIFE, every community creates times and places for total liberty and complete escape, or at least their illusion. The city park offers such safety valves to nourish the spirit. We know to what point the Plains of Abraham have stimulated Québecers' imaginations. With their location at the heart of the city, their innumerable riches, and their impressive physical qualities, the Plains have fed the fantasies of the citizens who live around it. As a place of predilection, they have been transformed in people's minds into a space that explores the limits of the acceptable, where liberty contradicts the established order, where the imaginary co-exists with the real.

To begin with, everything on the Plains seems simple, calm, ordinary, everyday, designed for the innocent Sunday stroller. But, in the spirit of Québecers, this pretty sequence flies apart in an image of the Plains roiling with agitation, perturbation, liberation. This duality in perceptions is manifested even in the name of the place: officially, it is National Battlefields Park; popularly, it is known as the Plains. From either perspective, it represents the impossible dream of an ideal world—a double illusion!

The first observations evoke an area of authority. A great number of signs remind us of rules of conduct, civility, life in society: "No trucks or motorcycles," "No left turn," "Stop," "Pedestrians only," "Turn left," "Reserved lane," "Police." Not so long ago, the park rules forbade sleeping on the grass or the benches, making speeches, bringing alcoholic beverages, wearing a disguise, being dressed in a bathing suit or an indecent manner, singing, shouting, or letting cows, bulls, horses, pigs, sheep, or other livestock wander or graze. Although it has long been retired from its original purpose, the Citadel represents strength and stability. Its glacis, trenches, walls, gates, parapets, redoubts, powder magazines, and towers present a defensive apparatus capable of repulsing all armed blunderers or dangerous festivities. When there are public events on the Plains, they are prepared long and carefully. Precise order rules the goings-on and old rituals surround them. On any given day, guides take visitors to the guard posts and the practice field. There is a military show, featuring

Horizons

marches and countermarches, symmetrical figures ruled by martial commands. To the sound of the fanfare, through its complex choreographic figures, the troop reproduces the very organization of the fortifications; a parading platoon is not given to confused improvisations. A citadel of stone, a citadel of men, the place of last resistance to the unforeseeable conduct of crowds. The spectators applaud politely.

Québecers smile. The "true" Plains are something that is not written in letters engraved on bronze. Through words and imagination, they are drawn to certain areas of the Plains, known by them alone, which evoke the first flutterings of the heart, the first revelations, attempts at seduction, kisses behind a tree, the first awkward touches, hearts beating with a delicious fear. Then imagination takes them even farther, to adolescent games that leave no time to read panels, signs, or commemorative plaques. Images of promiscuity are propagated by the urban folklore.

The Plains, symbol of the taming of wild nature, are also seen as a hunting ground, a place to look for lovers. Pleasant conversations. A parade of cars. Furtive or defiant looks. Along the avenues, bodies stretch out to catch the sun's rays. In the expectation of some kind of good luck, they are vain about the fascination they draw. Some stare openly, others steal glances. With a smile, blatant or understood, they embellish their lives shamelessly. An apprentice becomes a "dentist"; a clerk is now a "pharmacologist." Words float together in the air. Sometimes, people leave together. Illusion enriches the symbolism of the Plains. And there is no lack of imagination.

Even the crowd sometimes participates. On a nice evening before the Fête Saint-Jean-Baptiste, the sun sets behind the Laurentians and the shadows of the city lengthen in a great natural semicircle created by the valleys in front of the Citadel. Surrounded by barriers is the pile of wood for the Saint-Jean bonfire. A young woman asks a police officer, "What time is the party?" A burst of laughter. "The party? When it's dark, behind the bushes, over there!" Groups and couples arrive, settle on the grass and begin the melody of conversations, stories, songs, lies, laughs, politesse, enticement, the lovers' talk of Québecers.

The natural hemicycle is now covered with a sort of living carpet. From this crowd rises a dull rumble punctuated with cries, bursts of laughter, and the sound of bottles clinking. Great nervous currents roll through the crowd. No one is reading the panels or the signs. There are no one-way streets. Instructions are ignored. This evening, National Battlefields Park has lost its name; meaning vanishes; social order disintegrates. Individuals melt into a mass that laughs, cries, gets excited, and leaves its inhibitions behind. On this temporary stage, the evening's actors let themselves go into excess. The deep, unnamed festivities upset the order of the world.

At dawn, teams gather up the detritus of the party. Slowly, order is re-established. The signs announcing that stopping, going too fast, and turning are forbidden are once again obeyed. After a night of escape and transgression, the Plains find their vocation and their name once again.

Beyond the Plains, Québecers keep up a curious dialogue about them, which speaks of joyous sex, shameful sex, elbows jostling, feet flying, provocations. The popular dialogue exists in opposition to the institutional discourse that establishes the place as a historic site.

For Québecers, the Plains are a sort of place apart. The public space provides an opportunity for temporary metamorphosis. As if possessed by its spirit, individuals and groups act differently, liberating their demons. Defined as a historic site, it can be fragmented into different zones and sectors according to the moment. The Plains offer many stages, for actors and actresses to play out their comedies, melodramas, and farces.

The signs that create order, the intrusive plaques, the directions and prescriptions—all of this regulatory apparatus cannot tame this great park in the middle of the city. An open space where cultures have no hold, the Plains of Abraham contain surprises; by entering the space of another, one is sometimes transformed into the other.

The authors' best shot!

A Space of Leisure

Jean Provencher
and Jacques Mathieu

ALTHOUGH THEY ARE AN IMPORTANT HISTORIC and natural site, the Plains are increasingly used as a place to relax, adapted to the needs of Québecers. The lack of green spaces and public squares in Québec City means that Battlefields Park is a favourite spot. By force of circumstance, to the initial vocations has been added an urban dimension with a cultural and recreational character. This evolution of functions is, however, inspired by the primary mission. It enhances, rather than reduces, the pre-existing values of the park, and introduces other images and activities.

The Everyday

Since it was created, the park on the Plains has attracted great numbers of Québecers and visitors. People go there alone, in couples, in groups, freely or in guided groups. Some go infrequently, others practically live there. Some go in one season or another; for others, the weather makes no difference.

It is mostly Québecers who visit the Plains on a daily basis, but their use changes according to the time of day and of week. Most go there to relax in nature and, to a lesser degree, to partake of a sport or attend cultural activities. Except for respect for the place, there are no constraints, no required activities, no admittance fees. The commission responsible for the park requires nothing of visitors and users. It simply offers the widest possible variety of facilities.

To the enchanting landscape created by Frederick G. Todd at the beginning of the century, the Commission has added just a few delicate touches. Preservation of the park, however, requires constant effort. Trees must be treated, since the spring showers, hail storms, small animals, and a few ignorant visitors sometimes injure them severely. Plants and flowers are cultivated in a greenhouse and transplanted to give a colourful touch to certain areas of the park during the warm seasons. The birds are also carefully tended. Maintenance of the streets and walkways and keeping the peace require much expense and constant attention. Everything is aimed at making the visitor's stay a pleasant one. The Commission is following the mission defined when it was created in 1908:

Hail sometimes causes much damage. But it also creates dazzling panoramas. (**Skieurs sur les Plaines en 1937**, NBC)

A moment of relaxation before a rolling countryside.

The Québec City calèches roll along an avenue beside the Plains.

In all civilized countries, the importance of creating open spaces in populous centres is becoming increasingly recognized. ... The mass of the population, workers in boutiques and factories, all those who toil, closed in restricted places, could profit in good weather from the advantages of this park.

In summer, some read or get a tan on the grass. Others look for a good place to nap in the shade of the large trees that line the paths. Since a number of apartment buildings have been built in the surrounding area, increasing numbers of senior citizens frequent Parc des Braves. Thanks to their hills and dales, their paths and promenades, their tree-lined lanes, the Plains never seem crowded, even though there are sometimes thousands of visitors there. More often than not, the Plains do not attract crowds, but individuals and small groups who go there to relax. Gentlemen walk their dogs—on leashes, please. Families or friends bring picnic baskets and fly kites. Couples play checkers on a bench. Before the Centennial fountain, a person meditates in solitude. A small child straddles an old cannon. Over there, under an elm tree, a woman, shawl draped over her shoulders, strums her guitar. Not far away, in the underbrush, a man is picking mushrooms. For those who go there almost daily, the Plains are first and

Flower beds.

Jardin Jeanne-d'Arc in the spring, and its bordering trees, with buds just opening.

Nature and culture meet.

foremost a beautiful, big park, easily accessible, a place to relax, play, talk with friends.

Other visitors, enjoying the scenic view or the scent of the flowers, take a walk to deepen their knowledge of nature. With its arrangements comprising 150 species of flowers, perennial and annual, Jardin Jeanne-d'Arc fascinates connoisseurs. Since the flowers blossom from April to October, the garden changes through the season; bulbs, irises, peonies, phlox, asters, and annuals are featured. Visitors preferring the shade of the promenades can stroll the nature paths and learn about Québec plants. The floral mosaics have enchanted many. The park on the Plains was one of the first in North America to use this technique: in 1919, Lord Grey's motto "*De bon vouloir servir le roy*" was spelled out in flowers of different colours. The interest in horticulture and making the public aware of the importance of nature fits well with aims of those responsible for the park, who organized the meeting of the great gardens of Québec in 1990. Gathered under a large tent facing Jardin Jeanne-d'Arc, representatives of a dozen organizations presented the details of their work and offered horticultural advice. In spite of persistent rain, sometimes a downpour, more than twelve hundred visitors came to the meeting.

Visitors, passive or active, have only to let themselves by enveloped by nature to appreciate it. In any season, it penetrates the senses through the pores of the skin. Sight is the best-served sense: the different tones of green in summer, the incomparable colours of the two thousand maple trees in the autumn, and the landscape dipping off into the distance enrapture the eye. In the winter, the great leafless trees, black against an immaculate background of snow, are a nostalgic reminder of the poems by the great Émile Nelligan. Some people even bundle up and take a stroll in the snow to admire the winter landscape.

In the winter, children love to slide on the snowy slopes of the Plains, especially in the natural amphitheatre behind the old prison. It is also an ideal place for people who like to snowshoe or cross-country ski. For several years, the Commission has provided groomed trails and a changing room. In the spring of 1987, eight hundred skiers who had used the new trails signed a petition thanking the Commission for this "happy initiative, which has greatly improved the quality of life in Québec." The previous winter, the commission had inaugurated a telephone service providing recorded messages on ski conditions, a competitive trail for experts, and cross-country-skiing lessons. Today, four family-level cross-country-ski trails covering eleven kilometres are available to visitors.

Of course, physical activities continue throughout the summer. Runners can use a specially created trail or the natural terrain, and they sometimes draw interested spectators. Whether they are pushing the limits of their endurance or simply keeping in shape, they appre-

As this 1916 photo shows, floral mosaics are a tradition on the Plains. Here one reads Lord Grey's motto: "**De bon vouloir servir le roy.**" (NBC)

Floral mosaic at the foot of the monument to Wolfe.

297

Comfrey [**Symphytum officinale**]

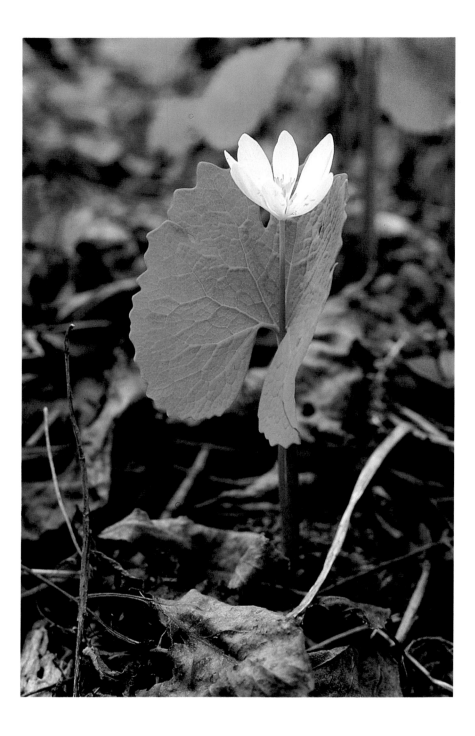

Bloodroot (**Sanguinaria canadensis**). Broken, the twig releases a red latex. One of the most remarkable indigenous plants, it was widely used in the ancient pharmacopia. In small doses, it was a remedy against respiratory ailments.

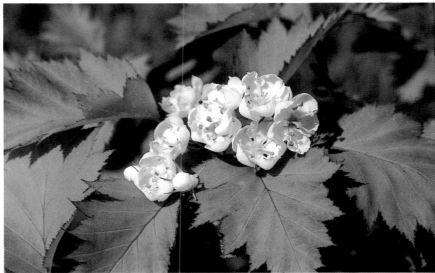

Tulips.

Hawthorn (**Crataegus**). Most varieties of this species grow in North America—four-fifths of the fifteen hundred varieties. Aboriginals ate the nuts, which were used as a medicine for stomach ailments. The very hard wood was used to make tool handles.

Unusual Winter Sports

"*Ski-joring*" *is something like water-skiing, except that the skier is pulled by a horse. "Indian Golf" is practised in a large, clear area resembling a golf course. "Golfers" wearing snowshoes compete on a course with nine flags, which they must hit with bows and arrows.* ∾

Recalling a tradition: a snowshoe race on the Plains during the Carnaval of 1991.

Like children; duchesses sliding on the snow during the Carnaval de Québec in 1991.

ciate the track on the playing field. In 1979, the cross-country-running club of Québec, the Centaures, felt that this well-maintained 1,600-metre course was the ideal place in Québec to hold a forty-eight-hour relay race. Since the Plains are very busy during the summer, this was an ideal opportunity, the organizers felt, to introduce the population to this type of physical activity.

Although the Plains of Abraham are first and foremost at the disposal of individuals seeking relaxation, the commission has from time to time granted permits for organized activities. Many films have been shot there. There have also been photography exhibits and tug-of-war, cricket, football, touch-football, soccer, bowls, and horse-shoe-tossing tournaments. A bicycle race was organized there with the goal of creating interest in this physical activity among young people. There have even been fruit and vegetable tastings. Starting in 1965, ice races for cars were held there, but in 1978 it was decided that this event clashed with the vocation of the site. Winter activities were organized as soon as the park was created. Part of one of the first outdoor film documentaries, *Skee Club*, was shot on the Plains. In 1909, the Québec Ski Club held its first ski races there, a sport unknown ten years earlier. The winner of the standing jump leapt almost twenty metres. In 1921, a ladies' ski club was formed; the ladies glided over the Plains in dresses and long coats. In 1925, a temporary bobsleigh run was set up. For a long time, the international dog races ended on the Plains. Some sports were even invented there that defy imagination, such as "Indian golf" and "ski-joring." The Fédération québécoise des brigadiers scolaires held its provincial Jamboree there in 1983. On the eightieth anniversary of its foundation, in August of 1988, the commission invited the population to a free concert by the Royal 22nd Regiment, featuring music by John Williams, Johann Strauss, and Philip Sousa, along with arrangements of Québec pieces. The cold temperature could not keep away three thousand spectators, who turned up with their chairs and blankets.

During the 1930s, the Œuvre des terrains de jeux de Québec obtained authorization to use "the space between Avenue Wolfe and the Plains of Abraham for the purpose of its work." Some twenty-eight hundred children were registered for the O.T.J. on the Plains. In 1936, the Commission even allowed installation of mechanical rides, two wading pools for children, and fountains, and the construction of a building containing offices, an infirmary, a shed for toys, toilets for boys and girls, and a shelter. The work of the O.T.J., in concert with the Commission, thus led to the creation of a small park for children, still existing beside Avenue Wolfe-Montcalm.

To these activities are added school sports. For more than twenty years, the Commission des écoles catholiques de Québec has been using the Plains of Abraham for soccer, football, and baseball matches and practices, athletics competitions in spring, and sporting

Lost in nature in the heart of the city.

Sliding on the Plains, a nineteenth-century tradition that is still living.

1918
Côte
des
Glaci

quebec

7

Le tremplin sur les Plaines

1924

In the first decades of the twentieth century, ski jumping was practised on the Plains. A ski jump was even erected near Martello tower 1. (NAC)

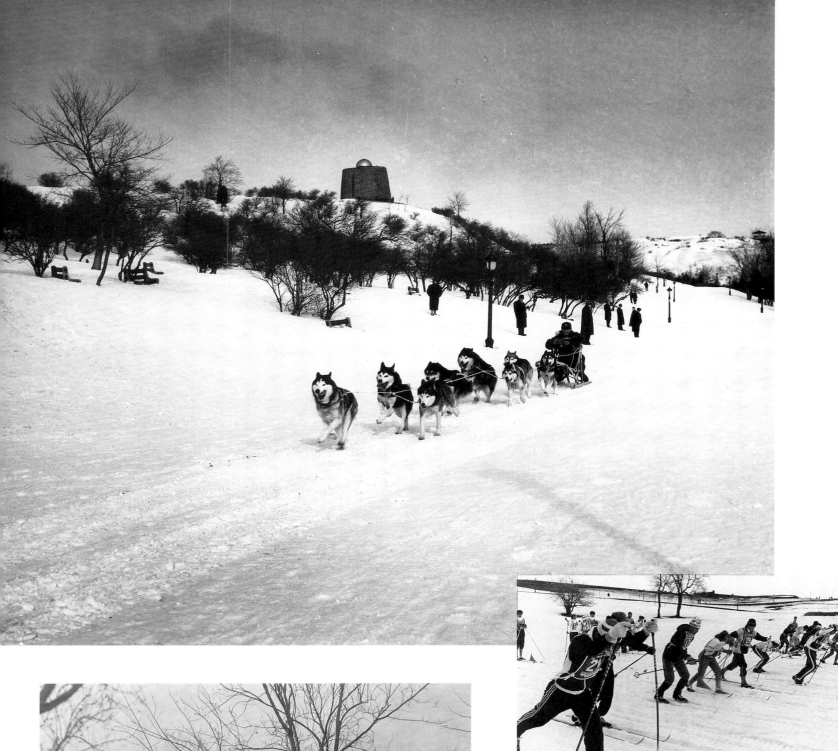

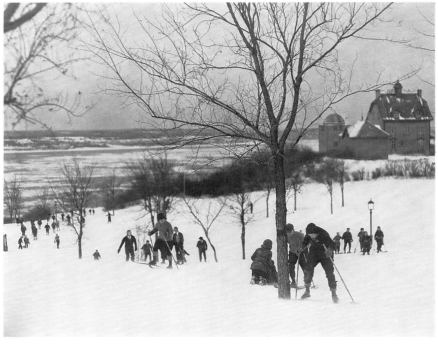

Dog race during the 1962 winter carnival. In the background, Martello tower 1, on which the Royal Astronomy Society installed its telescope. (ANQ)

Cross-country-ski race for cadets in March, 1987. (Photo: Yvon Mongrain, NBC)

Skiers on the Plains in 1933. (Photo: W.B. Edwards, NBC)

The Greenhouses

The National Battlefields Commission's greenhouses have existed since the 1910s, but the largest buildings were erected in 1927–28 and expanded twice in the 1930s. For more than sixty years now, the Commission has produced perennial and annual flowers to embellish its park. For instance, floral mosaics, the technique of creating a design or lettering with flowers, has been used, mainly at the base of monuments. Every year, new themes are featured. The Commission's greenhouses produce some one hundred thousand annual, bi-annual, and perennial plants, including more than thirty-seven thousand for floral mosaics. There are more than 120 varieties, the majority of them tuberous begonias, marigolds, dianthus, petunias, ageratum, and alyssum; there are also new varieties for which uses are constantly being found. ∽

In these greenhouses, built in the early twentieth century and expanded in the 1930s, all of the plants that decorate the park are grown.

competitions in the winter. Schools of the upper town regularly meet on the playing field for sports days. Occasionally, students organize a rally to raise funds for educational field trips. During the winter, visits to the greenhouses are organized for elementary-school children.

For nature lovers, the Plains also offer a chance to get to know about art and culture, thanks to exhibitions at the Musée du Québec, where Québec art is featured. Paintings, sculptures, metalwork, drawings, and prints comprise the majority of the collections; almost all well-known Québec artists are represented. But there are also collections of modern, Greek, and Roman art, as well as travelling exhibitions. Since it opened, in 1933, almost five hundred exhibitions have taken place there, some of which have drawn thousands of visitors. The Musée du Québec, expanded in 1991, is a happy complement to a visit to the Plains of Abraham. In the image of the National Battlefields Commission and in cooperation with it, the museum puts its expertise at the service of those who share its aspirations.

A Walk on the Plains

If we want to discover the wealth of the site, we must take a walk on the Plains. The point of the Citadel offers a good point of departure. The view is magnificent and eye-catching. The emerald strip of land and the turn in the river, the cliff and the heights of Lévis, the point of Île d'Orléans, and the Beauport coast form a uniquely beautiful panorama. Here, we pause to let these striking scenes sink in. From this high point on the edge of a sheer cliff, there is a feeling of immensity, of the grandeur of nature, beyond human scale. As we enter the park, we walk toward a highly contrasted, deep ravine. On one side, the summit slopes toward the St. Lawrence. The trees are close together and bushy, reflecting the wildness of nature. On the other side, the valley slopes gently and is well maintained.

In the depths of the valley, the space is calm and relaxed. The air, heated by the sun, is a little humid. Here and there, families are having picnics. A few young people are playing capture the flag and tag. Everywhere, everything is green, though stone walls and buildings are silhouetted on the far horizon.

Now, we slowly climb to the top of the valley, opposite the fortifications, and finds himself on an enormous flat space. The ground is perfectly horizontal, sprinkled with bushes at regular intervals. Here, some groups are more active; balls, balloons, and frisbees fly through the air. Over there, a child on all fours pretends to be a truck. On the edge of the open space, lolling on benches, lovers contemplate the scenery. A little girl and her brother are out of breath on top of the knoll. From the bottom of the hill, their parents watch them, offering advice and encouragement.

A look backward plunges us into a past, which we can try to decipher. From here, we can understand the defence system better.

The view into the distance is unencumbered. We can clearly see how soldiers entrenched in the shelter of the wall could keep watch, and retrace the path the French army took to gain the heights and stop the approach of Wolfe's troops. In our mind's eye, we see their disorganized race to deploy themselves across the entire width of the promontory, to reach the summit of the cliff, in order not to be overtaken. We realize why Wolfe aligned his soldiers a little farther away, beyond the range of the fort's cannons.

Now, our steps take us toward a large equestrian statue, visible through a curtain of trees to his left. When we arrive, we discover a large sunken flower garden, measuring at least 50 by 150 metres, filled with carefully arranged, brightly coloured flowers. Some senior citizens, in groups of two or three, are admiring the blossoms. Others stop, lean over, sniff, make comments.

A little farther, some knolls, some undulations in the terrain, some shrubbery, and some steles draw our attention. Heroes have strode here. What history reposes in this soil! The blood of generals Wolfe and Montcalm was spilled here. And the blood of how many soldiers? At least a thousand; eight regiments faced each other. It is very narrow, and they were very close to each other, perhaps fifty metres apart.

We cut across fields behind the Musée buildings. The Musée is worth a visit, but not today. A memory pops into our mind: happy times as a child, tobogganing. Today, the beautiful tree-lined lane, bordered by a multi-coloured flower bed, offers a moment of coolness, of rest. A few people are stretched out for a tan. There's a squirrel. A new view discreetly unfurls.

Below are a pleasant path, benches, large trees, various shades of green, harmonious colours. And birds are singing: blackbirds, spar-

During the summer of 1966, as part of the Symposium de Sculpture, international artists made wood sculptures on the Plains. Some students from the École des Beaux-Arts went to study these masterpieces, but children liked to play on them. (ANQ)

Watching these runners, one can imagine the race of the French soldiers to place themselves in front of Wolfe's troops in 1759.

rows, chickadees, warblers, and finches. The feeding stations draw them and keep them well nourished. That's a walk for another day. This day is almost over; as dusk descends, soft shadows invade the underbrush. Everything is quiet, and the park is almost empty of visitors.

Now, there are some brave people, running under the hot sun, putting all their effort into staying healthy. Their even rhythm matches that of the trees lining their path. Those guys over there, tossing the ball back and forth, look like they're having more fun. And they're showing off more than their great shape; are they hoping that their talent at throwing and catching will draw a glance, cause a smile, make a friend?

Here's one belvedere, and another is on the horizon. But here is where the troops came up the hill: in the middle of the night, silently, running through the large pines and cedars. What a climb! Now, here's the Plains bus: perfect, we're getting hungry, so it's time to go home. But we will have to come back, another day, another evening.

In the 1930s, some 2,800 children registered for the Œuvre des terrains de jeux.

306

Bravo!

CONCLUSION
A Place to Cherish

Michel Leullier
and Jacques Mathieu

T HE NATIONAL BATTLEFIELDS COMMISSION was created on March 6, 1908, with the clear, precise mandate of acquiring and preserving the great battlefields and converting them into a national park. Its area of responsibility was limited only by its financial resources. By the passage of the law creating the Commission, the Plains of Abraham officially entered the family of great public parks, joining those in London, Paris, New York, and the one in Banff, created in 1887.

The Mandate

Canada's prime minister, Wilfrid Laurier, felt that the Plains of Abraham, a work of nature, time, and humans, should be preserved for posterity. In the diversity and wealth of its elements, it was unique and exceptional; like the facets of a gem, these qualities existed without eclipsing each other, each sparkling brilliantly before the viewer. To enhance this effect, time and space had to be harmonized, nature and culture reconciled. The administrative mandate had to be sensitive to such feelings.

Since its creation, the Commission has been fulfilling its mandate, practising the "cult of the ideal," by constantly facing new challenges posed by modern times and finding in tradition the basis for its choices. Respect for the spirit of the place, anchored in its natural beauty and historic value, are behind the design and landscaping of the park. But it is not enough to preserve the space: its development must also correspond to the original vocations of the site, fulfilling the expectations of its visitors and constantly adapting to new needs. The Commission's activities are thus part of a continuously evolving cultural dynamic. Through its decisions, the Commission wants to make sure that a visit to the Plains is always an experience that is both valuable and unforgettable.

This living heritage belongs to the community, and thus it is a shared responsibility. Since the very beginning, there have been people to promote creation and development of the park. Donations from a wide variety of sources enabled the dream to come true: individuals, municipalities, cities, provinces, the federal government,

The Montcalm Monument

A monument to the memory of Marquis Louis-Joseph de Montcalm is found near National Battlefields Park. It was donated to Québec City by France and inaugurated with great pomp on October 16, 1911. This monument portrays Montcalm, mortally wounded and supported on the right-hand side by an angel with long wings. In his left hand, the angel holds a wreath over the head of the hero. The monument is a replica of the one erected the previous year at Vauvert, a few kilometres from Nîmes, Montcalm's birthplace. In National Battlefield Park, between Martello towers 1 and 2, a stele indicates where Montcalm was wounded. ✌

Monument Montcalm

The Birds

A precise ornithological inventory of the Plains has yet to be created. However, during thirty-eight sessions in the winter of 1977–78, observers were able to identify twenty-seven species of birds within ten metres of the feeding stations. The most frequent user of the feeders is the black-capped chickadee (180 times), followed by the redpoll linnett (105 times), and the evening grosbeak (64 times). Also seen were dark-eyed juncos, brown-headed cowbirds, American crows, mourning doves, downy woodpeckers, house sparrows, American tree sparrows, blue jays, purple finches, a redwinged blackbird, and a song sparrow. These figures change from winter to winter; the redpoll linnett and the evening grosbeak are "erratic" species, present in great numbers some winters and entirely absent others.

In 1954, three hundred birdhouses were installed to encourage nesting. In November, 1976, the Canadian Wildlife Service, Québec Region, proposed to the commission that bird feeders be installed for the benefit of the public, in an effort to keep over the winter certain birds which under normal conditions would migrate south. Another intention was to gather local birds in such a way that it would be easy to observe and photograph them. ☙

and other Commonwealth countries contributed to the acquisition of the land; from the volunteer commissioners to those who simply love the Plains and have an eye to safeguarding them, everyone has his or her part in the beautification and enhancement of the site. Over the years, the Commission has also installed various services to preserve or improve the park's attractions. Each year, the horticultural department does its work taking care of the flowers in the gardens, borders, and flower beds. Maintenance and public security make sure that the place is beautiful and peaceful. A reception and interpretation department distributes information on the site's many features. Occasionally, historians and landscape architects lend a hand. Finally, citizens, as members of the Amis des Plains d'Abraham association, give special support to the Commission as it pursues its objectives of making Québecers, Canadians, and visitors from other countries aware of the riches of the site. This solidarity extends, in the end, to all visitors to the park, whether they come regularly or occasionally. History buffs, art and nature lovers, sports teams and families, and people who just want a taste of the countryside all enjoy the park's qualities and contribute to the realization of its principal functions.

The Park's Functions

Many vocations must be combined in one space: national park, natural park, urban park, commemorative park, recreational park. The Plains themselves bring these values together harmoniously so that they grow and mutually enhance each other. Like the colours and angles of a painting, the highest priority is to ensure the coherence of the whole, the fusion of the two main functions of the park: to preserve and highlight both nature and history.

This programme is ambitious. It associates the spirit of the site with the meaning of the events that took place there in order to reinforce both the site's innate characteristics and its historic significance. To maintain its high level of maturity, the site of the Plains must be developed with flexibility and a multitude of uses in mind. It must lend itself as easily to nostalgic serenity and contemplative languor as to sporting events and large festive gatherings. Like a vast fresco with many panels, it aims to nourish both the body and the spirit, to excite the senses and stimulate the sensibilities. The user and the contemplator must both appreciate the personality of the park and see themselves reflected in it.

This overall plan can be broken down into an infinite number of equally important components; every detail is as significant as the next. For example, when a tree is planted, it is not just any tree, anywhere, anyhow. Each plant gets special attention, at each stage of its growth and in each season. In the same way, the path of a road would never be changed without a great deal of thought. Such a change, seemingly innocuous, could tear the fabric of coherence; it

could detract from the surprises inherent in the topography of the site. An astounding sight could be relegated to the blink of an eye, a drop of satisfaction, an appreciation without excitement. The veracity of historic fact is no less exigent. For instance, the original configuration of the area dictated the exact placement of the military engagements, the name of the place, and the location of the Martello towers. It must also be kept in mind that Montcalm did not die on the battlefield to understand how events unfolded. In short, every intervention requires prudence and precision, for the particularities of nature and history must, paradocixally, take the visitor to the Plains outside of time and space, into a world marked by symbolism and imagination, beyond cars and bad weather.

Nature's Great Kingdom

This expression is borrowed from the designer of this magnificent Romantic garden, Frederick G. Todd. It conveys the philosophy that was behind the presentation of his plan in 1909, a plan which proceeded from an aesthetic concept of the countryside and was based on two principles: respect for the site's original physical qualities and the visitor's emotions.

This relationship to the countryside must provoke the human senses. The breathtaking views, the birds' songs, the scent of the flowers, the colours of the autumn leaves, the texture of the bark of the trees must enrich perceptions, encourage the senses, feed the

An unnamable beauty.

311

Soirs d'automne

Voici que la tulipe et voilà que les roses,
Sous le geste massif des bronzes et des
marbres,
Dans le Parc ou l'Amour folâtre sous les arbres,
Chantent dans les longs soirs monotones et
roses.

Dans les soirs a chanté la gaîté des parterres
Où danse un clair de lune en des poses
obliques.
Et de grands souffles vont, lourds et
mélancoliques,
Troubler le rêve blanc des oiseaux solitaires.

Voici que la tulipe et voilà que les roses
Et les lys cristallins, pourprés de crépuscule,
Rayonnent tristement au soleil qui recule,
Emportant la douleur des bêtes et des choses.

Et mon amour meurtri, comme une chair qui
saigne,
Repose sa blessure et calme ses névroses.
Et voici que les lys, la tulipe et les roses
Pleurent les souvenirs où mon âme se baigne.
Émile Nelligan ∞

imagination. Thus, the panoramas are distinctive for their unity and their diversity: the majestic river; the abrupt cliff; the uneven topography; the undulating relief; the varied vegetation. Beside the paths, with their picturesque explanations of flora and fauna, are shadowy spaces, areas for relaxation and intimacy. Nature awakens the senses.

The park has been developed over time. It took more than fifty years and as much tact as tenacity to acquire, lot by lot, the hundred hectares of the highly coveted space. The landscaping took just as much time; the last structures that marred the site were demolished only in the 1950s. At the same time, the Commission gradually endowed the park with the elements of its valorization by planning Parc des Braves, erecting belvederes, designing Jardin Jeanne-d'Arc, and creating innovative floral mosaics. In 1991, it laid out a horticultural path, thus increasing the range and quality of areas to discover. In addition to the good company one brings to or finds in the park, there are five thousand trees of more than eighty species, and a hundred thousand flowering plants of a hundred and twenty species to seduce the senses of people visiting or crossing the Plains.

A Place for the Mind

On the plains, the mind is just as stimulated as the senses. But it is again nature that provides the greatest satisfactions, in this New World laboratory. For centuries, from before the New France era to the present day, the site of the Plains has hosted scientific investigations. For example, children, perpetuating a long tradition of discovering nature, still come to collect leaves for their collections. Each period of history fed similar aspirations: momentary victories, costing lives for glory in eternity. The heroes of the 1759 and 1960 battles expected no less. On the Plains, scholars have broadened the world of knowledge; Québecers have found salubrity; the wealthiest once envisioned a golden life. It is a place for people to play their favourite sports; artists have found a home for their work. The historical aspects of the Plains both follow and accentuate long-established and -recognized traditions.

On the Plains the past lives around us and in us. In this space, there is a fertile coupling between modernity and heritage. Like art and nature, it takess forms enliven the senses. It exists in the preserved remains, such as the walls of the Citadel. It is recalled by the spaces, the plaques, the monuments, the Croix du Sacrifice, and the Monument aux Braves. The site hosts annual events, such as the *Fêtes nationales*, and unique gatherings, such as those to mark major anniversaries. The Musée du Québec, dedicated to the arts, natural science, and archives, also has many commemorative dimensions, manifested by its siting, its architecture, its Québec and international artistic content, and in the synthesis of its aesthetic and memorial productions. In the park, a sundial recalls the efforts to master time,

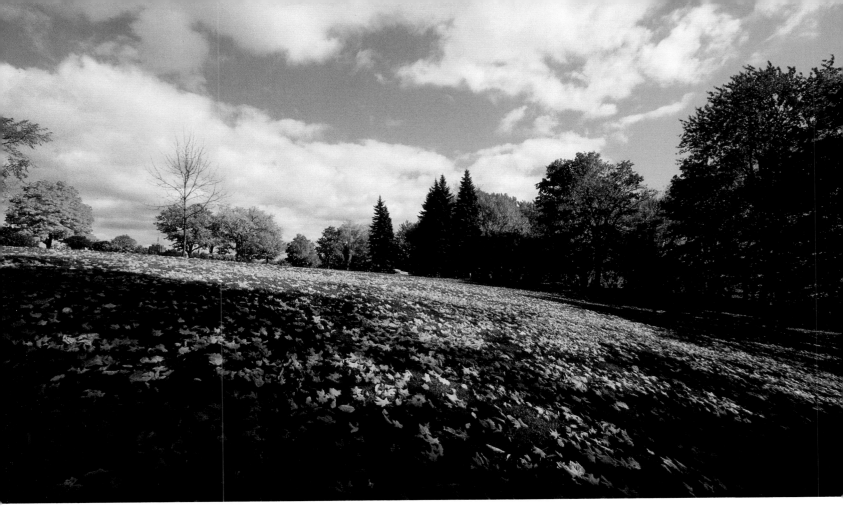

to last forever. Elsewhere, the cannons, happily, are now only playthings for children practising to be mountain climbers or acrobats. To each a victory, and a victory to each!

An Affair of the Heart

Among the million people who come to Battlefields Park each year, a majority are regular visitors. Most are simply looking for a place to relax, no doubt because the physical context lends itself admirably to this use. It is not necessary to remind these regular visitors about respect for nature or protection of the historic heritage. They have discovered in the park a sense of history and the environment and a pleasant place to partake of their favourite activities. They do not wonder about all the effort it took to create the park. They are content to cherish it.

In this sense, they are continuing traditions. They appreciate and love the Plains. Perhaps unconsciously, they themselves provide the link between nature and culture, between the past and the future. Cherished Plains, cherished visitors: today for tomorrow!

ILLUSTRATION CREDITS*

Chapter 1

P. 16, NAC, neg. no. NMC-59019; p. 19, NAC, neg. no. C-1515; p. 24, NAC, neg. no. C-15844; p. 27, ANQ, Henry Hiché, CN1-135, neg. no. N773-174; p. 28, NAC, neg. no. C-80267; p. 31, NAC, neg. no. C-15722; NAC, neg. no. C-23558; p. 33, NAC, neg. no. NMC-62943.

Chapter 2

P. 39, BNQ, Montréal; p. 41, NAC, neg. no. C-1514; p. 42, BNQ, Montréal; p. 44, Service historique de l'Armée, Vincennes, FrNACe; p. 45, Bibliothèque nationale, Paris; p. 47, NAC, neg. no. C-2029; p. 51, ANQ, Henry Hiché, CN1-135, neg. no. N773-174; p. 54, BNQ, Montréal; p. 55, BNQ, Montréal; p. 56, Oil on canvas Pierre Mignard. Musée de l'île Sainte-Hélène; p. 58, BNQ, Montréal; p. 62, Musée national de la Finlande, Helsinki; p. 65, Musée de l'île Sainte-Hélène; p. 66, NAC, neg. no. MNC 16056; p. 68, NAC, neg. no. 15995; p. 69, NAC, neg. no. C-21760; p. 70, BNQ, Montréal; p. 71, NAC, neg. no. C-42181; p. 73, NAC, neg. no. C-6022.

Chapter 3

P. 78, NAC, neg. no.. C-27665; p. 79, NAC, neg. no. C-3916; p. 81, ROM, Canadian Department, Sigmund Samuel Collection 949.28.2; p. 82, NAC, neg. no. NMC-54105; p. 85, NAC, NAC; p. 86, NAC, neg. no. C-350; p. 88, Parks Canada, Ottawa; p. 89, ANQ, Collection initiale, neg. no. GH-970-159; p. 90, *Reports of Royal Canadian Society,* section II, 1899; p. 91, NAC; NAC, neg. no. C-2736; p. 92, NAC, neg. no. C-12248; p. 93, Musée du Québec; p. 94, NAC; p. 95, NAC, neg. no. C-350; p. 96, NBC; p. 98, NAC, neg. no. C- 361; p. 101, ANQ, Collection initiale, neg. no. N-474-35; National Gallery of Canada 18489.

Chapter 4

P. 108, NAC; p. 111, NAC, neg. no.. C-358; p. 112, NAC, neg. no.. NMC-2310; p. 113, NAC, neg. no. C-40585; p. 114, NAC, neg. no. C-46334; p. 118, NAC, neg. no. C-55469; p. 120, NAC, neg. no. C-812; p. 122, NAC, neg. no. C-29195; p. 124, NBC; p. 127, NAC, neg. no. C-70720; p. 129, NAC, neg. no. C-63967; NAC, neg. no. C-46004; p. 130, NAC, negatif no. C-829; p. 133, AVQ, no. 10225; Bibliothèque de l'Université Laval; p. 134, NAC, neg. no. C-12636; p. 135, NAC, neg. no. C-1864; NAC, neg. no. C-35943.

Chapter 5

P. 138, NAC, neg. no. C-874; p. 140, ANQ, Collection initiale, neg. no. N-1173-110; p. 143, Bibliothèque de l'Université Laval; NAC, neg. no. C-45492; p. 144, Bibliothèque de l'Université Laval; p. 147, NAC, neg. no. C-1050; p. 149, NAC, neg. no. C-73082; p. 150, AVQ, 9940; p. 152 et 153, *Le Soleil,* 14 mai et 2 juin 1900; p. 154, NAC, neg. no. C-65101; p. 158, ROM, Allodi, no. 331, Cat. 942. 48. 68; p. 160, NBC; p. 161, NBC; p. 164, NAC, neg. no. C-40173; NAC, neg. no. C-40178; p. 166, NAC, neg. no. PA-24066; NAC, neg. no. C-136667; p. 167, ANQ, Collection initiale, neg. no. N-277-245A; p. 168, NAC, neg. no. C-12649; p. 169, NAC, C-102392; NAC, neg. no. C-12494; p. 170, NAC, neg. no. C-73094; p. 171, Musée du Québec, A-34427-S.

Chapter 6

P. 175 et 176, Musée du Québec; p. 177, Musée du Québec; p. 179, NAC, neg. no. C-3251; p. 180, Archives du monastère des Ursulines de Québec; p. 181, Musée du Québec; p. 182, NAC, neg. no. PA-122945; NAC, neg. no. C-79037; p. 186, NAC, neg. no. C-56617; p. 187, AVQ, D-343-1873; p. 188, NAC, neg. no. C-1014; p. 194, NBC, P1-31.

* When there is more than one illustration on a page, credits are given from left to right and from top to bottom. Photographs with no credit are by Eugen Kedl.

Chapter 7

P. 206, NBC, P4-20; NAC, neg. no. C-12684; p. 207, NAC, neg. no. C-33290; p. 212, NBC; NAC, neg. no. C-22683; p. 213, NBC; p. 214, Musée McCord, Montréal; p. 216, NBC, G1-8 et G2-2; p. 219, NBC, D2-101; p. 220, NBC, W1-19; p. 226, NBC, C3-4; p. 227, NBC, P1-36; p. 228, NBC; p. 229, NBC, C4-6; p. 230, NBC, T2-2; NBC, T2-15; AVQ, Office municipal du tourisme, P33/3,7; p. 231, NBC, J1-54; NBC J1-4; NBC, J1-8; p. 233, NAC, neg. no. PA-29235; NBC, NAC, neg. no. C-3390; p. 234, AVQ, Edwards, 76; p. 235, NBC, T3-68, NBC, T3-19b; p. 236, NAC, PA 107373; NAC, neg. no. PA-99837; AVQ, A-H-5200-332; p. 237, NBC, C4-14; ANQ, Collection initiale, neg. no. N-974-140.

Chapter 8

P. 242, NBC; p. 243, NBC, P1-1; p. 244, ANQ, fonds Magella Bureau, CPN-64/35; p. 245, NAC, neg. no. PA-24132; p. 246, ANQ, Collection initiale, Q17-212-1573, neg. no. N-81-3-3; p. 250 et 251, NBC; p. 251, NAC, neg. no. PA-24128; p. 252, NAC, neg. no. PA-165608; NAC, neg. no. PA-164816; p. 254 et 255, NAC, neg. no. PA-20884; ANQ, P600-6/GH 470-55; p. 257, NBC; p. 265, Photo K. Elder. NBC, T3-33; p. 268, ANQ, P428 PN-431/514.

Chapter 9

P. 276, ANQ, Collection initiale, Q4-35-381; p. 278, NBC, C1-1 et C1-6; p. 279, ANQ, Collection initiale, neg. no. N-275-42; p. 282, ANQ, E10-NN-74-456 (7A); ANQ, Q-E-67-742-1271; p. 292, NBC, O1-12); p. 297, NBC; p. 302, NAC, neg. no. C-38664 et C-38667; p. 303, ANQ, Fonds de l'Office du film du Québec, neg. no. 639-62-H; NBC; NBC, O1-6; p. 305, ANQ, P428-PN-431-754.

The Authors

The Plains of Abraham: The Search for the Ideal is the work of a number of researchers, under the direction of Jacques MATHIEU.

Alain BEAULIEU, research assistant in the history department, Université Laval, author of *Convertir les fils de Caïn* (Nuit Blanche, 1992).

Yvon DESLOGES, historian, Parks Canada, co-author of *Québec, ville fortifiée* (Pélican, 1982).

Jean DU BERGER, ethnology professor at Université Laval, author of *Pratiques culturelles traditionnelles* (Célat, 1988).

Donald GUAY, author of a number of books on the history of sports, including *Histoires vraies de la chasse au Québec* (1983), *Histoire des courses de chevaux au Québec* (VLB, 1985), *Introduction à l'histoire des sports au Québec* (VLB, 1987), and *Histoire du hockey au Québec* (JCL, 1990). In 1990, he also published *Histoire de l'éducation physique (1830–1980)*.

Alain LABERGE, history professor at Université Laval, co-author of *L'occupation des terres dans la vallée du Saint-Laurent (1723-1745)*, Septentrion, 1991.

Jacques LACOURSIÈRE, scientific historian and popularizer, co-author of *Journal Boréal Express*, *Canada-Québec, synthèse historique*, and *Nos racines*.

Jacques LETARTE, cartographer and geography professor at Université Laval.

Michel LEULLIER, secretary, National Battlefields Commission.

Yves MELANÇON, doctoral student, geography department, Université Laval.

Guy MERCIER, geography professor and researcher at CRAD (Centre de recherche en aménagement et développement), co-editor of a special issue of *Cahiers de géographie du Québec* (1992) on "La géographie humaine structurale."

Claude PAULETTE, iconography expert and publishing consultant. Co-author, with Pierre Lahoud, of *Québec à ciel ouvert* (Libre expression, 1987).

Jean PROVENCHER, historian and author of a number of books, including *Québec sous la Loi des mesures de guerre* (Boréal Express, 1971), *René Lévesque, portrait d'un Québécois* (La Presse, 1973), and *Les quatre saisons dans la vallée du Saint-Laurent* (Boréal, 1988).

Gilles RITCHOT, geography professor at Université Laval, author of a number of books, including *Les essais de géomorphologie structurale* (PUL, 1975), and co-author of *La forme de la terre* (Préambule, 1984), *Morphodynamique structurale de la terre et des astres* (Préambule, 1988), and of studies on structural geography for the special issue of *Cahiers du CRAD* (1991).

CONTENTS